Visions of Heaven

The Dome in European Architecture

Visions of Heaven
The Dome in European Architecture

DAVID STEPHENSON

With essays by Victoria Hammond and Keith F. Davis

PRINCETON ARCHITECTURAL PRESS
NEW YORK

Published by
Princeton Architectural Press
37 East Seventh Street
New York, New York 10003

For a free catalog of books, call 1.800.722.6657.
Visit our web site at www.papress.com.

© 2005 Princeton Architectural Press
All rights reserved
Printed and bound in China
09 08 07 06 05 5 4 3 2 1 First edition

Images © David Stephenson, appearing courtesy Julie Saul Gallery, www.saulgallery.com

Editing: Nicola Bednarek
Design: Jan Haux

Special thanks to: Nettie Aljian, Dorothy Ball, Janet Behning, Megan Carey,
Penny (Yuen Pik) Chu, Russell Fernandez, Clare Jacobson, John King, Mark Lamster, Nancy Eklund Later,
Linda Lee, Katharine Myers, Lauren Nelson, Molly Rouzie, Jane Sheinman, Scott Tennent, Jennifer Thompson,
Paul Wagner, Joseph Weston, and Deb Wood of Princeton Architectural Press
—Kevin C. Lippert, publisher

Library of Congress Cataloging-in-Publication Data
Stephenson, David, 1955–
Visions of heaven : the dome in European architecture / David Stephenson ;
with essays by Victoria Hammond and Keith F. Davis
p. cm.
Includes bibliographical references.
ISBN 1-56898-549-5 (alk. paper)
1. Architectural photography—Europe. 2. Domes—Europe—Pictorial works.
3. Photography of interiors—Europe. 4. Stephenson, David, 1955–
I. Hammond, Victoria. II. Davis, Keith F. III. Title.
TR659.S74 2005
779'.4—dc22
2005009068

Contents

Admiration and Awe
David Stephenson and the Photographic Sublime 6
by Keith F. Davis

I.
Classical, Byzantine, Islamic,
Romanesque, and Gothic Architecture 14

II.
The Renaissance 56

III.
The Baroque
in Southern and Western Europe 80

IV.
The Baroque and Rococo
in Central and Eastern Europe 116

V.
The Nineteenth Century 154

The Dome in European Architecture 160
by Victoria Hammond

Bibliography 192

Admiration and Awe
David Stephenson
and the Photographic Sublime

by Keith F. Davis

Over the last quarter-century, David Stephenson has produced a remarkable body of work: one that is rigorously conceived, richly varied, critically informed, inventive, and poetic. This work is composed of a series of discrete and systematic investigations of a single large subject: the idea of the sublime.

Much, of course, has been written on the artistic meaning and philosophical tradition of the sublime. Developed in the eighteenth century from the writings of (among others) Joseph Addison, Edmund Burke, Alexander Gottlieb Baumgarten, and Immanuel Kant, this idea forms a cornerstone of modern aesthetic theory.[1] The sublime involves a specific set of emotions and qualities: terror, obscurity, power, vastness, and infinity. The examples of the natural sublime cited by these writers include such familiar motifs as the boundless ocean, powerful storms, tall mountain peaks, deep chasms with raging torrents, and the starry night sky.

There are (at least) two key ideas in this reading of the sublime. First, the sublime is a matter not merely of objective, physical experience, but of one's subjective involvement *in*, or meditation *on*, the experience. Kant, for example, clearly states that sublimity is a product of the human mind, not a quality actually inherent in things. As such, the sublime represents a powerful synthesis of world and self, facts and ideas, images and feelings. Second, because this process involves the temporary alteration or expansion of our normal frames of reference, the sublime—for all its terror—can be a pleasurable and even necessary experience. As Joseph Addison wrote in 1712:

> Nothing is more pleasant to the fancy than to enlarge itself by degrees, in its contemplation of the various proportions which its several objects bear to each other, when it compares the body of man to the bulk of the whole earth, the earth to the circle it describes around the sun, that circle to the sphere of the fixed stars.[2]

Or, as Burke put it, "Infinity has a tendency to fill the mind with [a] sort of delightful horror."[3]

The "delightful horror" of things vast and powerful stands, paradoxically perhaps, as an emblem of human freedom. Addison suggested that vast scenes present an image of liberty: endless realms in which the eye and imagination can roam unfettered. The play of imagination triggered by the sublime allows the self to symbolically engage subjects or feelings that would otherwise be inaccessible. These sensory and emotional experiences constitute a new form of understanding—a complement to reason as traditionally understood. They illuminate a powerful and paradoxical truth: we are at once insignificantly small in the face of nature and an integral part of it.

Kant's complex analysis of the freedom of the imagination posits an absolute linkage between aesthetic ideas, reason, and morality. All aesthetic response is an

expression of the "free lawfulness" of the imagination, a lawfulness in which we find the freedom to conduct ourselves autonomously by the universal and transcendent dictates of reason. Thus, aesthetic beauty, the precepts of morality, and the structure of the universe are intimately related. In Kant's remarkable and memorable words:

> Two things fill the mind with ever new and increasing admiration and awe, the more often and steadily we reflect upon them: *the starry heavens above me and the moral law within me.* . . . I see them before me and connect them immediately with the consciousness of my existence. The first starts at the place that I occupy in the external world of the senses, and extends the connection in which I stand into the limitless magnitude of worlds upon worlds, systems upon systems. . . . The second begins with my invisible self, my personality, and displays to me a world that has true infinity, but which can only be detected through the understanding, and with which . . . I know myself to be in not, as in the first case, merely contingent, but universal and necessary connection.[4]

In this reading, the sublime is central to the larger notion of aesthetic experience, which in turn provides a suggestion or symbol of *who* and *where* we are, in the deepest sense imaginable.

This enormously rich set of ideas has been interpreted, extended, and critiqued by succeeding generations of artists, theorists, and philosophers. Stephenson is one of an important group of contemporary photographic artists who have explored the legacy of the sublime and, in so doing, have helped reinvent it. This contemporary quest is an appropriately skeptical and critical one. No element in the eighteenth-century equation of the sublime—nature, transcendence, the self, reason, freedom, morality—can be understood as simple, self-evident, or timeless. And yet, each of these terms *does* have meaning for us today—a meaning that begins with its own historical genealogy.

Stephenson's work of the past quarter-century represents a deeply personal attempt to rethink the meaning of the sublime. His artistic path over these years has been remarkably disciplined and focused. With the benefit of hindsight, we can see that he has—through some purely individual combination of method and intuition—explored and reconsidered most of the key themes of this history. A recent large exhibition, titled "Cosmos: From Romanticism to the Avant-garde," documented the ways in which artists and scientists have imagined nature (on the largest scale) from the late eighteenth century to the present.[5] Stephenson's work recapitulates the central motifs in this survey: the mystery and promise of the untamed wilderness, the forbidding purity of the polar regions, and the infinite majesty of the heavens. In

addition to these facets of the natural sublime, Stephenson has explored the techno-logical and cultural sublime: great works of industry and the architecture of transcendence. Finally, in addition to this extended meditation on the sublime, Stephenson's work consistently acknowledges its own means—the basic nature and potentials of photography itself. His pictures strike a consistent and energizing balance between the (objective) subject and the (subjective) process of perception, construction, and interpretation.

Stephenson's first serious body of work, begun during his graduate studies, is titled *New Monuments* (1979–83). Inspired by a host of artistic precedents—from Carleton Watkins to Robert Smithson—these images depict large-scale industrial structures such as bridges, dams, and the Alaska pipeline. While Stephenson conceived these photographs as single views, he soon shifted to the production of panoramas of three to five overlapping prints. It was appropriate that, like the subjects he was recording, these composite photographs were viewed as artifacts, overtly constructed things. After his arrival in Tasmania in 1982, Stephenson extended this work to include the controversial hydroelectric projects then under way on the island. While these pictures expressed clear environmental and political concerns, his next series—*Composite Landscapes* (1982–88)—was more mythic in nature. Many of these large mosaic works, made in the Tasmanian wilderness, the American West, and the Indian Himalayas, deal with grand natural vistas that are clearly indebted to the motifs of the Romantic-era sublime. The physical complexity of these images led to a deliberate move toward simplification; Stephenson's next project; *Pinhole Photographs* (1988–89), used the most basic of imaging tools to record spare ocean vistas and horizons.

The series *Clouds* (1990–93) was stimulated by Stephenson's interest in the histories of both photography and transcendental thought. On one level, these pictures are an homage to Alfred Stieglitz's celebrated *Equivalents* of the 1920s—images of clouds intended (in classic Romantic fashion) to trigger a host of subjective moods and emotions. Stephenson's blurred, brooding photographs hold this artistic legacy up to examination—they are postmodern "Equivalents" that at once confirm and question the possibility of transcendent experience. In this period, Stephenson was also involved in a collaborative project, *Kindred Spirits/The Overland Track* (1990–92), with the Tasmanian-based printmaker and painter Ray Arnold.[6] Stephenson's contribution to this project included views of the Tasmanian landscape joined with brief, poetic texts.

In these years, Stephenson was fascinated by the dauntingly alien landscape of Antarctica. He made two visits there, in 1990 and 1991, as well as a related trip to the Arctic regions of northern Europe. These trips resulted in three bodies of work. *Vast* (1990–91) deals with the elemental themes of water, air, and time in juxtaposed

diptychs of Scandinavian skies and streams, and icy Antarctic vistas. In both cases, Stephenson's presentational strategy (diptychs composed of either vertical or horizontal pairings) aimed at creating a tension between an apparently transparent rendition of the "real" world and a more complex pictorial and conceptual abstraction. For his series *The Ice* (1991–93), Stephenson printed black-and-white negatives on color paper, creating ethereal images in a pale, ghostly blue. These photographs stand on the boundary between description and abstraction, sight and sensibility. In *Blue-Green Horizon Line/Southern Ocean* (1991–93), he made a similar use of false color for expressive, rather than descriptive, purposes. In these seven-print ocean panoramas, the hue of the image shifts gradually from one side to the other, from pale green to delicate blue—symbolizing the voyage south from the warm Tasmanian Sea into the icy waters of the Antarctic.

Stephenson's life and work underwent significant change in the early 1990s. After returning from many weeks in the stark environment of the Antarctic, he was struck anew by the green—and lush growth—of the Tasmanian forest. He responded to this verdant subject in a collaborative project, *Dark Nature* (1992–93), with his academic colleague (and later wife) Anne MacDonald. Together, the pair created images exploring the landscape's range of possible meanings, from the benign and spiritual to the hostile and oppressive. This landscape is, at once, a symbol of order and chaos, life and death, freedom and claustrophobia. With his series *Interiors* (1992–93), Stephenson turned for the first time to an exclusively cultural subject. These details of a once majestic but now decaying Regency mansion provide a poignant metaphor for the turmoil of his personal life at the time.

Beginning in 1993, Stephenson began the projects for which he has received the most international attention. In that year, he was awarded an Australia Council Studio Residency in Besozzo, Italy. He flew out of Hobart with great eagerness but little specific idea of what he would photograph in Italy. Quickly, however, he found inspiration. On a visit to Rome, he went to the Pantheon, where he was overwhelmed by the vast internal space and majestic dome of the ancient structure. A new series was born. During his remaining three months in Italy, he traveled extensively to record the domes of over one hundred churches and cathedrals. At the same time, he explored other subjects: trees, surfaces of water, and the ceramic photographic portraits attached to gravestones. Stephenson combined these four Italian motifs in the exhibition "Transfigurations." This title underscored his interest in the largest possible themes: nature and culture, perception and memory, life and death, time and transcendence.[7]

These profound issues also lie at the heart of Stephenson's *Stars* (1995–96) series. These remarkable photographs use extended, interrupted, or overlapping exposures to

transform the starry night sky into a matrix of elegantly arcing lines. Here, photography, drawing, light, and time are woven together into something at once new and ancient. Through Stephenson's artistic intercession, the camera becomes a tool of almost magical power—the means by which the cosmos "draws" itself in a potentially endless series of permutations. This body of work combines a surprising simplicity of means with an extraordinarily rich set of cultural and historical references. Throughout history, humankind has looked to the heavens for both geographical and spiritual orientation: when in doubt as to where we are going, we have always looked upward.

The same reflex—finding ourselves by looking up—is at the heart of our experience of sacred architecture. Stephenson returned to photographing domes in 1996 and has been at it ever since, expanding his quest beyond Italy to include cupolas in nearly every European country. Stephenson revels in the infinite variety of these forms: domes, like snowflakes, are at once generic and unique. No two are really alike, and yet the feelings we experience standing beneath them are interestingly consistent. These are special and protected spaces that glow with a carefully orchestrated light. As we look up into a dome, we feel elevated, uplifted; we have, in a sense, stepped out of the flow of secular time and—for a moment—into eternity. Domes present an image of geometric clarity—more or less intricate in pattern, each is structured as a boldly symmetrical design around a central oculus or focal point. The effect of this is at once spiritual and rational. As we are (psychologically) drawn upward into these spaces, we also recognize the symbolic language of their precise and logical construction. The dome's symmetry presents an image of unity, totality, and resolution. This design has no beginning or end: we perceive—with God-like clarity—everything at once. We are given, in essence, a divine vision of the cosmos. Appropriately, this insistent geometry stands as a symbol of thought itself—of the capacity (perfect in God, less so in Man) to construct and to perceive flawless coherence in disparate pieces and parts. The bold geometry of these domes is important to their power: beginning with the ancient Greeks, geometry and logic have been closely allied.[8] Finally, of course, these domes are images of heaven, with all its attendant motifs and associations: angels, infinity, transcendence, and salvation.

As an artist, Stephenson is only in mid-career: it is abundantly clear that he has many productive years, and projects, ahead of him. That said, I can only marvel at how elegantly all his previous concerns are crystallized and summarized in his domes work. The experience of the dome is one of an ideal realm—a remarkable synthesis of engineering and metaphysics, a space of the imagination in which volume is revealed as a function of design. Before taking his first dome photograph, Stephenson roamed the world to record the American West, the Tasmanian rain forest, the Himalayas, the Scandinavian north, the frigid expanse of the Antarctic, and such elemental subjects as

water, clouds, and stars. In every case, he sought to create photographs with an essentially dual meaning—images balancing his genuine respect for the reality of things with his awareness that the world is inevitably informed and shaped by the ideas we bring to it. Thus, every landscape photograph is a hybrid of what we see and what we think; each is an attempt to imagine a totality—a satisfyingly complete and coherent (visual) world in miniature. This ideal is closely allied to our experience of domes, which provide the "Equivalent" of a flawlessly unified (and thus transcendent) experience, one in which man's constructive intellect stands as a symbol of (or our longing for) a divine genius and logic. This experience can only be a synthesis of the objective and the subjective—what we see, and what we think and feel. As Stephenson understands so well, our "enlightened" skepticism cannot negate the resonance of this encounter. His domes are a perfect emblem of the sublime: a conception of space in which reason and intuition become one.

1 For a concise overview of this rich subject, see, for example, Paul Guyer, "The Origins of Modern Aesthetics: 1711–35," in Peter Kivy, ed., *The Blackwell Guide to Aesthetics* (Oxford: Blackwell Publishing, 2004), 15–44.

2 Ibid., 33.

3 Edmund Burke, *A Philosophical Inquiry into the Origin of our Ideas of the Sublime and Beautiful* (1757), cited in Charles Harrison, et al., *Art in Theory 1648–1815: An Anthology of Changing Ideas* (Oxford: Blackwell, 2001), 520.

4 Immanuel Kant, *Critique of Practical Reason* (1788); cited in Guyer, ed., *The Cambridge Companion to Kant* (Cambridge: Cambridge University Press, 1992), 1.

5 The exhibition was organized by the Montreal Museum of Fine Arts. See Jean Clair, ed., *Cosmos: From Romanticism to the Avant-garde* (Munich: Prestel/Montreal Museum of Fine Arts, 1999).

6 The title of this body of work pays clear homage to Asher B. Durand's famous painting of the same name, from 1849.

7 This was presented at Fotofeis '95 International Festival of Photography, in Scotland. A slightly later exhibition under the same title, at Robert Lindsay Gallery in Melbourne, was composed of just domes and gravestone portrait images.

8 For example, as the scholar Wilbur Knorr has written: "To the ancient Greeks we owe the notion of mathematics as a form of theoretical knowledge. . . . In this conception, the project of geometry is not the manipulation of figures in physical constructions but the understanding of their properties in pure thought." From "Mathematics," in Jacques Brunschwig and Geoffrey E. R. Lloyd, eds., *The Greek Pursuit of Knowledge* (Cambridge, Mass.: Belknap Press, 2003), 235. It is interesting to note that two of the most remarkable works in the history of philosophy—Spinoza's *Ethics* and Wittgenstein's *Tractatus Logico-Philosophicus*—are strongly indebted to the form of the geometrical theorem or proof.

I.
Classical, Byzantine, Islamic, Romanesque, and Gothic Architecture

*Every effort has been made to identify architects, artists, and
building dates associated with the domes represented in this
book, but particularly with early buildings, information is scarce
or inconsistent; at present some details remain unknown.

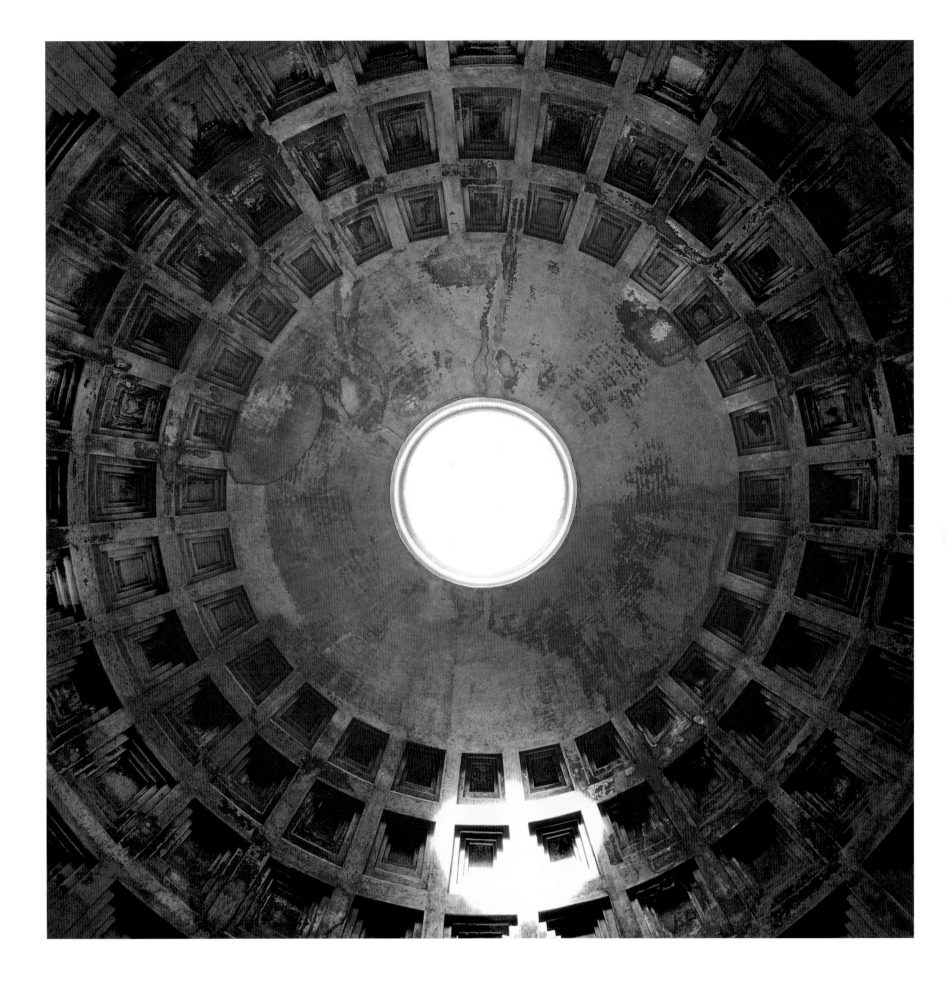

PANTHEON
Rome, Italy, 117–138,
built by Hadrian (76–138)*

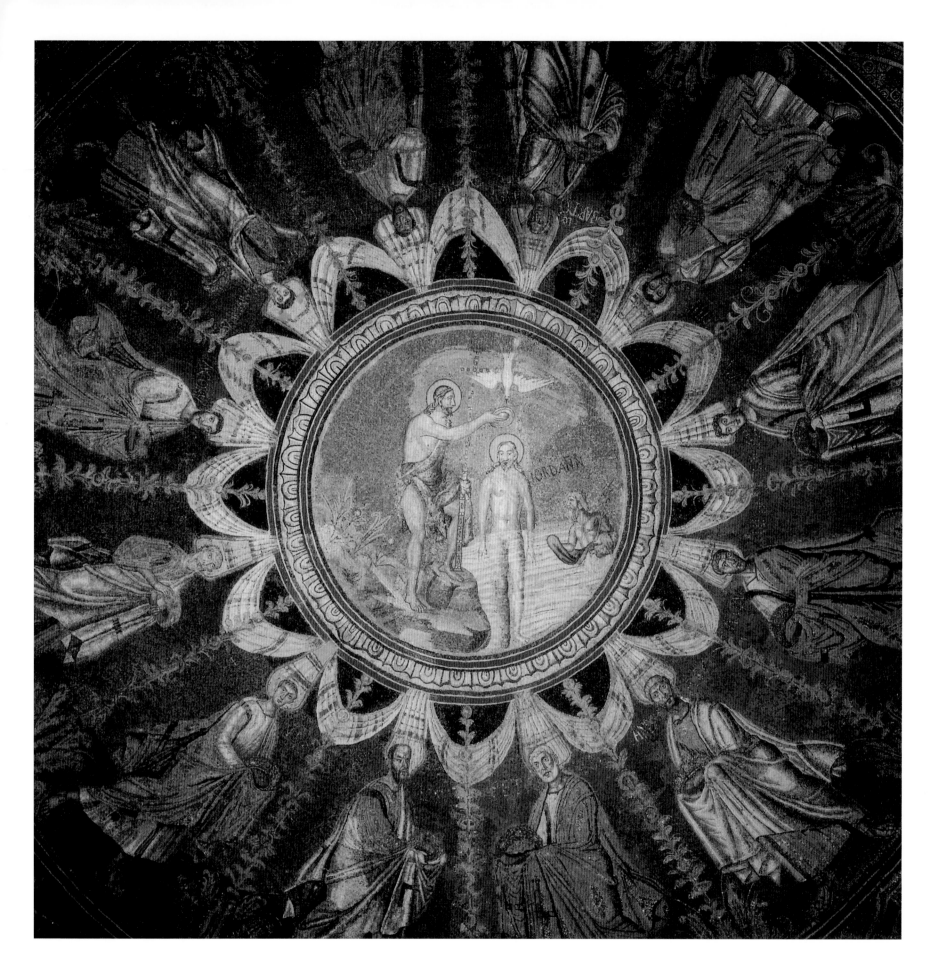

BATTISTERO DEGLI ORTODOSSI
Ravenna, Italy, 400–500

16

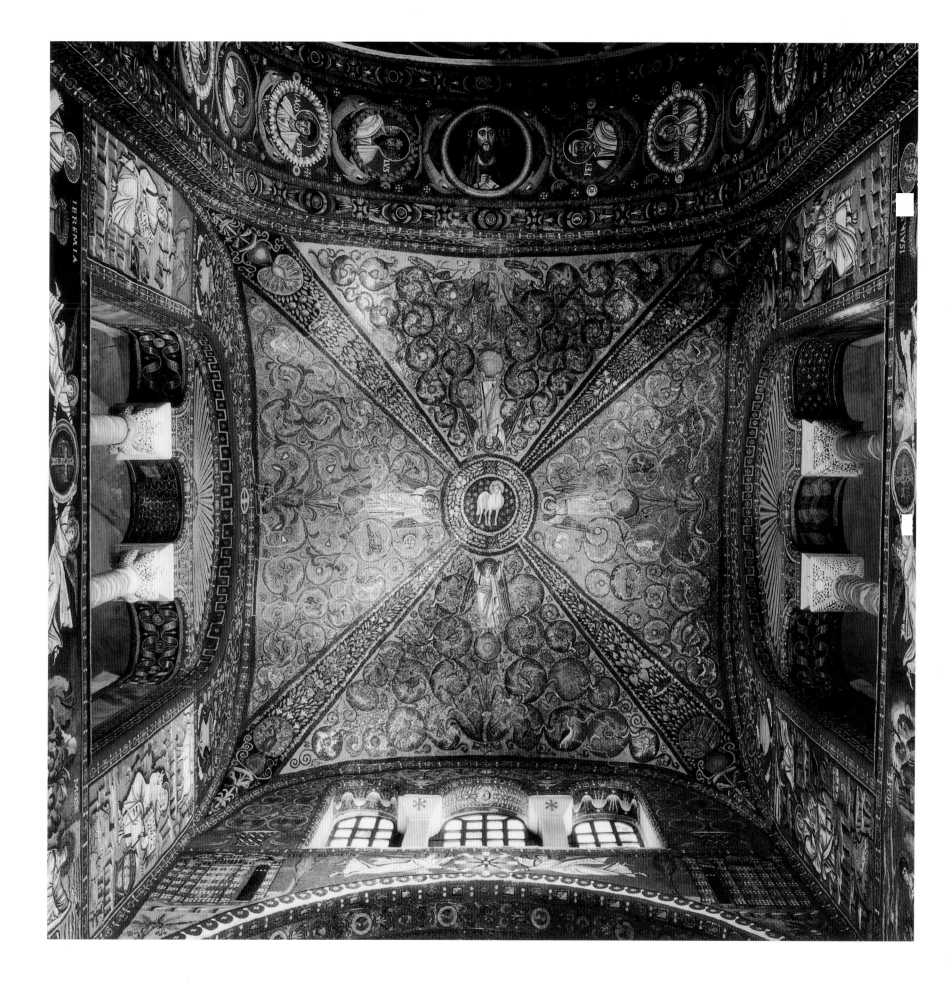

APSE, SAN VITALE
Ravenna, Italy, 526–47

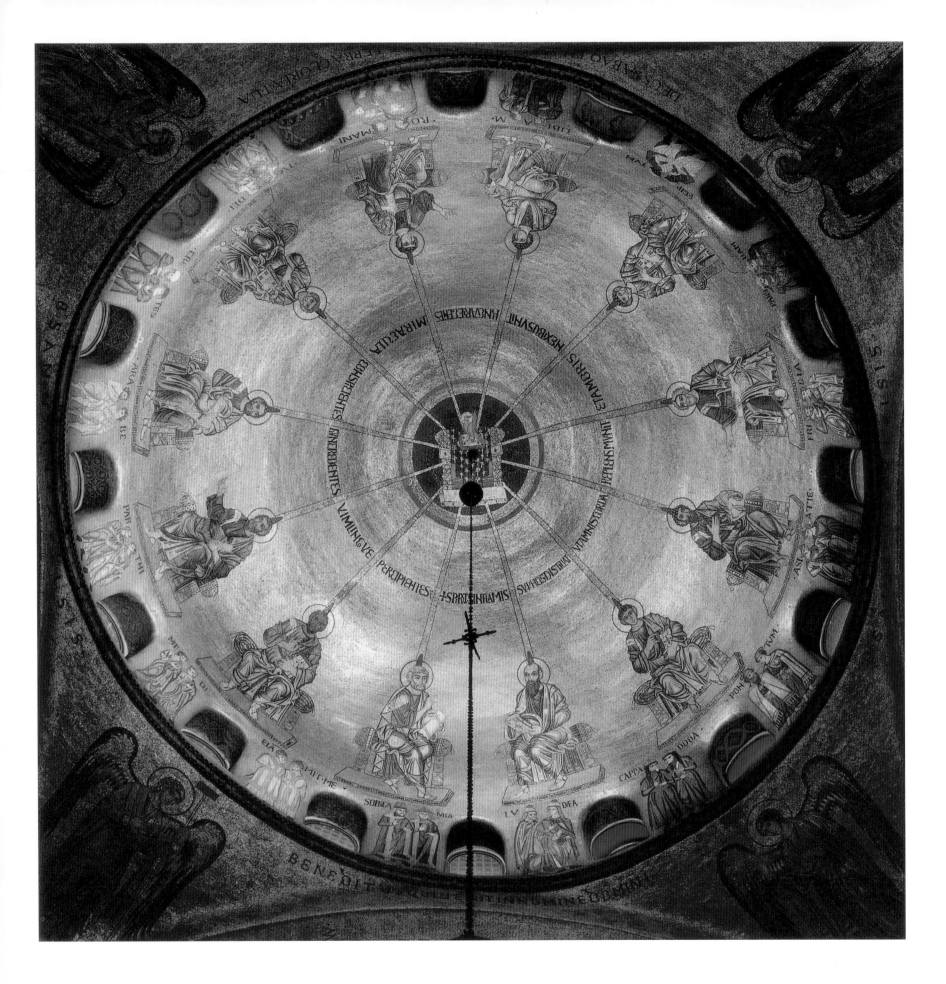

PENTECOST DOME, SAN MARCO
Venice, Italy, begun 1063,
Mosaics c. 1108–88

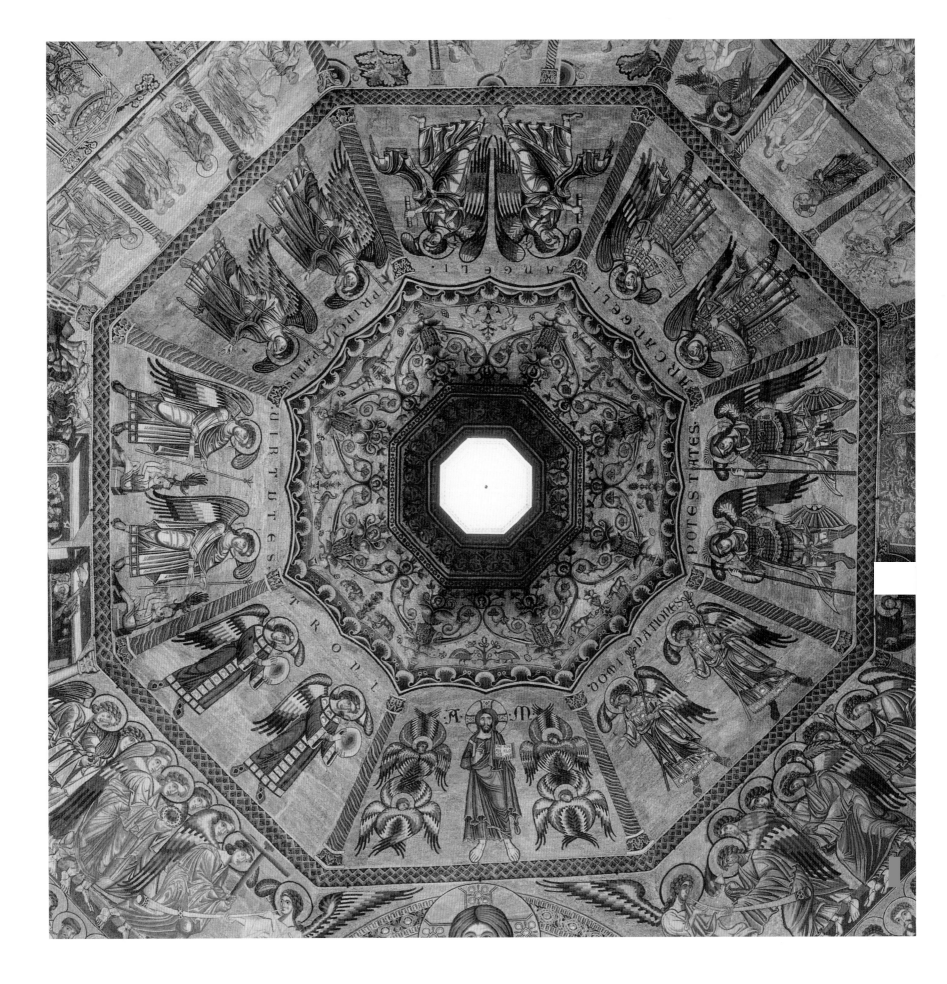

BATTISTERO
Florence, Italy, begun by 1113,
mosaics begun 1225

19

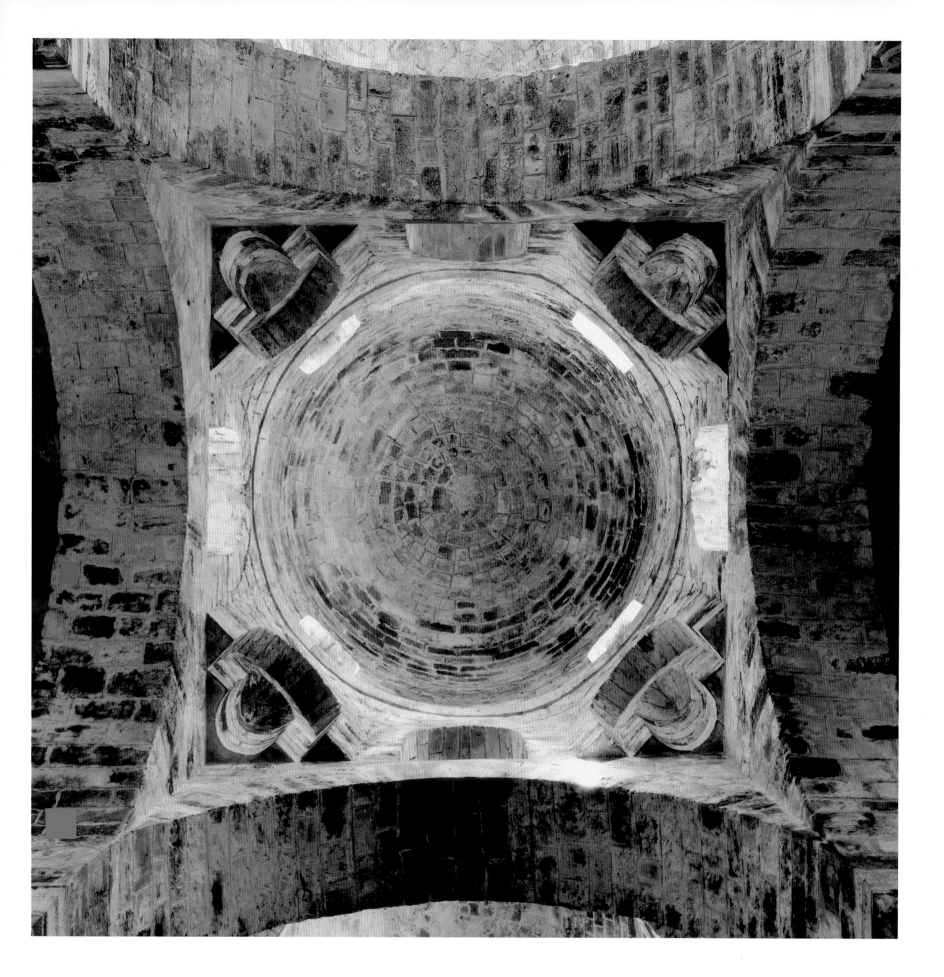

SAN CATALDO
Palermo, Italy, c. 1161

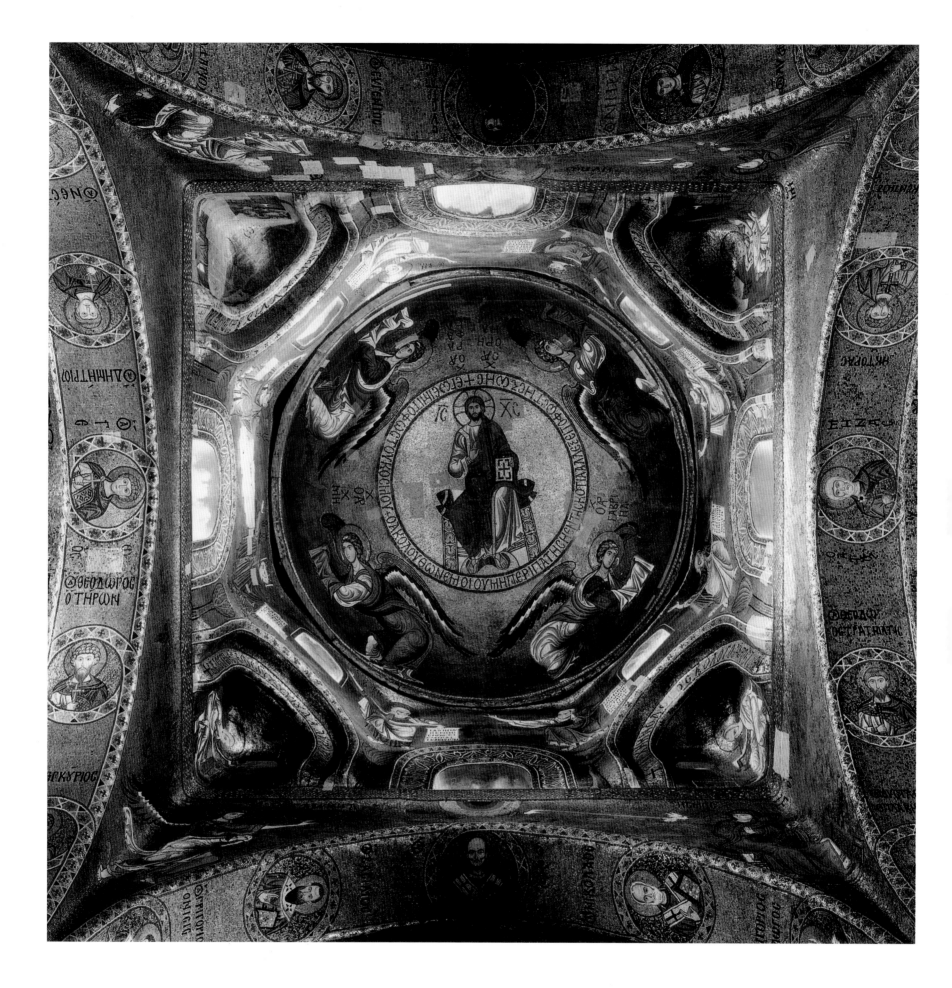

La Martorana (Santa Maria del Ammiraglio)
Palermo, Italy, 1143–51

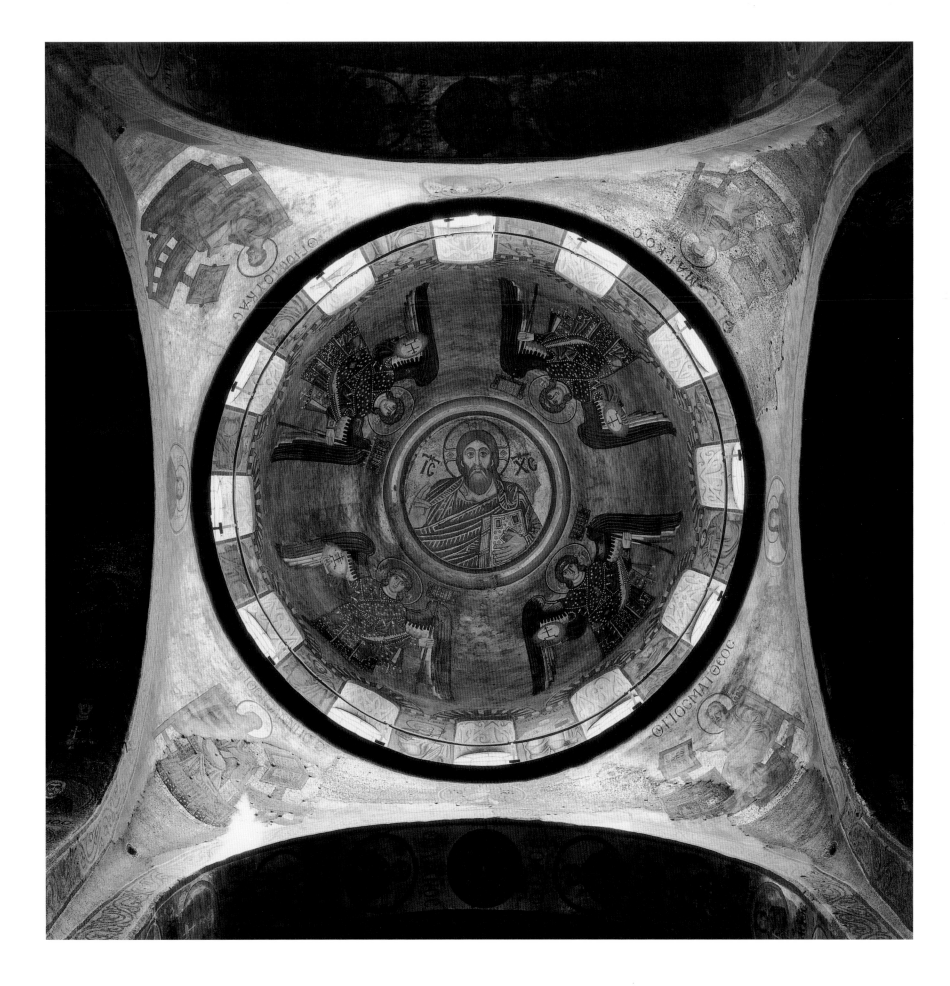

St. Sophia

Kiev, Ukraine, begun 1037

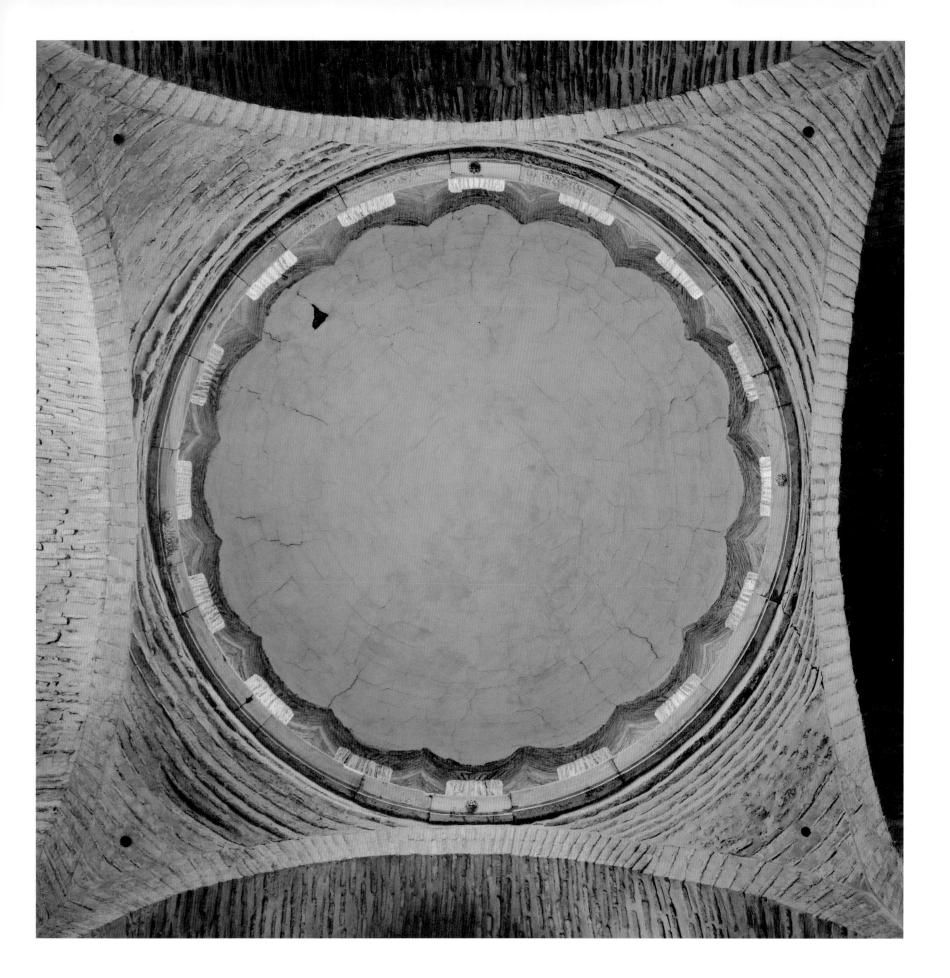

CHURCH OF THE CHORA
Istanbul, Turkey, c. 1050–1320

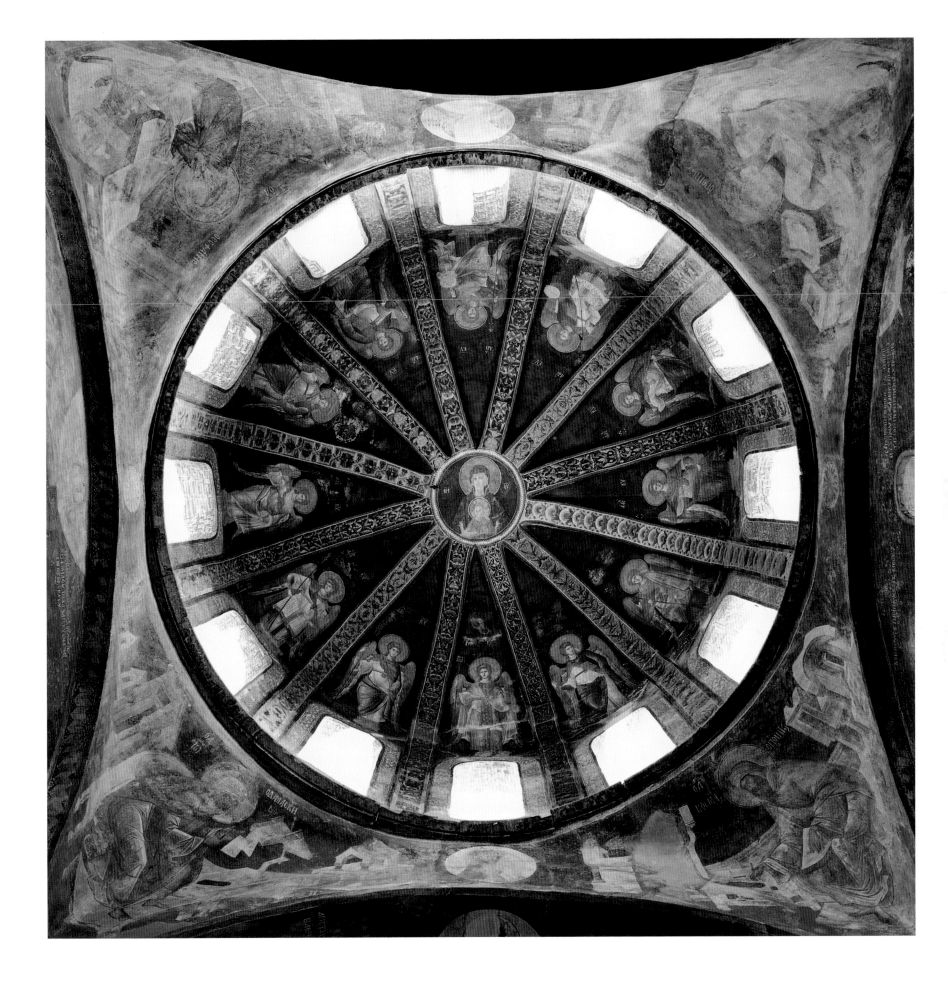

CHURCH OF THE CHORA
Istanbul, Turkey, c. 1050–1320,
fresco c. 1303–20

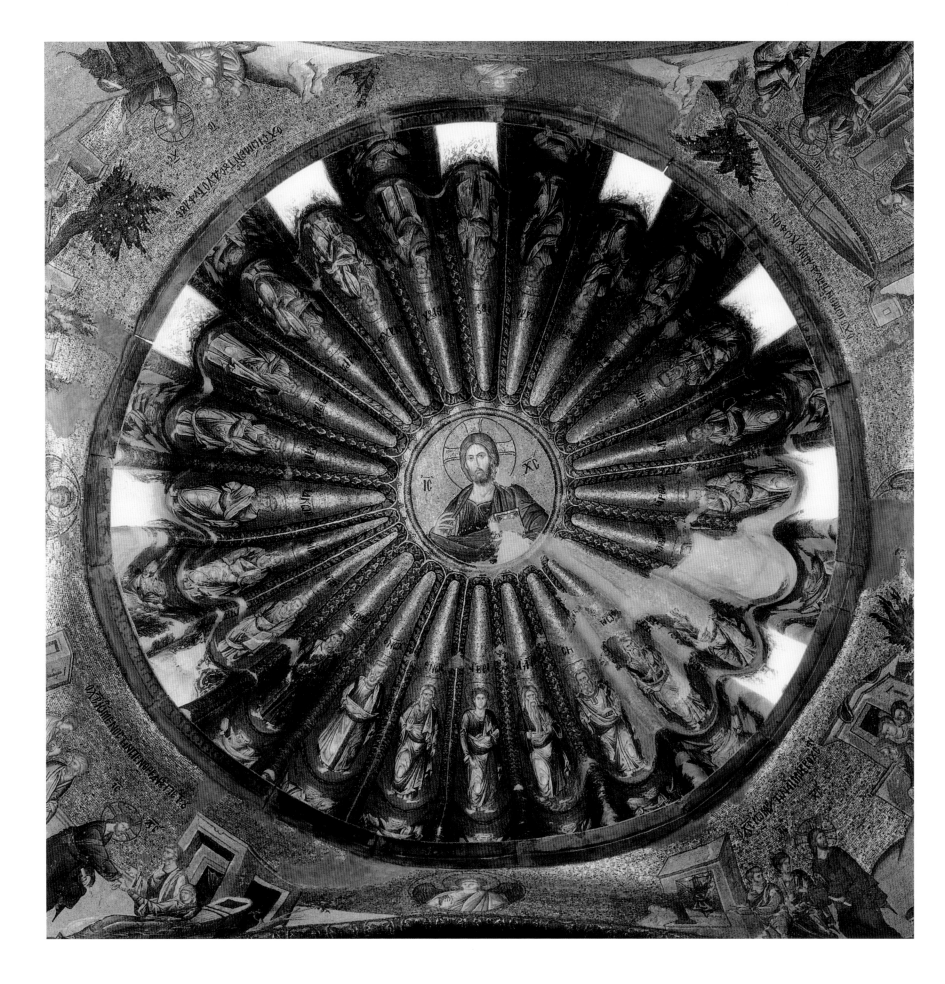

CHURCH OF THE CHORA
Istanbul, Turkey, c. 1050–1320,
mosaics c. 1303–20

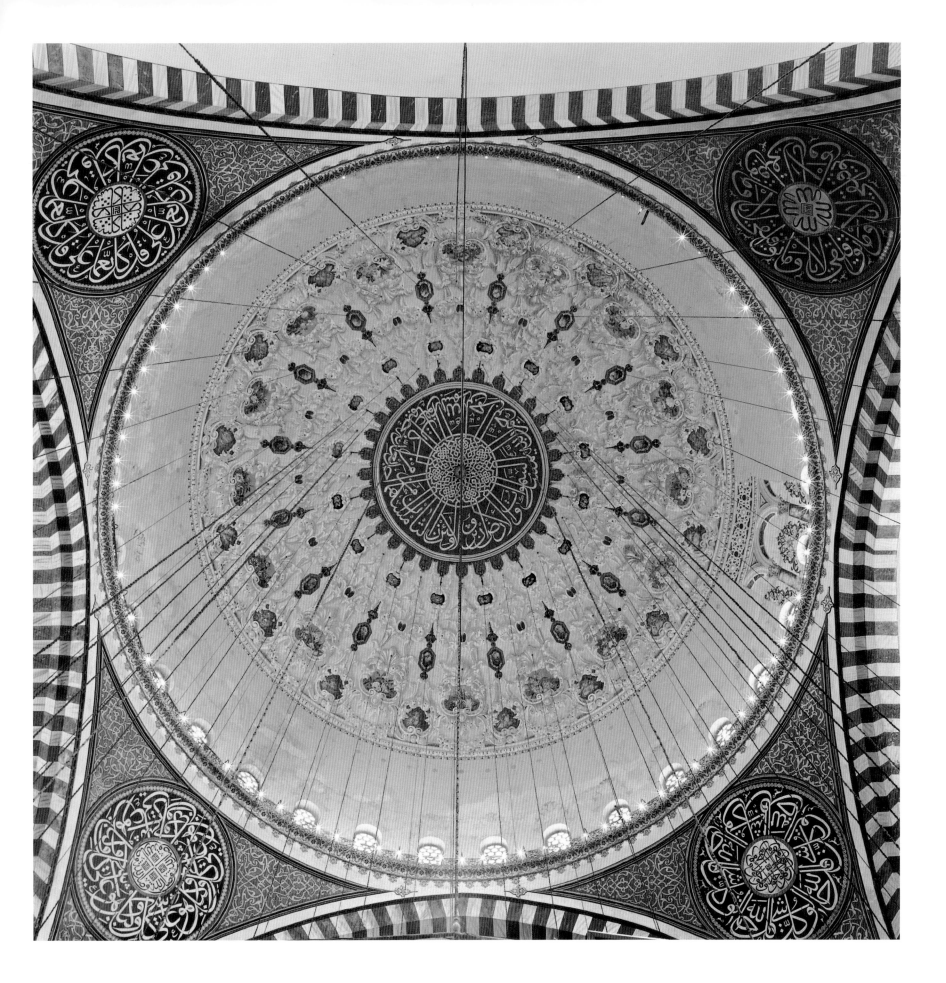

SULEYMANIYE MOSQUE
Istanbul, Turkey, 1550–57,
Sinan (c. 1491–1588)

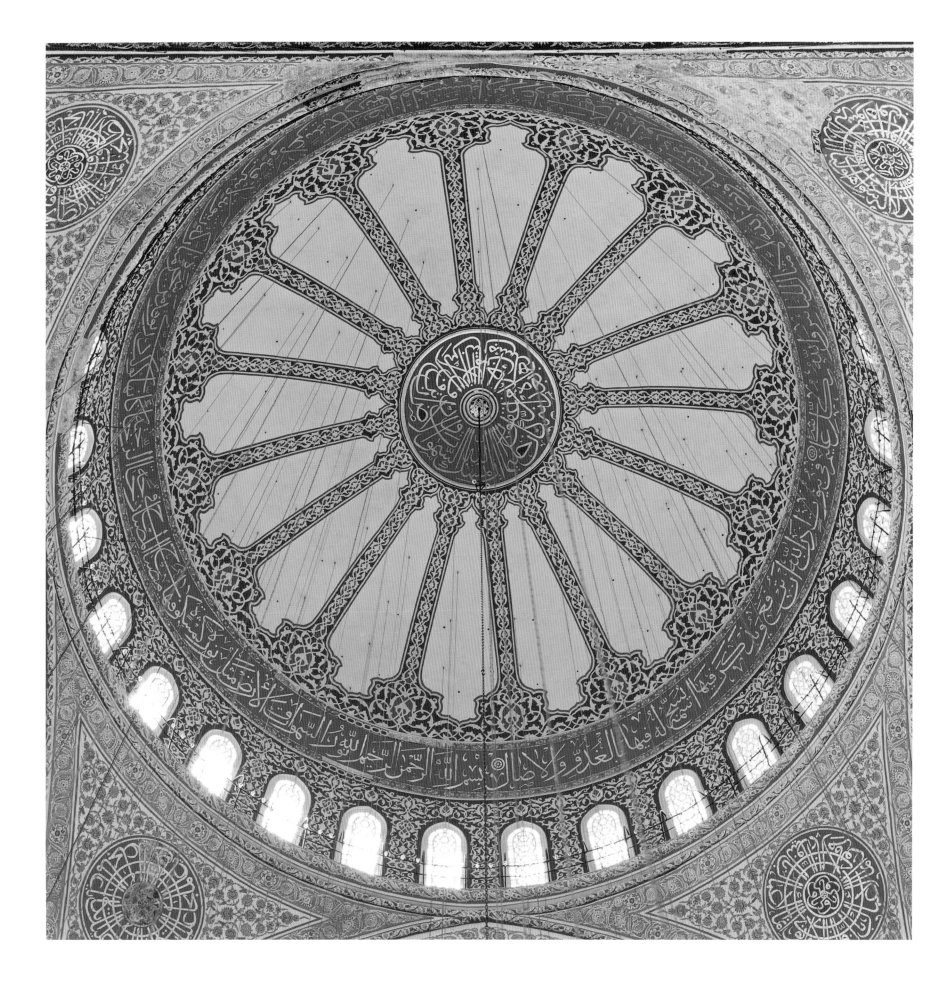

Sᴜʟᴛᴀɴᴀᴍʜᴇᴅ MᴏsQᴜE (Blue Mosque)
Istanbul, Turkey, 1609–17,
Mehmed Agha (d. 1622)

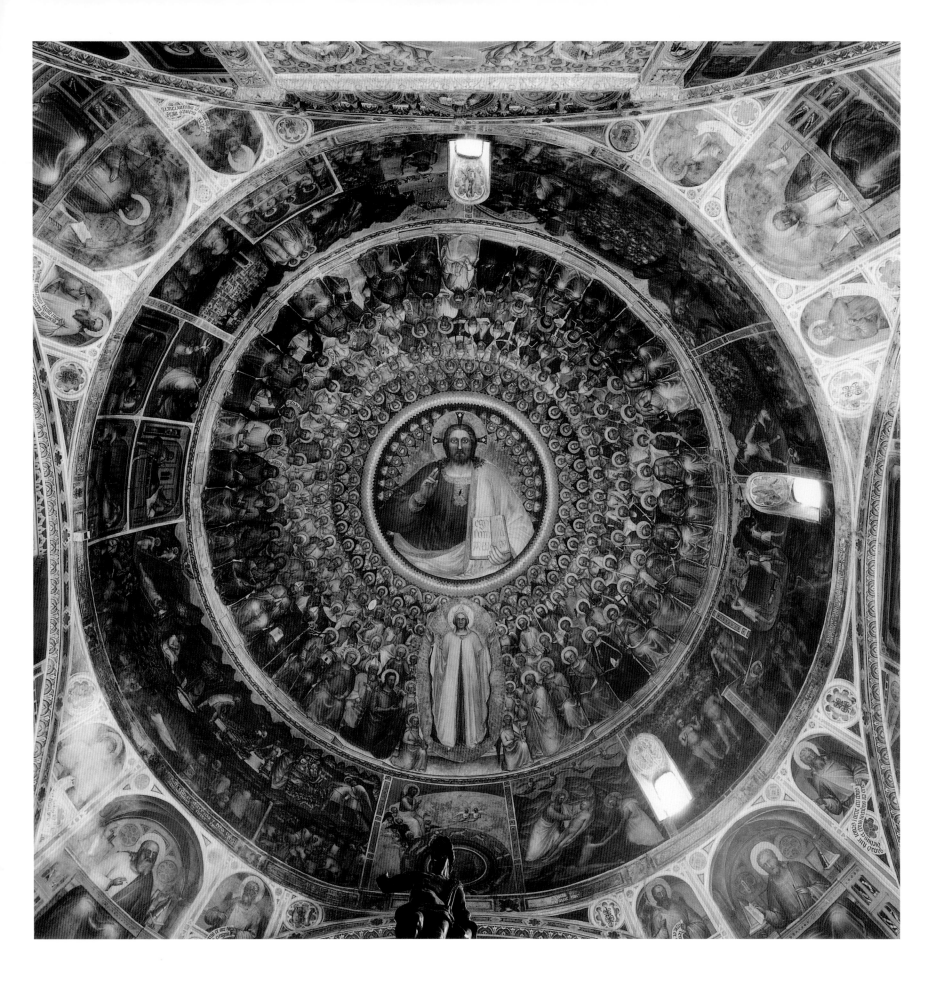

BATTISTERO

Padua, Italy, c. 1200–1378,
fresco mid-1370s by Giusto de' Menabuoi

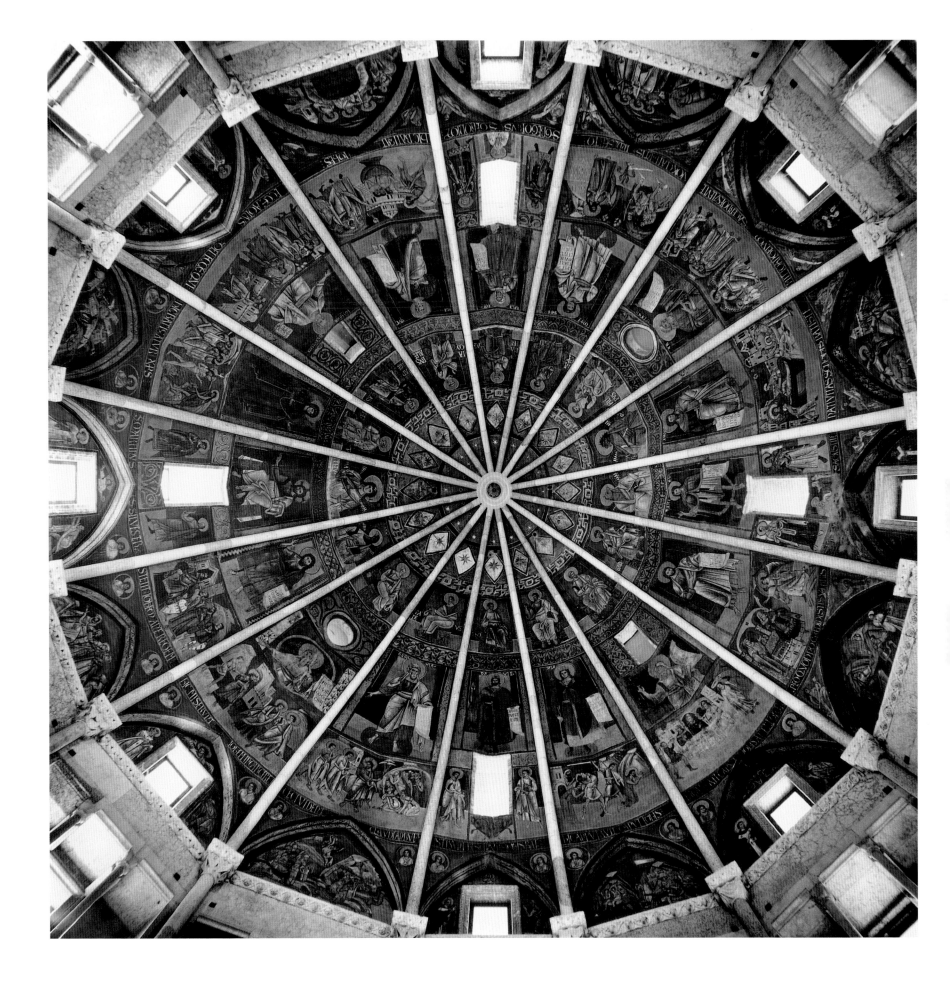

BATTISTERO
Parma, Italy, 1196–1216,
Benedetto Antelami (c. 1150–1230)

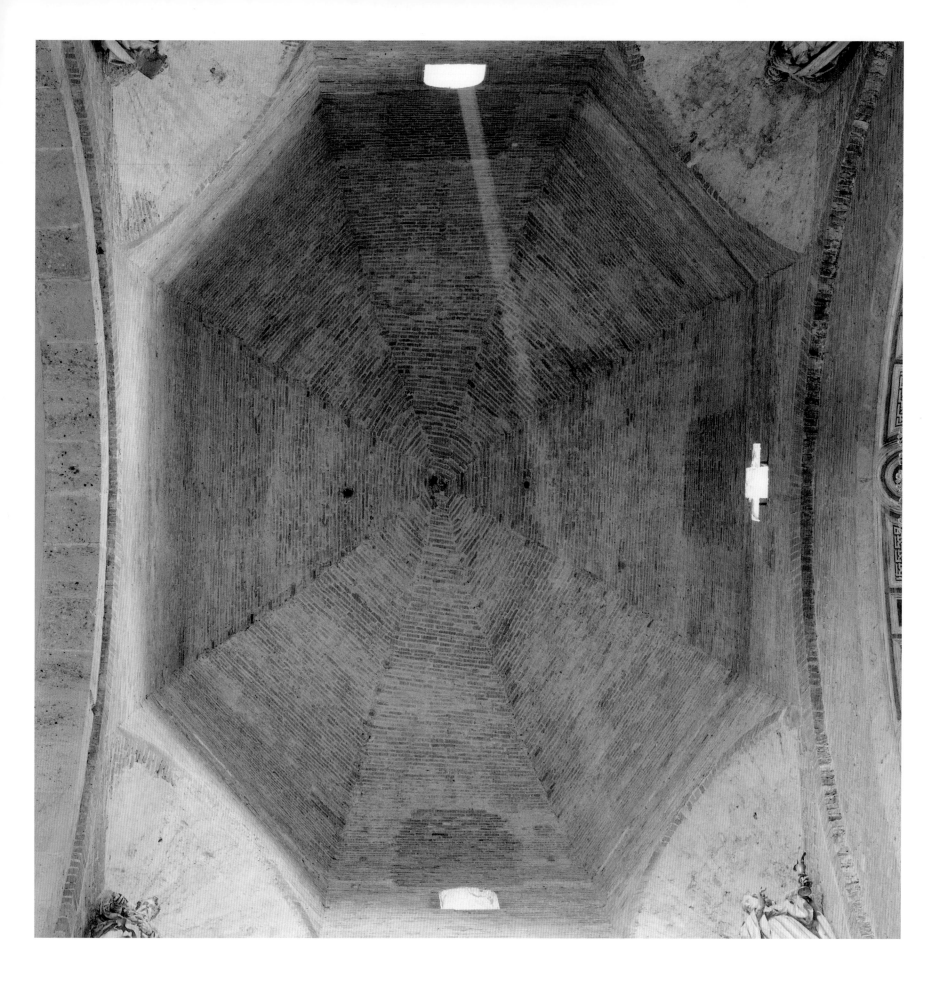

San Simpliciano
Milan, Italy, 4th century,
remodeled 12th–13th century

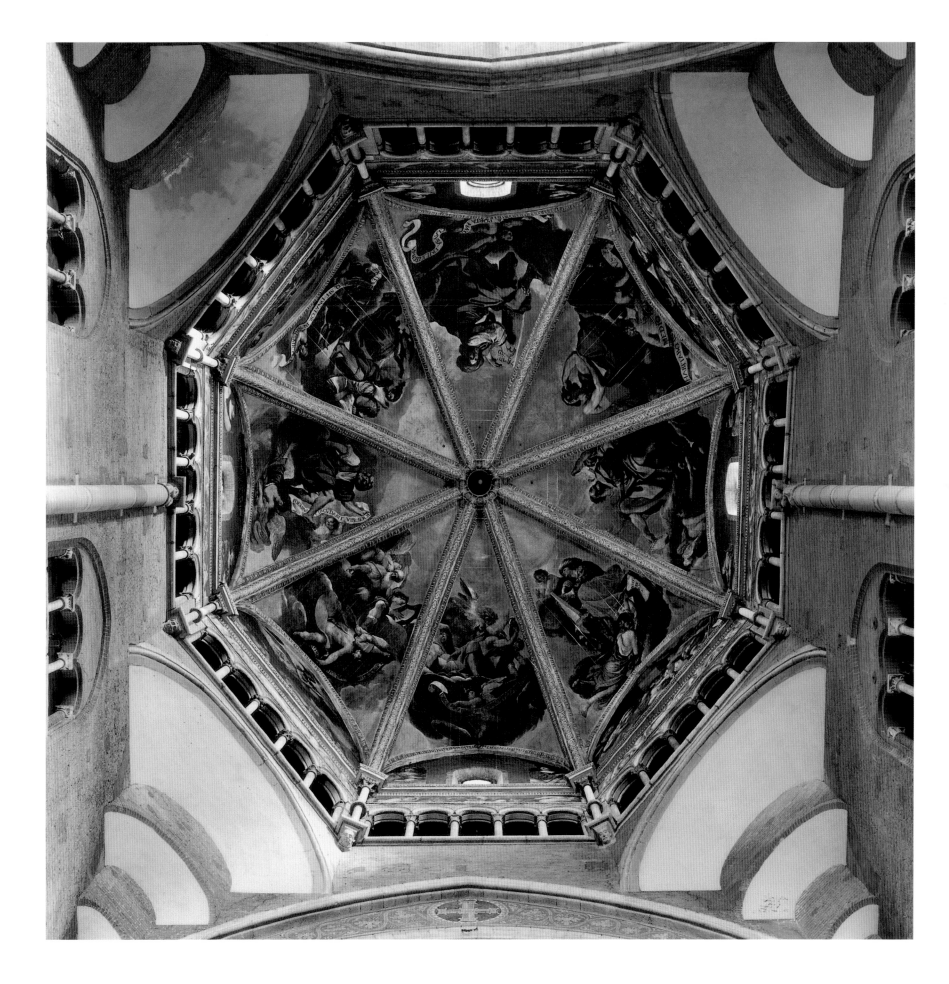

DUOMO
Piacenza, Italy, 1122–58,
some rebuilding in 13th century, fresco 17th century by Morazzone (1573–1626) and Guercino (1591–1666)

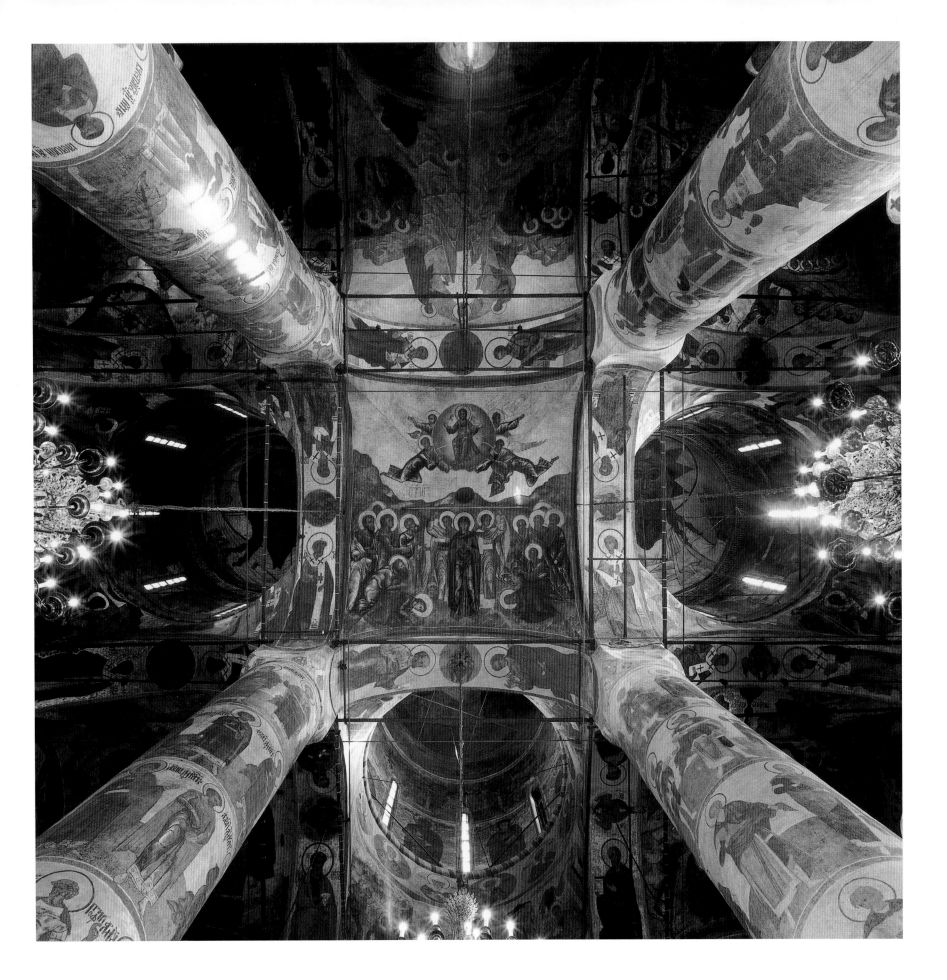

CATHEDRAL OF THE ASSUMPTION
Kremlin, Moscow, Russia, 1475–79,
Alberto (Aristotele) Fioraventi (c. 1415–1486), fresco 1642–44 by Sidor Pospeev and Ivan and Boris Paisein

34

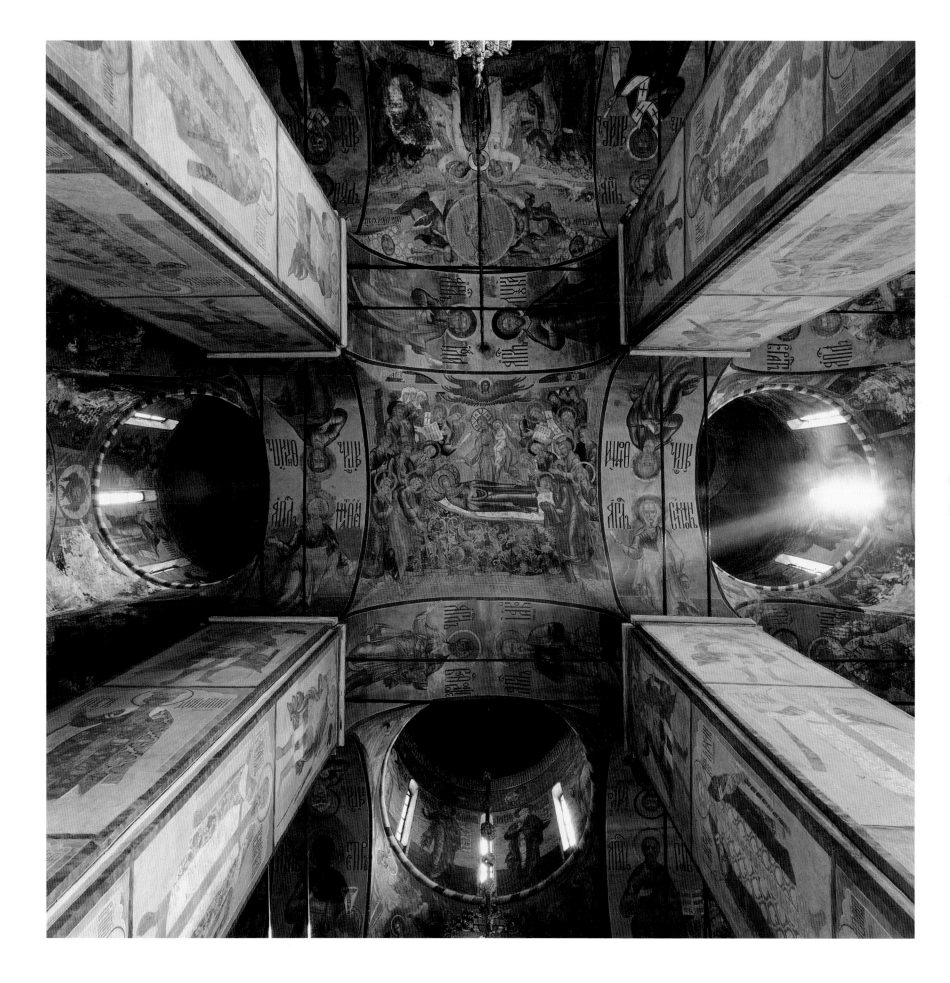

CATHEDRAL OF THE ASSUMPTION
Trinity Monastery of St. Sergius, Sergiev Posad, Russia, 1559–85,
after Alberto Fioraventi's Cathedral of the Assumption at the Kremlin

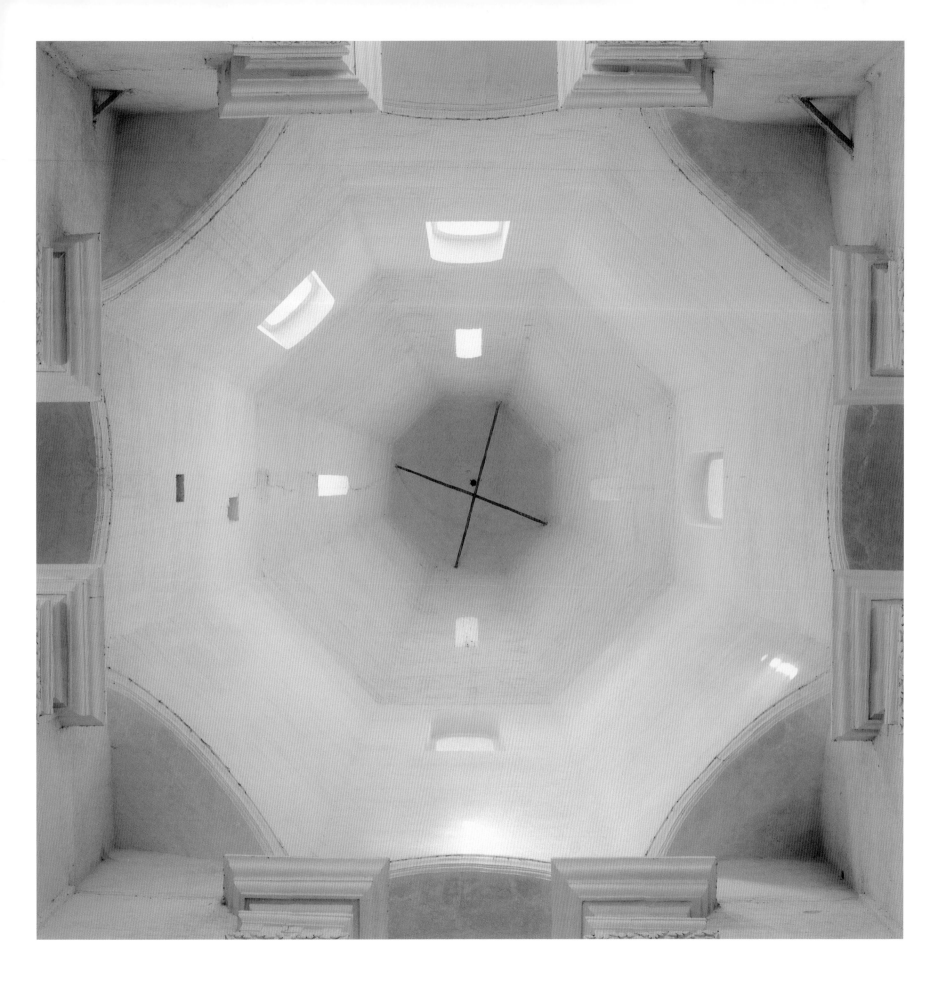

CHURCH OF THE ASCENSION
Kolomenskoe, Moscow, Russia, c. 1532

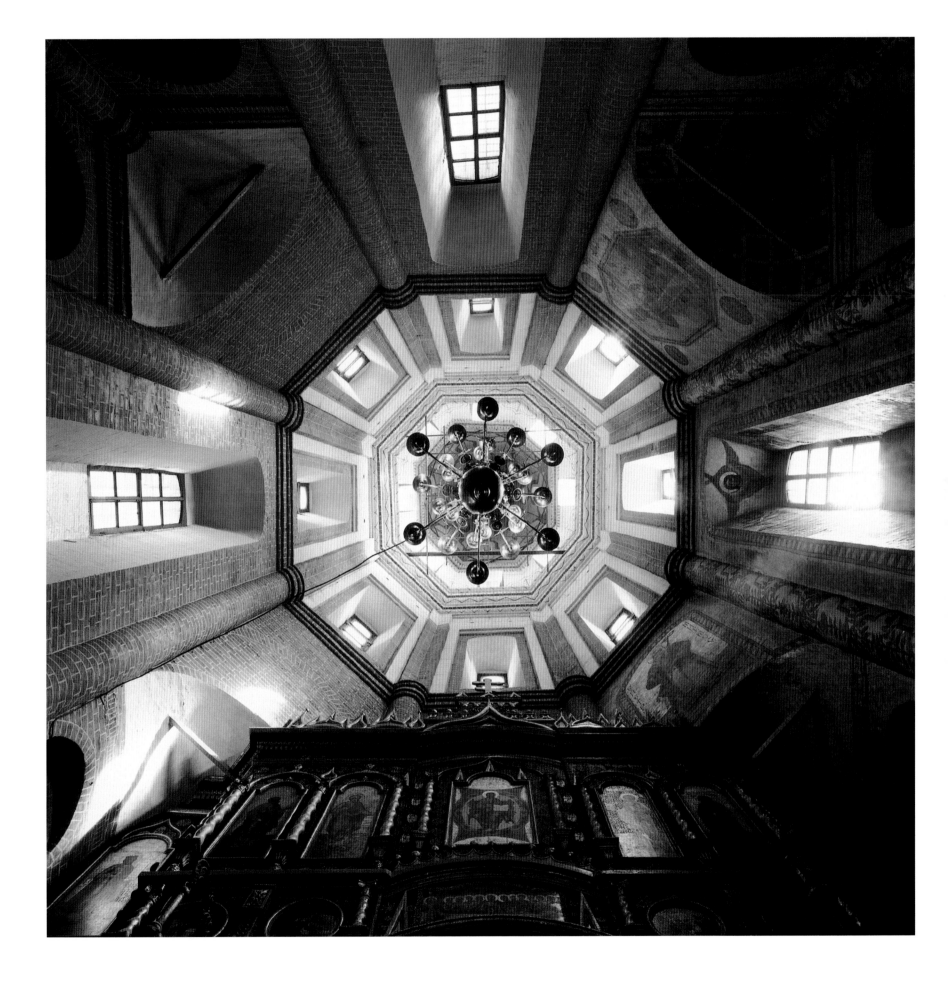

ST. BASIL'S CATHEDRAL
Red Square, Moscow, Russia, 1555–60,
Barma and Postnik

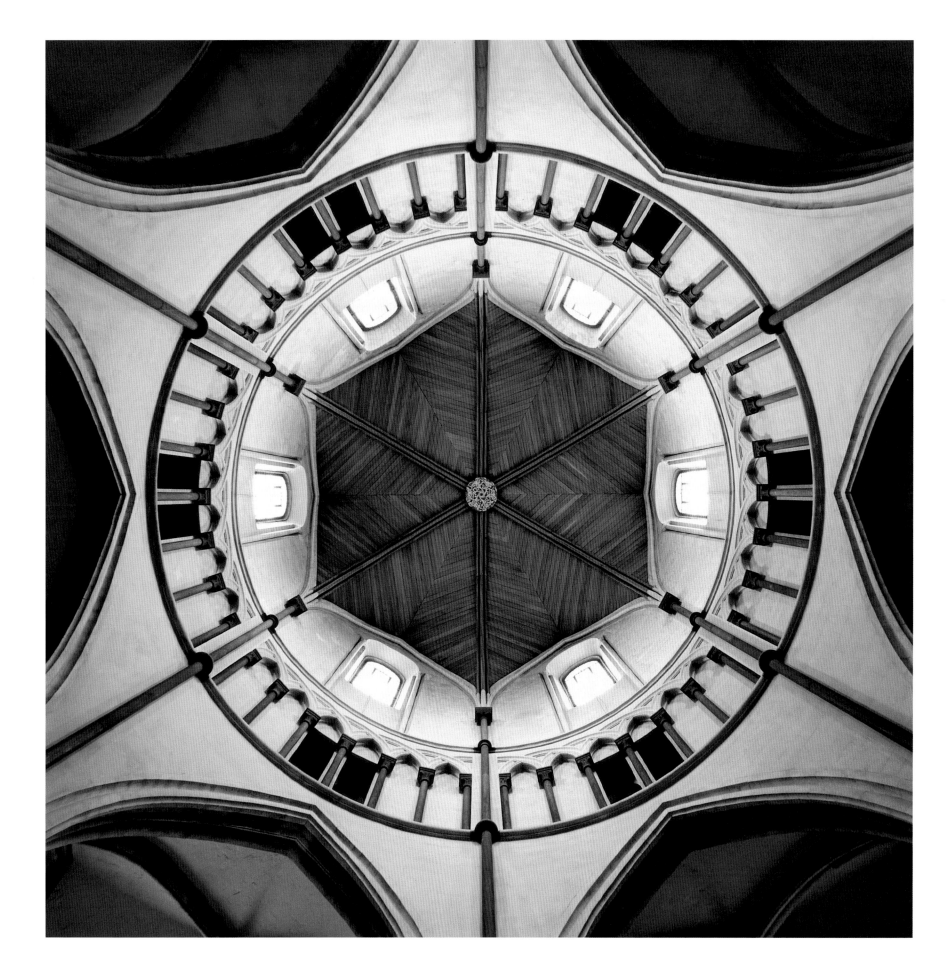

TEMPLE CHURCH
London, England, consecrated 1185,
rebuilt 20th century

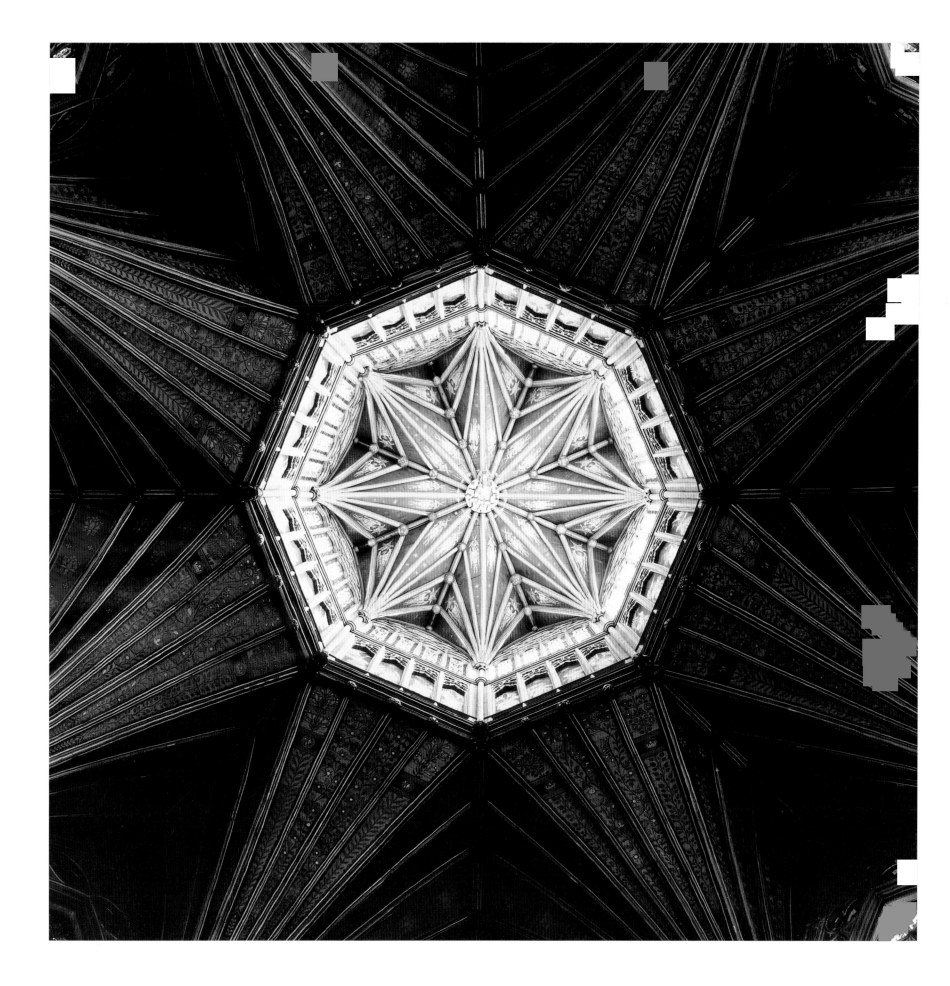

CATHEDRAL
Ely, England, begun 1090,
crossing vault 1328–42 by William Hurley (d. 1354)

41

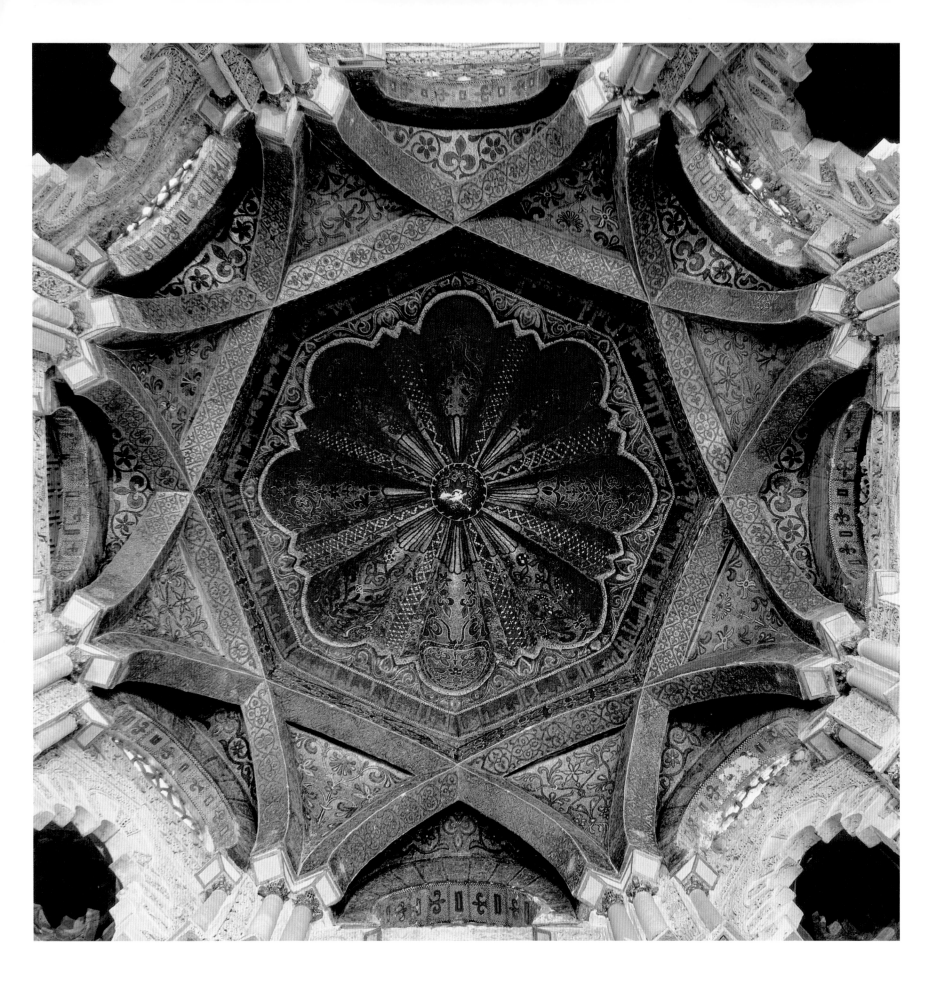

Dome over the Mihrab, Mezquita (Great Mosque)
Córdoba, Spain, c. 961–76

42

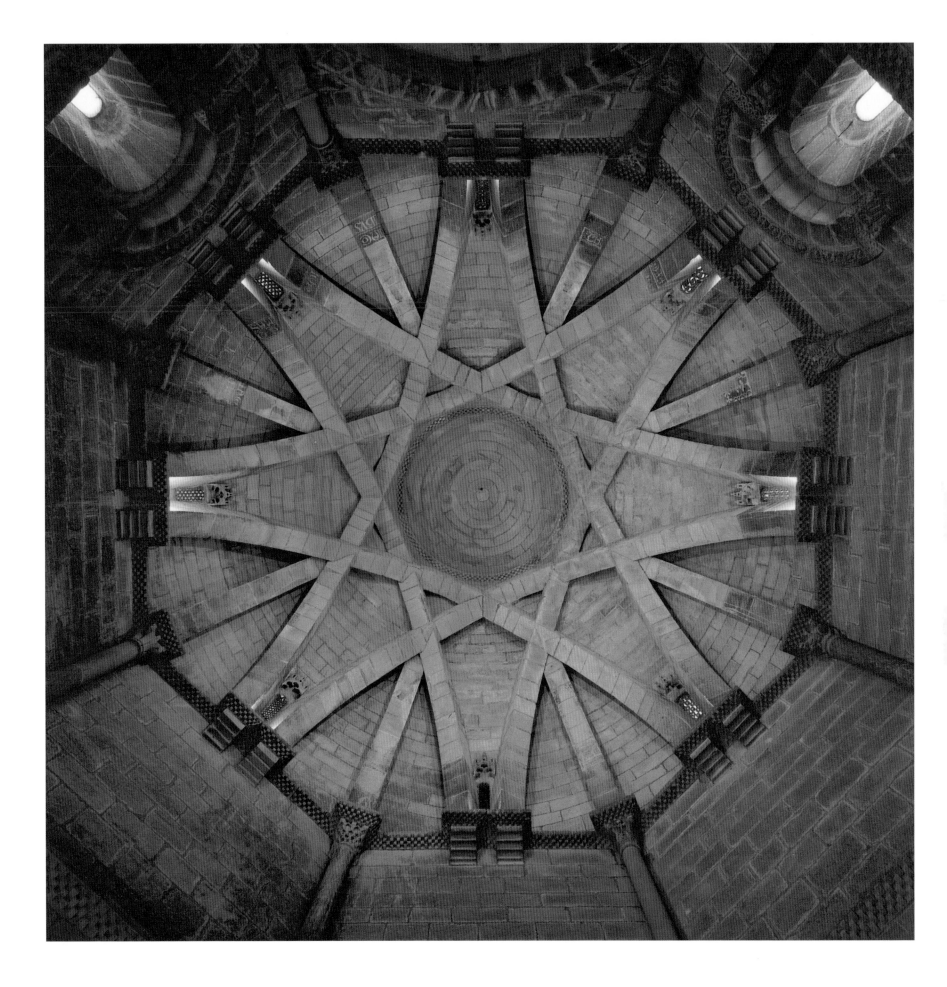

IGLESIA DEL SANTO SEPULCRO
Torres del Rio, Navarre, Spain, late 12th/early 13th century

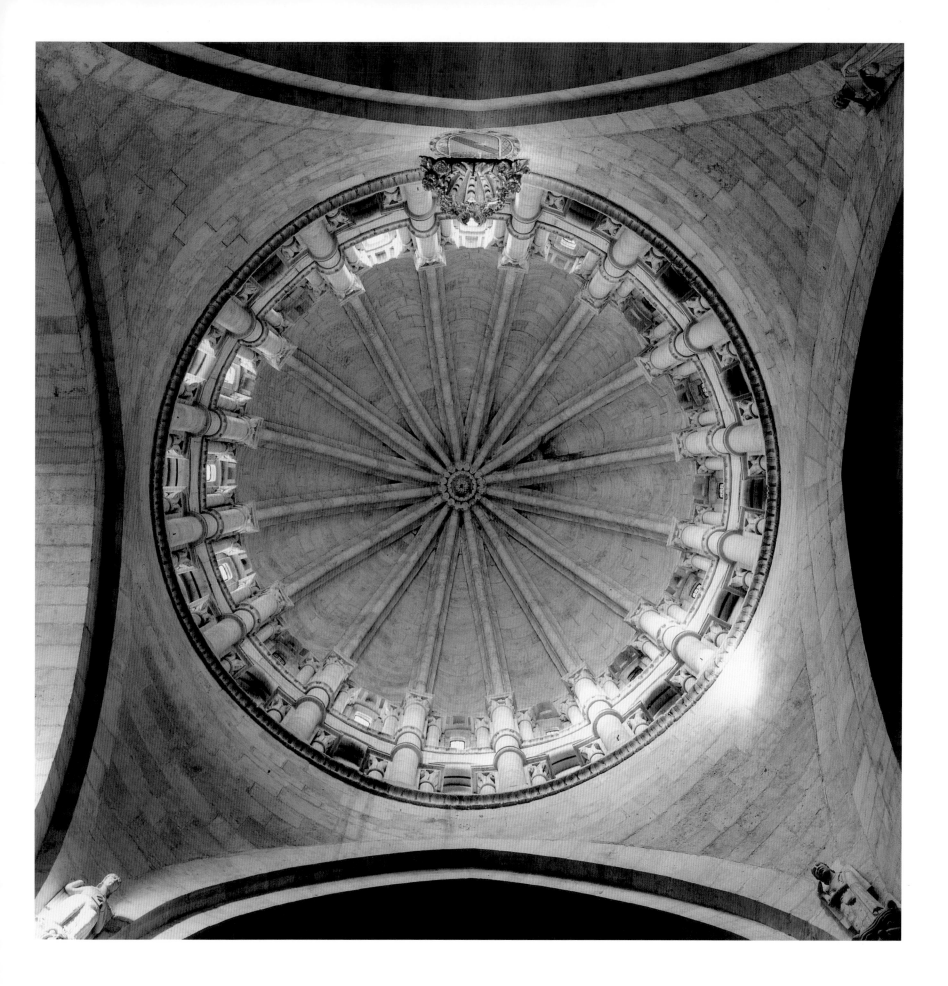

CATEDRAL VIEJA
Salamanca, Spain, c. 1152–1250,
possibly Pedro Petriz

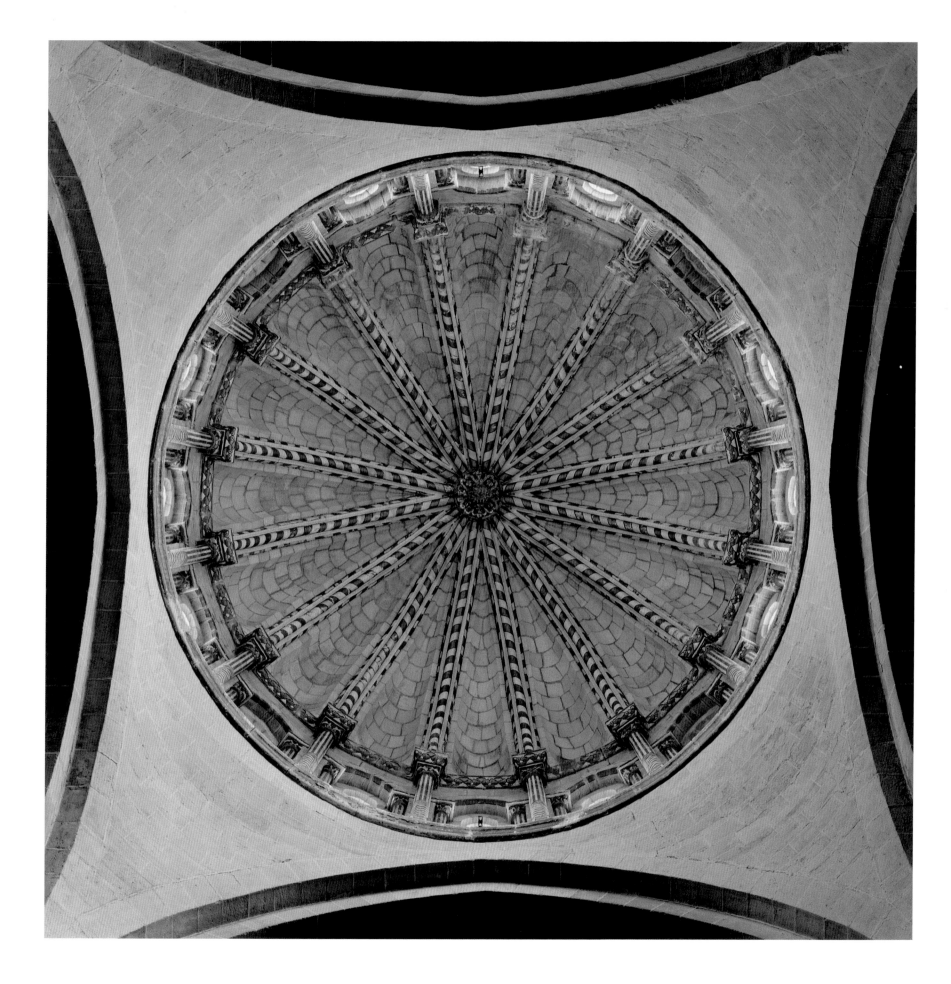

CATEDRAL

Zamora, Spain, c. 1151–74

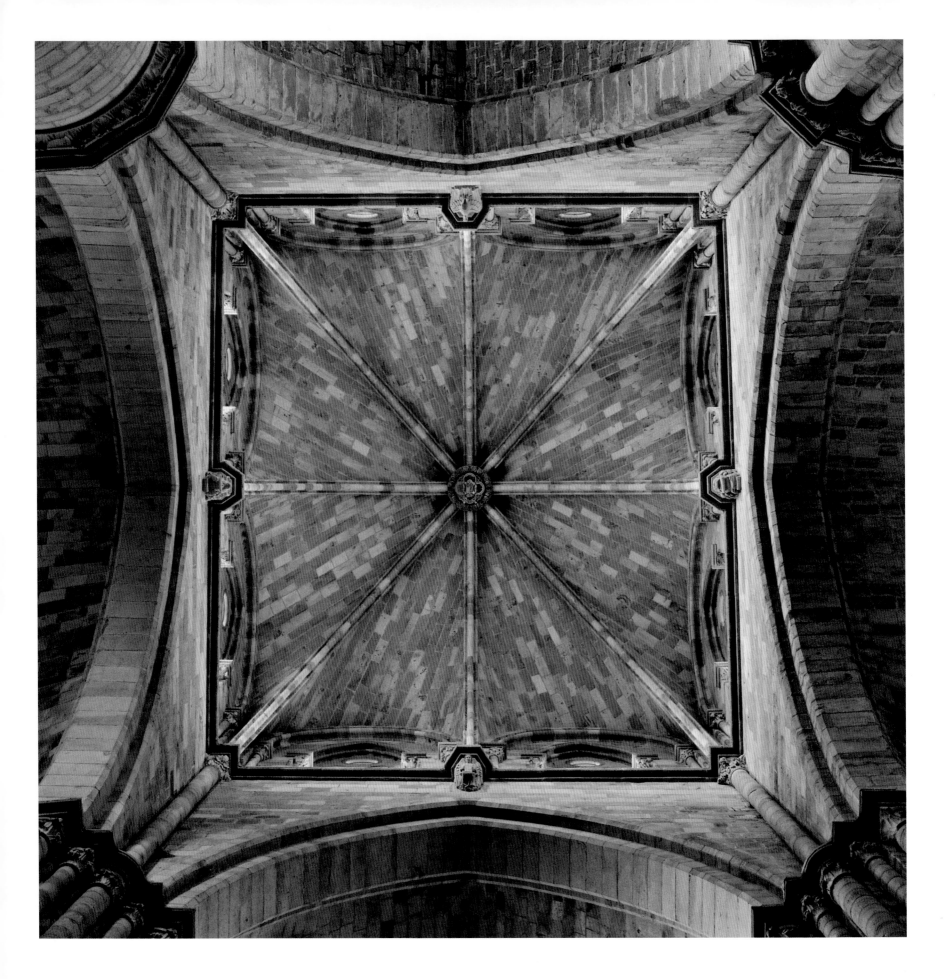

CATEDRAL

Siguenza, Spain, begun 12th century and completed by 1495,
rebuilt after 1945

46

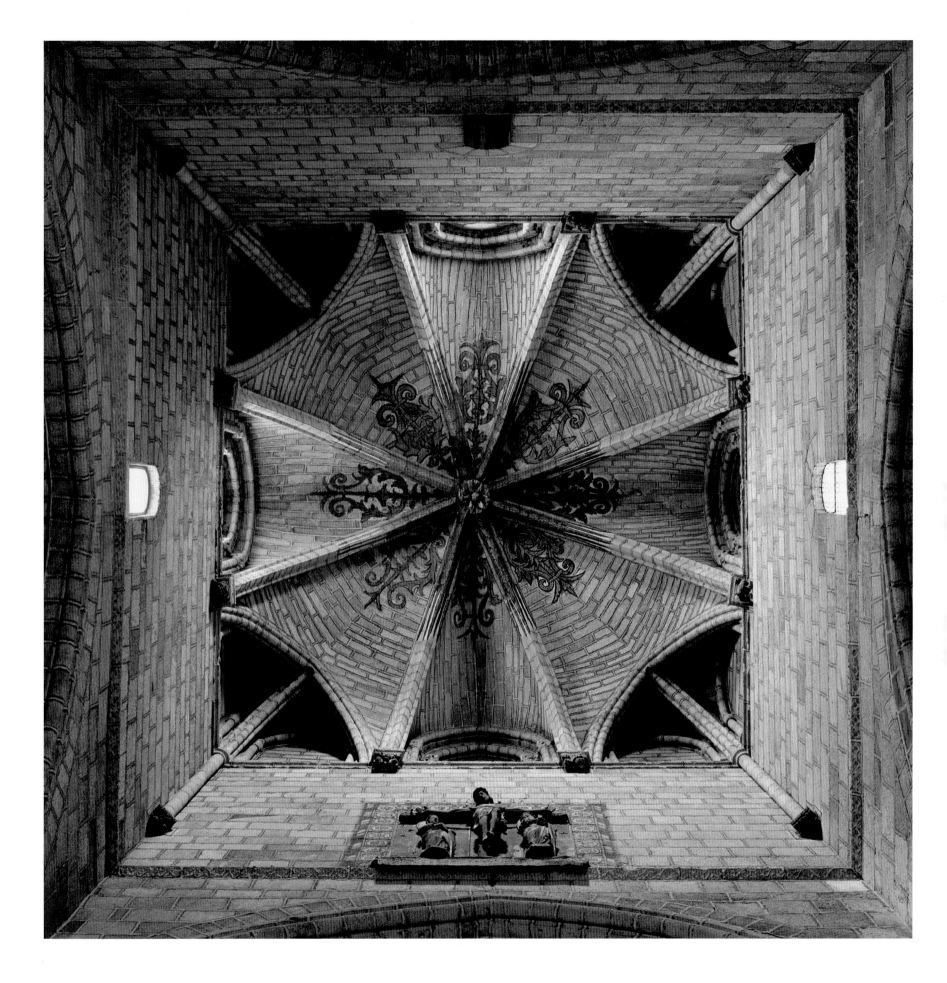

Basílica de San Vicente
Avila, Spain, begun c. 1109,
crossing vault 14th century 47

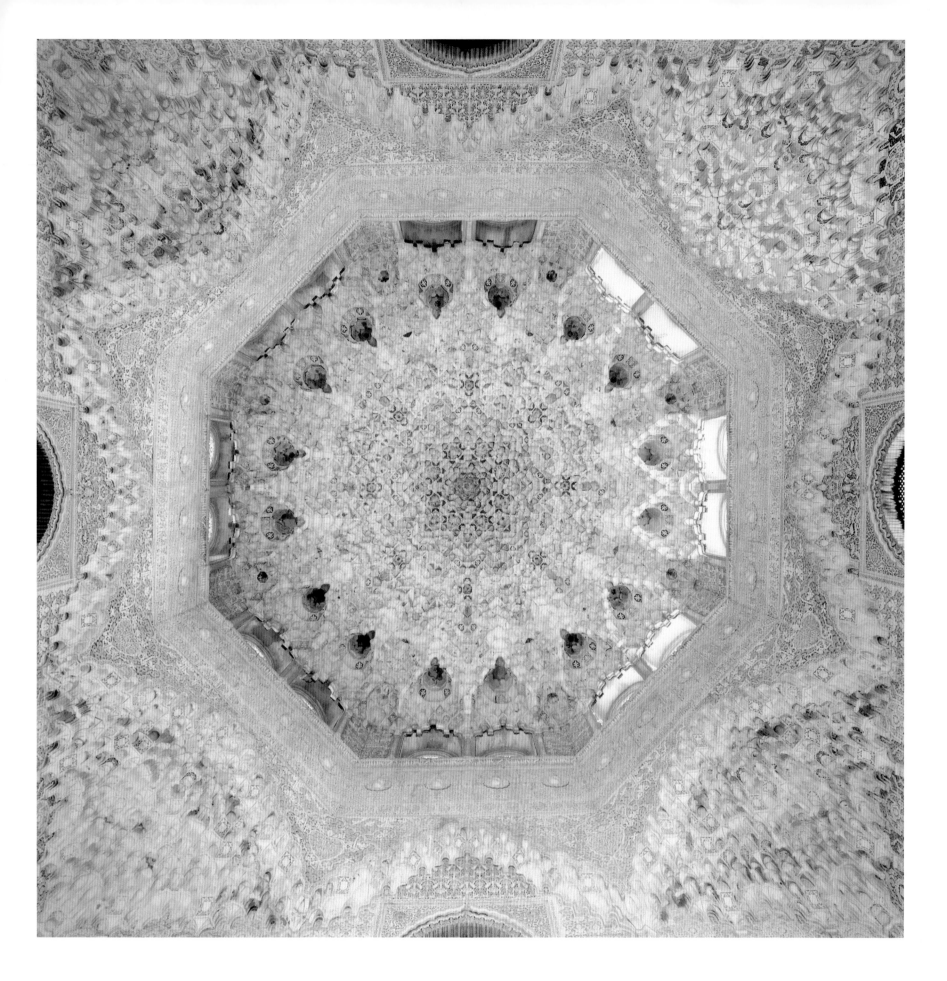

SALA DE LAS DOS HERMANAS, ALHAMBRA
Granada, Spain, c. 1333–54

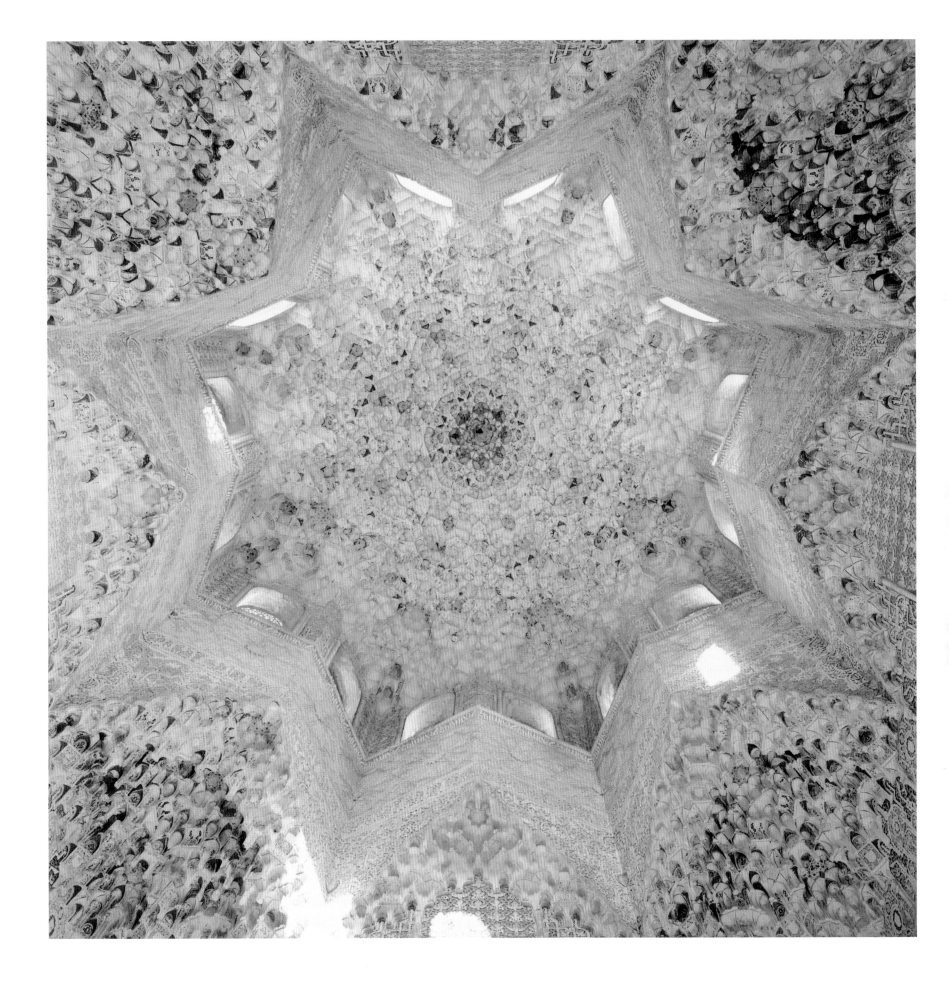

Sala de los Abencerrajes, Alhambra
Granada, Spain, c. 1333–91

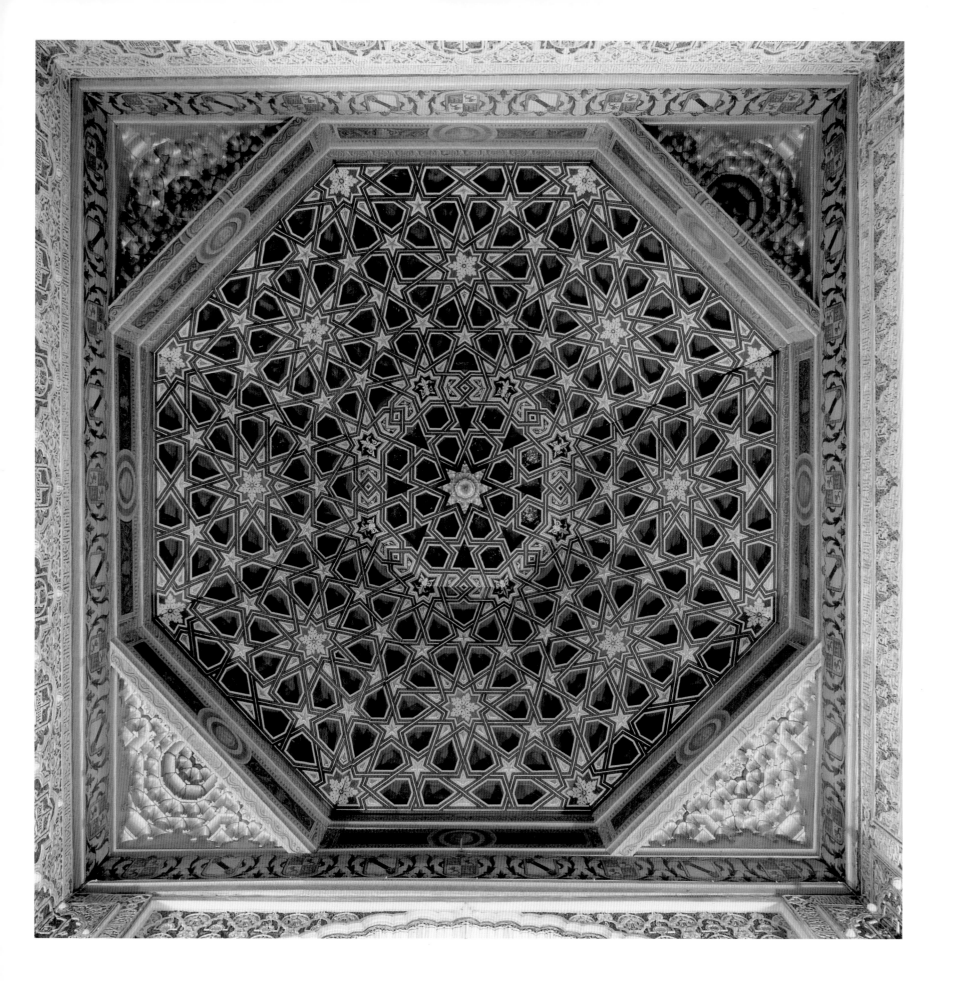

SALA DE LA JUSTICIA, ALCÁZAR
Seville, Spain, c. 1427

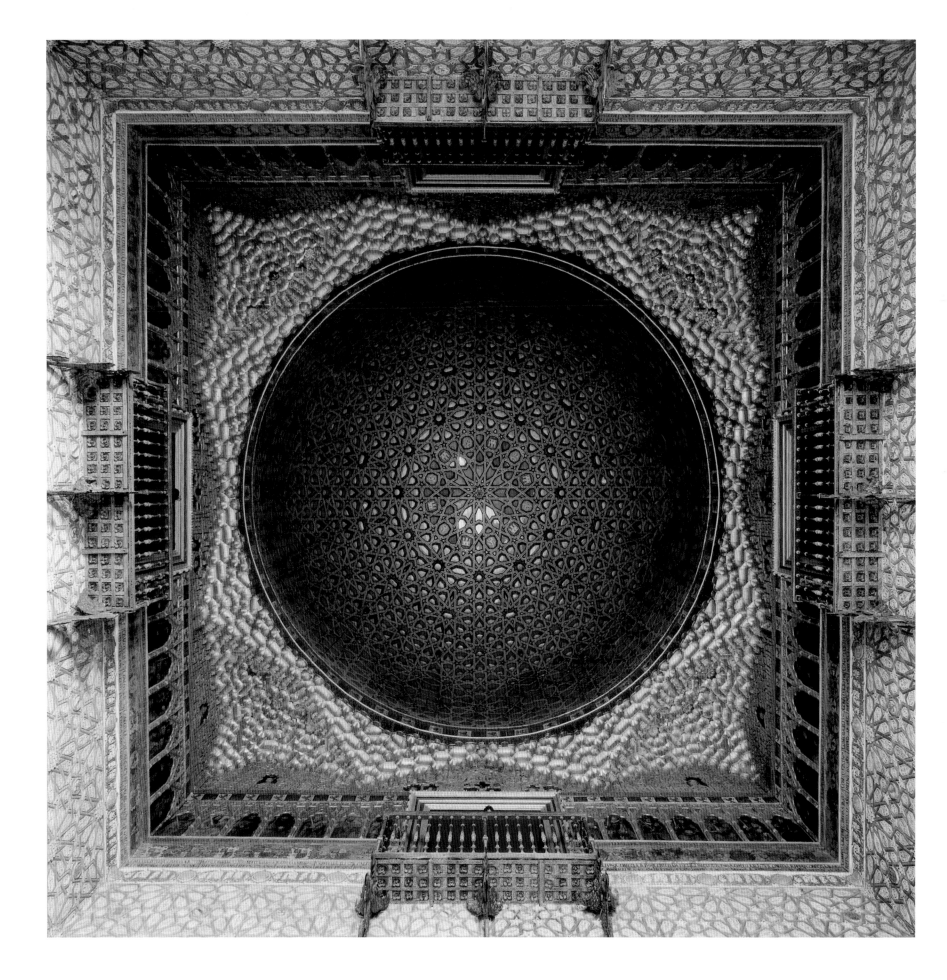

SALÓN DES EMBAJADORES, ALCÁZAR
Seville, Spain, c. 1427

51

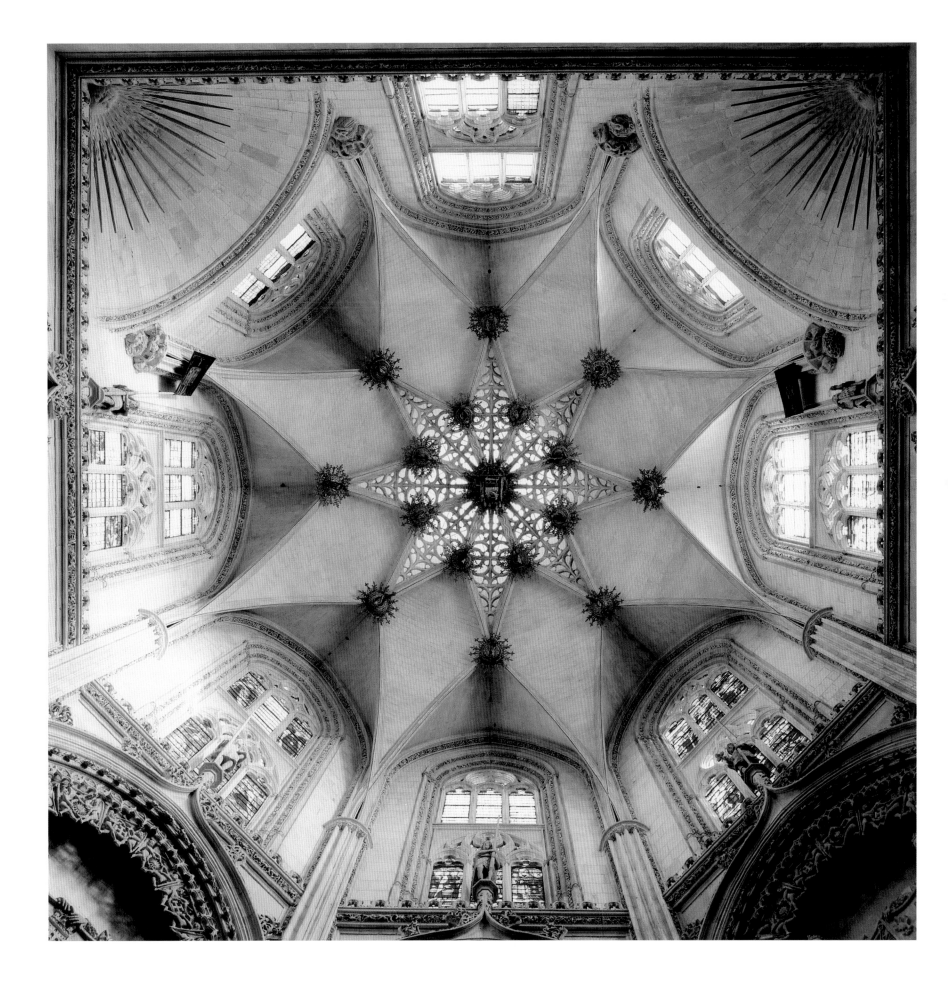

CAPILLA CONDESTABLE, CATEDRAL
Burgos, Spain, 1482–94,
Simón de Colonia (c. 1440–1511)

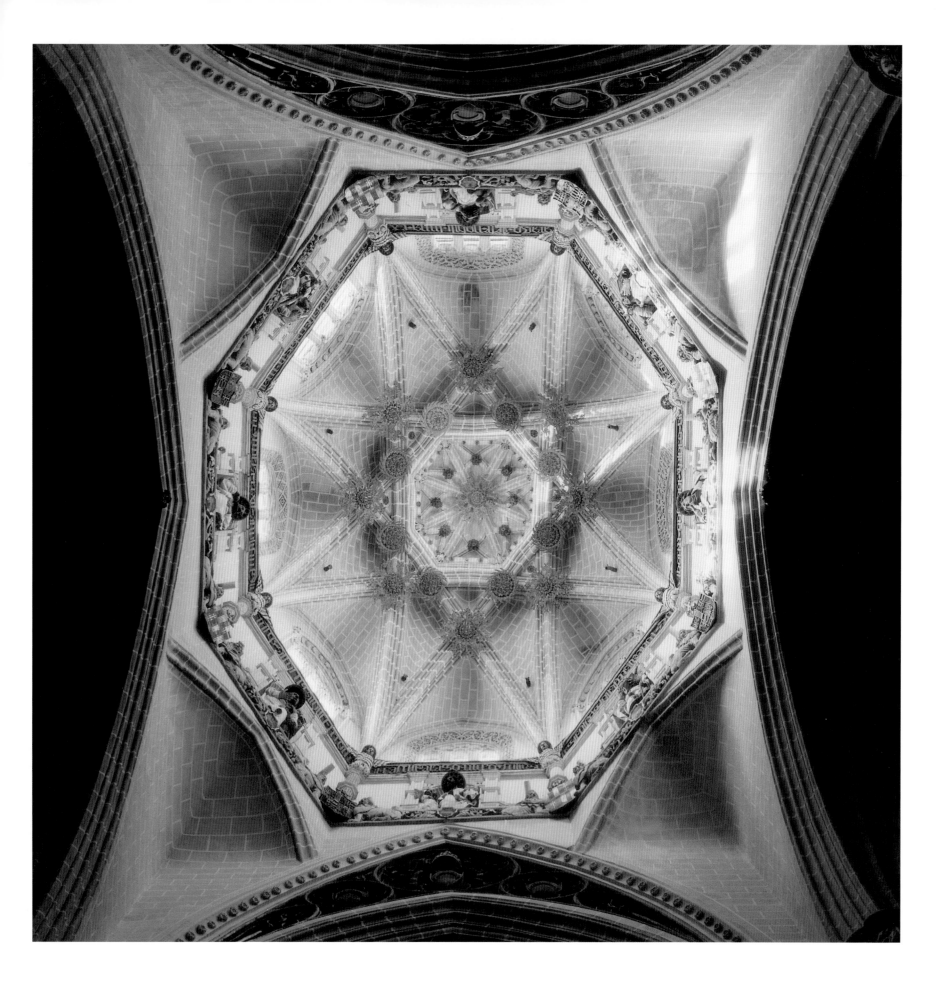

LA SEO
Zaragossa, Spain, begun 1412,
crossing vault 1505 by Enrique Egas (d. 1534)

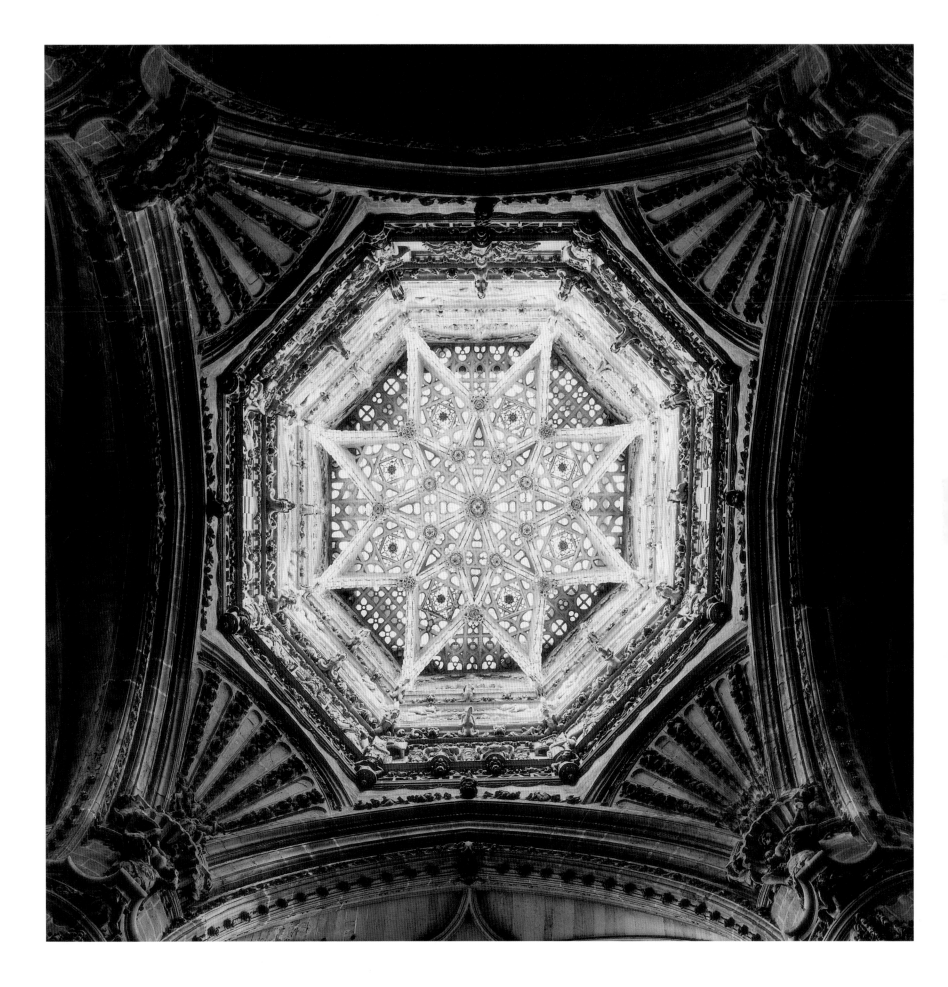

CATEDRAL
Burgos, Spain, begun 1221,
crossing tower 1567 by Francisco de Colonia (d. 1542) and Juan de Vallejo

II.

The Renaissance

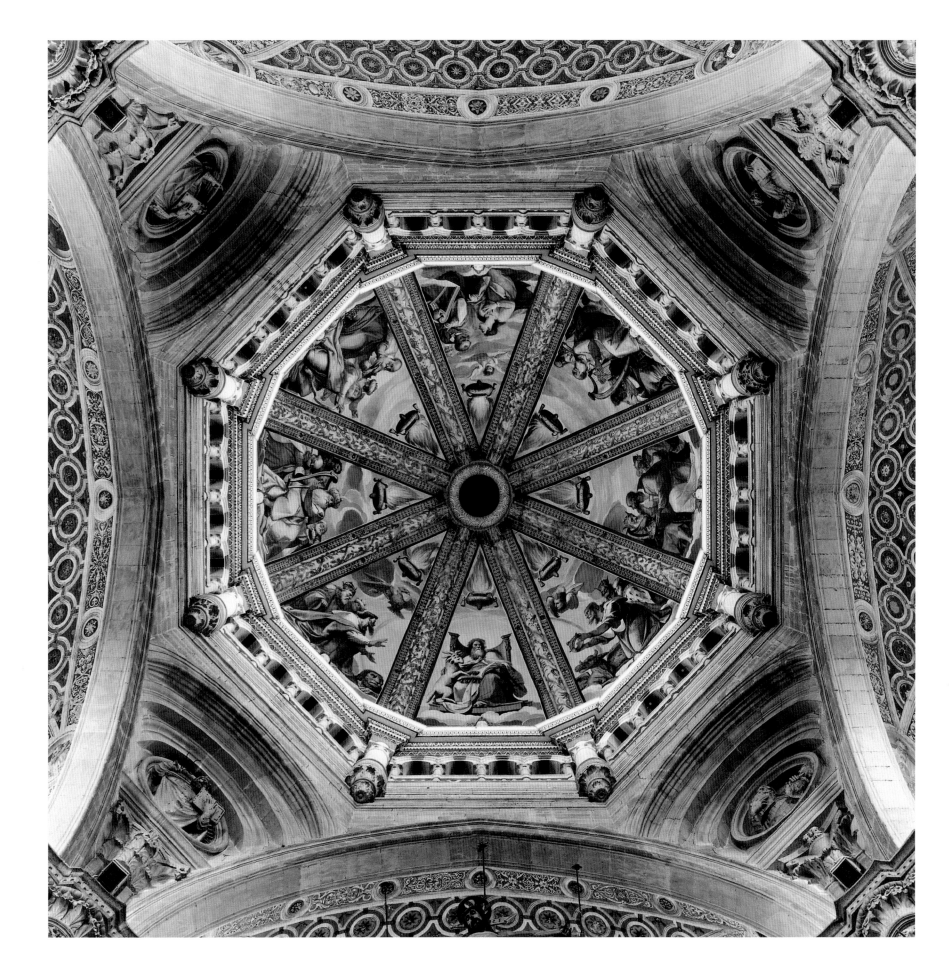

CERTOSA DI PAVIA
Pavia, Italy, 1396–1473,
Giovanni (1410–) and Guiniforte (1429–1481) Solari

57

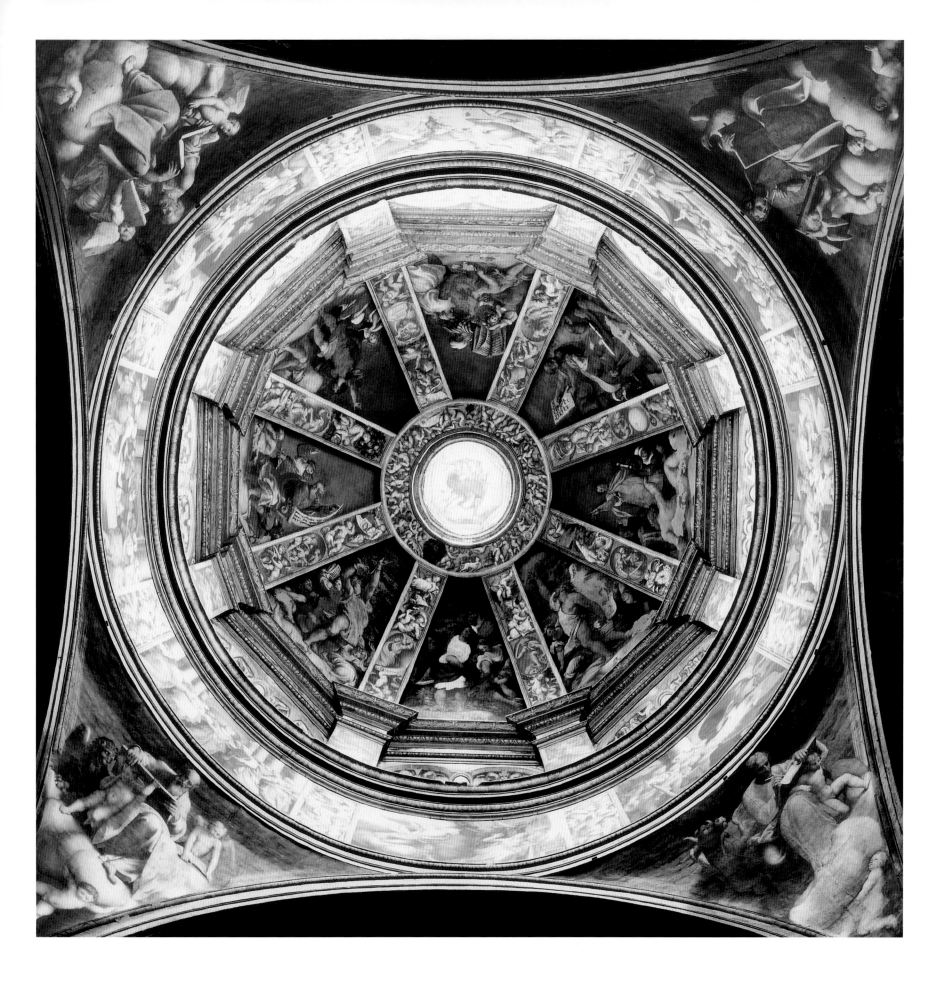

MADONNA DI CAMPAGNA

Piacenza, Italy, 1522–28,

Alessio Tramello (c. 1470–1529), fresco by Il Pordenone (c. 1484–1539)

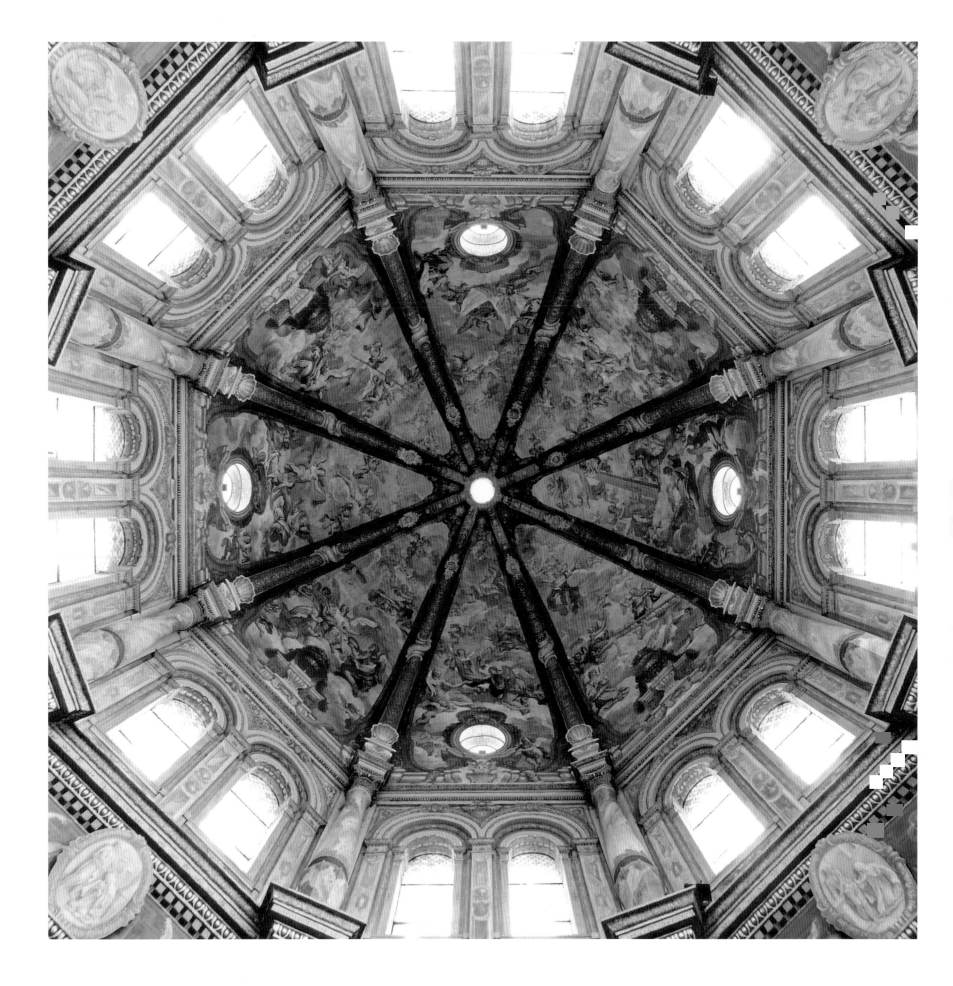

SANTA MARIA DELLA CROCE
Crema, Italy, c. 1490–1500,
Giovanni Battaglio

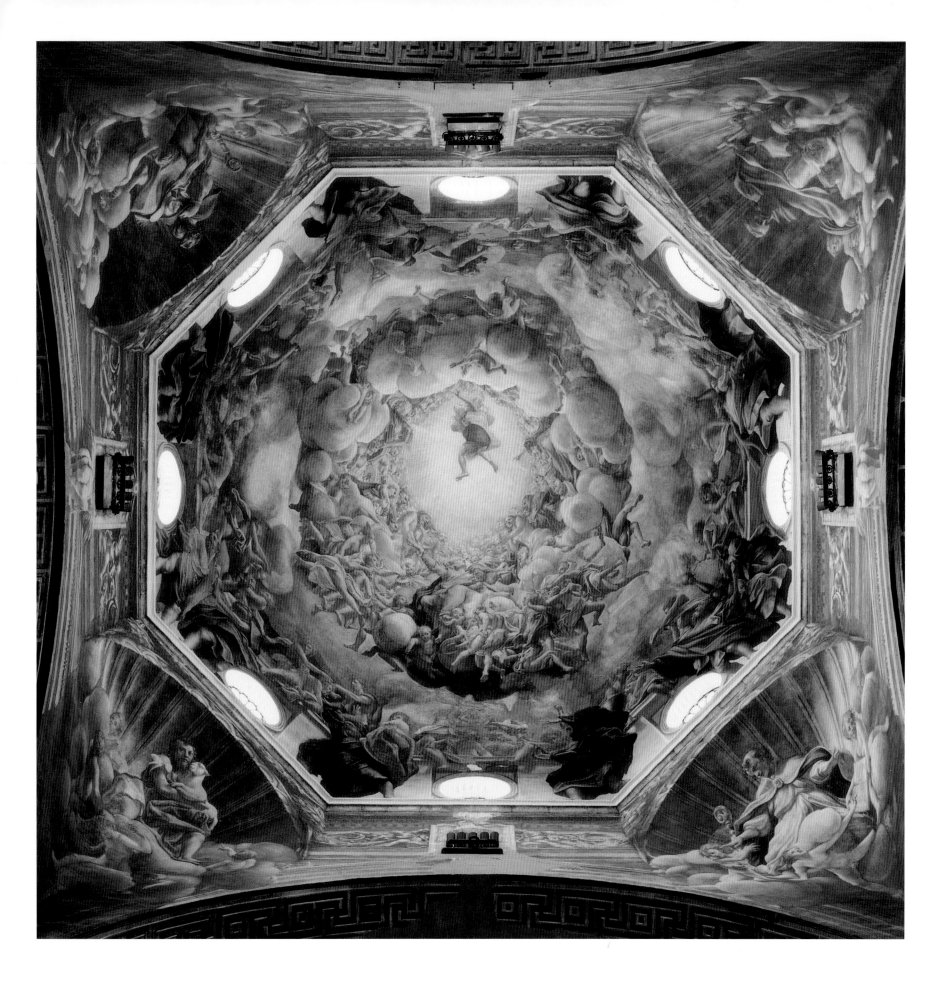

DUOMO
Parma, Italy, 1090–1130,
remodeled with fresco 1523–30 by Correggio (1489?–1534)

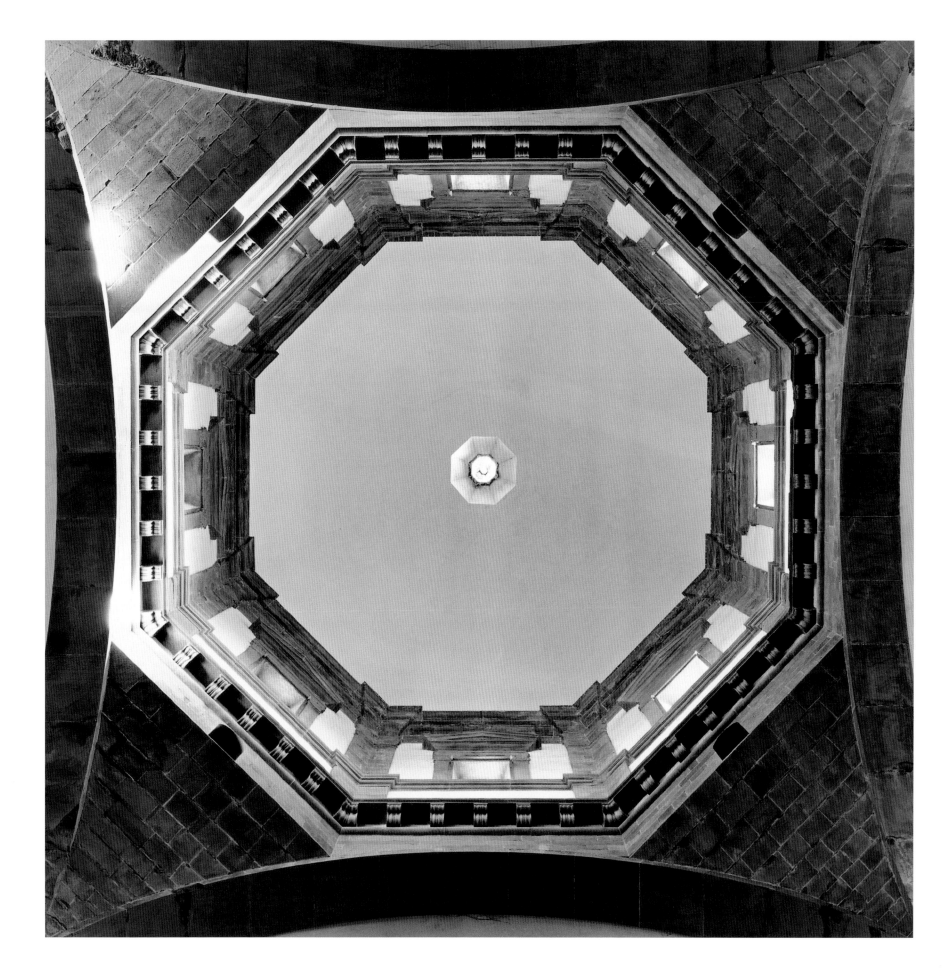

Santa Maria del Calcinaio
Cortona, Italy, 1485–1513,
Francesco di Giorgio Martini (1439–1501)

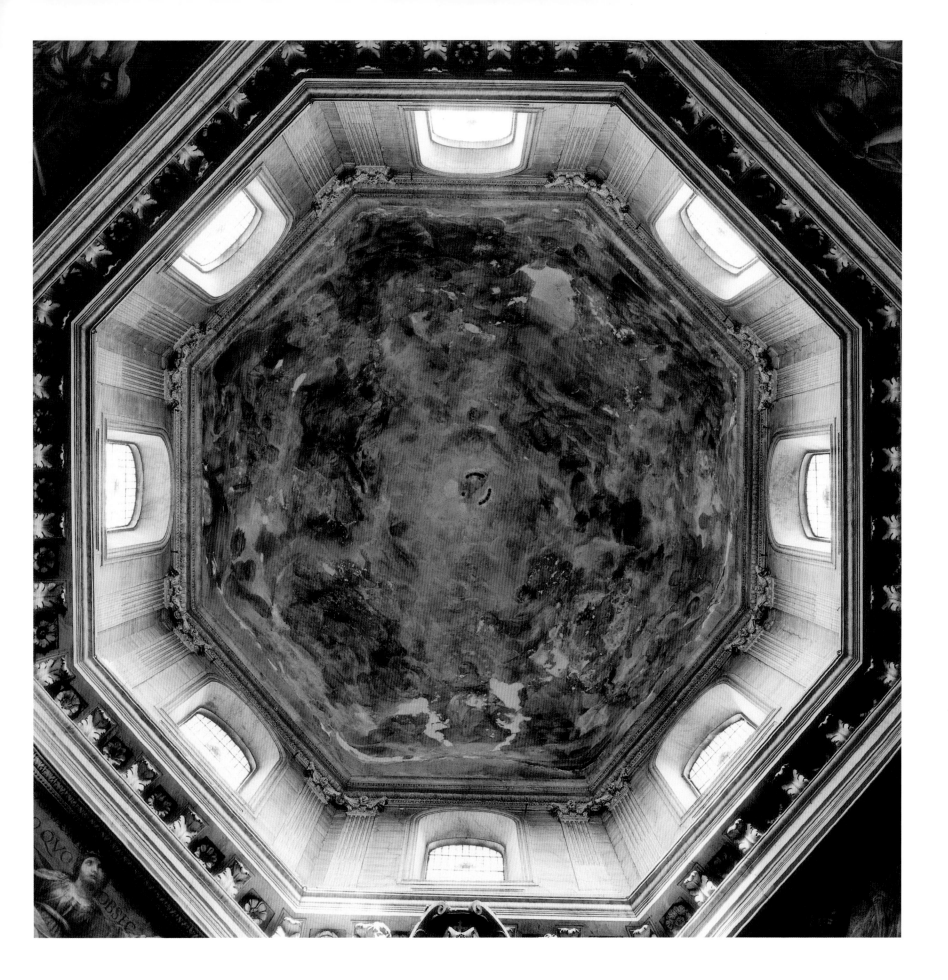

SANTA MARIA DEL POPOLO
Rome, Italy, 1472–80

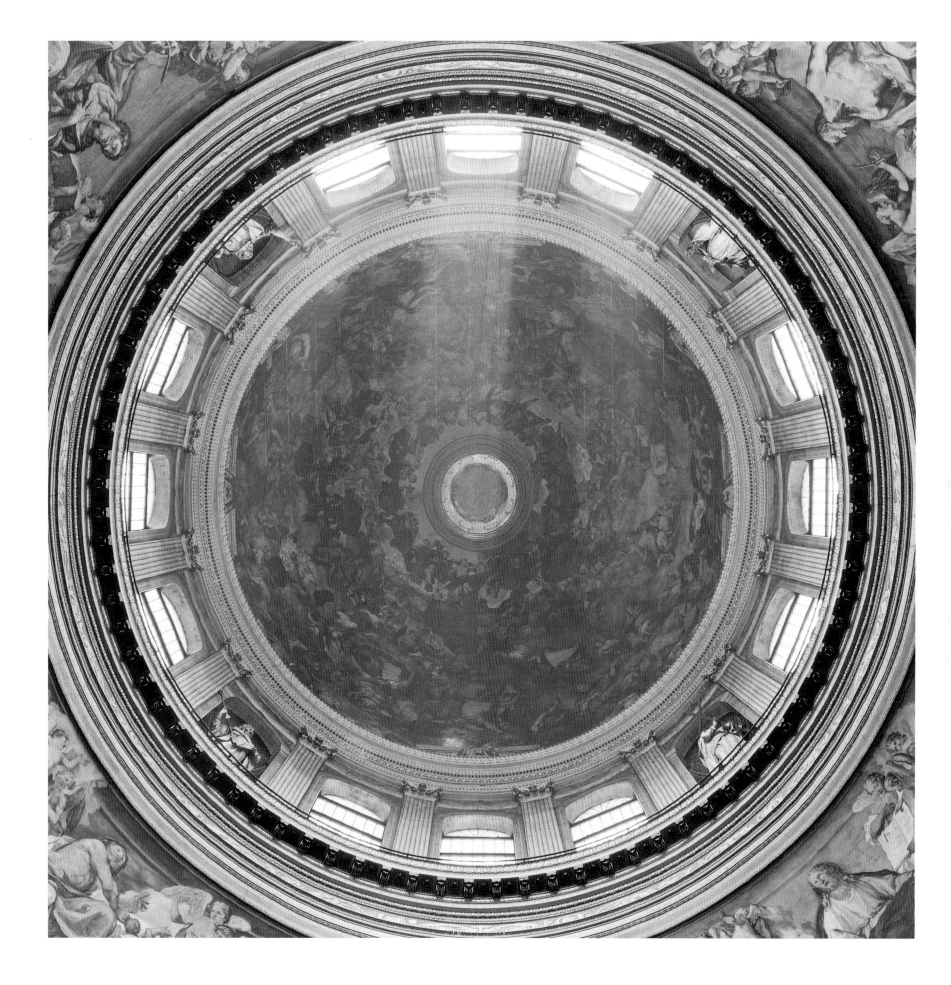

SANT'ANDREA
Mantua, Italy, 1470–76,
Leon Battista Alberti (1404–1472), dome 1733–81 by Filippo Juvarra (1678–1736)

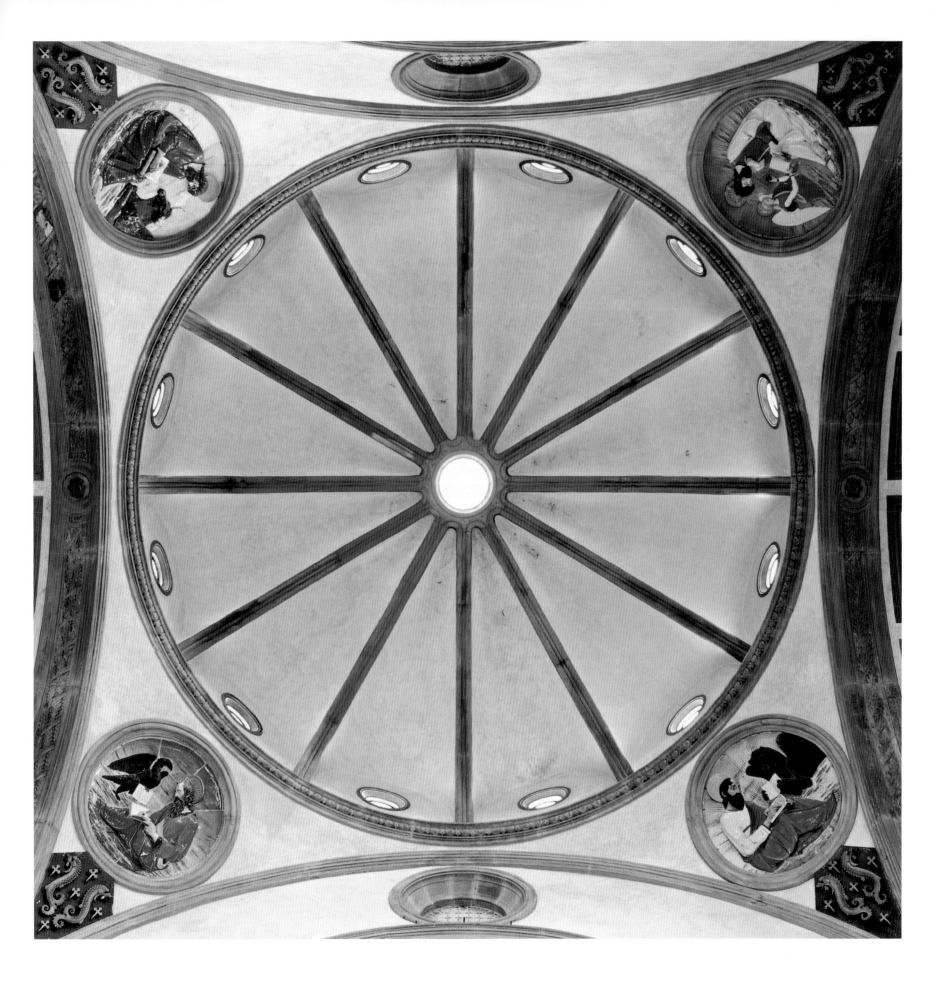

CAPELLA DEI PAZZI (Pazzi Chapel), SANTA CROCE
Florence, Italy, 1430–52,
Filippo Brunelleschi (1377–1446)

61

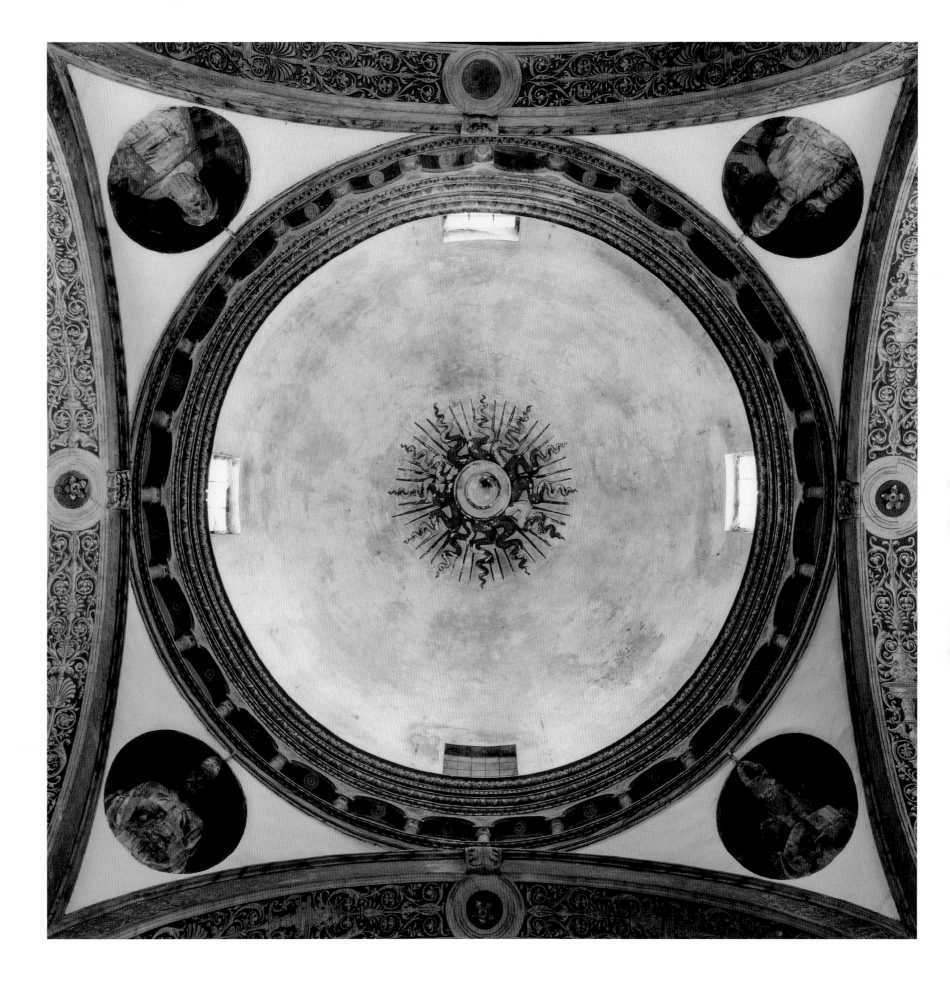

SAN SISTO
Piacenza, Italy, 1499–1514,
Alessio Tramello (c. 1470–1529)

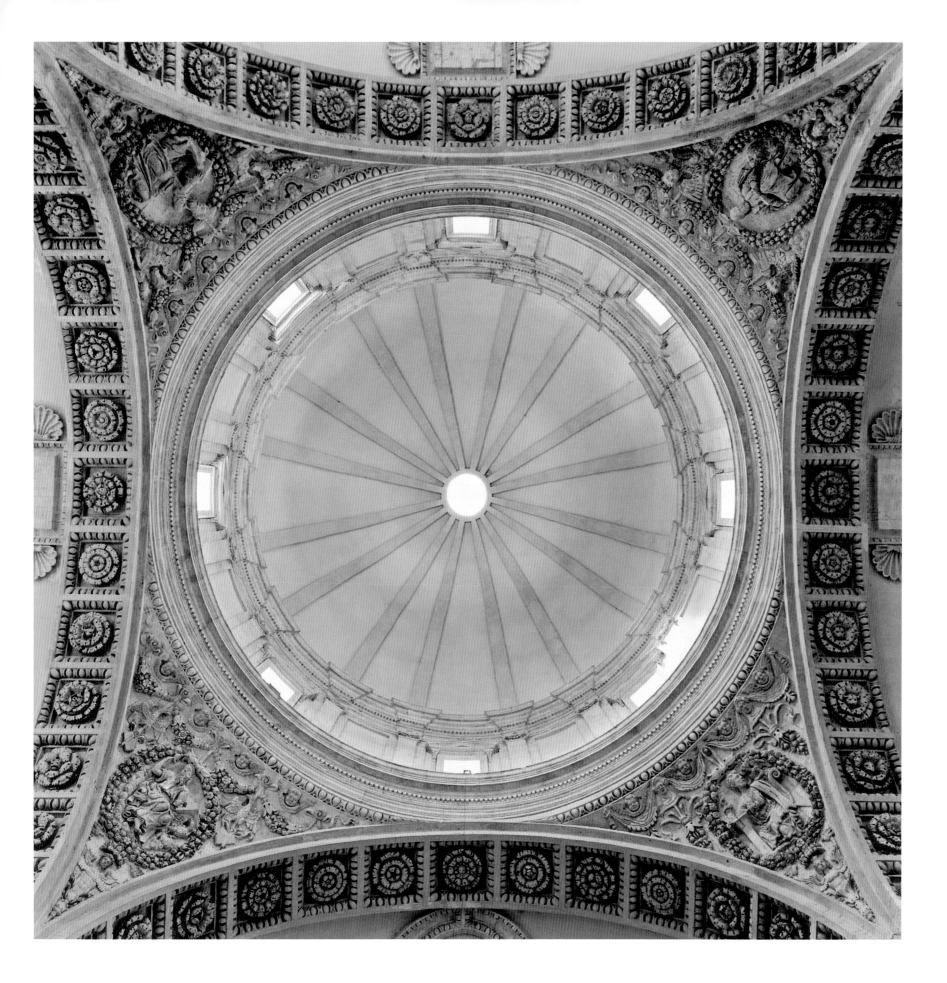

SANTA MARIA DELLA CONSOLAZIONE
Todi, Italy, 1508–1607,
Cola di Caprarola (d. 1518), possibly after a design by Donato Bramante

66

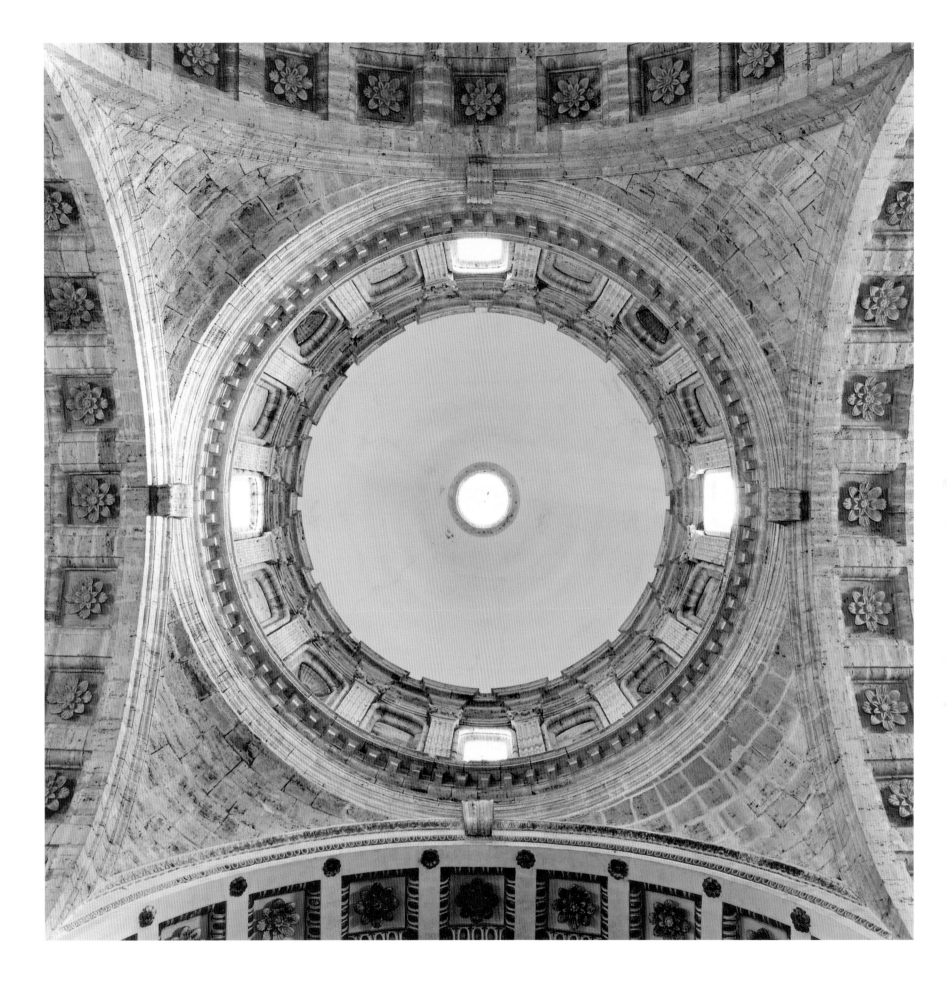

MADONNA DI SAN BIAGIO
Montepulciano, Italy, 1519–1526,
Antonio da Sangallo the Elder (1463–1534)

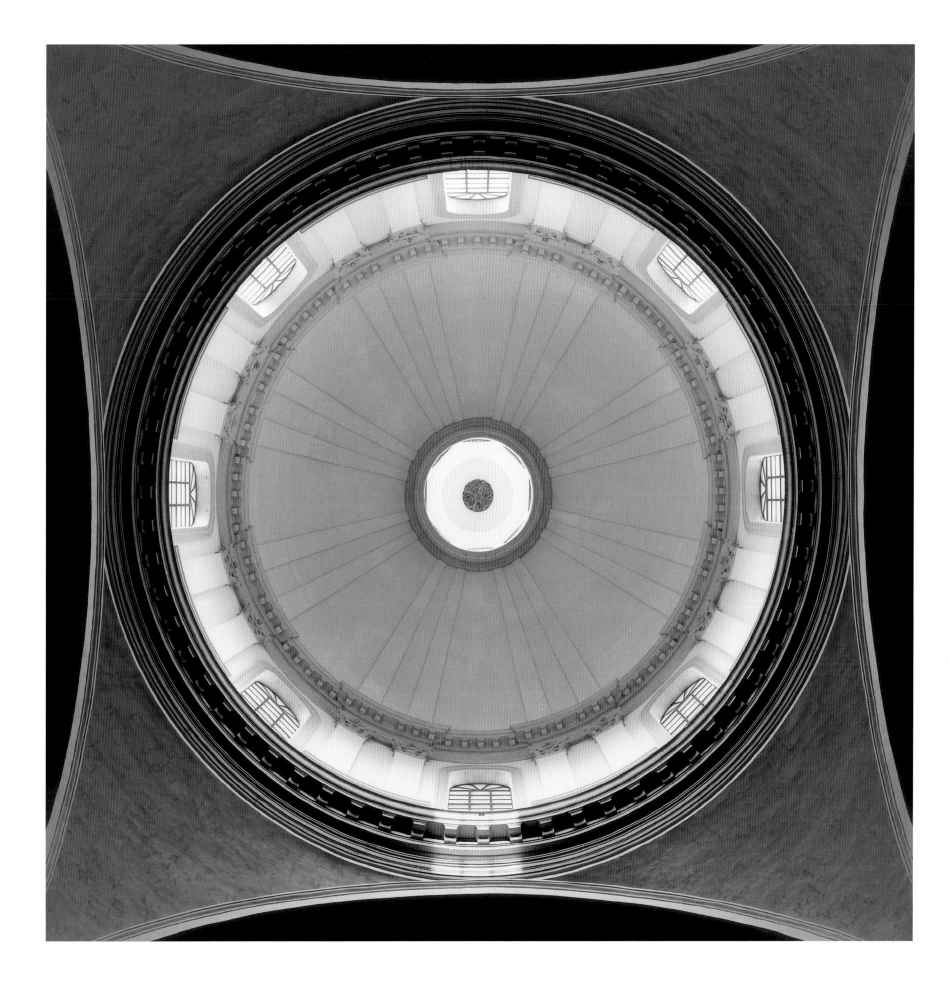

DUOMO
Padua, Italy, remodeled 1552,
Andrea della Valle (d. 1577), Michelangelo Buonarroti (1475–1564), and others

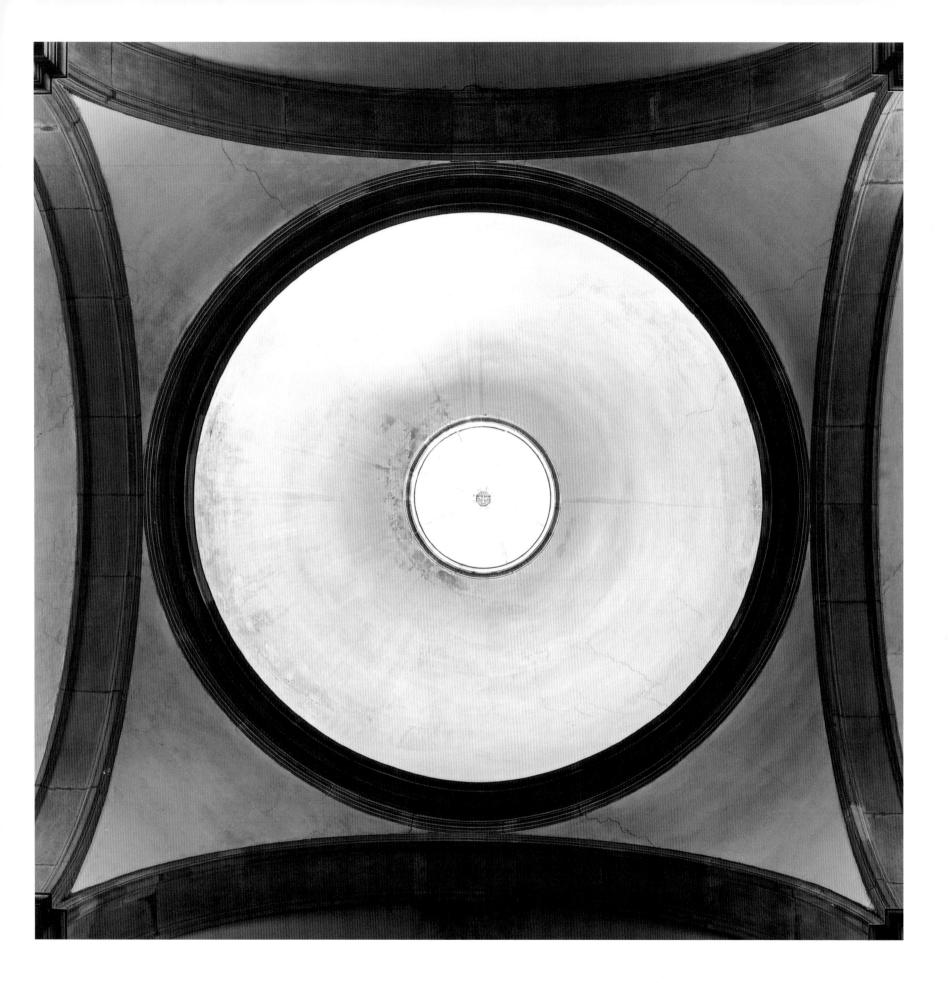

SAN SALVATORE
Venice, Italy, 1512–1607,
Giorgio Spavento

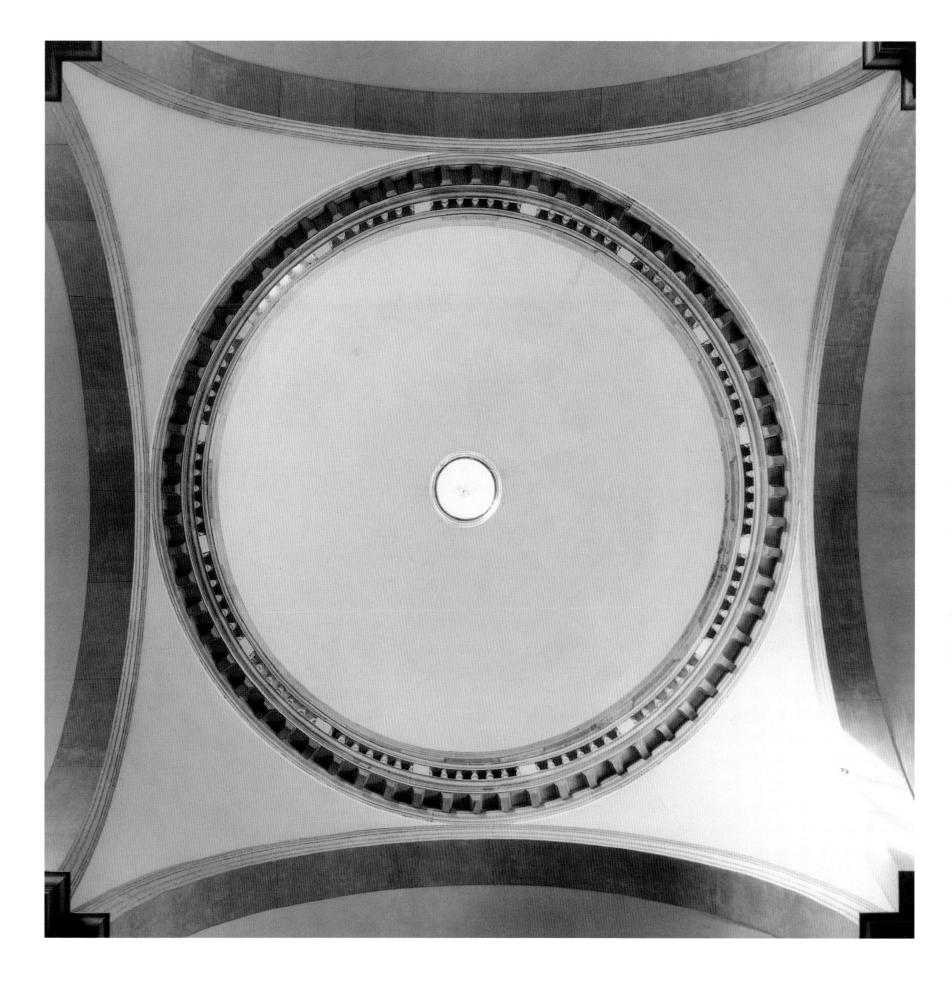

SAN GIORGIO MAGGIORE
Venice, Italy, 1566–1610,
Andrea Palladio (1508–1580)

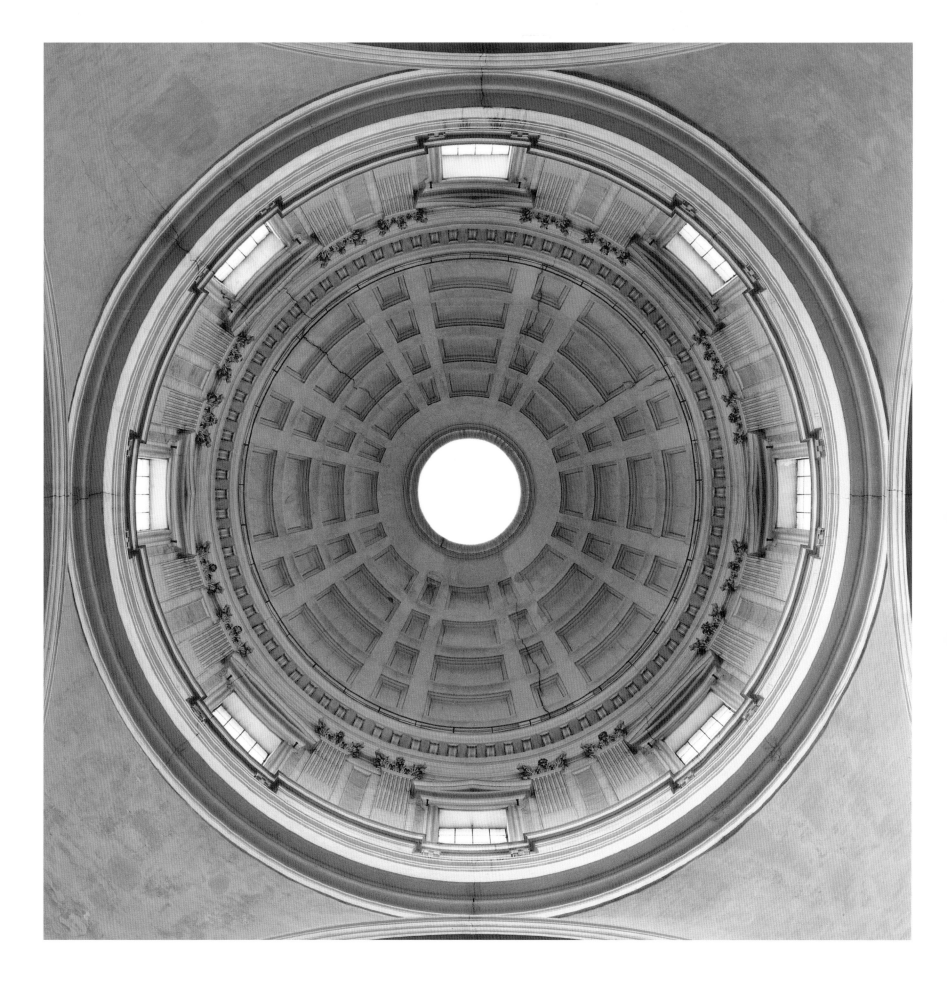

Santa Maria di Carignano
Genoa, Italy, 1549–72,
Galeazzo Alessi (1512–1572)

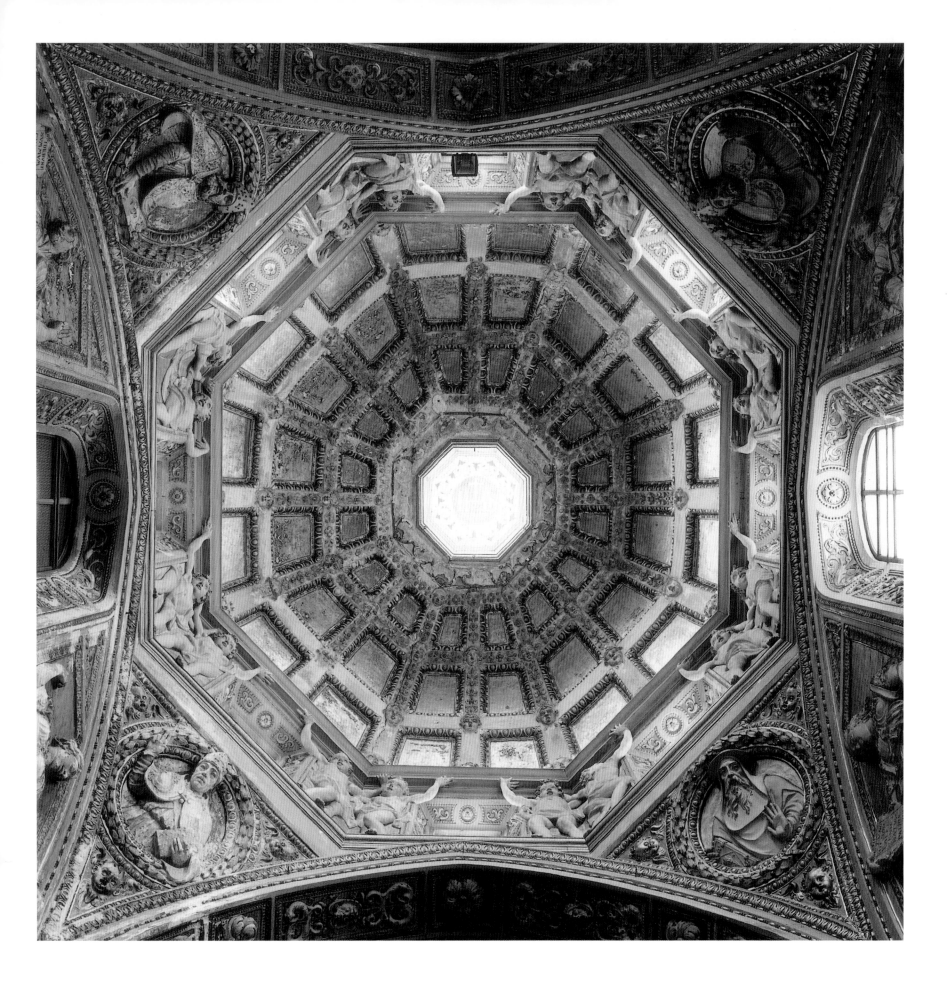

SAN MATTEO
Genoa, Italy, founded 1125 by Martino Doria,
renovated 16th century

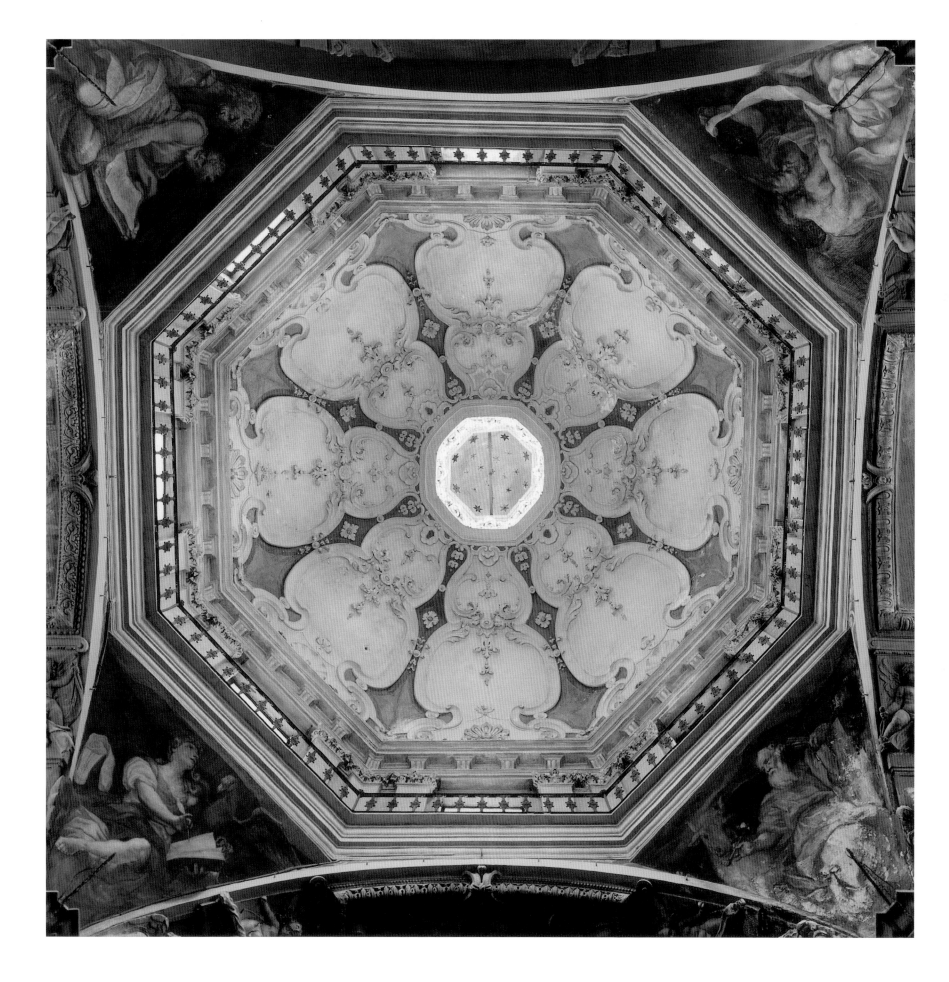

SAN PIETRO IN BANCHI
Genoa, Italy, 1570–76,
Taddeo Carlone (1543–1613)

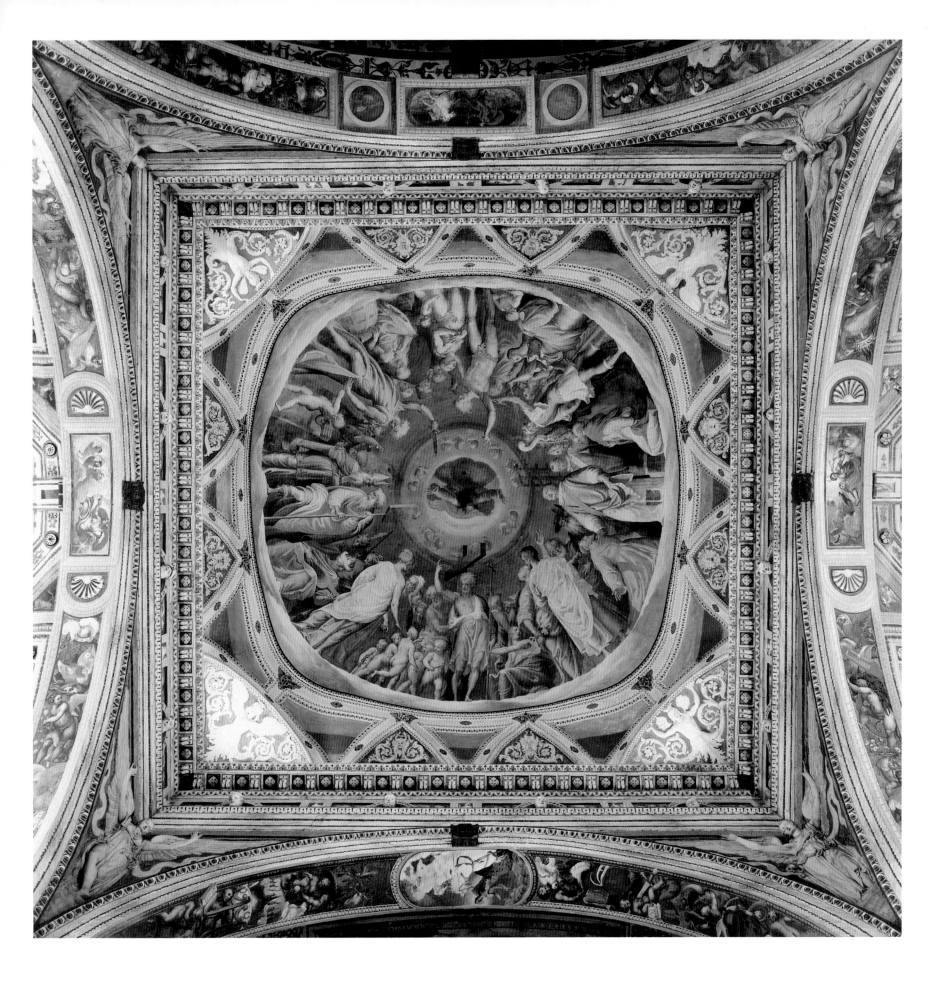

SAN SIGISMONDO
Cremona, Italy, begun 1463,
fresco c. 1533–59 by Camillo Boccaccino (1511–1546) and Giulio (c. 1508–1573) and Bernardino (c. 1522–1590) Campi

76

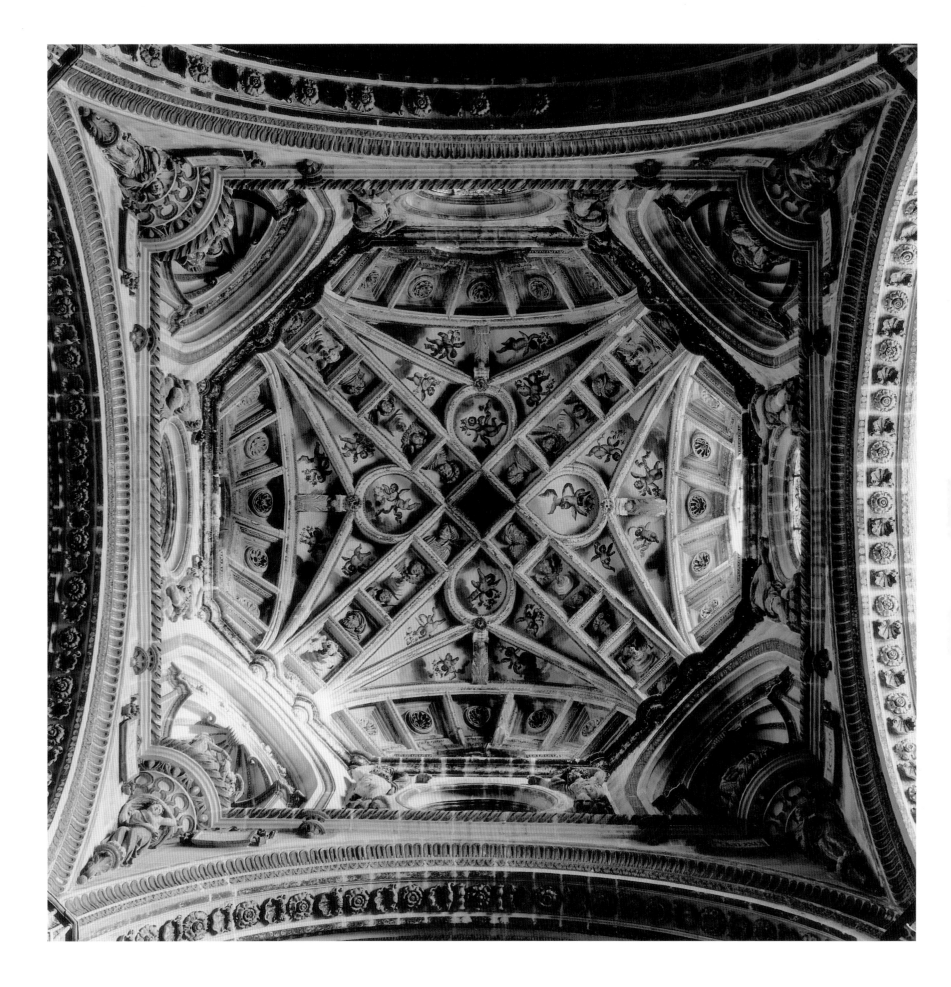

San Jerónimo
Granada, Spain, 1523–43,
Francesco Florentino and Diego de Siloe (c. 1495–1563)

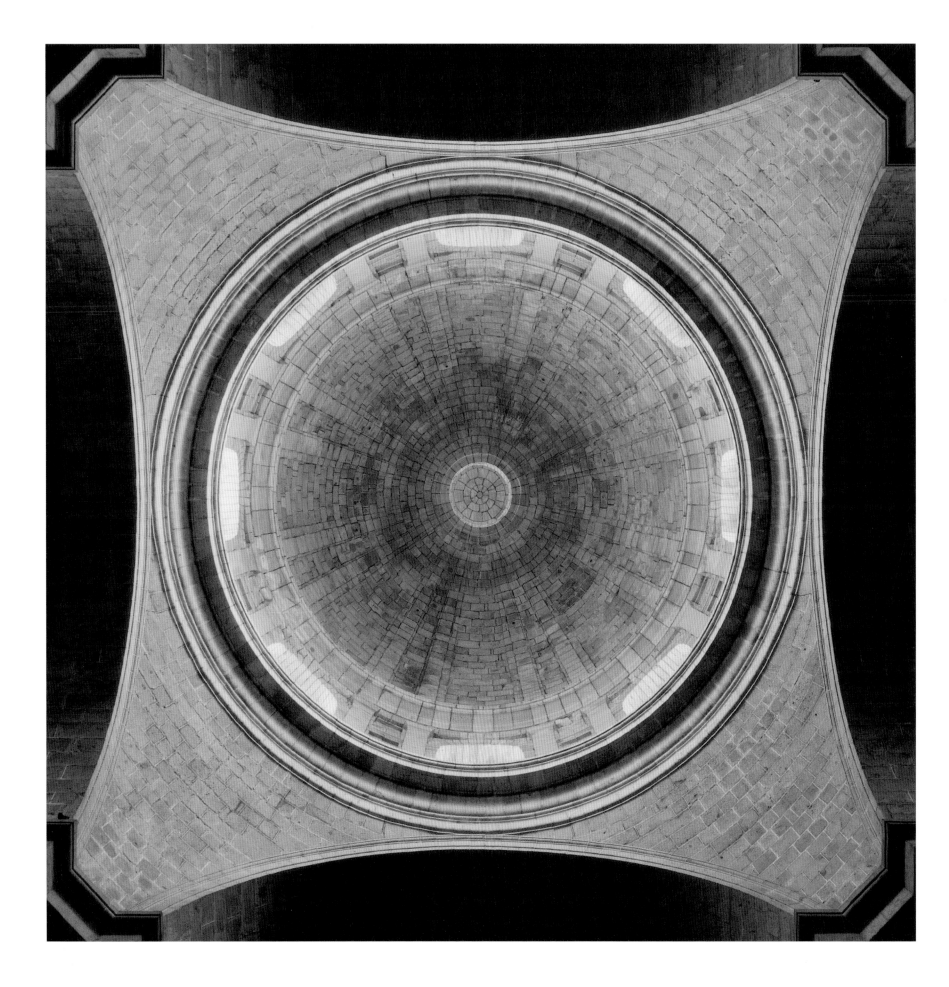

Monasterio de San Lorenzo de El Escorial
El Escorial, Spain, 1563–84,
Juan Bautista de Toledo (d. 1567) and Juan de Herrera (1530–1597)

III.

The Baroque
in Southern and Western Europe

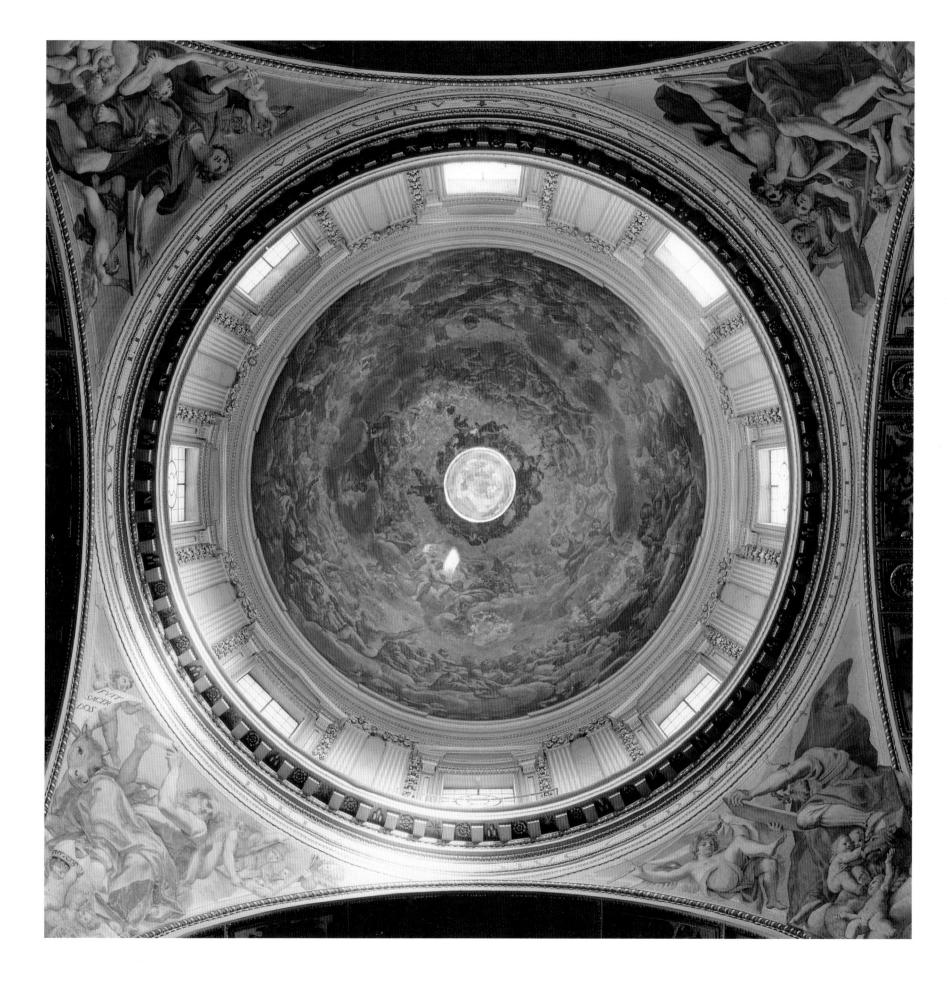

Sant'Andrea delle Valle
Rome, Italy, 1608–25,
Carlo Maderno (1556–1629)

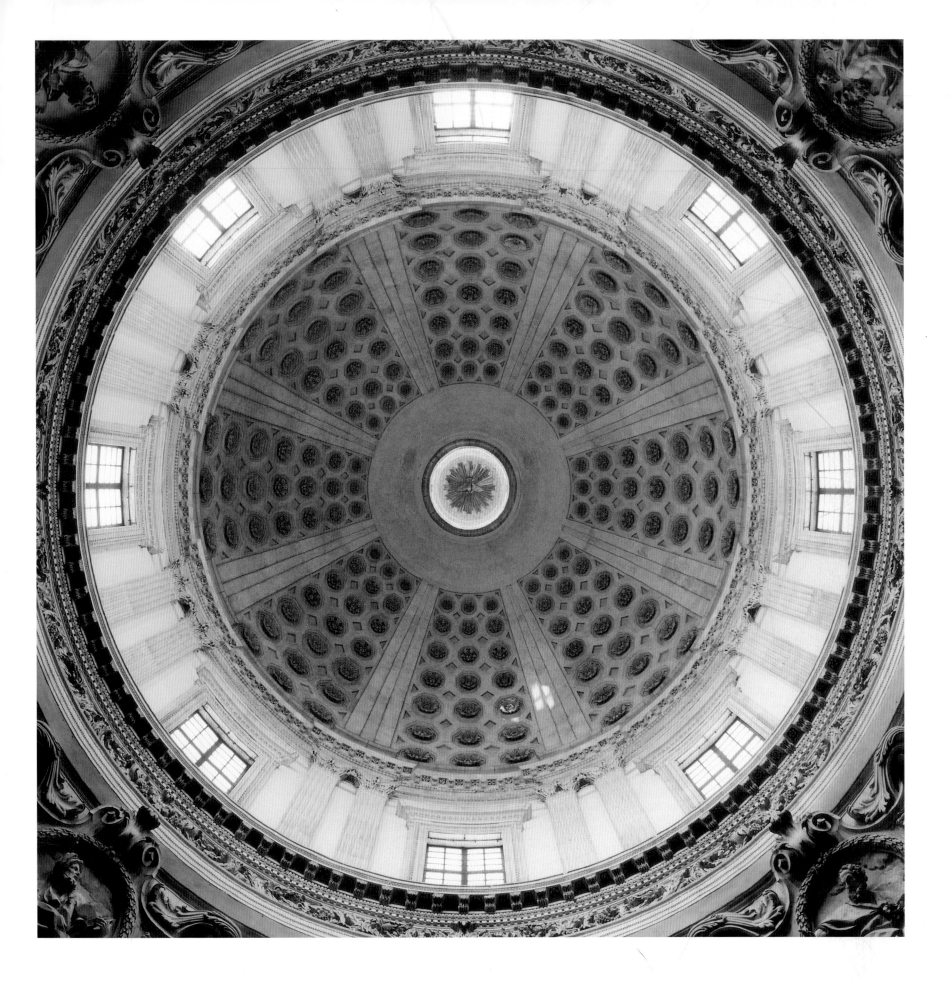

DUOMO NUOVO
Brescia, Italy, 1604–1825,
dome possibly by Luigi Cagnola (d. 1833)

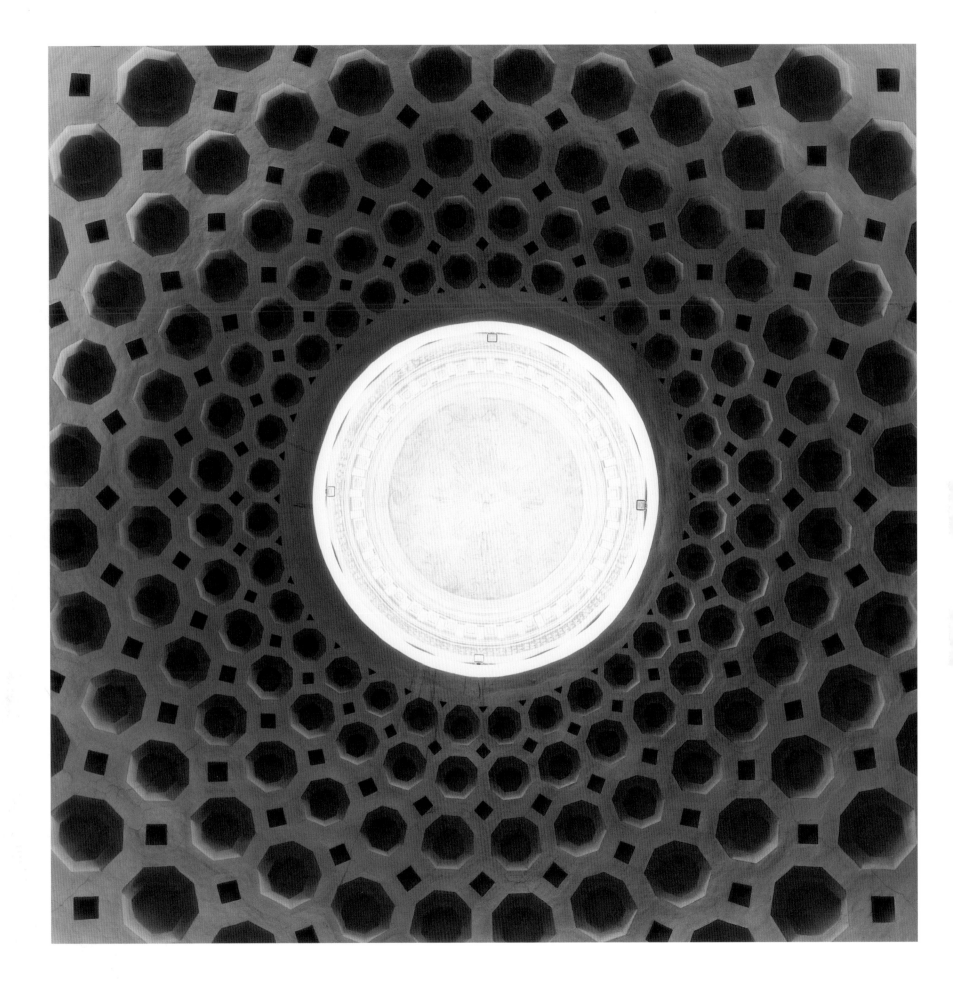

San Bernardo alle Terme
Rome, Italy, c. 1603,
possibly Camillo Mariani (1556–1611)

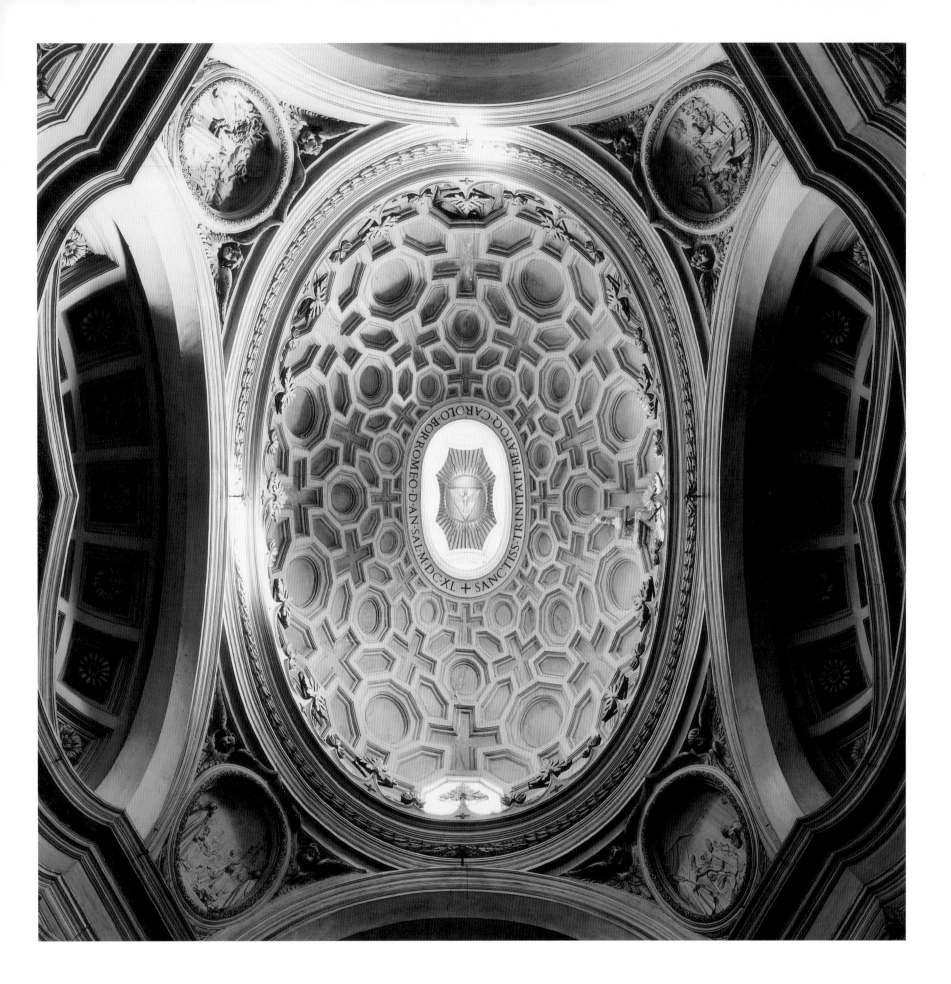

San Carlo alle Quattro Fontane
Rome, Italy, 1638–41,
Francesco Borromini (1599–1667)

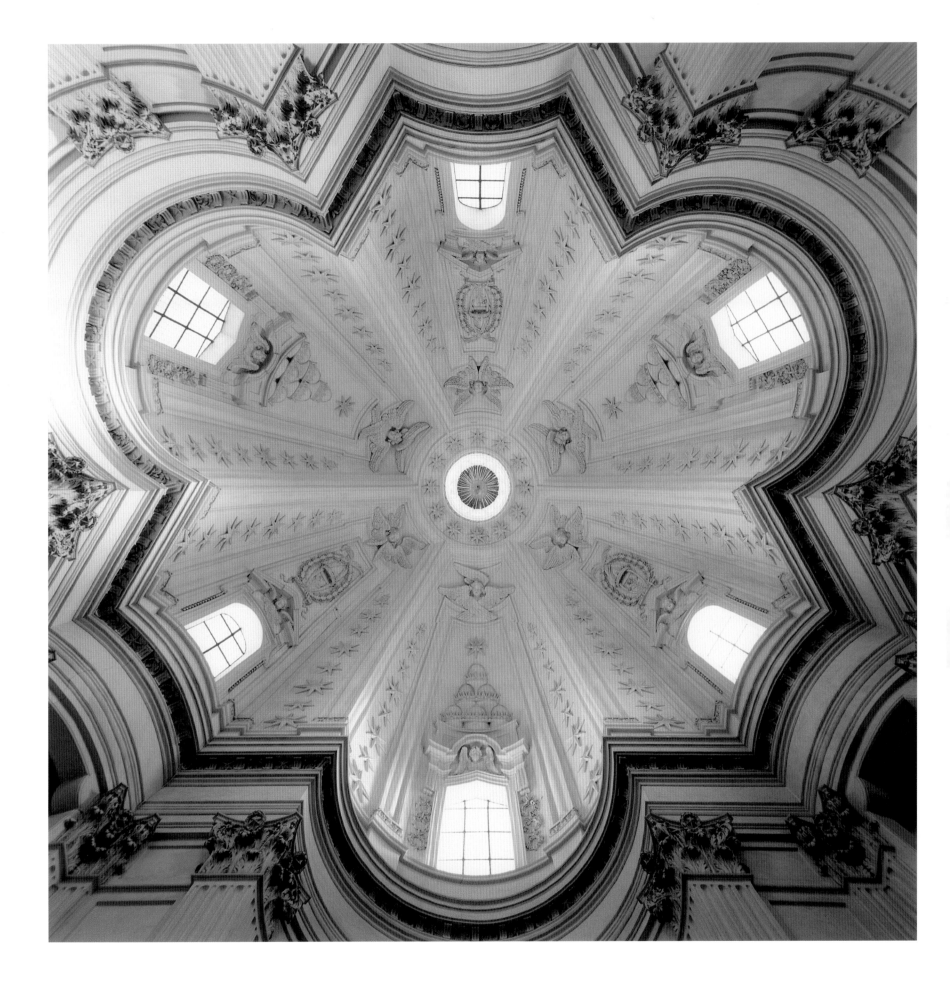

Sant'Ivo alla Sapienza
Rome, Italy, 1642–50,
Francesco Borromini

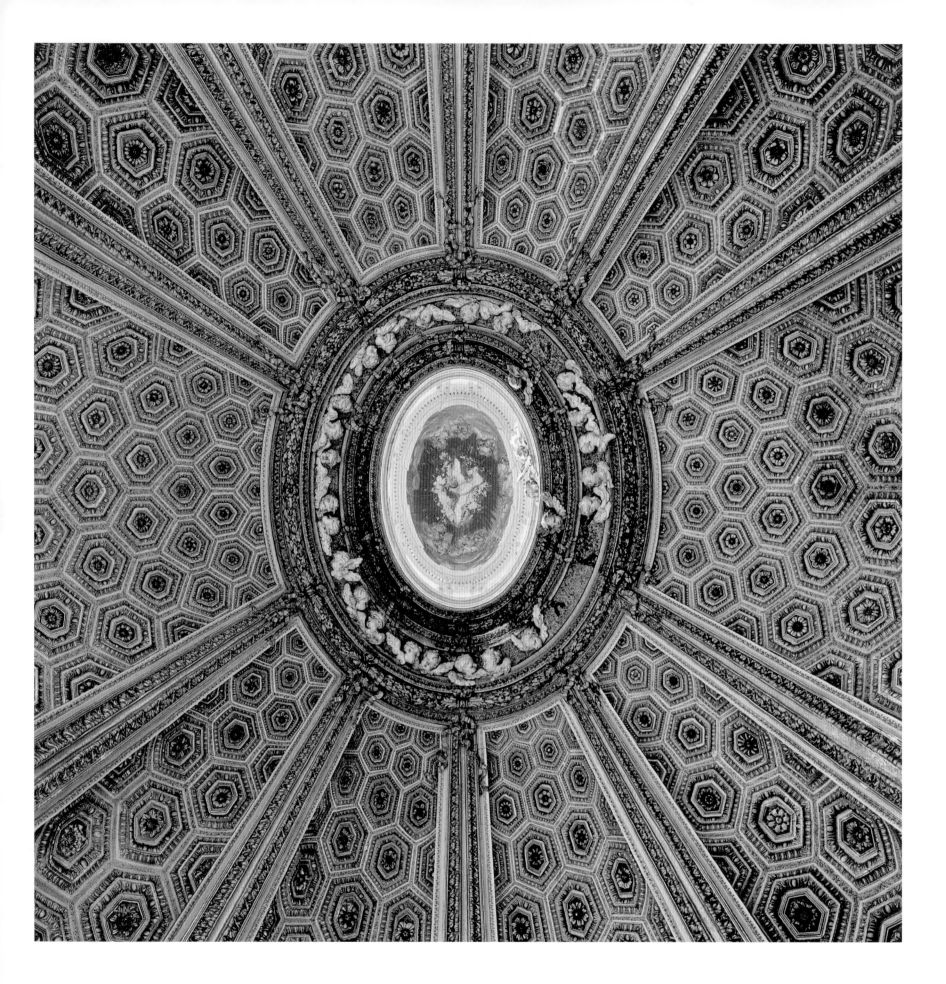

SANT'ANDREA AL QUIRINALE
Rome, Italy, 1658–61,
Gian Lorenzo Bernini (1598–1680)

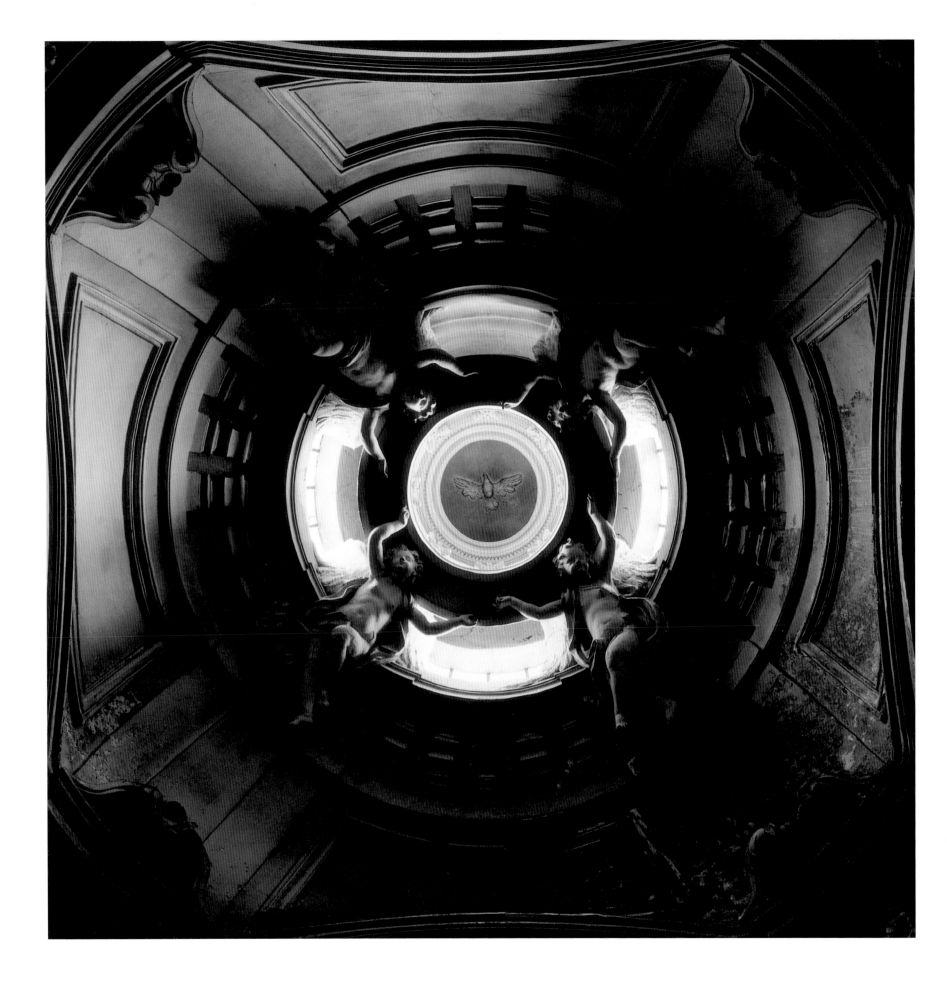

AVILA CHAPEL, SANTA MARIA IN TRASTAVERE
Rome, Italy, begun 1680,
Antonio Gherardi (1644–1702)

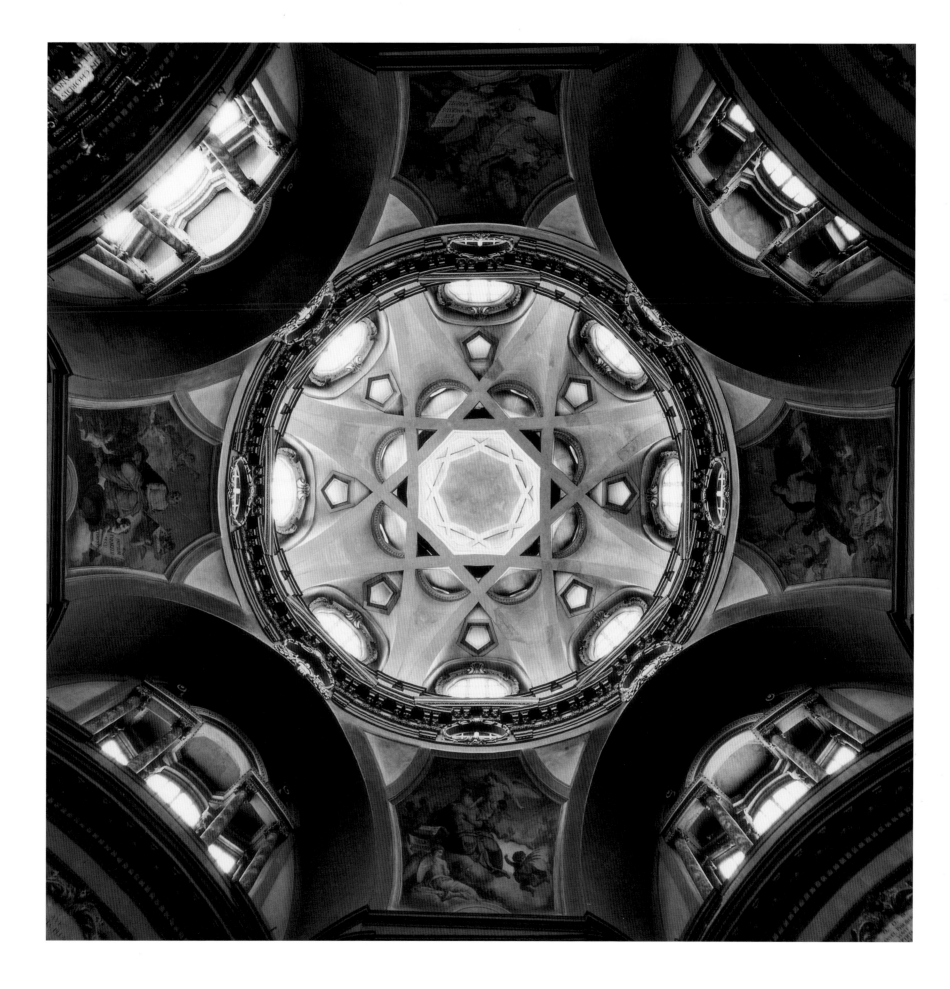

SAN LORENZO
Turin, Italy, 1668–87,
Guarino Guarini (1624–1683)

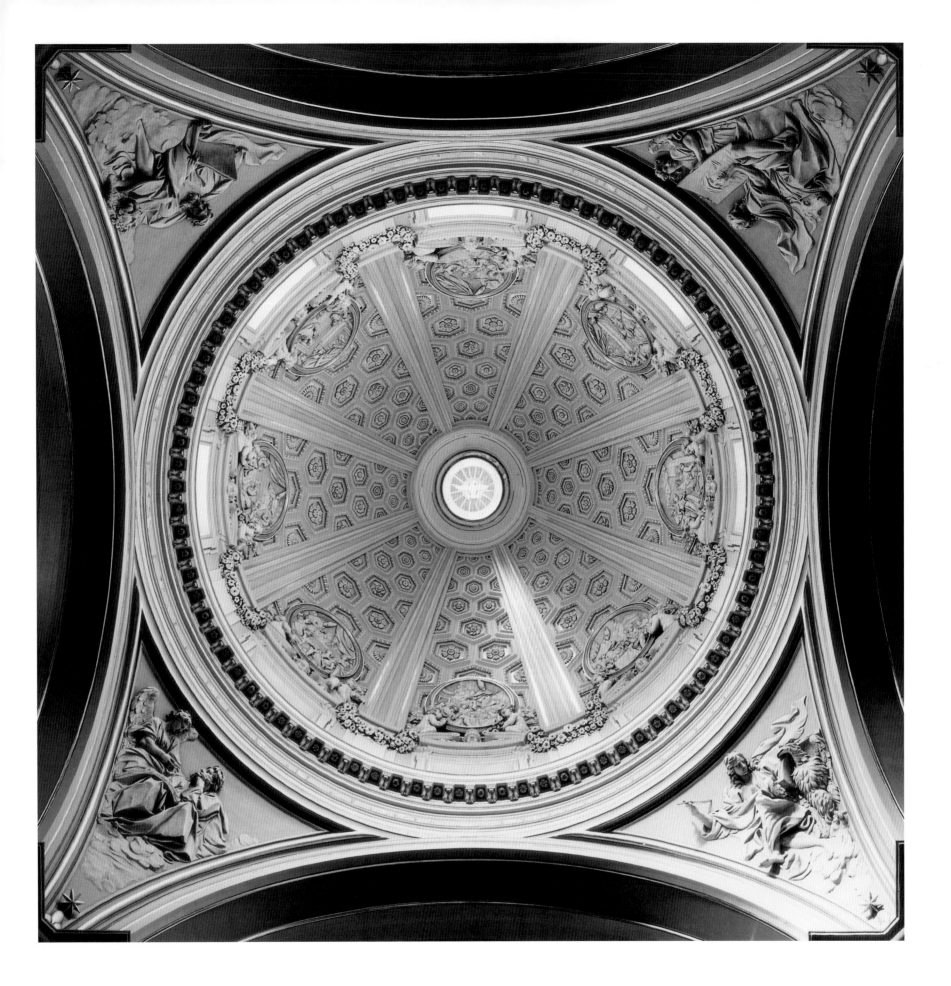

San Tommaso da Villanova, Castelgandolfo
Rome, Italy, 1658–61,
Gian Lorenzo Bernini

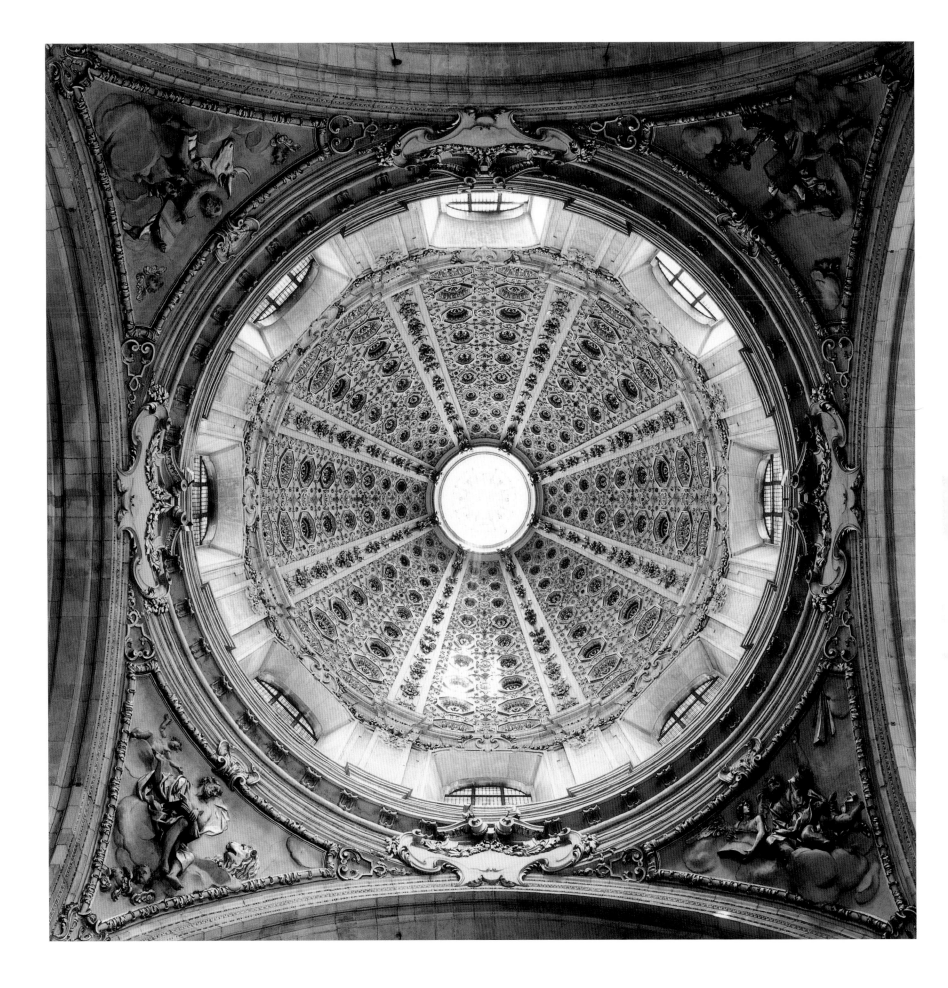

DUOMO
Como, Italy, dome 1688,
by Carlo Fontana (1638–1714)

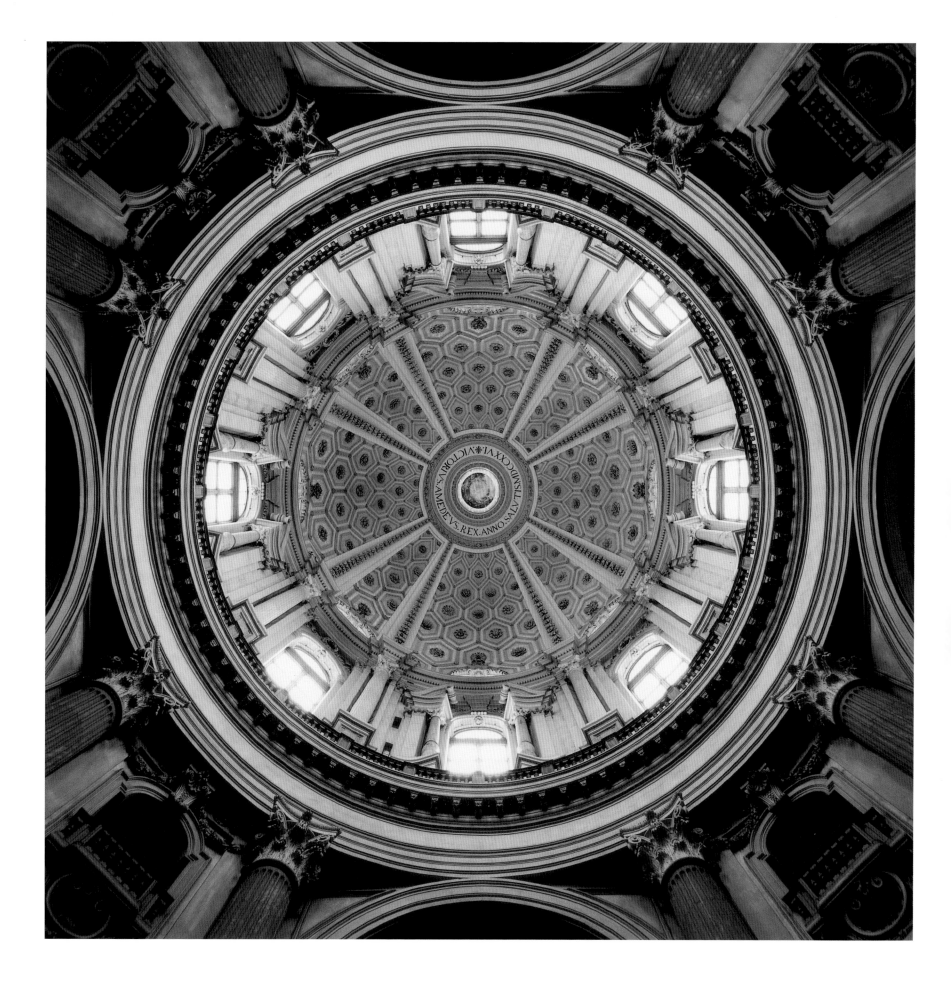

BASILICA DI SUPERGA
Turin, Italy, 1717–31,
Filippo Juvarra (1678–1736)

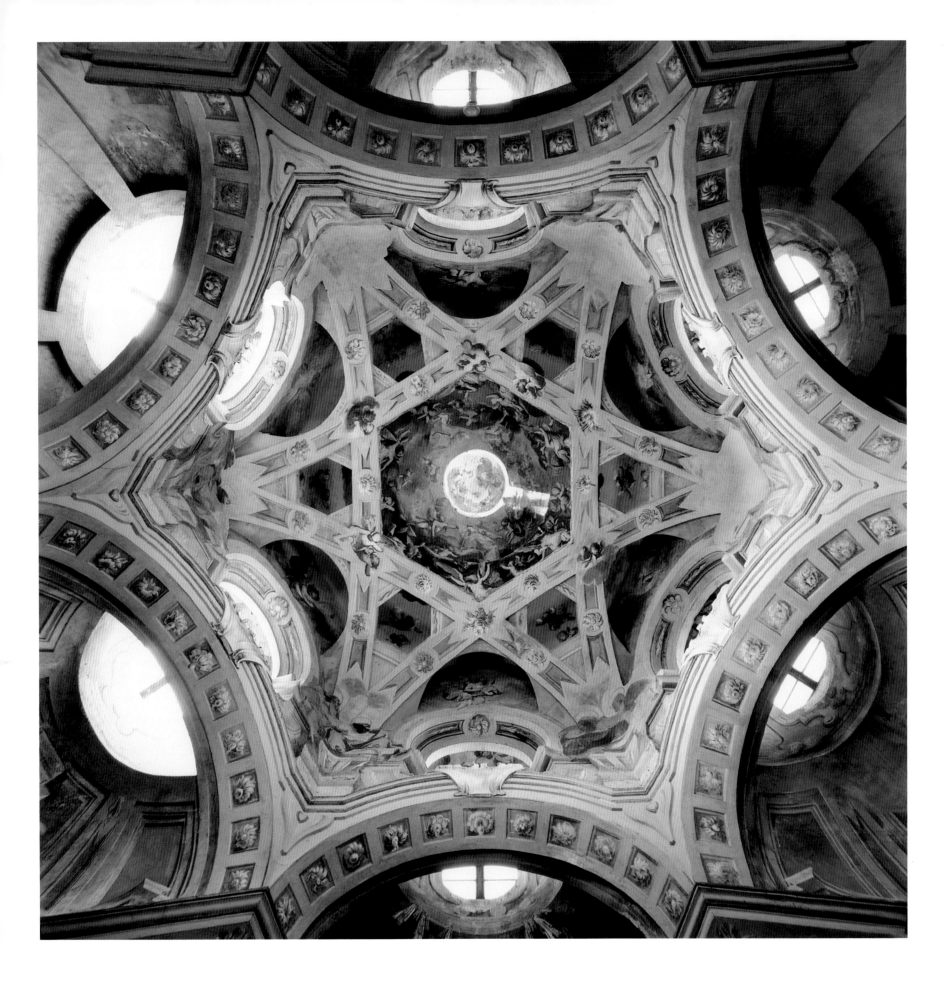

Capella della Visitazione (Chapel of the Visitation), Sanctuary of Valinotto
near Carignano, Italy, 1738–39,
Bernardo Vittone (1702–1770)

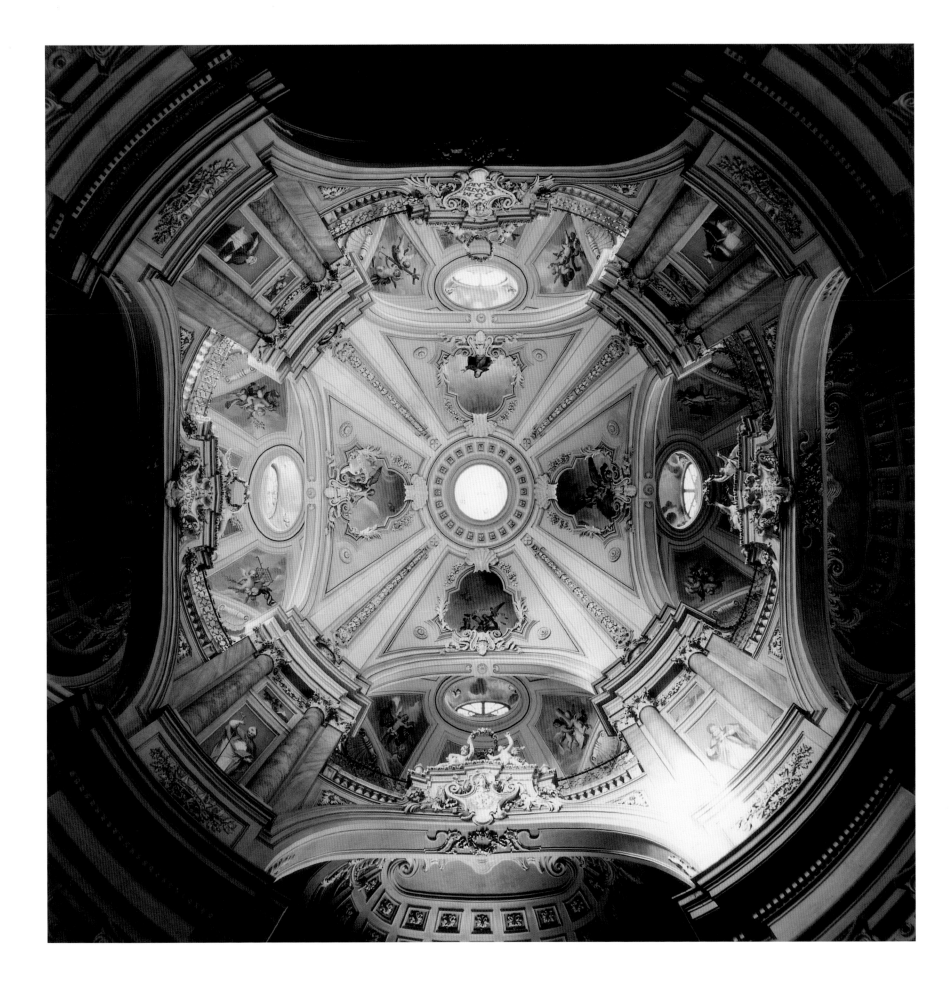

SANTA CHIARA
Bra, Italy, 1742–48,
Bernardo Vittone

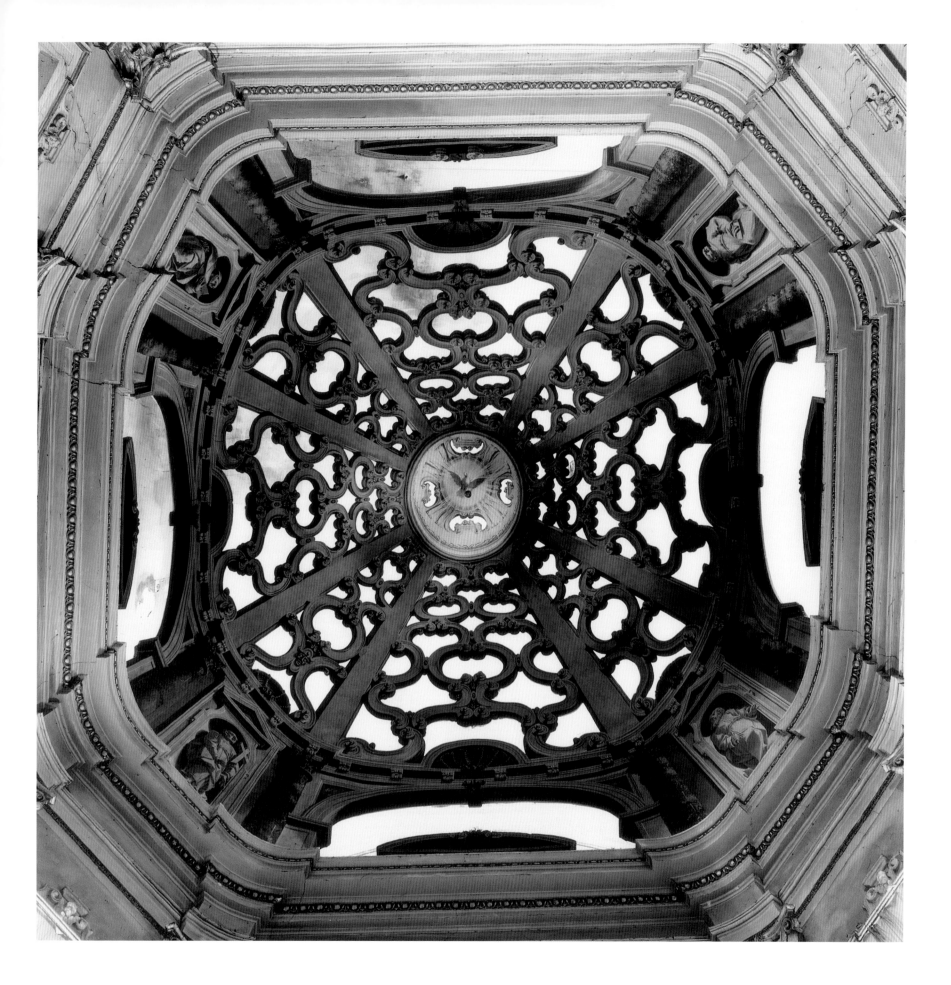

SANTA MARIA ASSUMPTA
Sabbionetta, Italy, c. 1770,
Antonio Galli Bibiena (c. 1700–1774)

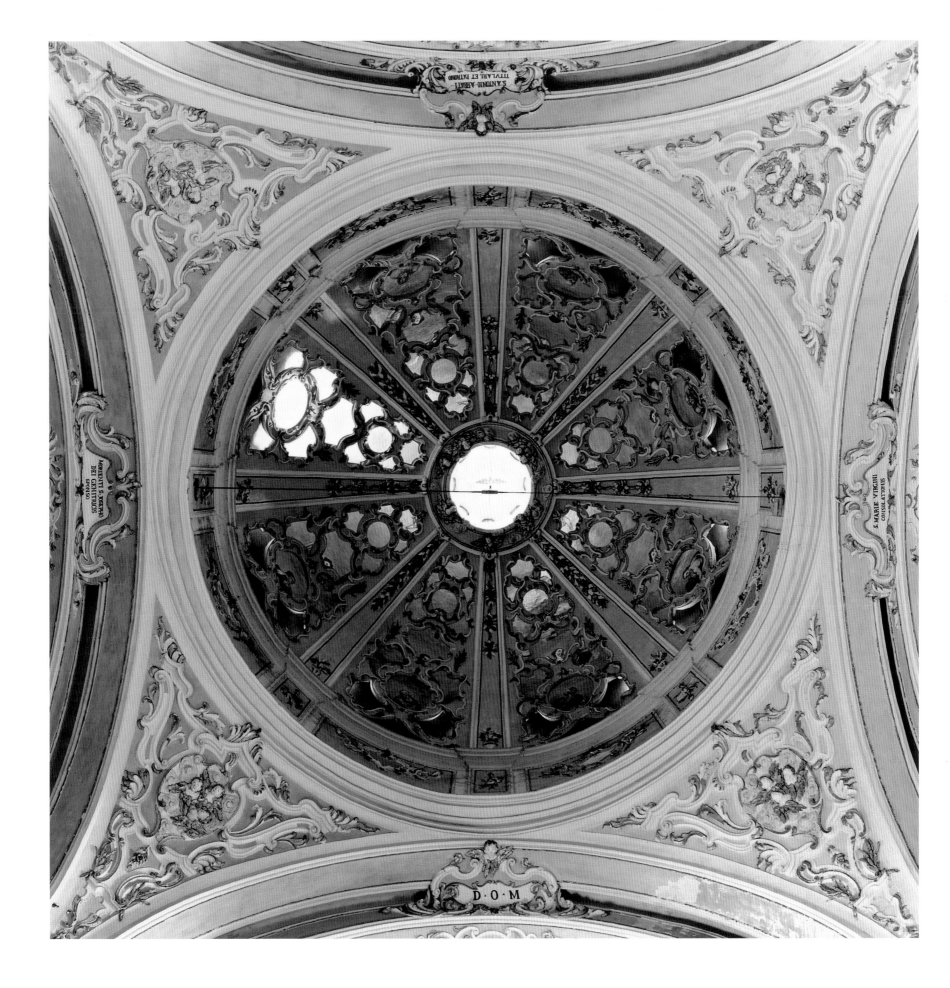

PARISH CHURCH
Villa Pasquali, Italy, 1765–74,
Antonio Galli Bibiena

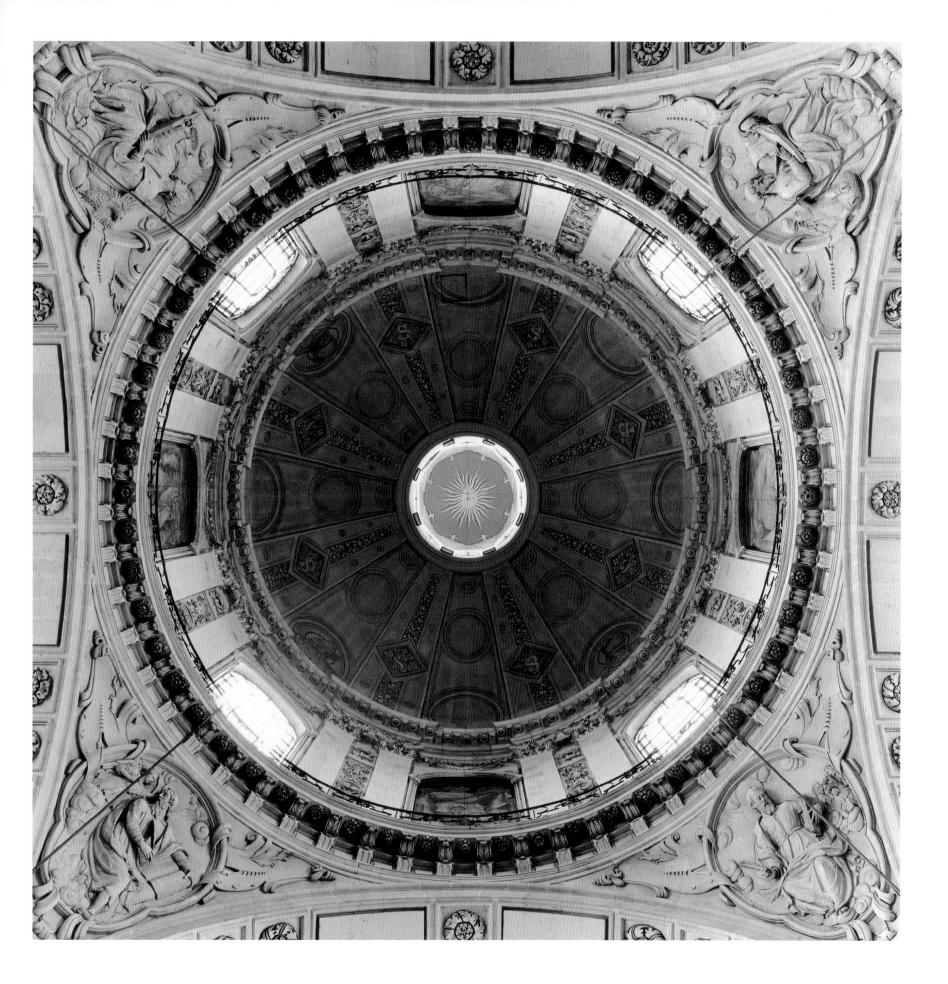

ST. PAUL-ST. LOUIS
Paris, France, 1627–41,
François Derand (1591–1644)

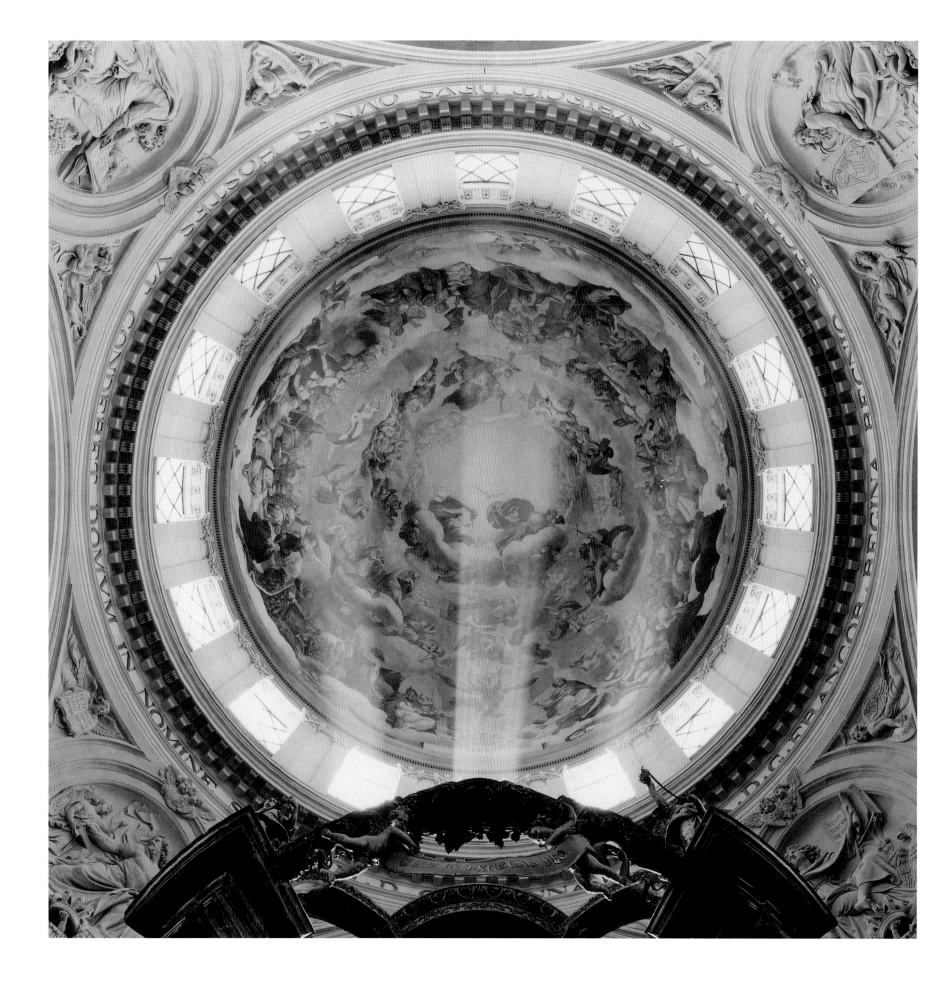

VAL-DU-GRACE
Paris, France, 1645–1710,
François Mansart (1598–1666), dome by Jacques Lemercier (c. 1585–1654)

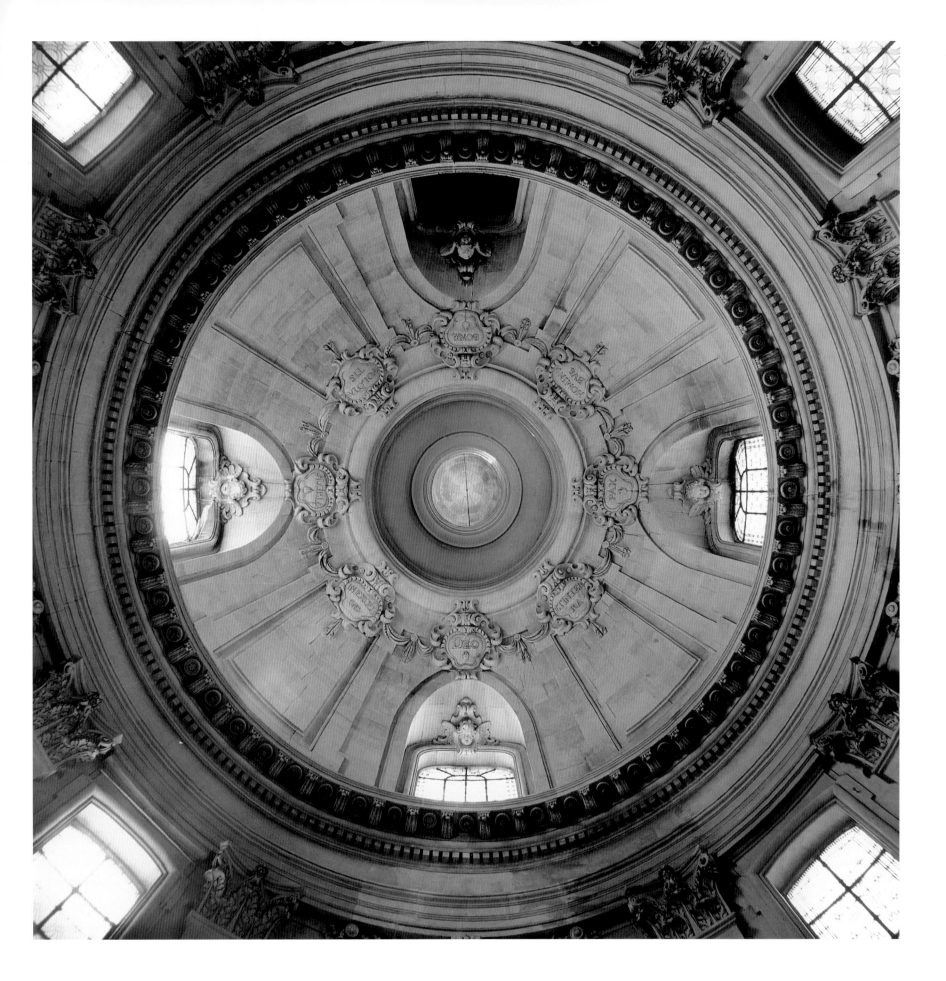

St. Marie de la Visitation
Paris, France, 1632–33,
François Mansart

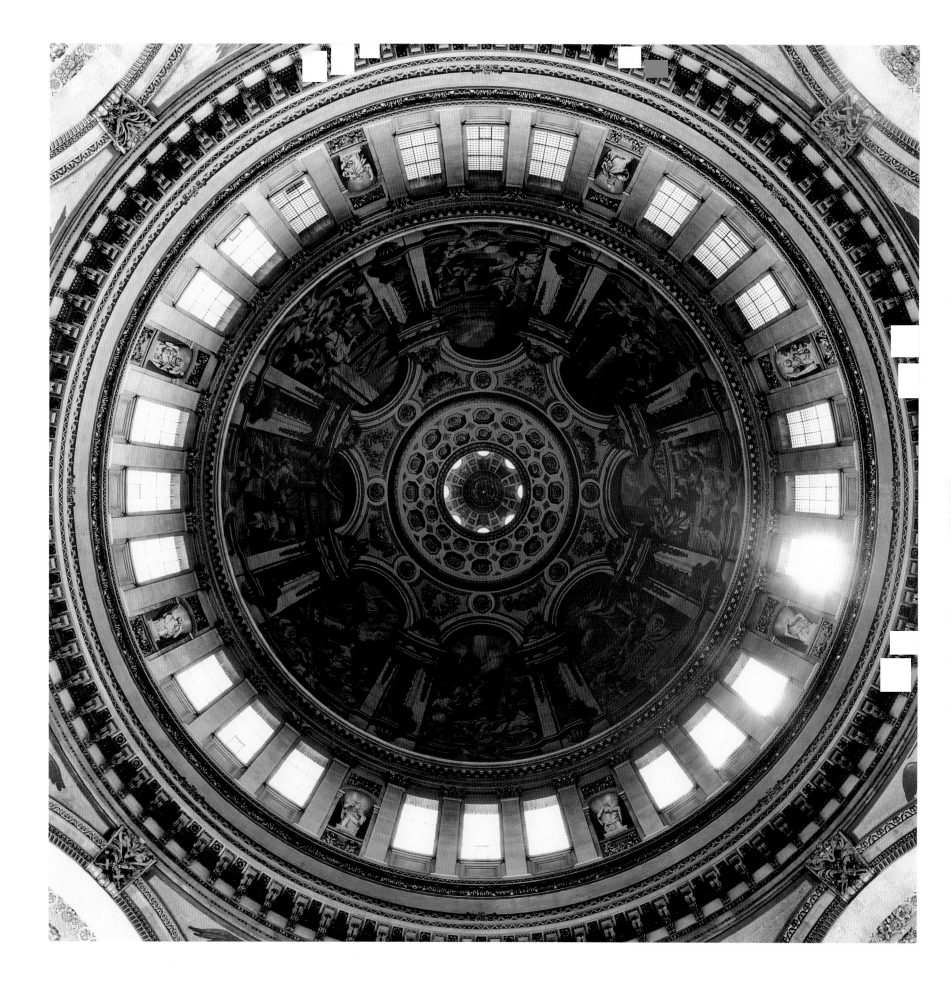

ST. PAUL'S CATHEDRAL
London, England, 1675–1711,
Sir Christopher Wren (1631–1723)

101

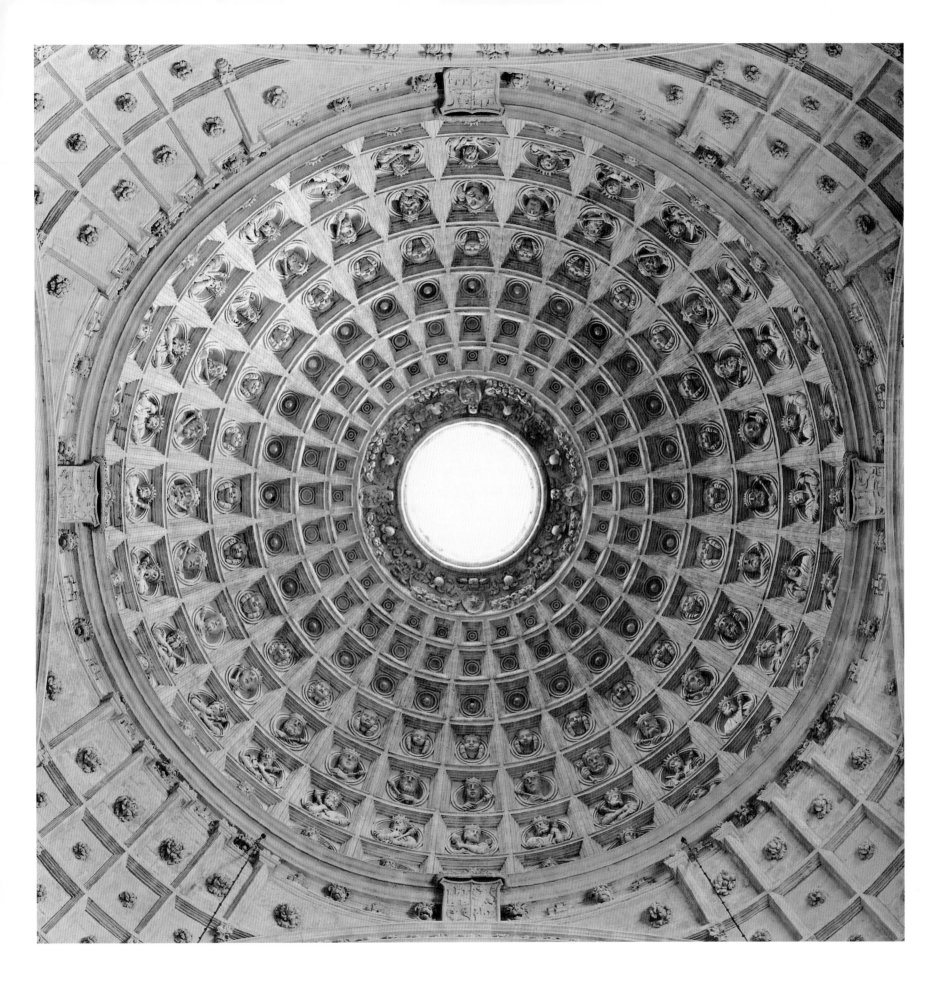

IGLESIA DEL SAGRARIO, CATEDRAL
Sevilla, Spain, 17th century

104

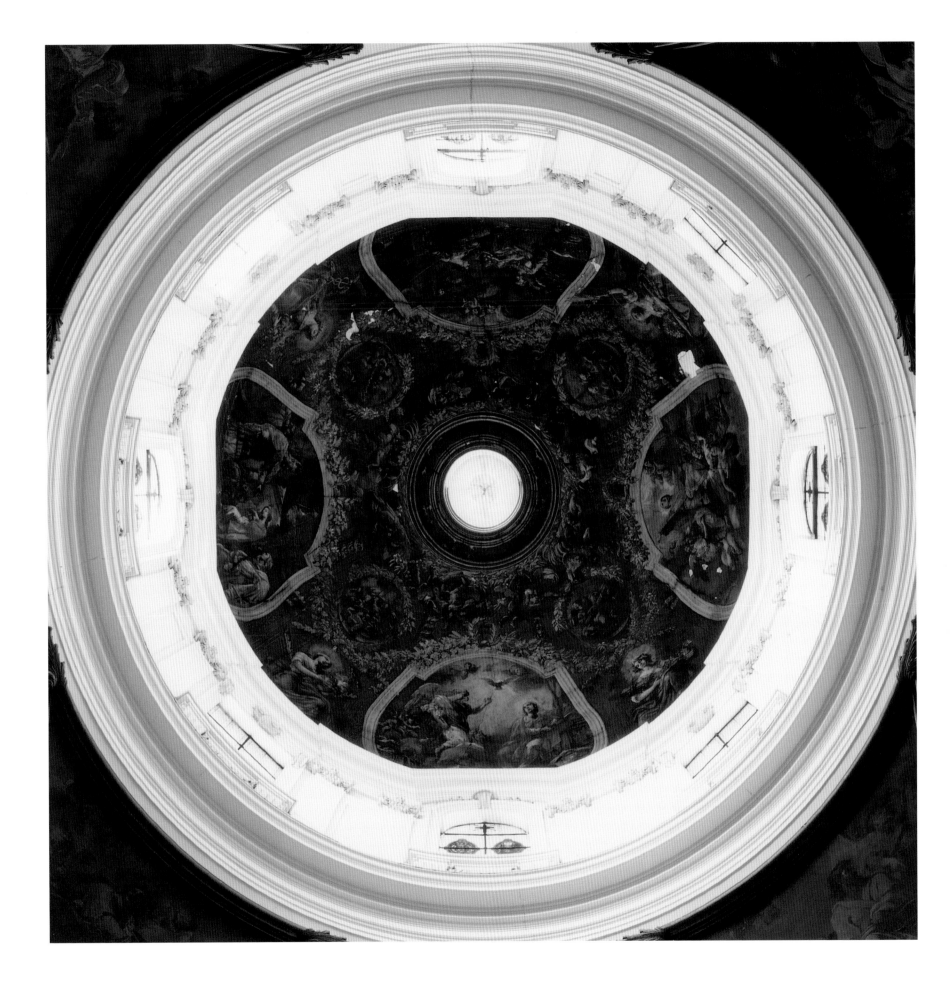

IGLESIA DE LAS SALESAS REALES
Madrid, Spain, 1750–58,
François Carlier (1707–1760)

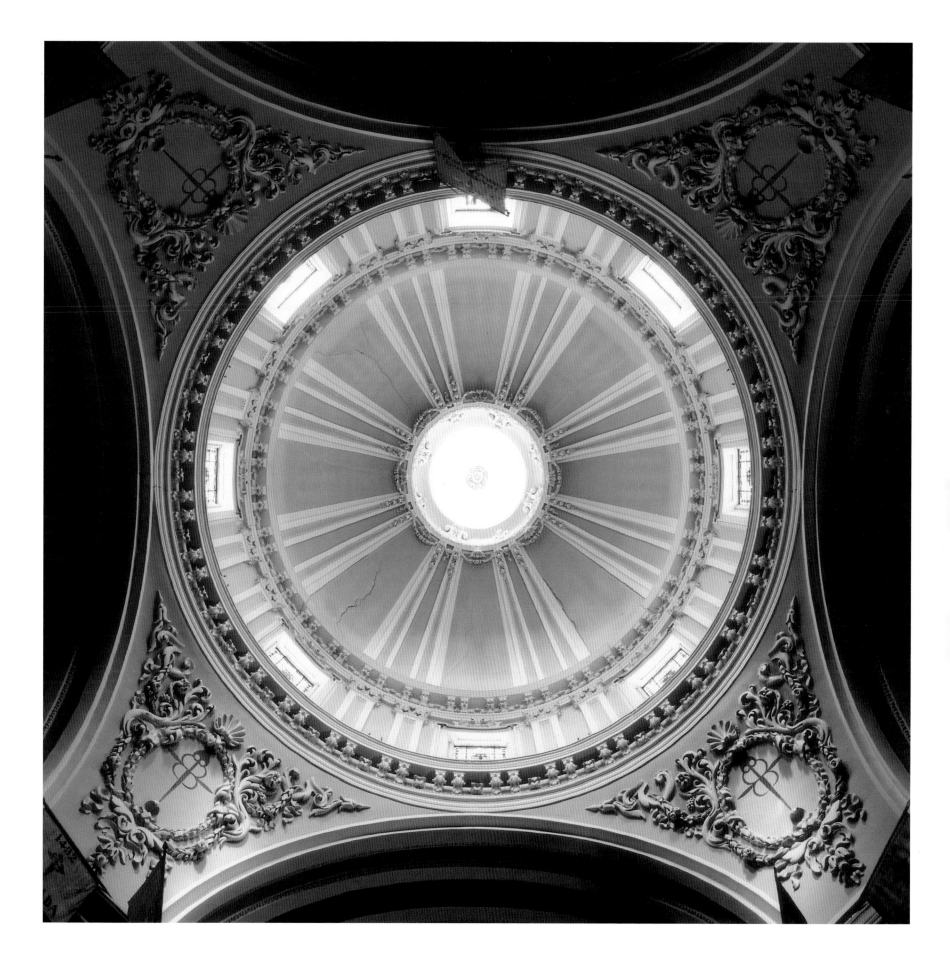

COMENDADORAS DE SANTIAGO
Madrid, Spain, 1667–79,
Manuel and José del Olmo

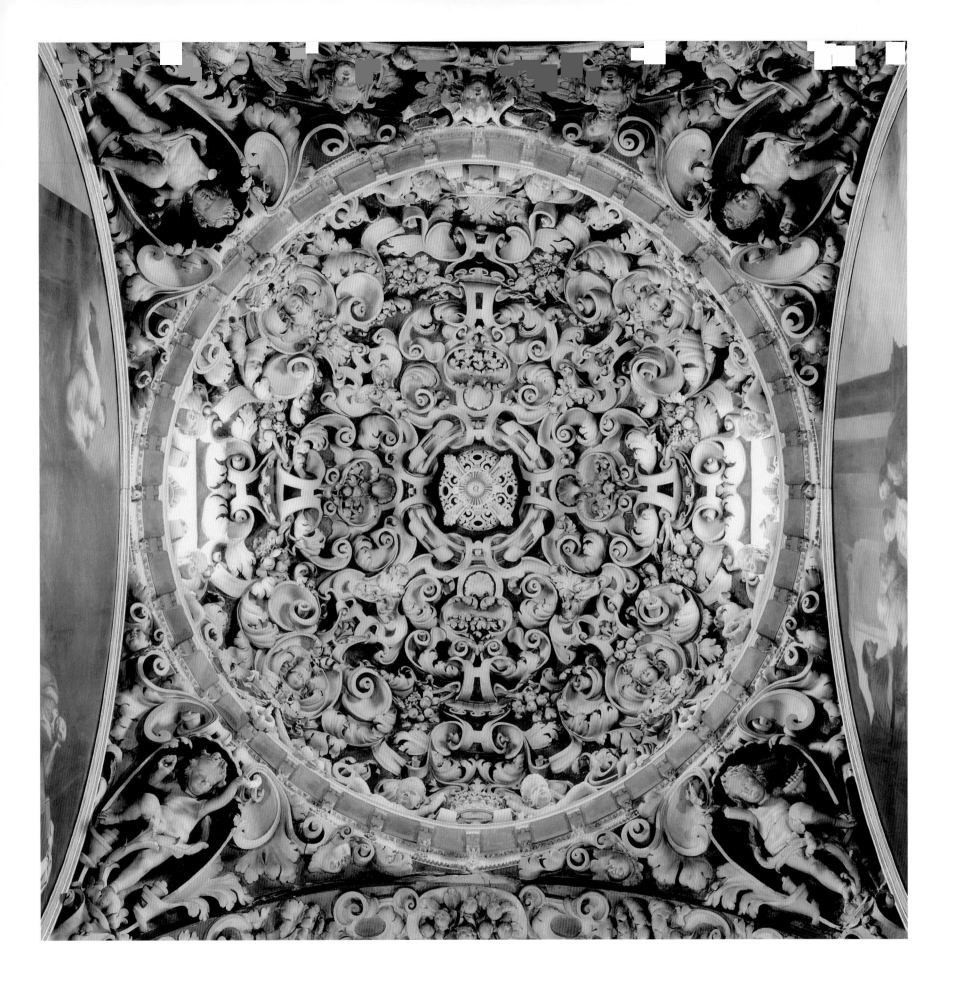

SANTA MARIA LA BLANCA
Sevilla, Spain, begun 1659,
Pedro and Miguel de Borja

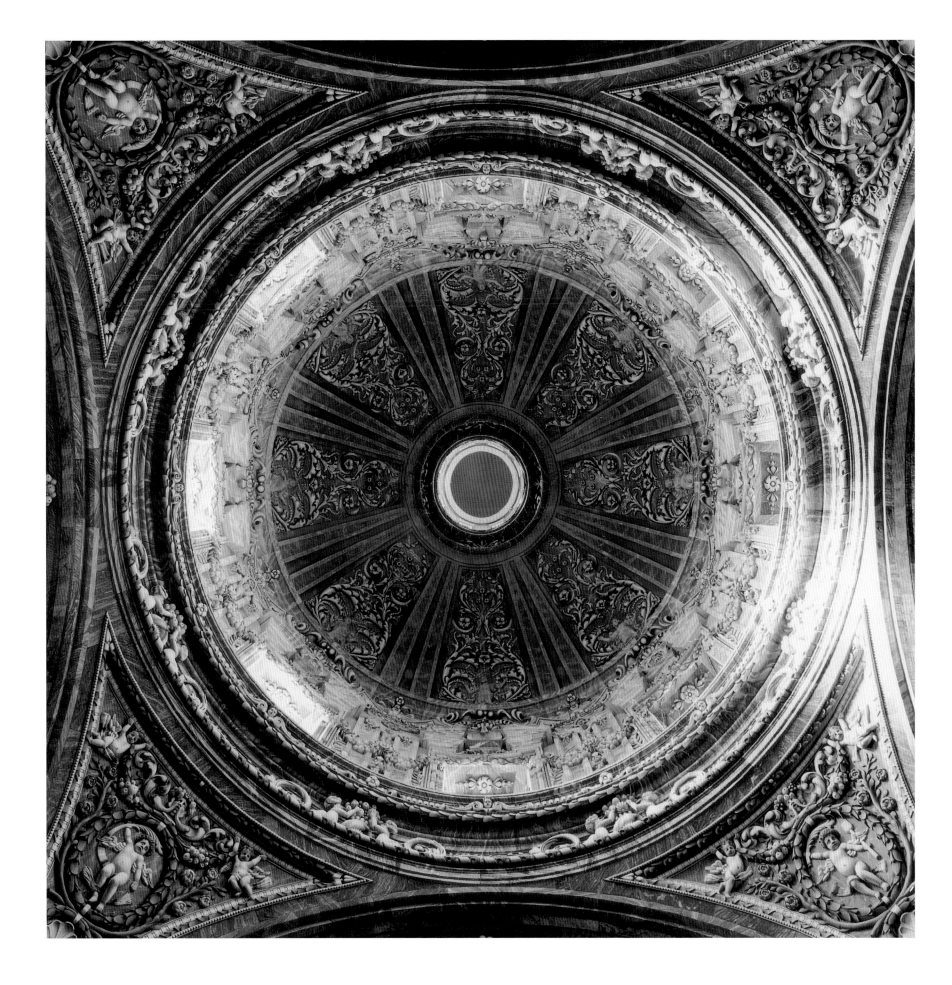

CAPILLA DE SAN ISIDRO EN SAN ANDRÉS
Madrid, Spain, 1657–62,
José de Villarreal

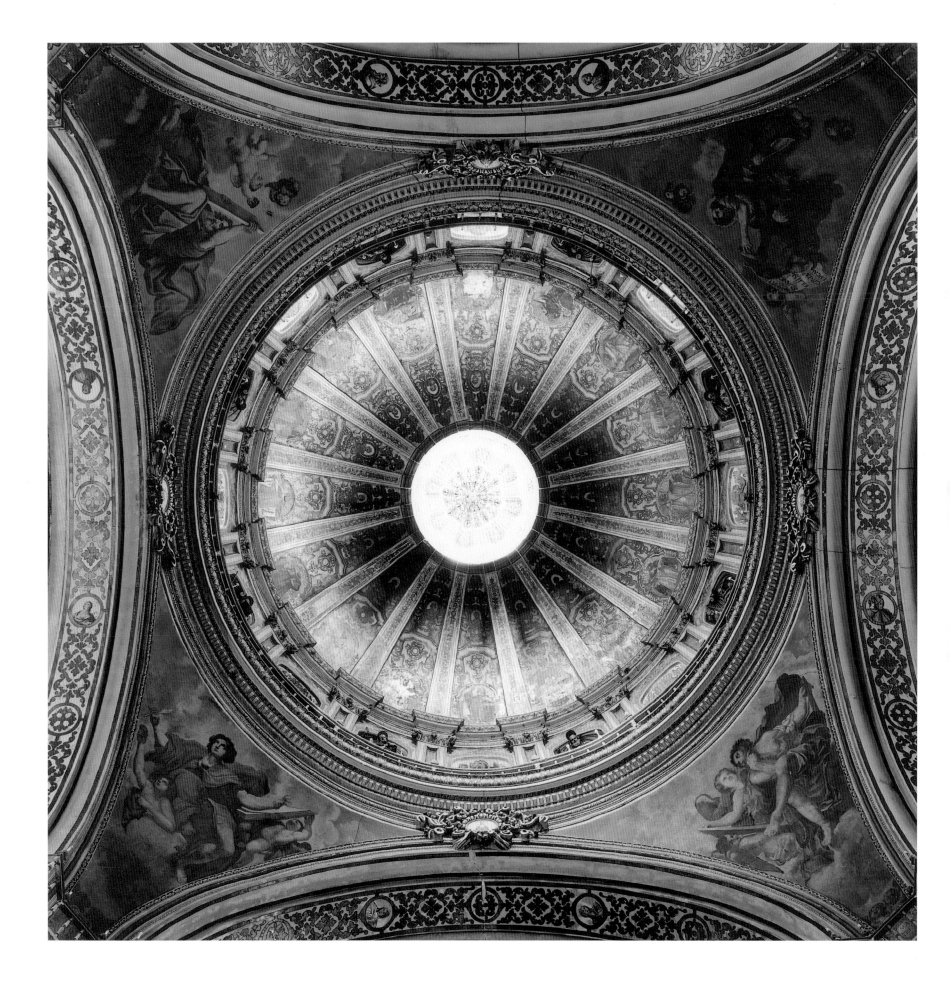

SAN JUAN DE DÍOS
Granada, Spain, 1739–59,
José de Bada (1691–1751)

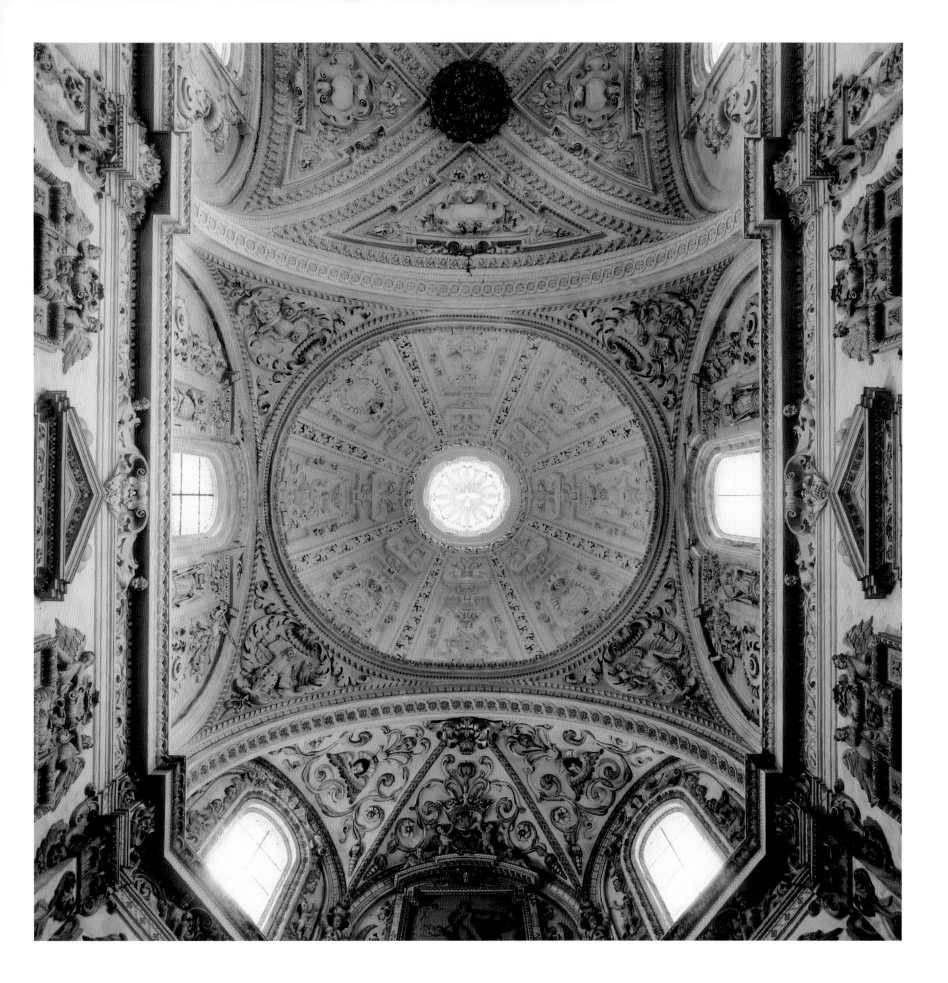

La Cartuja
Granada, Spain, begun 1702,
probably Francisco de Hurtado Izquierdo (1669–1725)

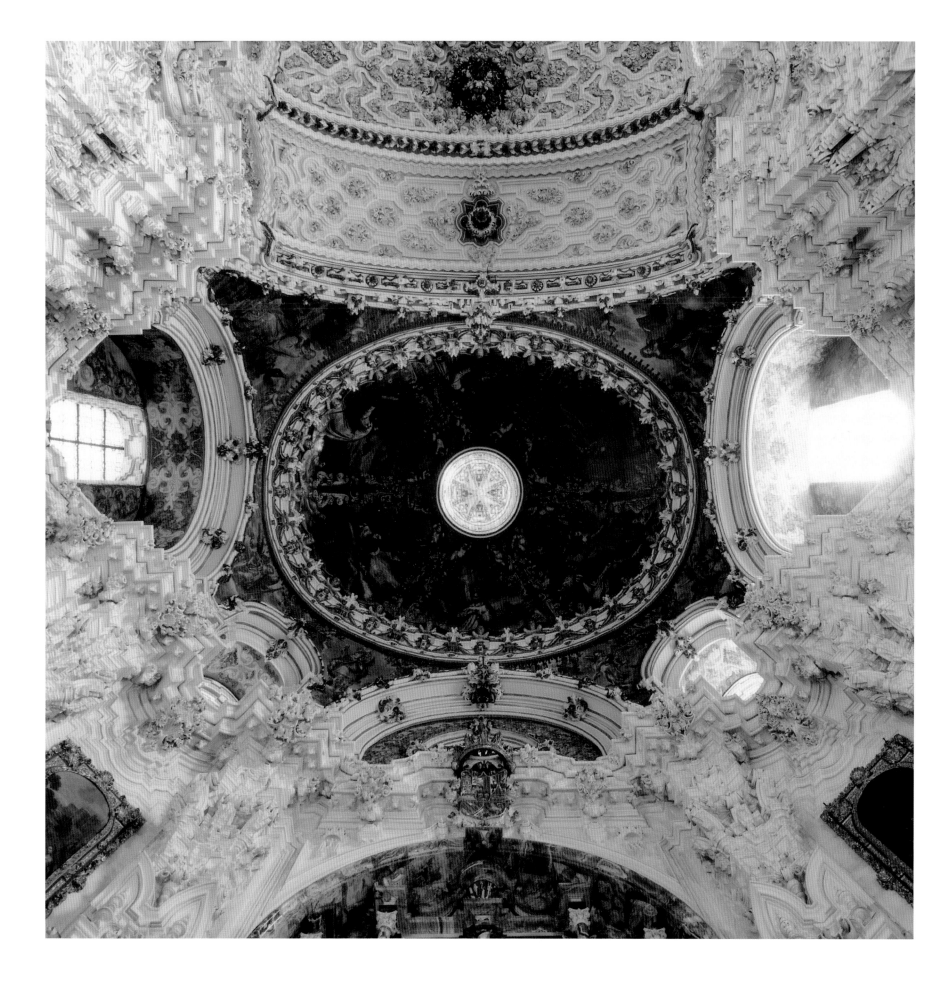

SACRISTIA DE LA CARTUJA
Granada, Spain, 1713–42,
probably Francisco de Hurtado Izquierdo

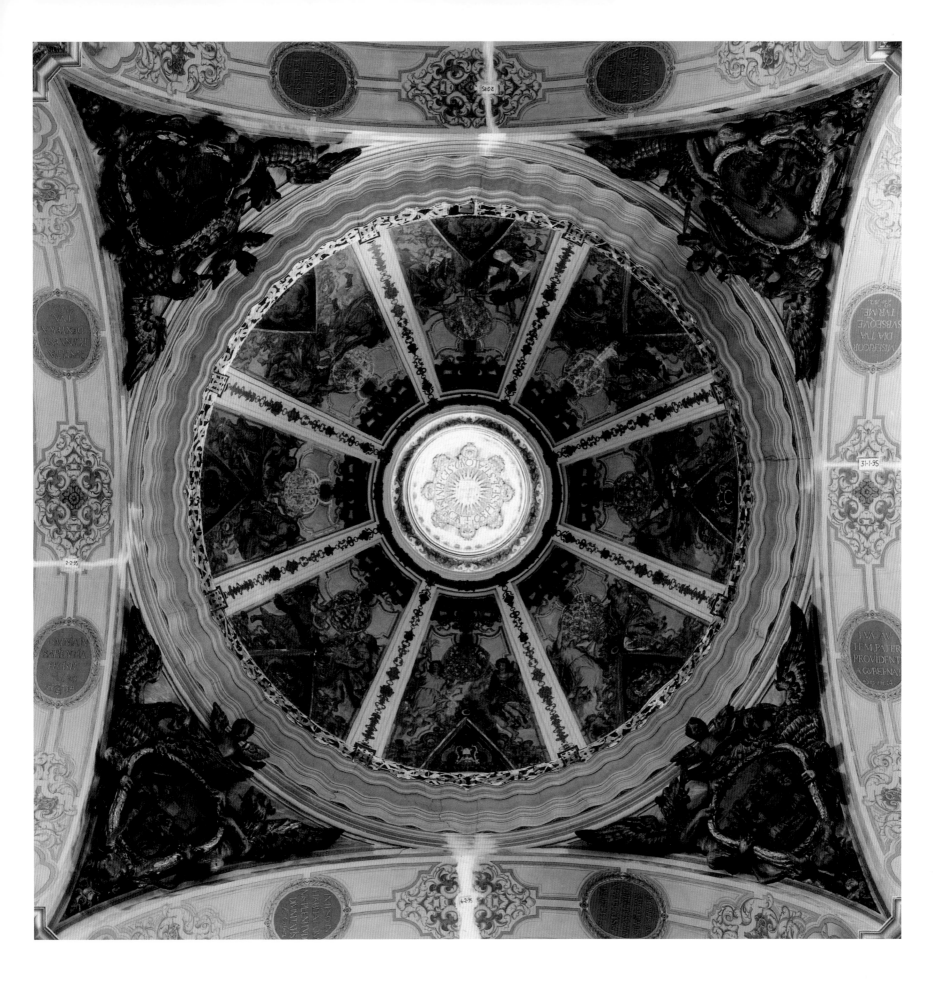

La Magdalena
Sevilla, Spain, 1691–1709,
Leonardo de Figueroa (c. 1650–1730)

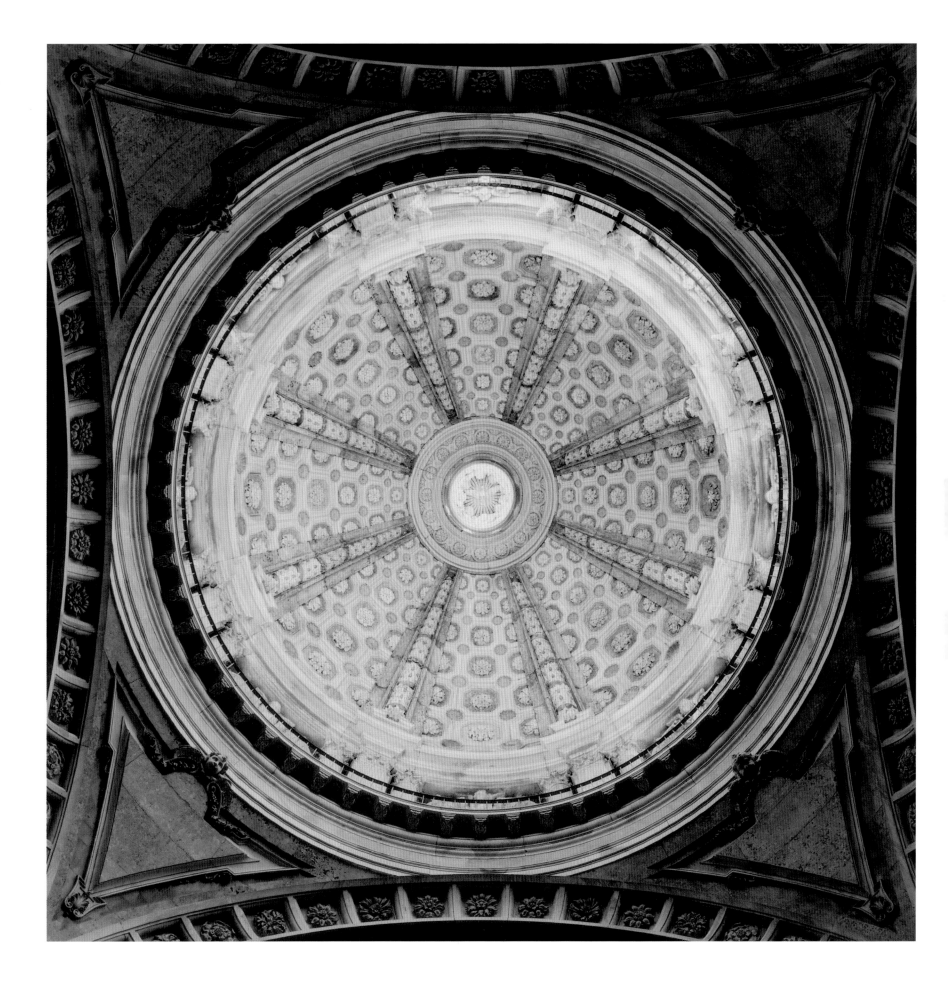

BASÍLICA, PALÁCIO DE MAFRA
Mafra, Portugal, begun 1717,
Johan Friedrich Ludwig (1670–1752)

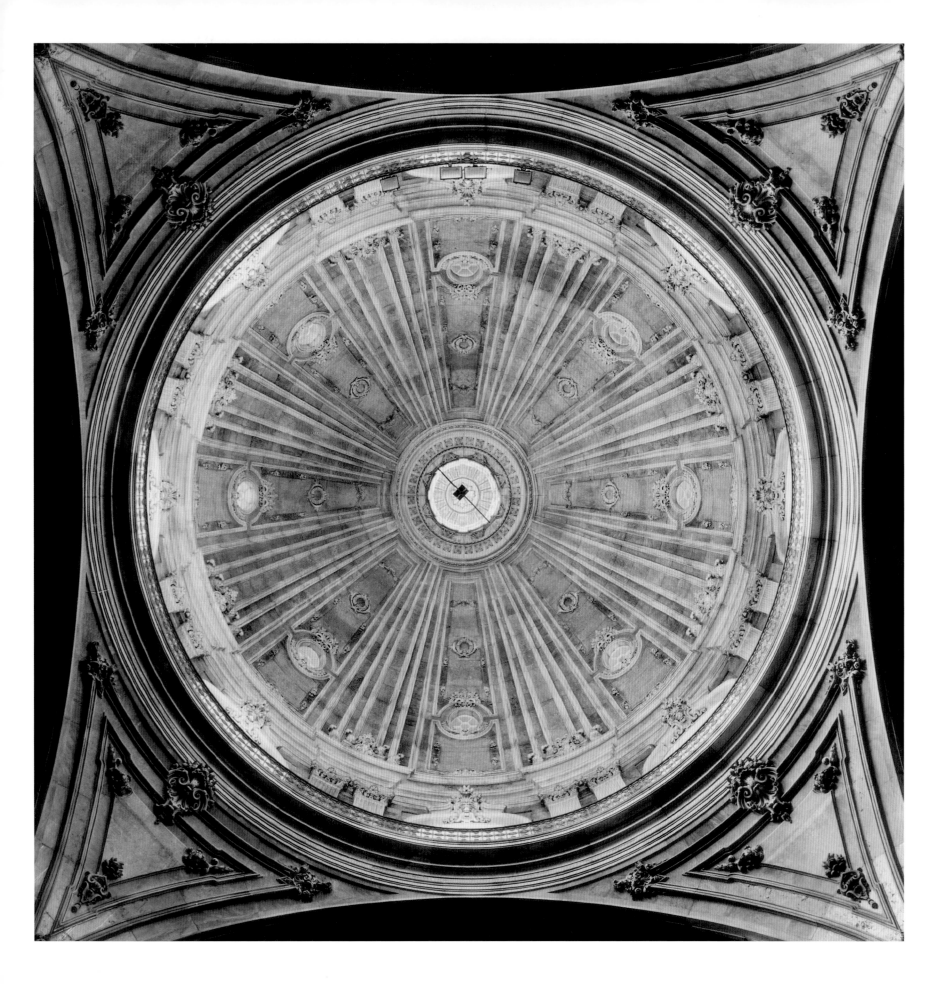

BASÍLICA DA ESTRELA
Lisbon, Portugal, 1779–92,
Mateus Vicente and Reinaldo Manuel

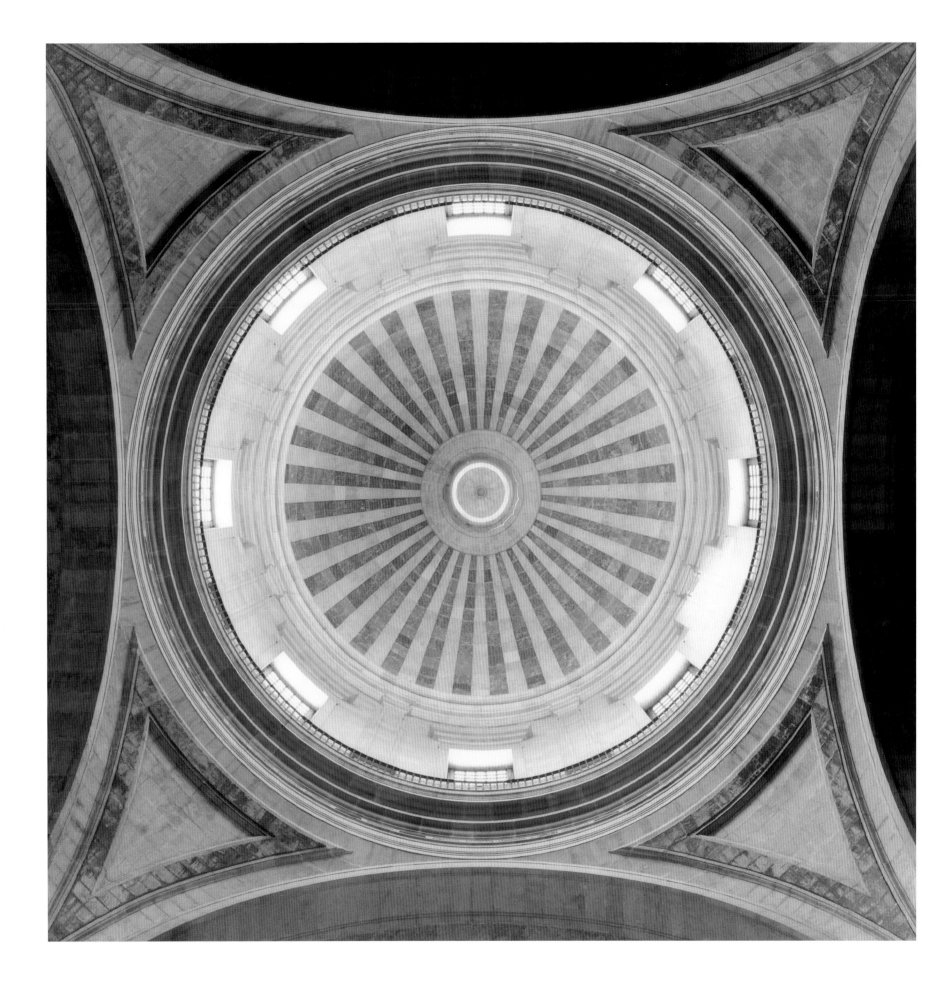

SANTA ENGRACIA (National Pantheon)
Lisbon, Portugal, 1682–1966

IV.

The Baroque and Rococo
in Central and Eastern Europe

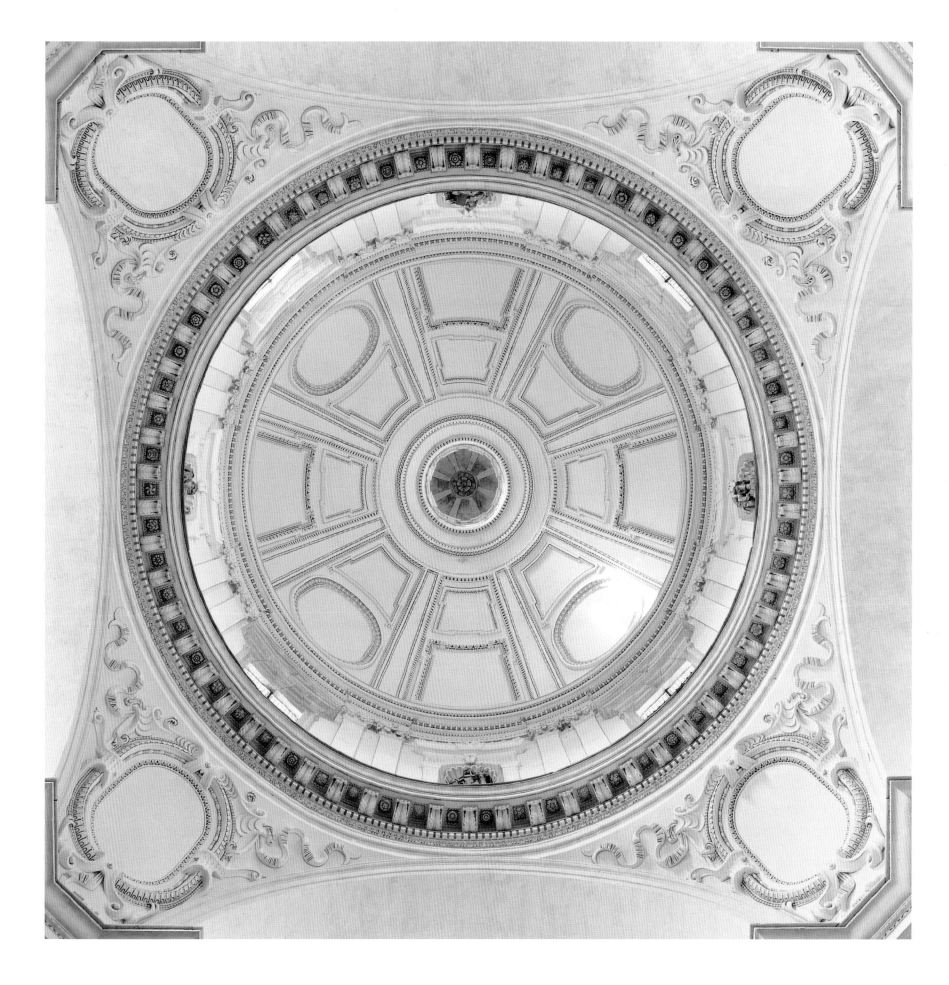

St. Peter and Paul
Kraków, Poland, 1605–09,
Giovanni Trevano

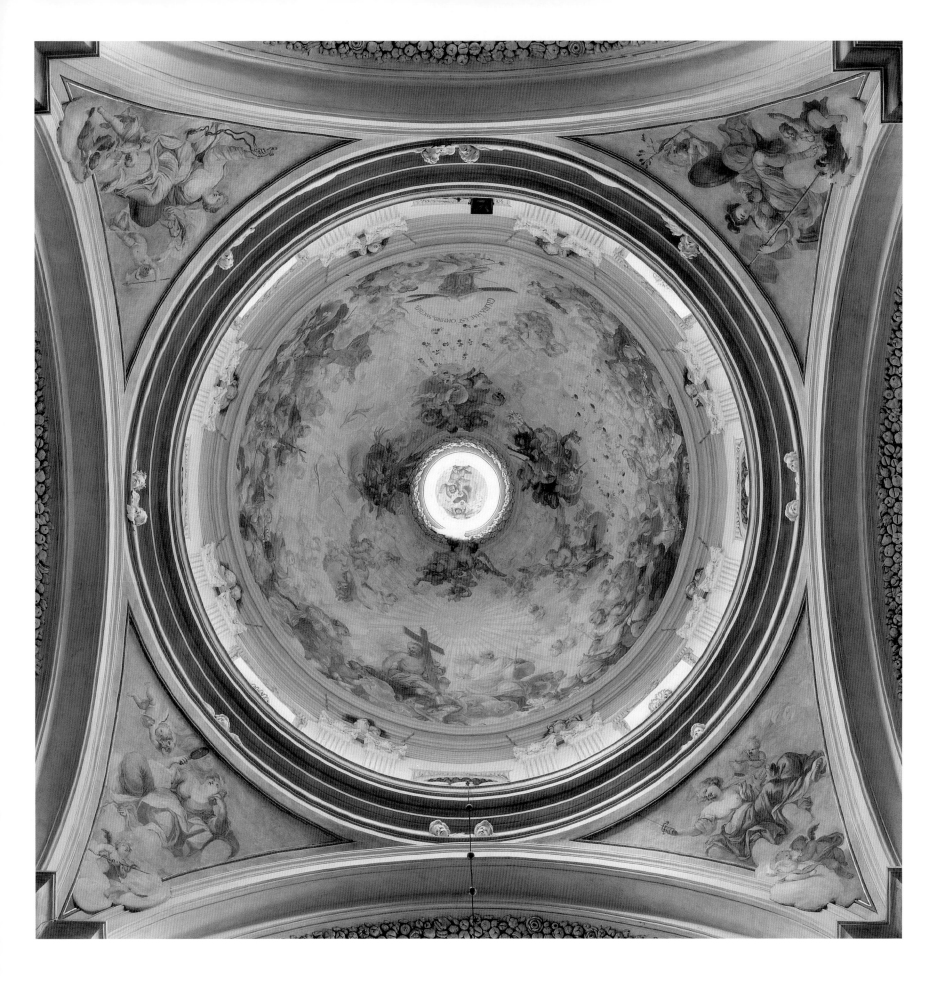

St. Anne's
Kraków, Poland, 1689–1706,
Tylman van Gameron (c. 1630–1706)

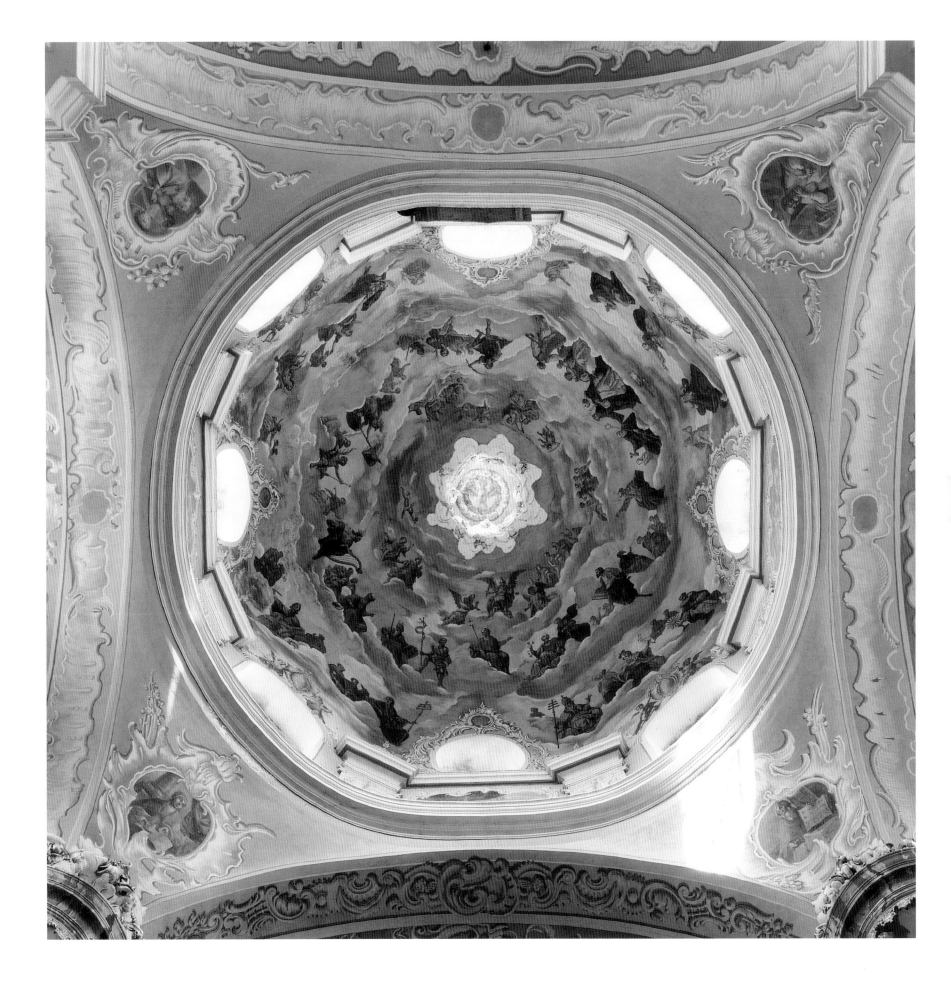

CHURCH OF THE HOLY SPIRIT
Vilnius, Lithuania, 1753–70

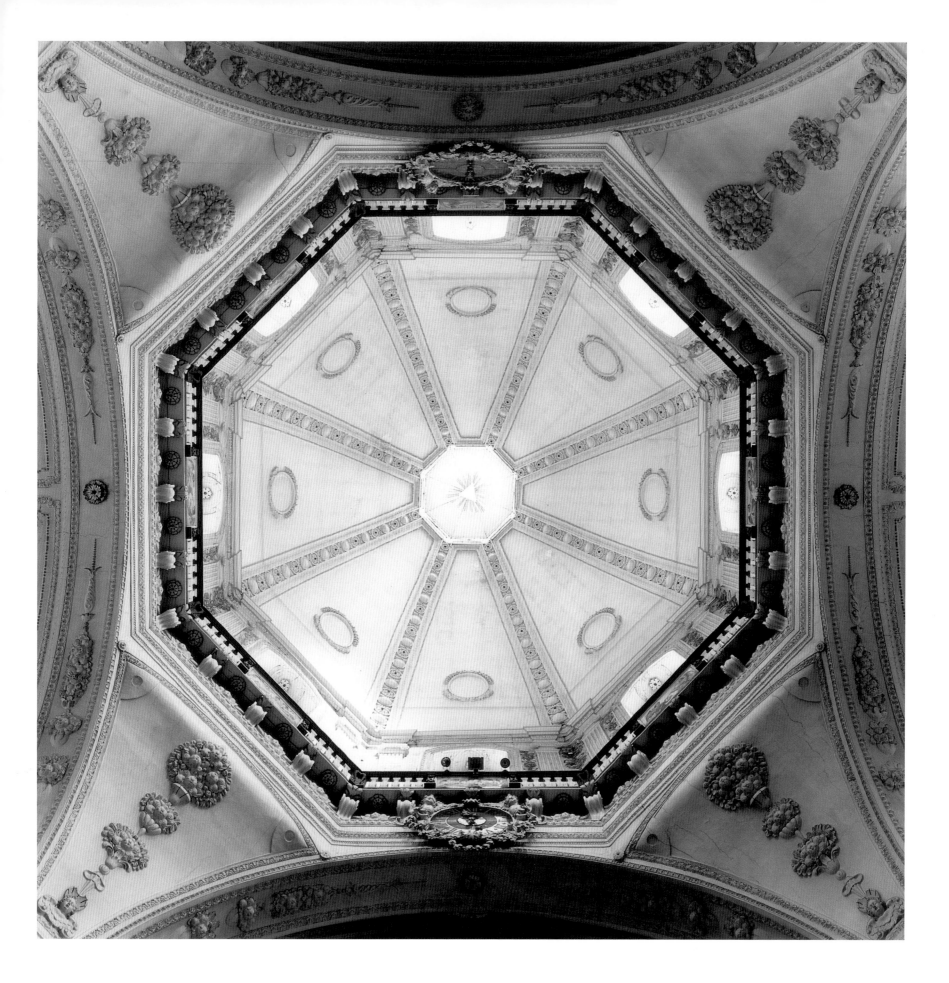

JESUITENKIRCHE
Innsbruck, Austria, 1627–40,
Santino Solari (1576–1646)

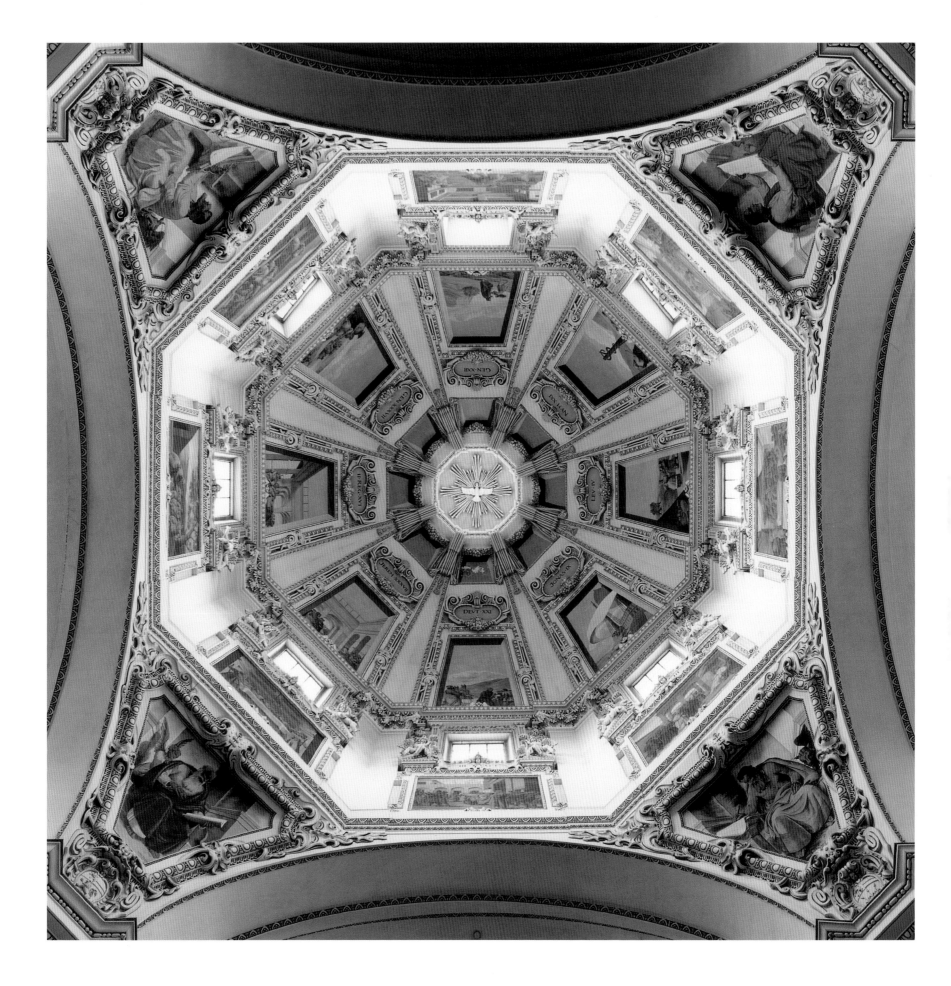

Dom
Salzburg, Austria, 1614–28,
Santino Solari

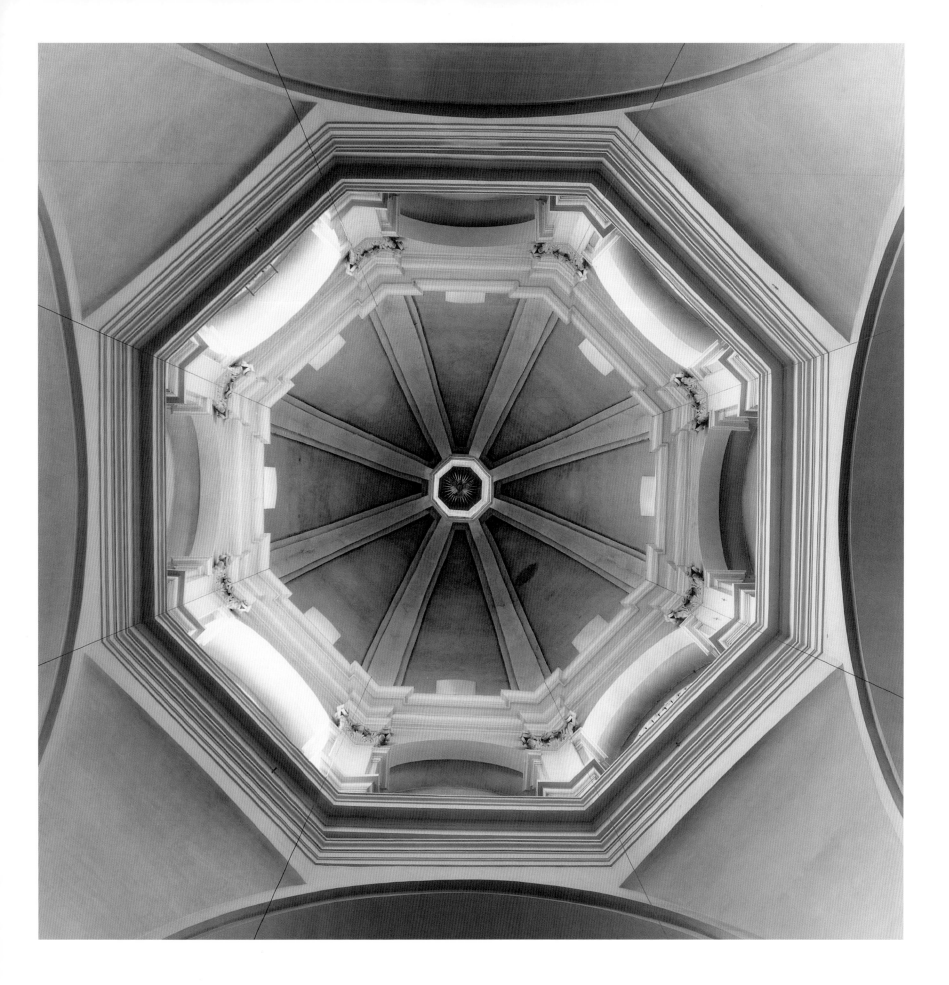

STIFT HAUG
Würzburg, Germany, 1670–91,
Antonio Petrini (d. 1701)

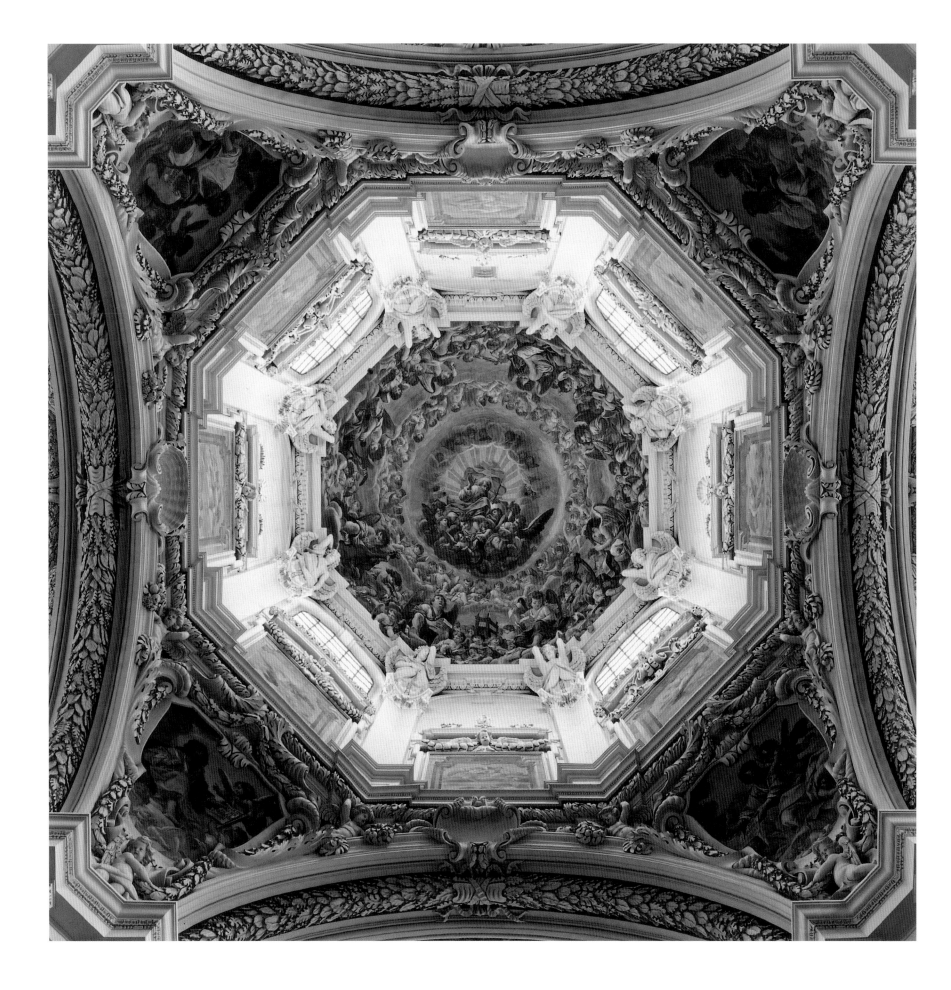

Dom
Passau, Germany, 1668–78,
Carlo Lurago (1618–1684) and Giovanni Battista Carlone (c. 1650–), fresco by Carpoforo Tencalla (1623–1685)

123

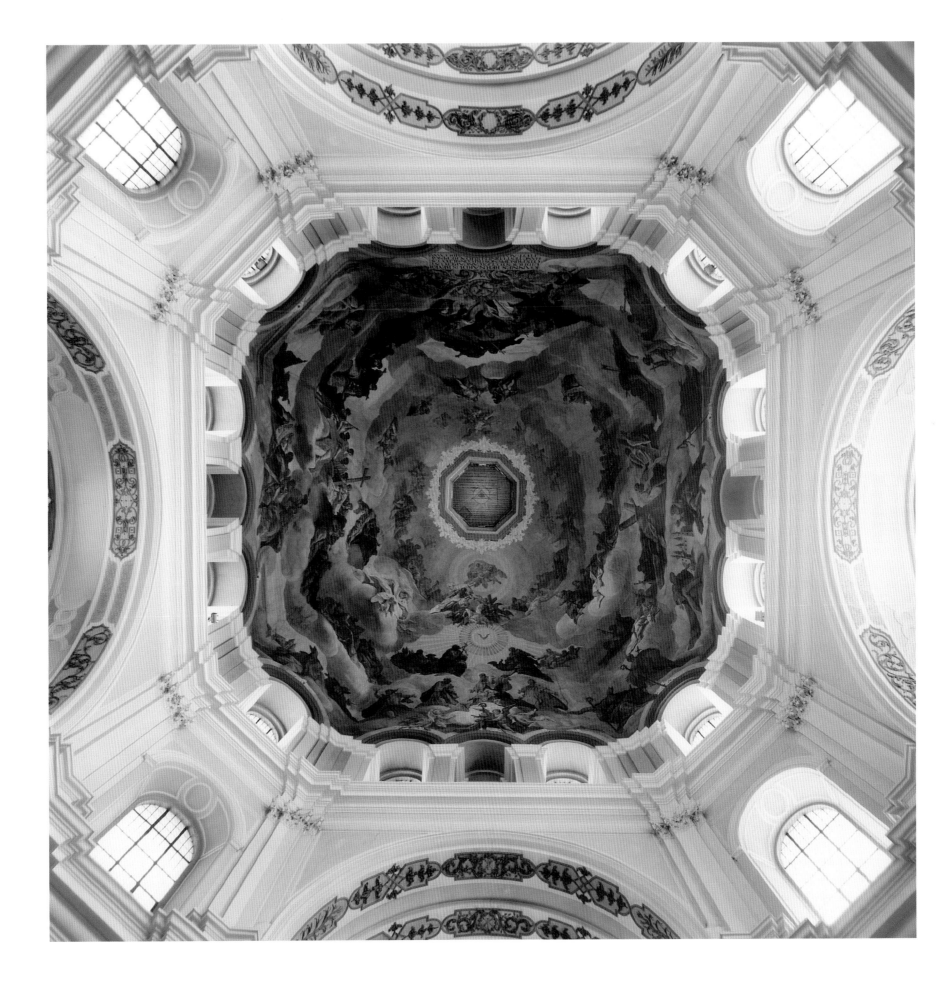

NEUMÜNSTER
Würzburg, Germany, begun 1711,
Joseph Greissing (1664–1721)

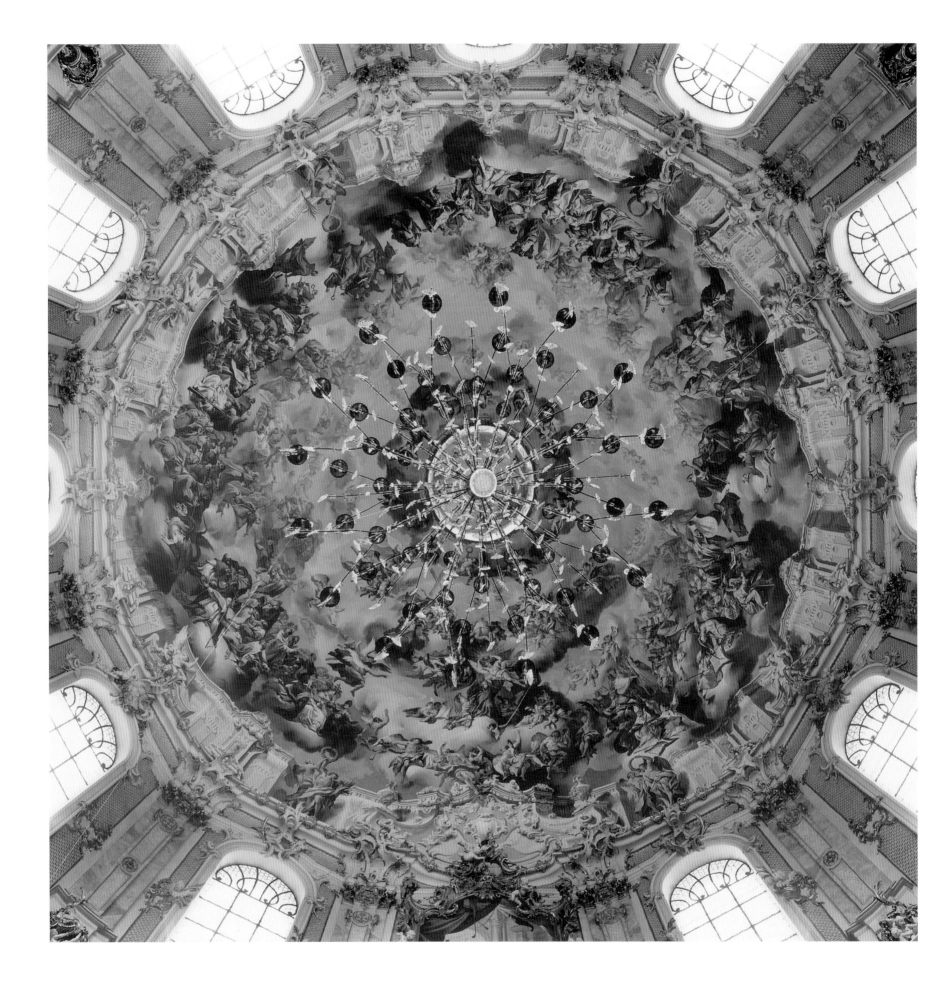

BENEDICTINE MONASTERY
Ettal, Germany, founded in 1330 and renovated in 1709–45
by Enrico Zucalli (1642–1724) and Joseph Schmuzer (1683–1752), fresco 1769 by Johann Jakob Zeiller (1708–1783)

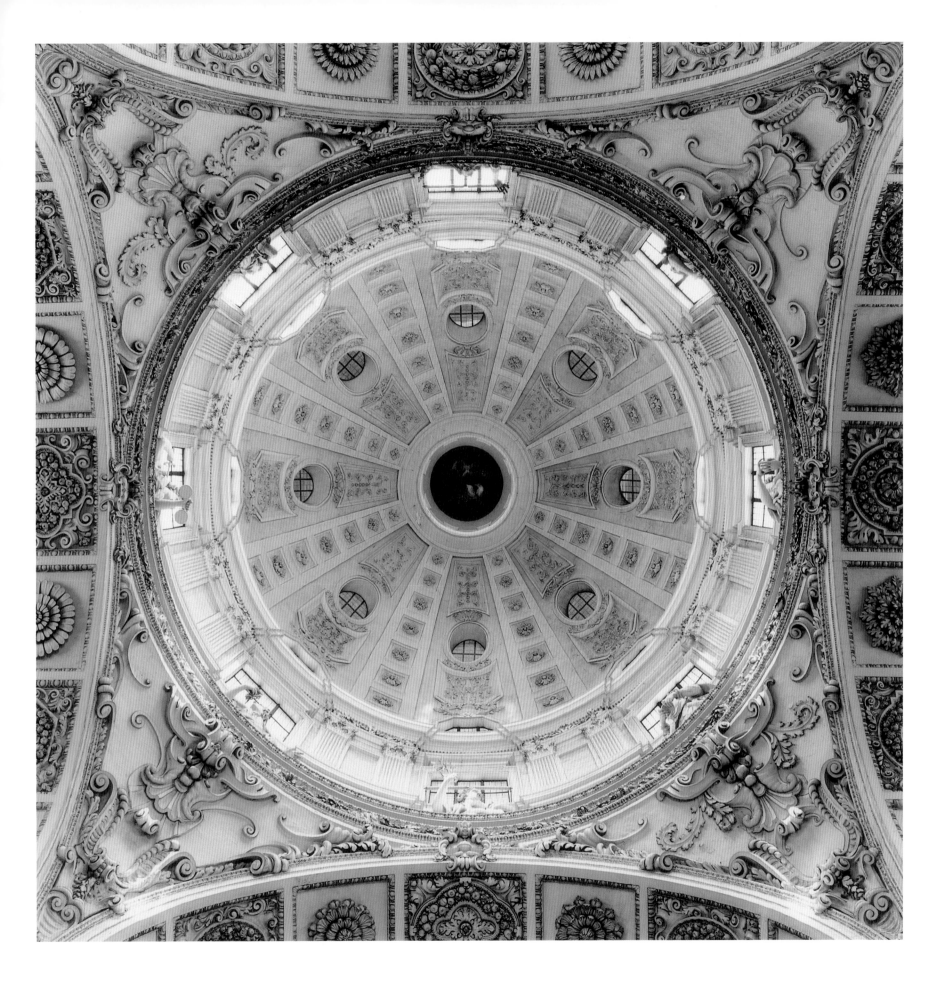

THEATINERKIRCHE ST. CAJETAN
Munich, Germany, 1674–92,
Enrico Zucalli

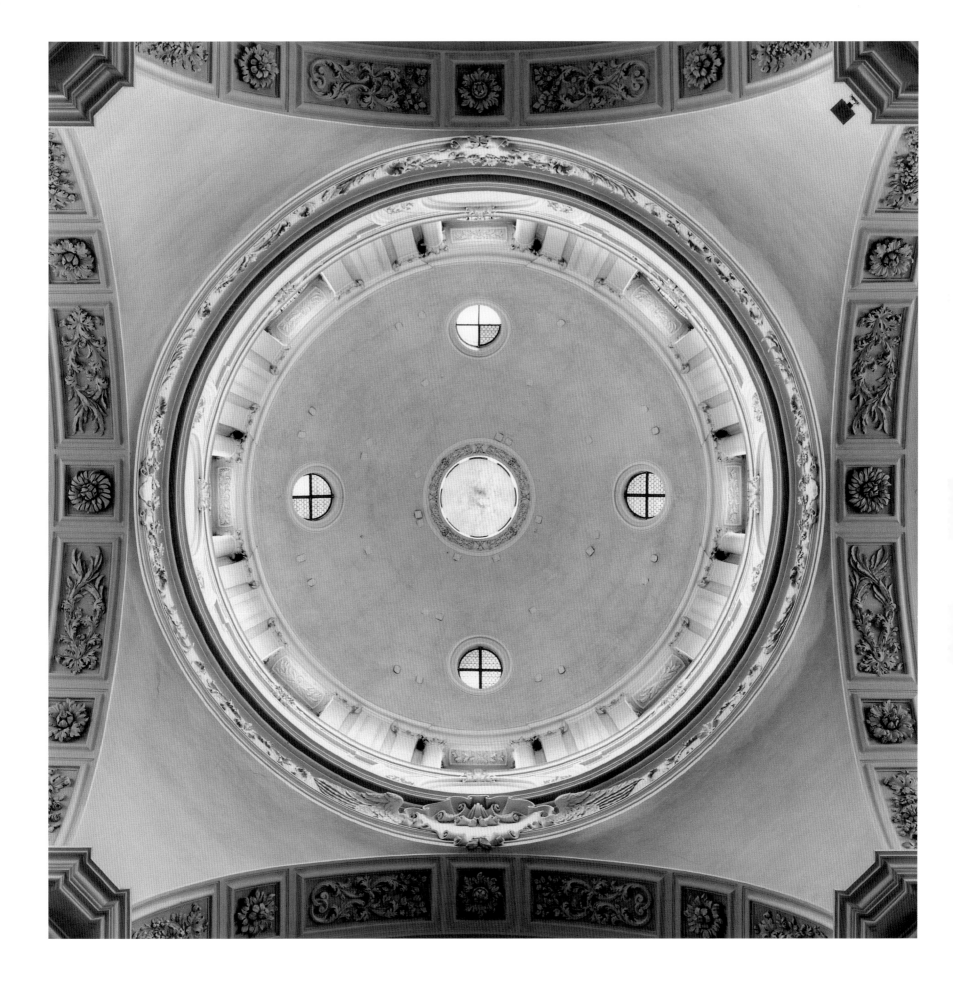

KOLLEGIENKIRCHE
Salzburg, Austria, 1696–1707,
Johann Bernhard Fischer von Erlach (1656–1723)

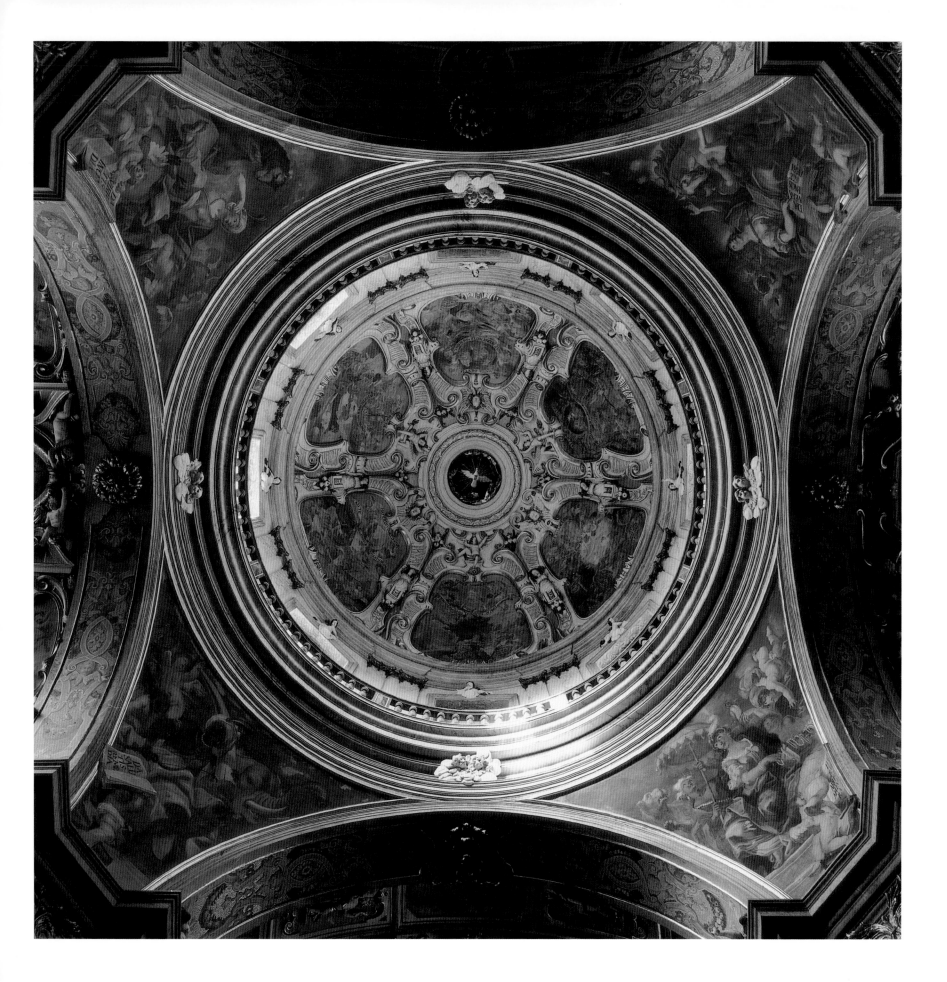

CHURCH ON THE HOLY MOUNTAIN
Olomouc, Czech Republic, 1669–79,
probably Baldassare Fontana and Giovanni Pietro Tencalla (1629–1702)

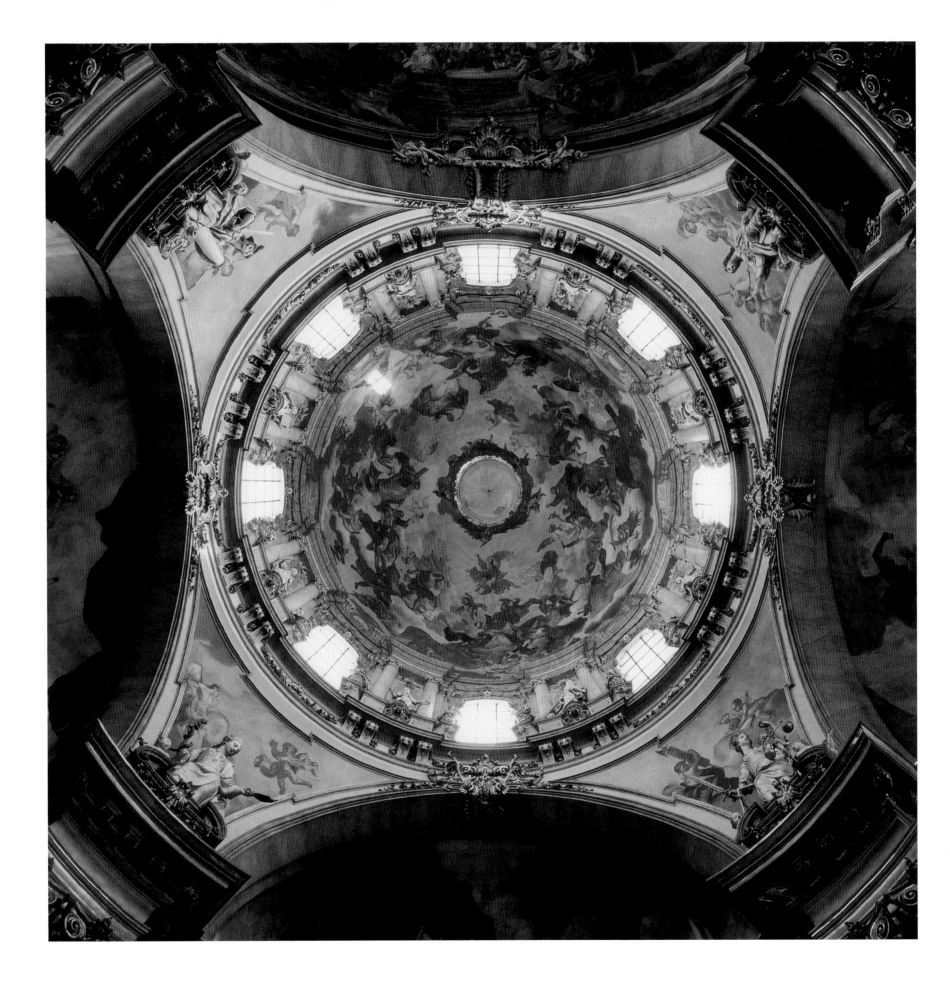

St. Nicholas, Mala Strana
Prague, Czech Republic, 1703–51,
Cristoph (1655–1722) and Killian (1690–1751) Dientzenhofer

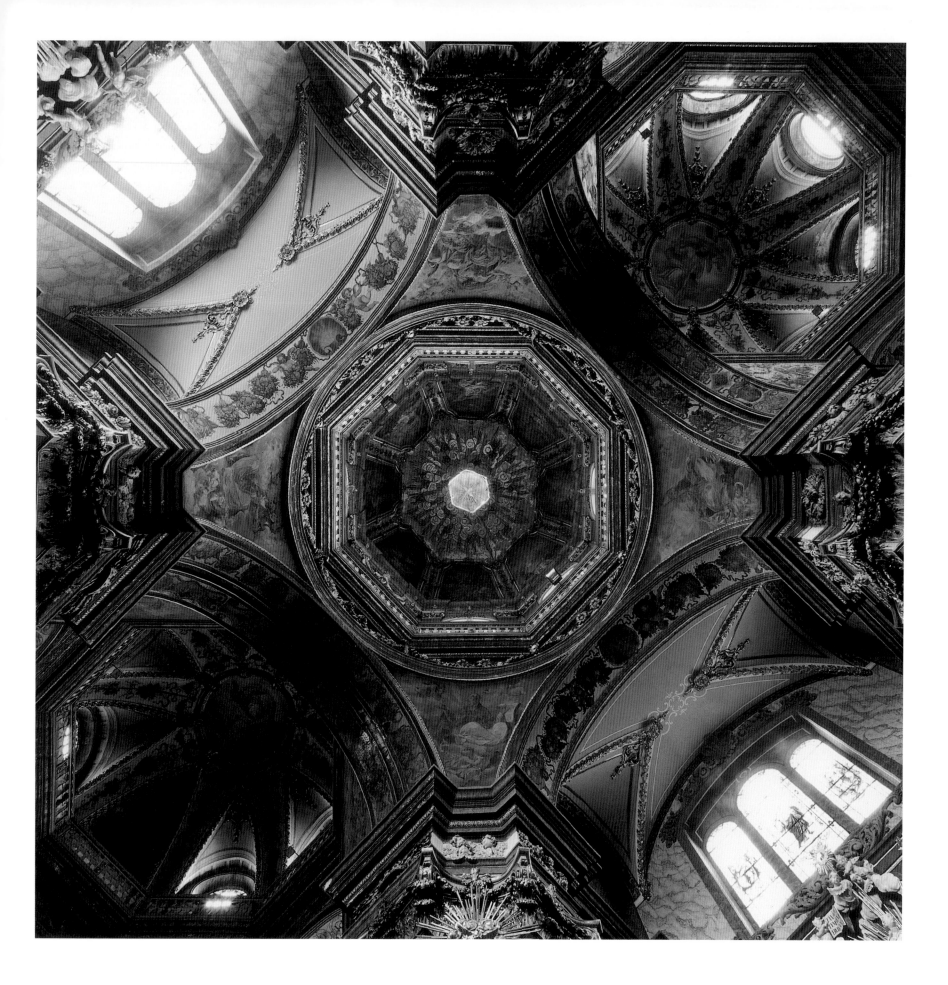

ST. MICHAEL
Olomouc, Czech Republic, begun by 1250,
rebuilt 1673–99 by Giovanni Pietro Tencalla, renovated 1892–98 by Richard Völkel

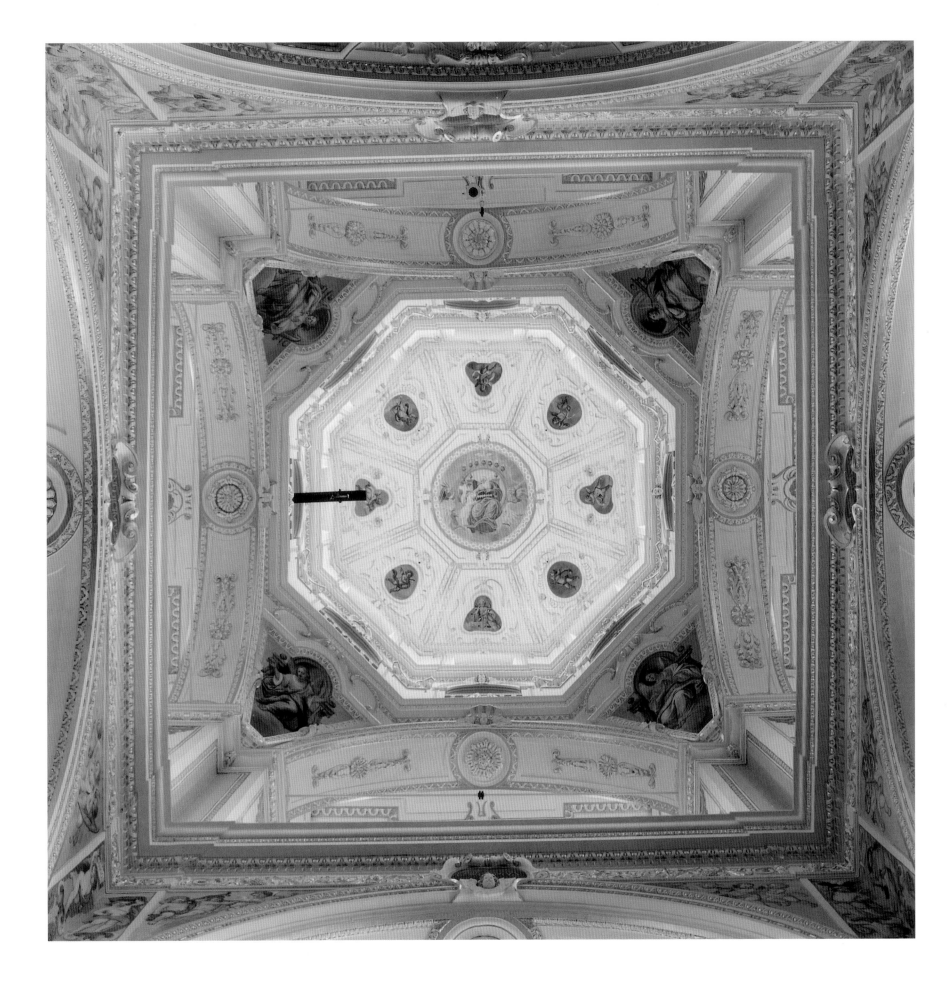

BASILIKA ST. LORENZ
Kempten, Germany, 1652–66,
probably Michael Beer (d. 1666), completed by Johannes Serro

133

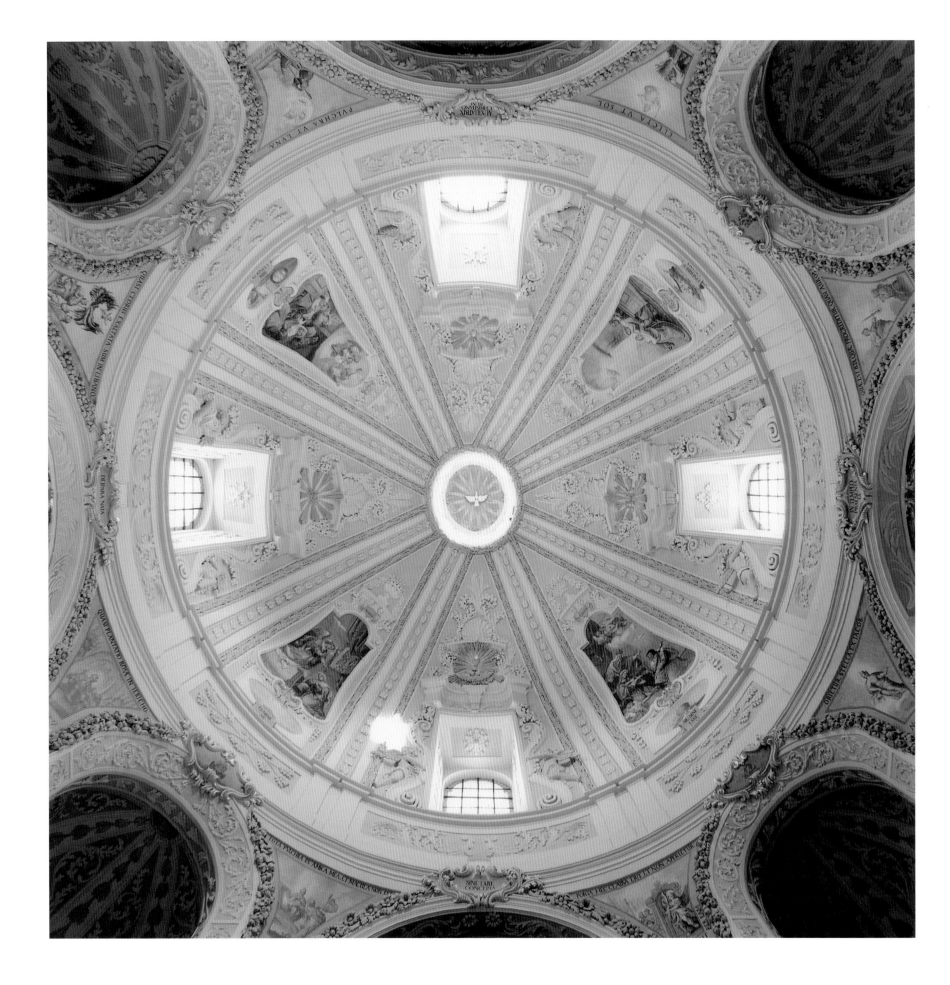

Wallfahrtskirche Mariahilf
Freystadt, Germany, 1700–10,
Giovanni Viscardi (1647–1713), fresco by Cosmas Damian Asam (1686–1739)

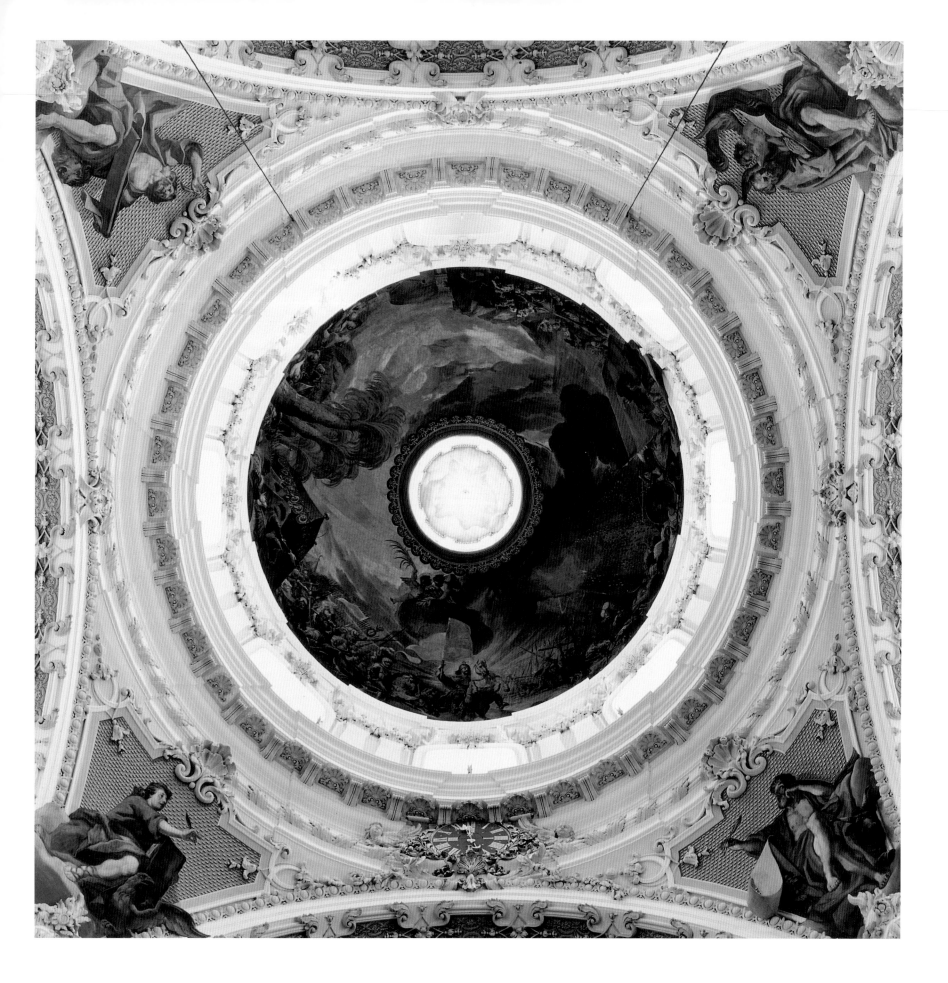

Dom St. Jakob
Innsbruck, Austria, 1712–17,
Johann Jakob Herkommer (1648–1717), fresco by Cosmas Damian Asam and Egid Quirin Asam (1692–1750)

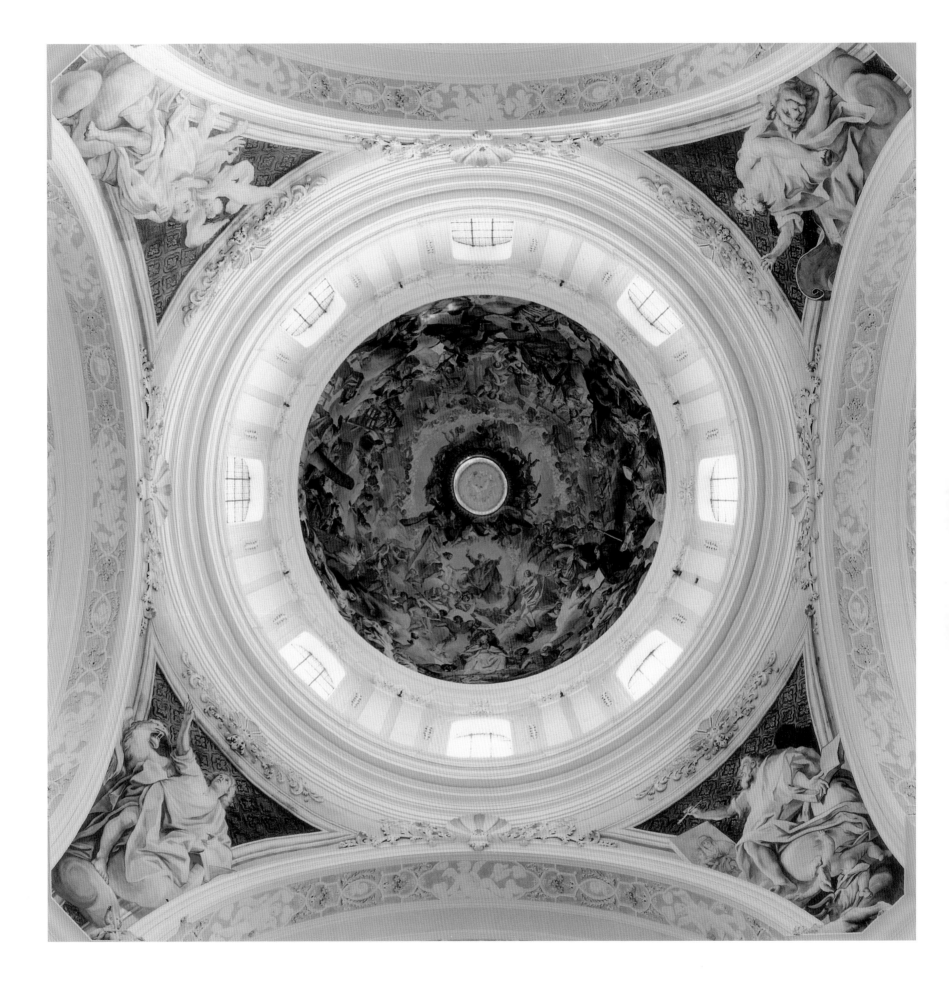

WEINGARTEN ABBEY
Weingarten, Germany, 1715–20,
Franz Beer (1659–1726) and Caspar Moosbrugger (1656–1723), fresco by Cosmas Damian Asam and Egid Quirin Asam

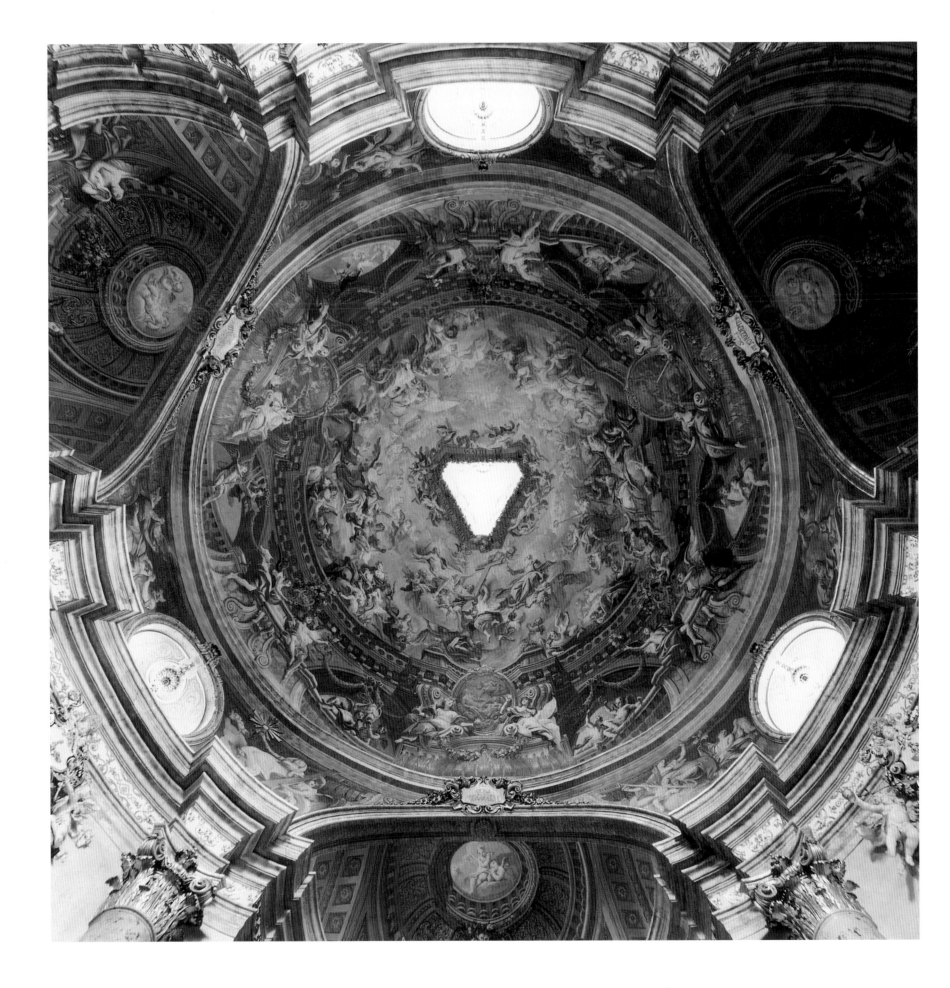

DREIFALTIGKEITSKIRCHE (Church of the Holy Trinity)
Stadl Paura, Austria, 1714–24,
Johann Michael Brunner (1669–1739)

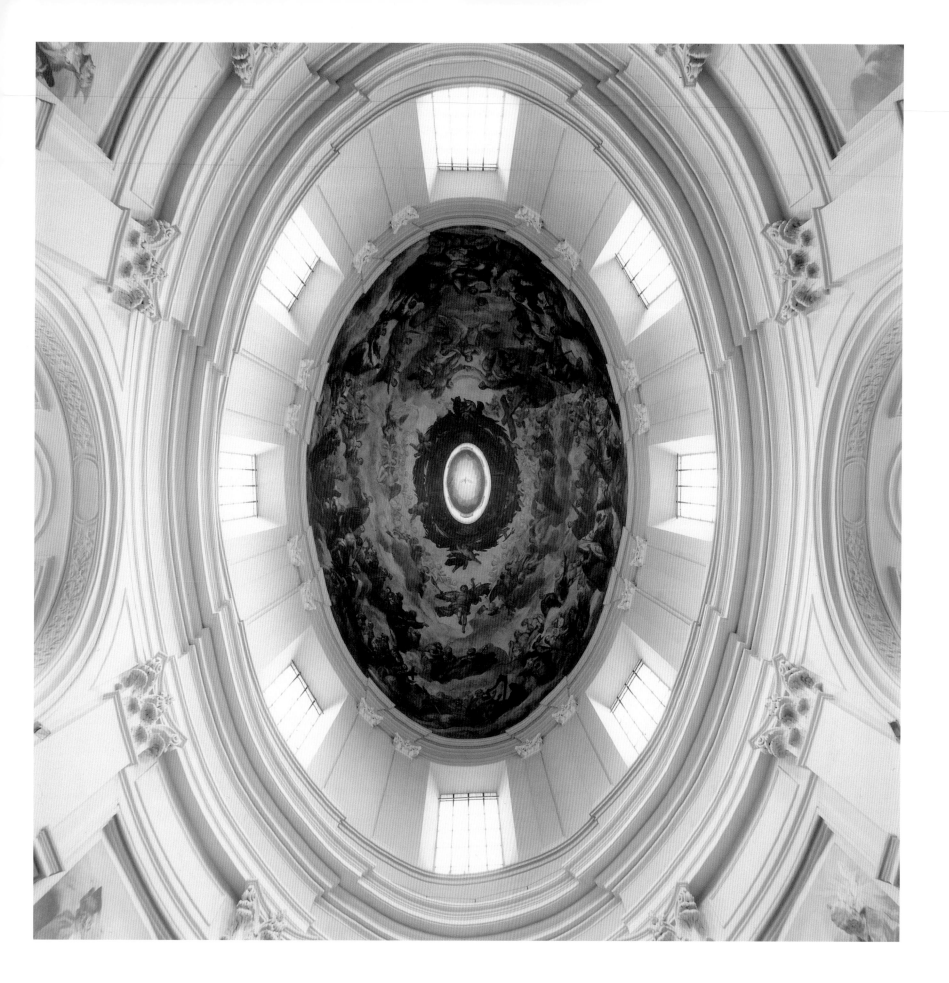

DREIFALTIGKEITSKIRCHE (Church of the Holy Trinity)
Salzburg, Austria, begun 1694,
Johann Bernhard Fischer von Erlach

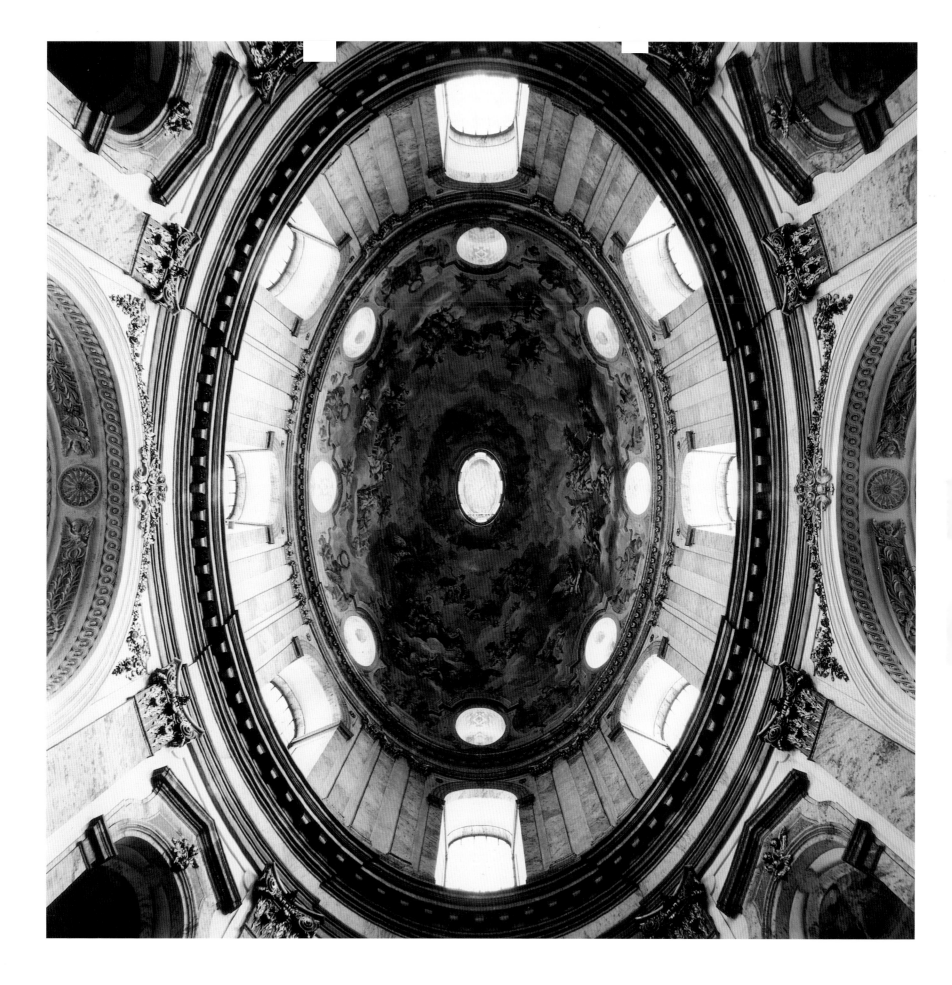

KARLSKIRCHE
Vienna, Austria, 1716–24,
Johann Bernhard Fischer von Erlach, fresco by Johann Michael Rottmayr (1654–1730)

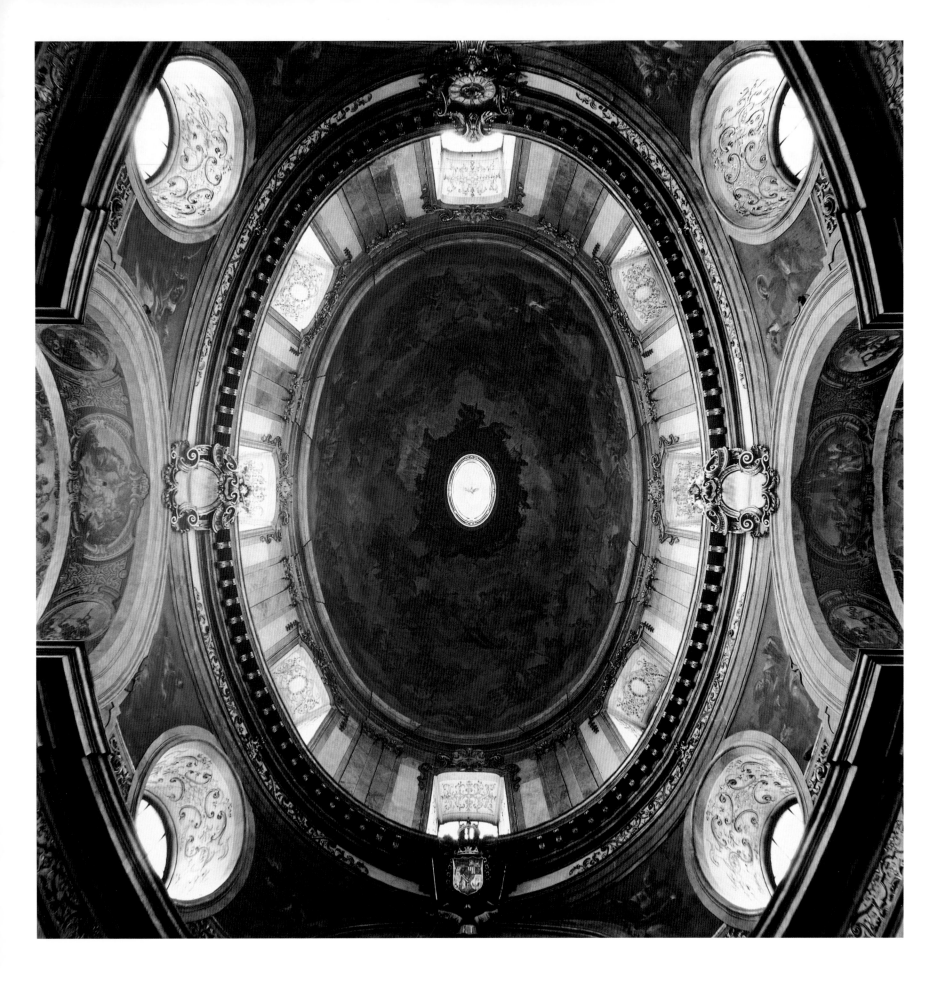

PETERSKIRCHE

Vienna, Austria, 1702–33,

Johann Lukas von Hildebrandt (1668–1745) and Antonio Galli Bibiena, fresco by Johann Michael Rottmayr

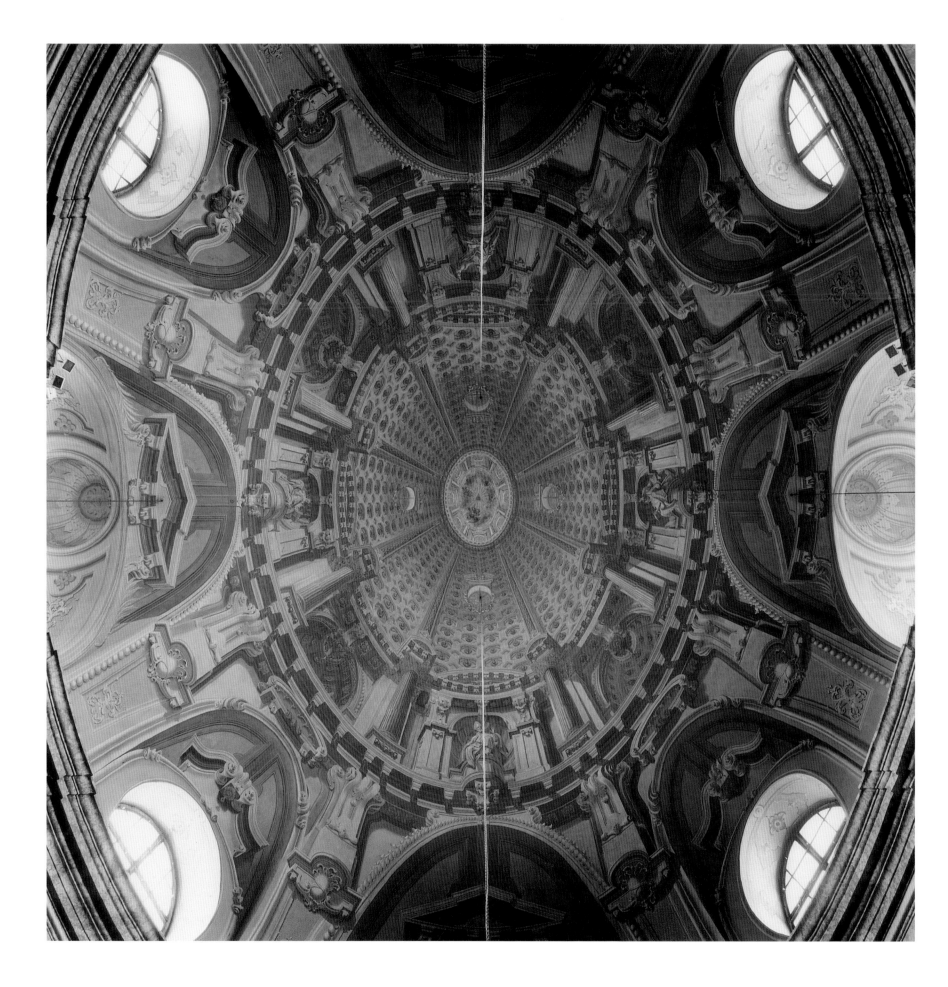

HOLY TRINITY
Bratislava, Slovakia, 1717–45,
dome 1744–45 by Antonio Galli Bibiena

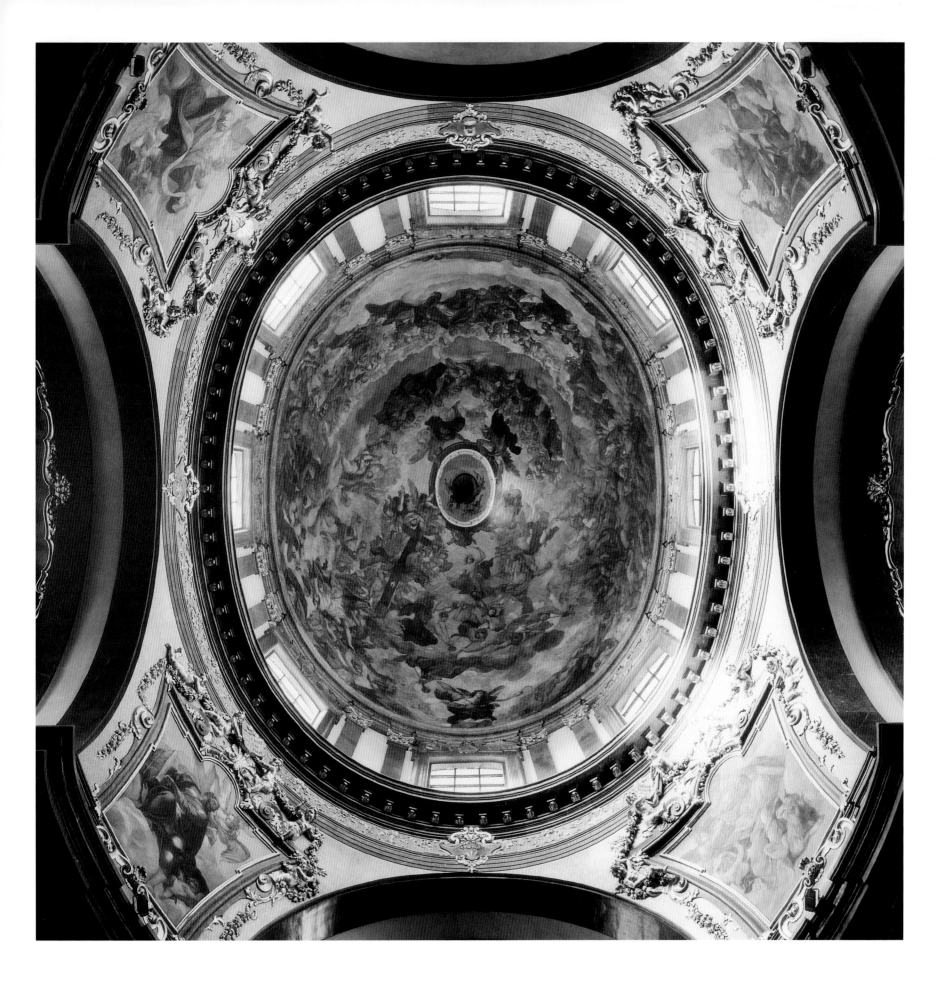

St. Francis of the Order of the Knights of the Cross
Prague, Czech Republic, 1679–88,
Jean-Baptiste Mathey (1630–1695)

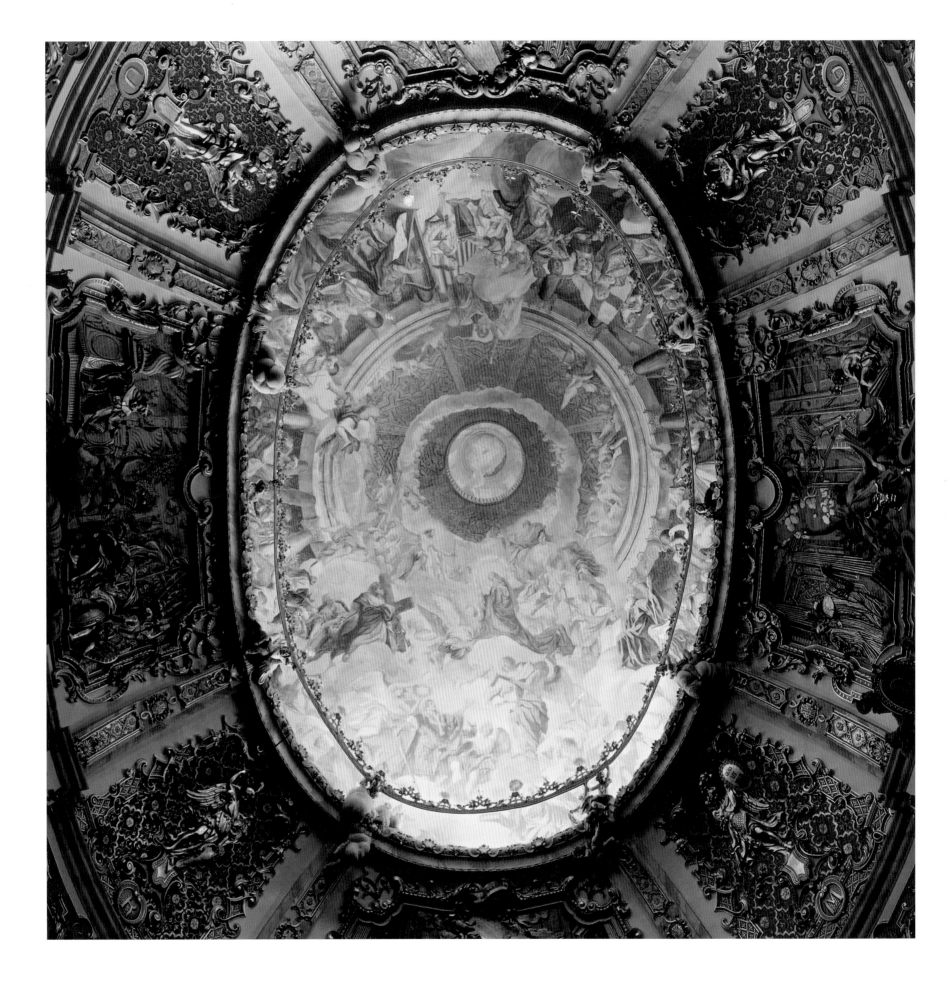

ABBEY
Weltenburg, Germany, 1716–21,
Cosmas Damian Asam, stucco work by Egid Quirin Asam

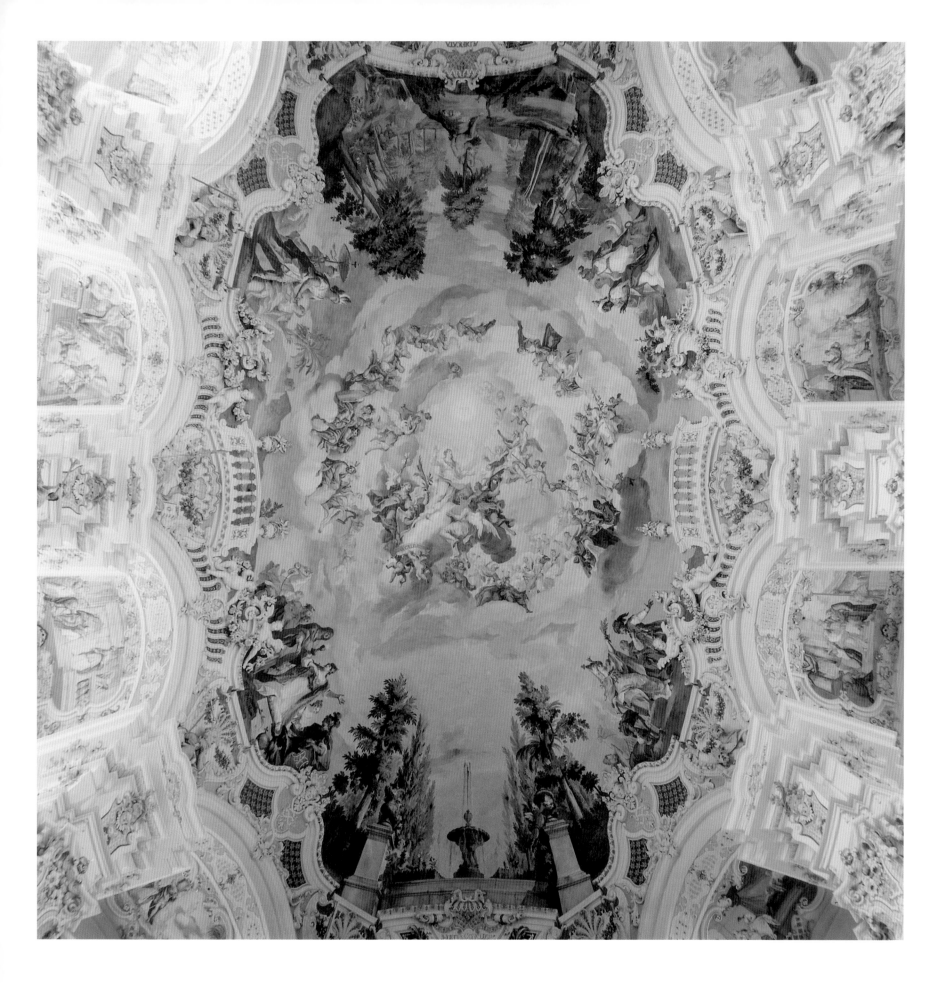

St. Peter and Paul
Steinhausen, Germany, 1728–31,
Dominikus Zimmermann (1685–1766), fresco by Johann Baptist Zimmermann (1680–1758)

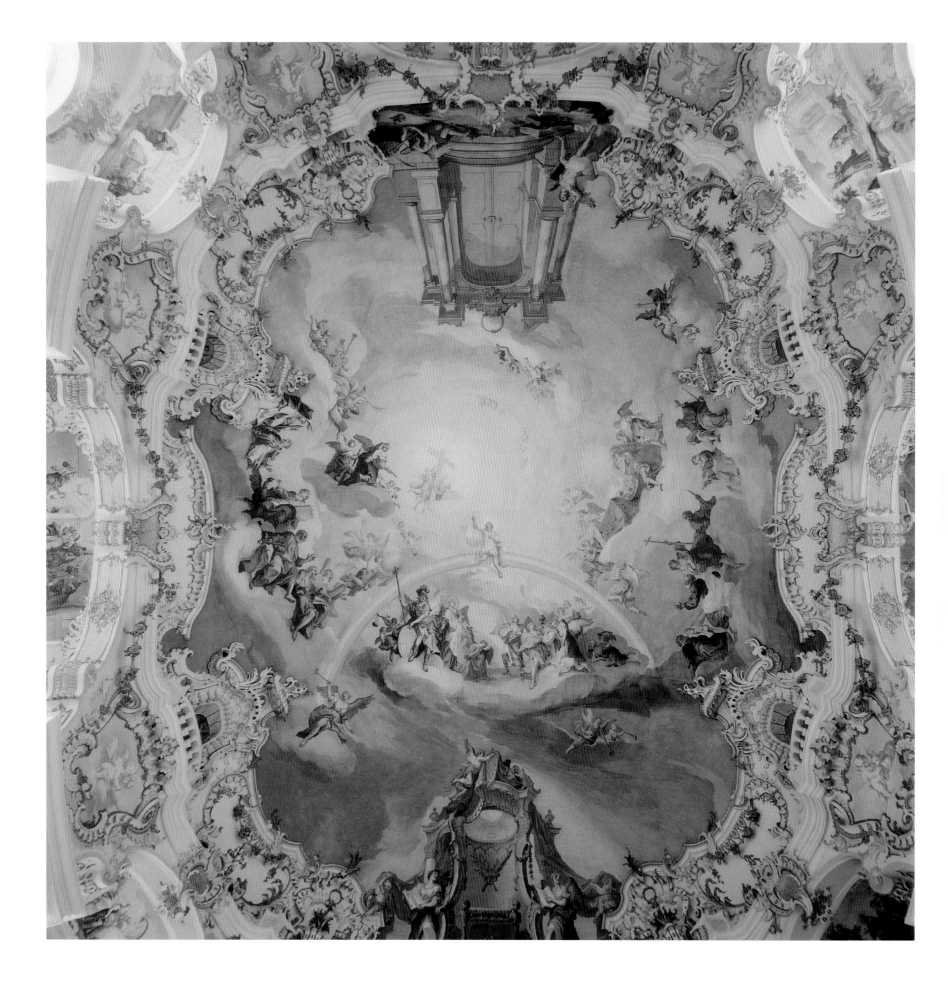

WIESKIRCHE
Die Wies, Germany, 1745–54,
Dominikus Zimmermann, fresco by Johann Baptist Zimmermann

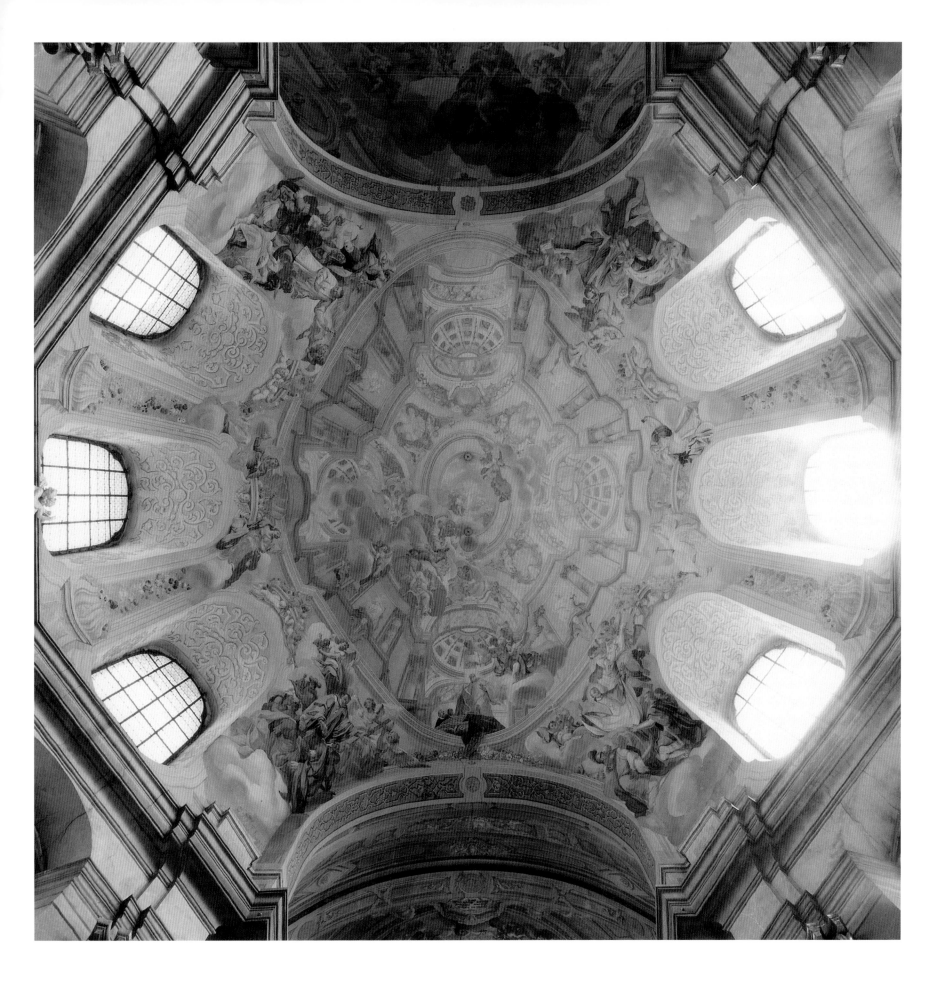

ST. PETER AND PAUL, BENEDICTINE MONASTERY
Rajhrad, Czech Republic, 1722–24,
Jan Santini-Aichel (1667–1723)

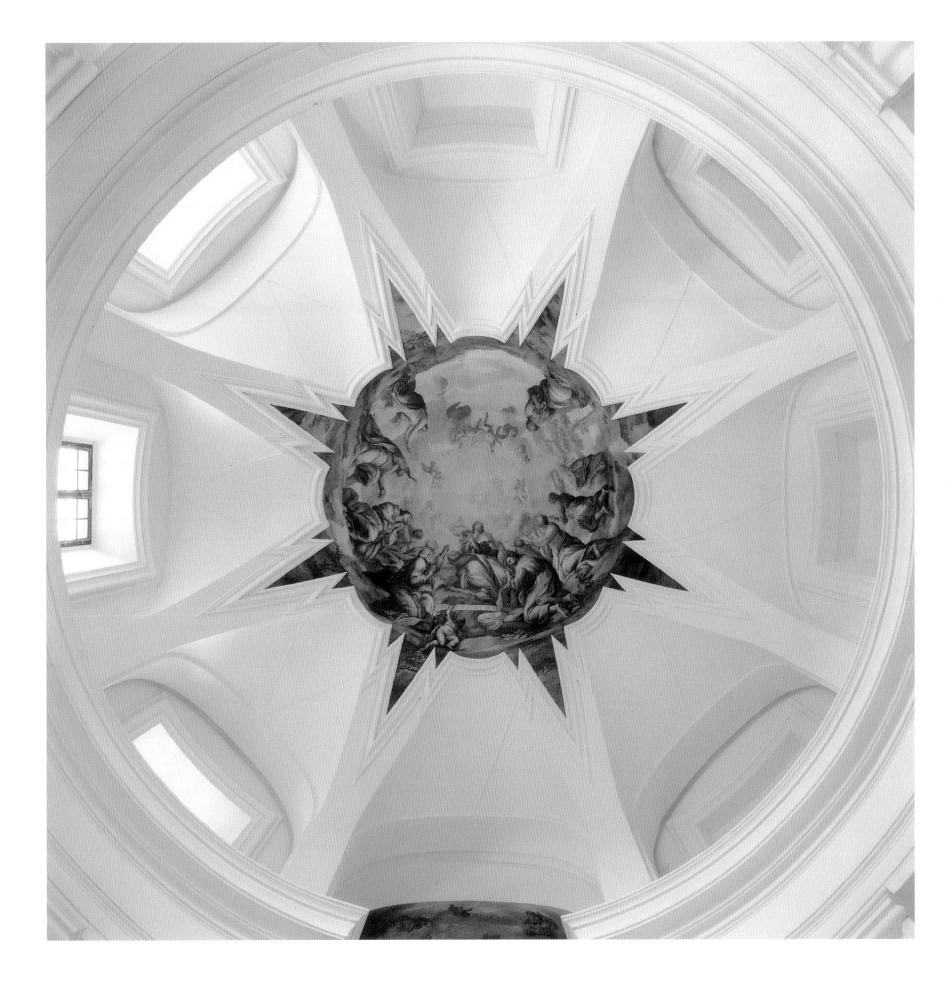

St. Bernard's Chapel, Cistercian Monastery
Plasy, Czech Republic, 1711–28,
Jan Santini-Aichel

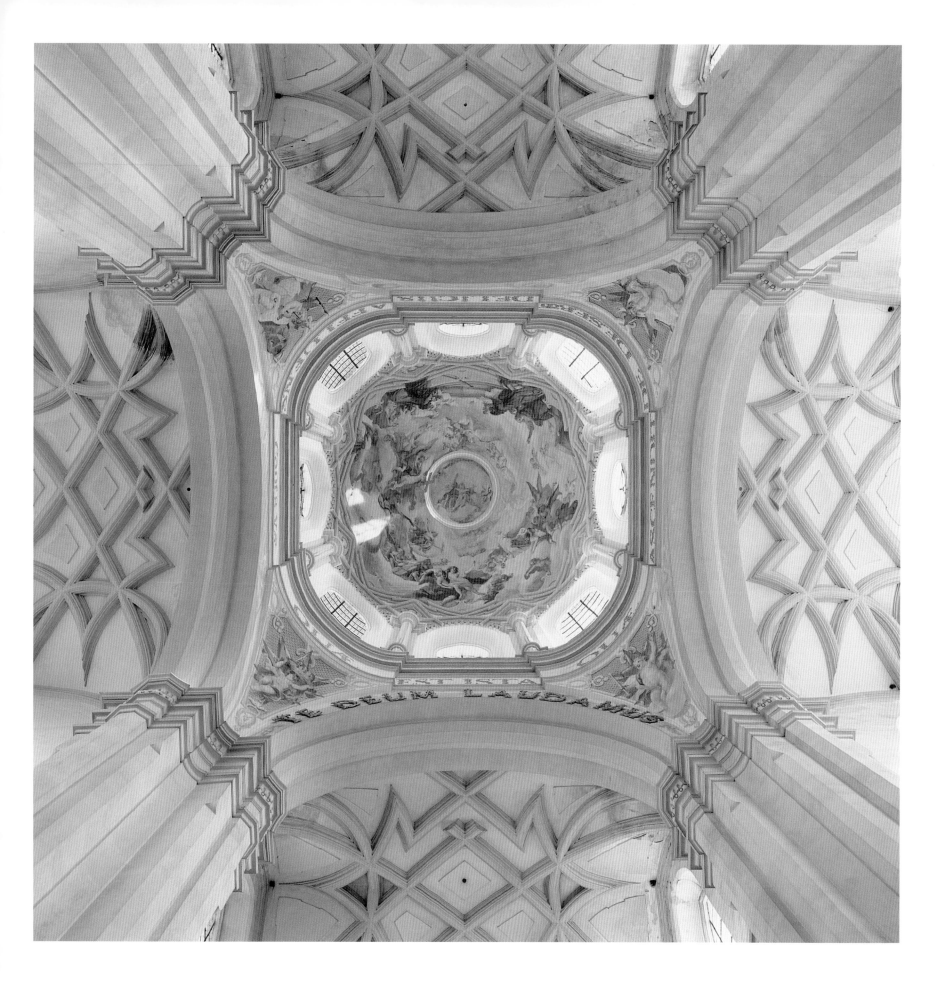

BENEDICTINE MONASTERY
Kladruby, Czech Republic, 1712–26,
Jan Santini-Aichel, fresco by Cosmas Damian Asam

150

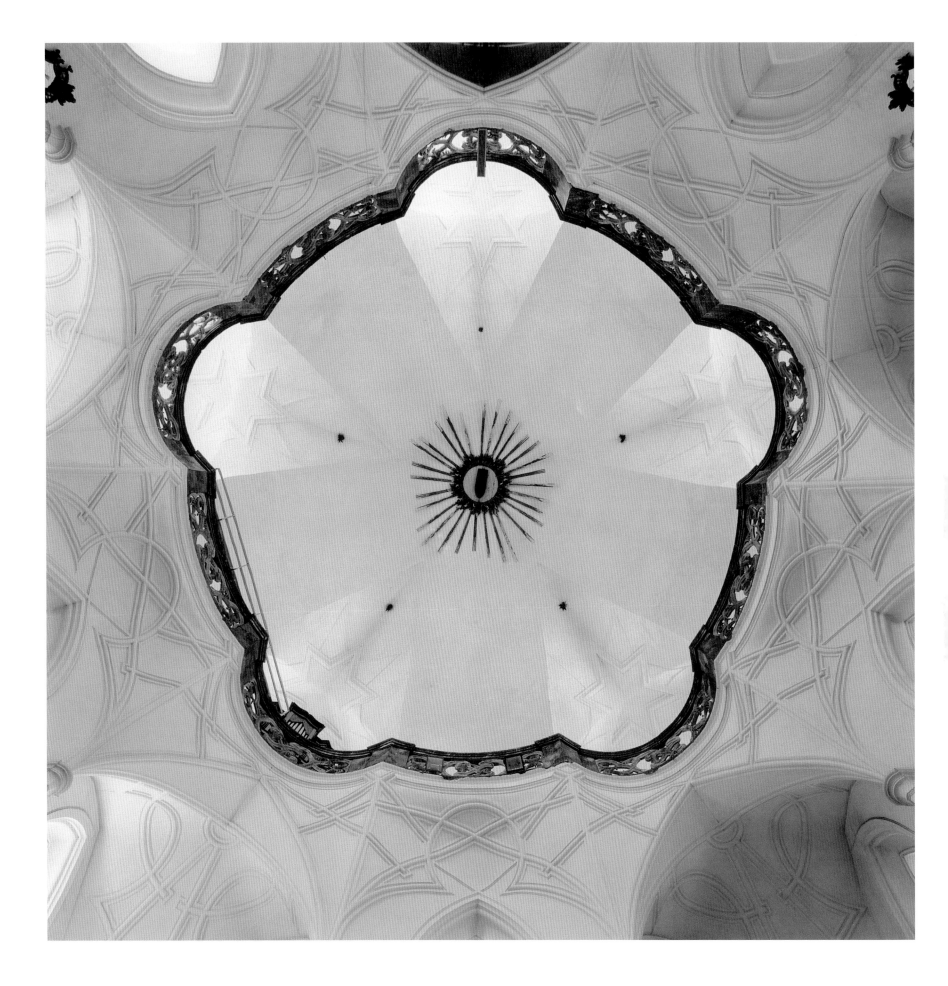

CHAPEL OF ST. JAN NEPOMUK, Zelena Hora
Zd'ar nad Sazavou, Czech Republic, 1719–22,
Jan Santini-Aichel

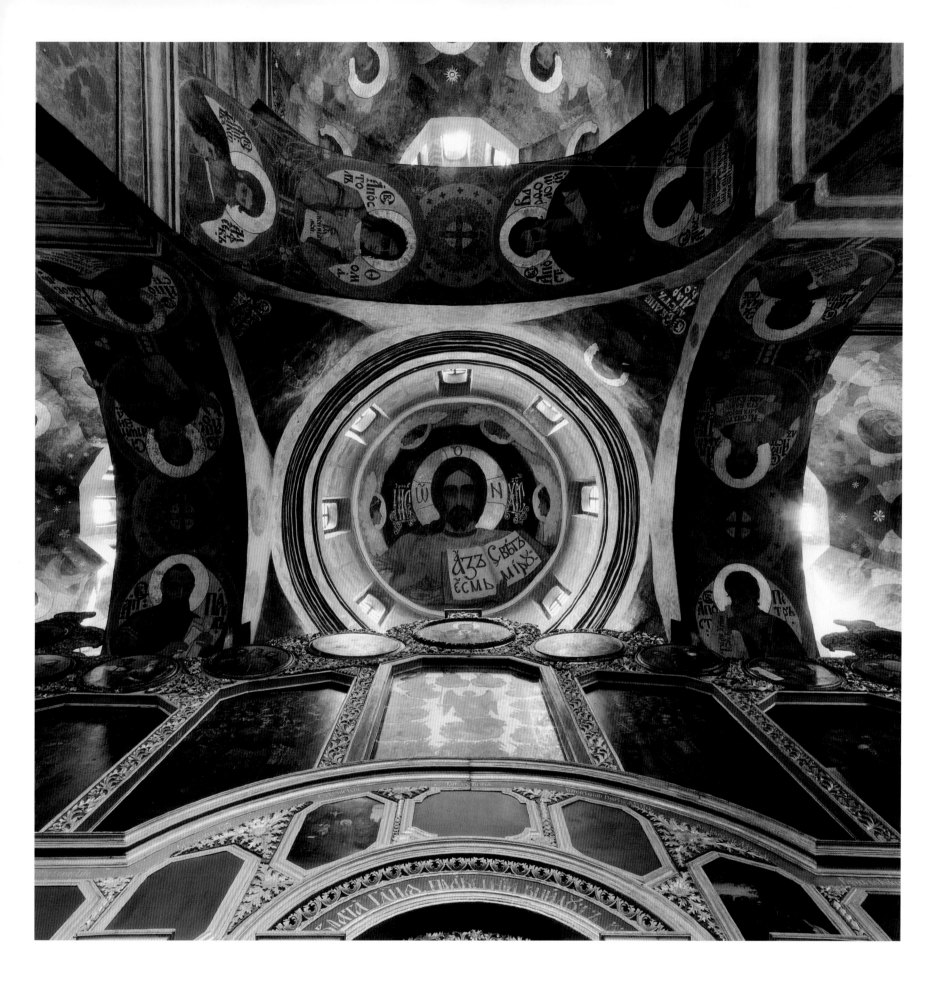

ALL SAINTS CHURCH, KYIV PECHERSK MONASTERY
Kiev, Ukraine, 1696–98,
paintings early 20th century under supervision of Ivan Izhakevych (1864–1962)

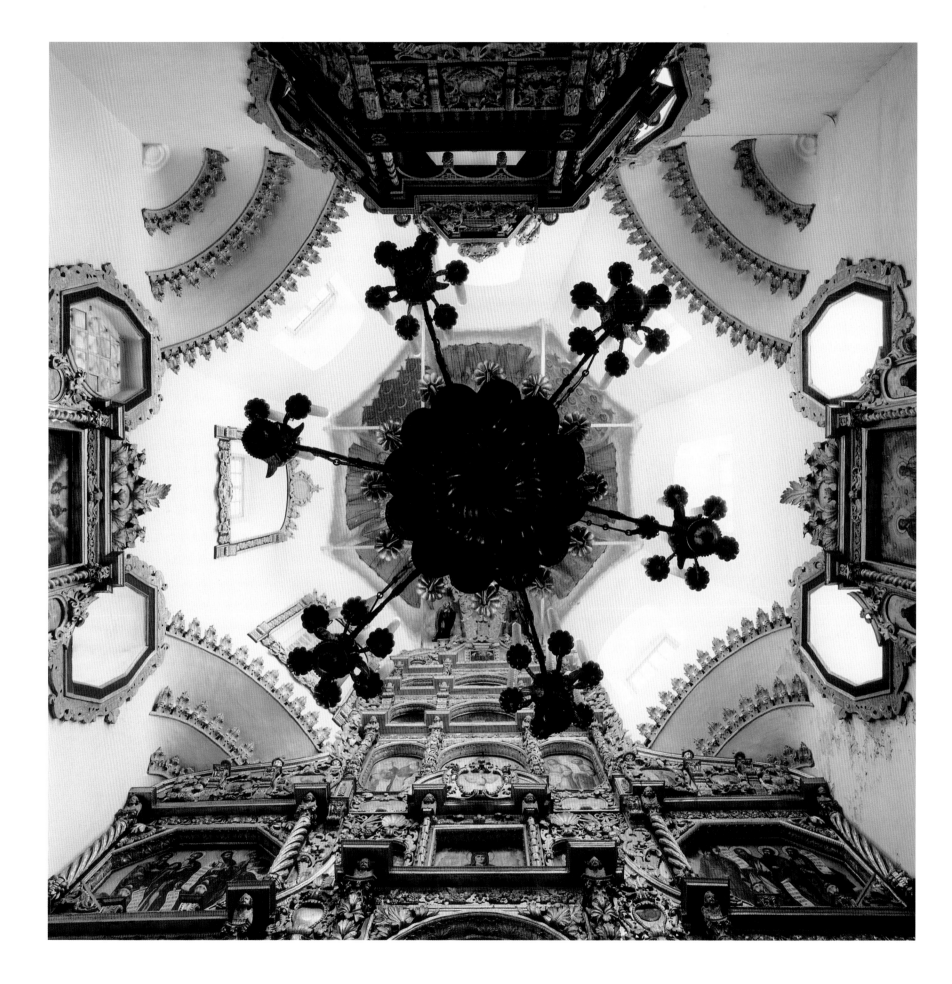

CHURCH OF THE INTERCESSION IN FILI
Moscow, Russia, c. 1690–93,
iconostasis by Karp Ivanovich Zolotarev

153

V.

The Nineteenth Century

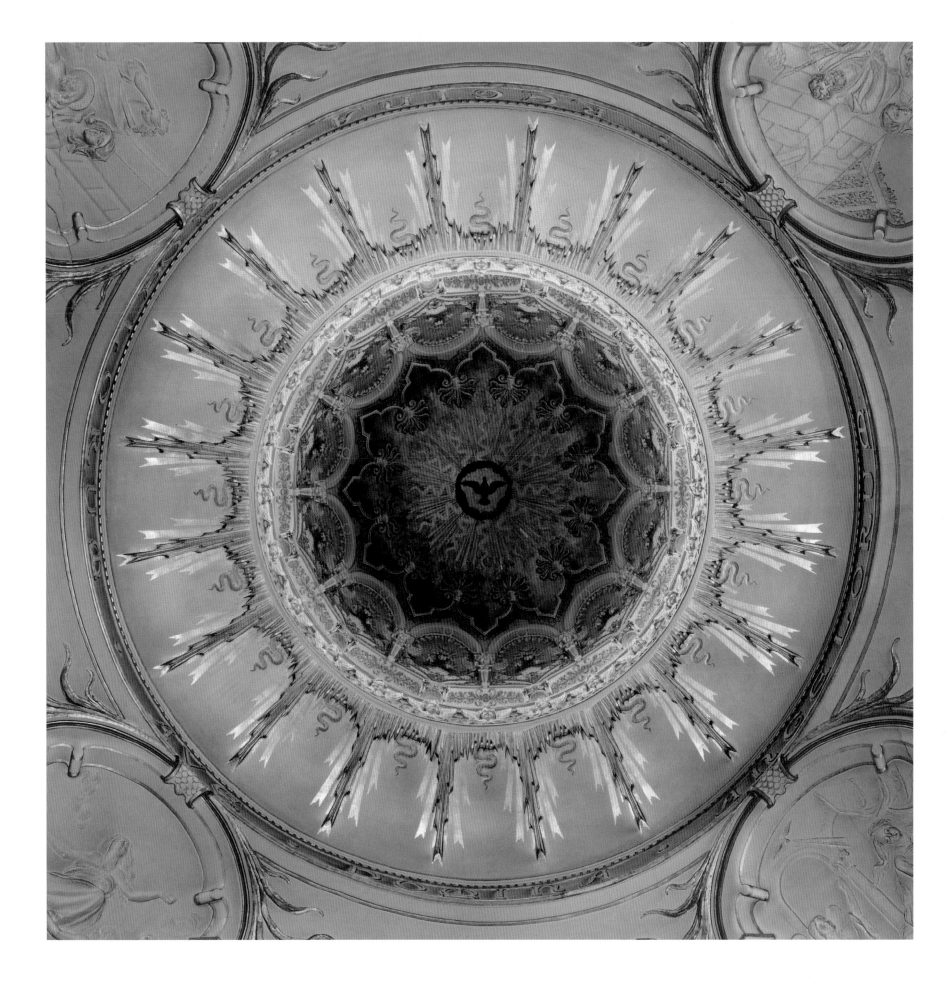

MADONNA DEGLI ANGELI
Turin, Italy, begun 1665,
dome 1901 by Carlo Ceppi (1829–1921)

155

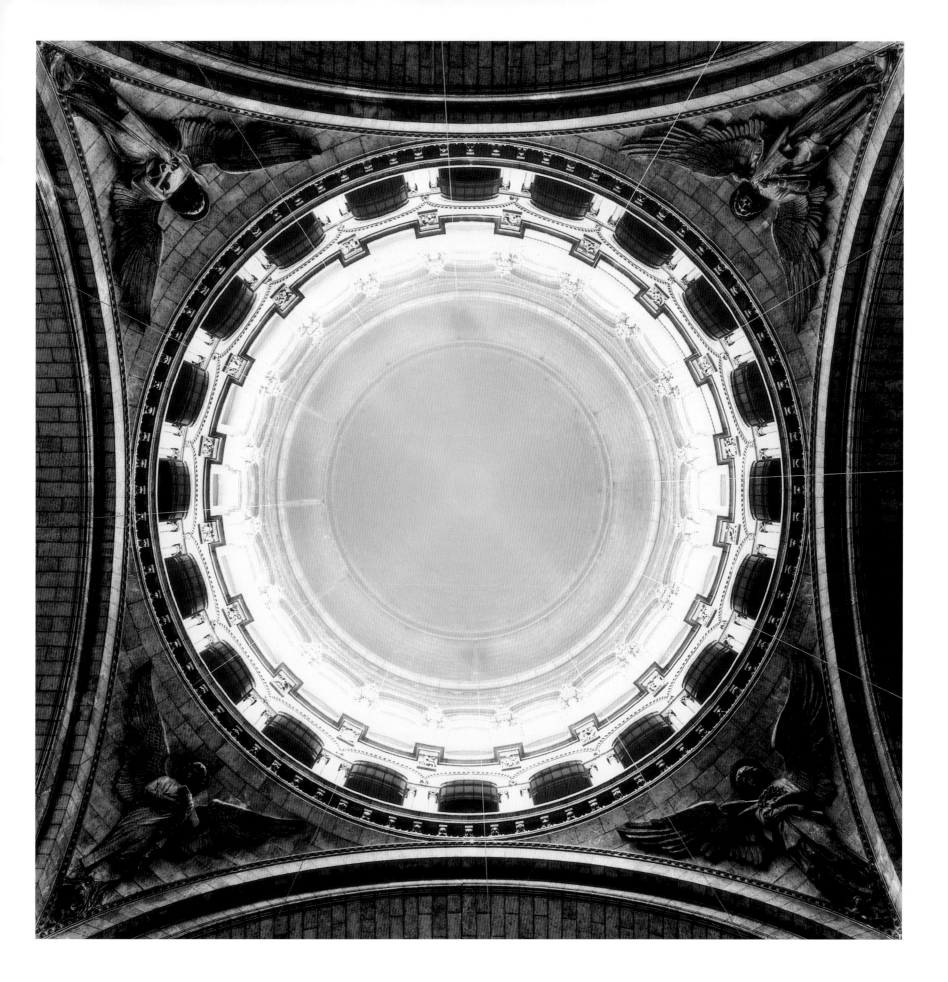

SACRE COEUR
Paris, France, 1875–1914,
Paul Abadie (1812–1884)

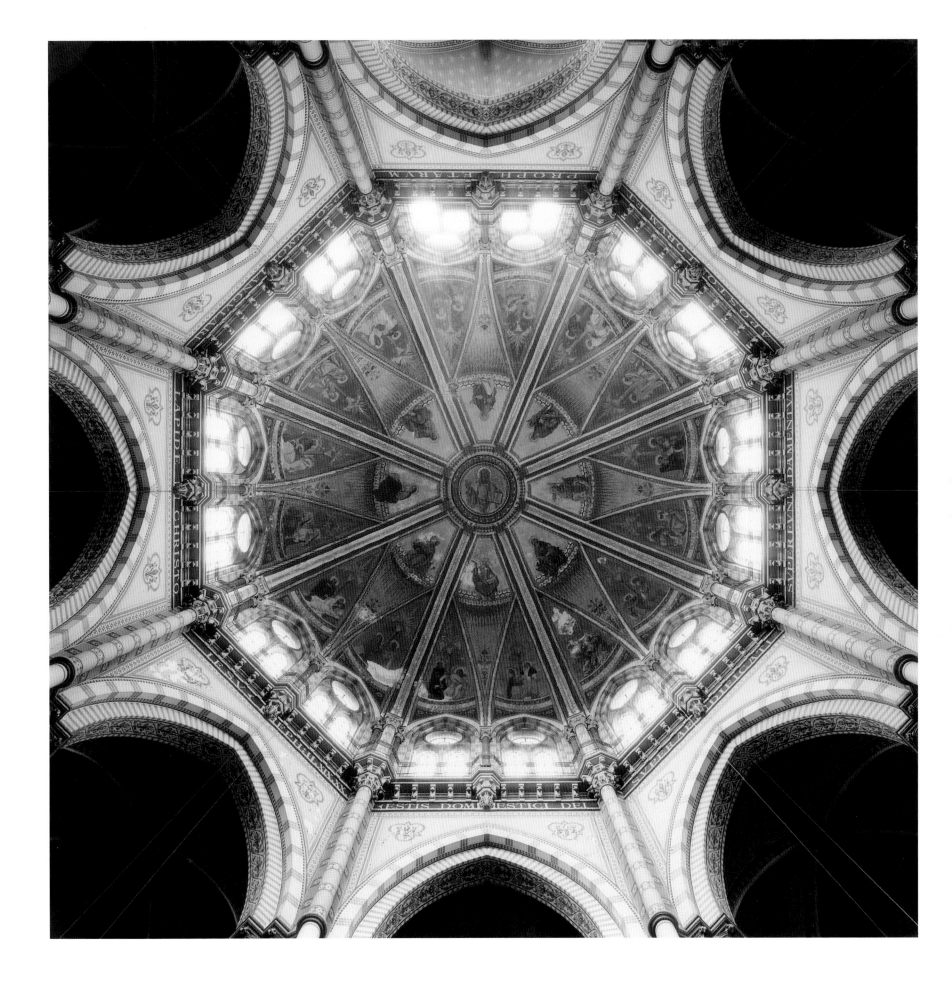

KIRCHE MARIA VOM SIEGE (Mary of Victory)
Vienna, Austria, 1868–75,
Friedrich von Schmidt (1825–1891)

157

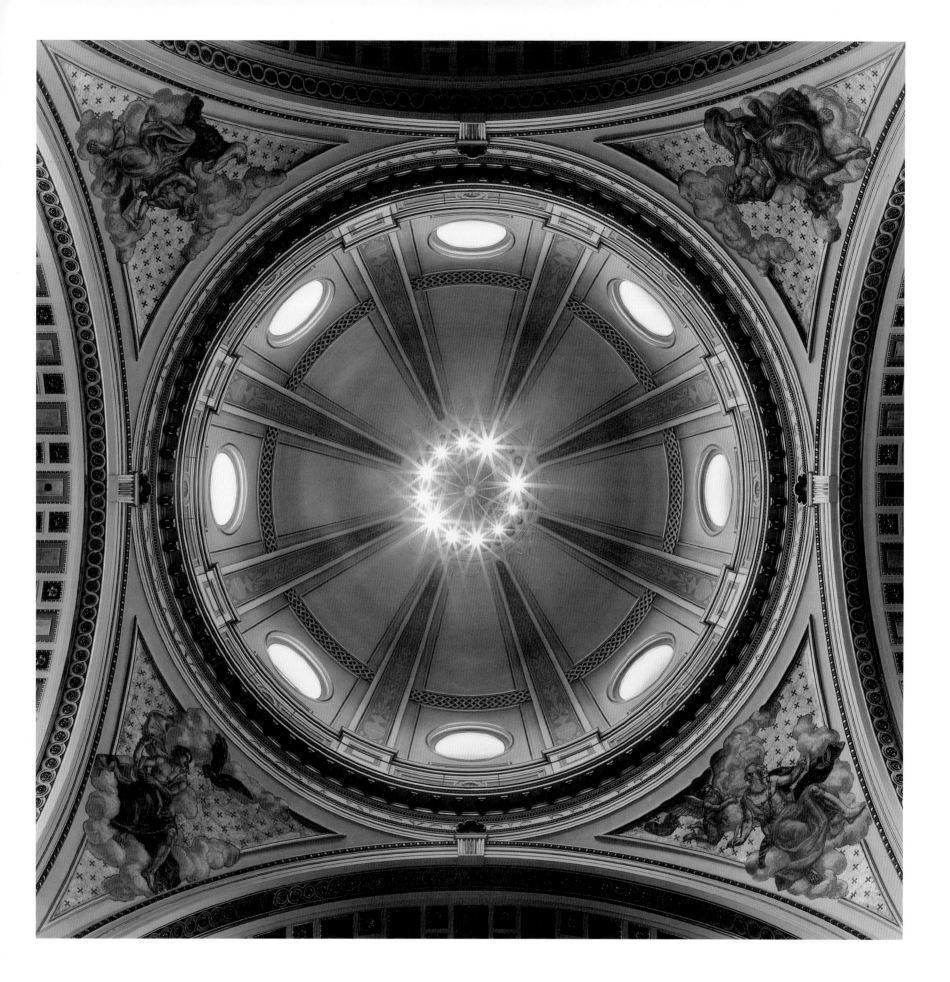

ORATORY OF ST. PHILIP NERI
London, England, 1878–96,
Herbert Gribble (1847–1894), dome 1895–99 by George Sherrin (1843–1909)

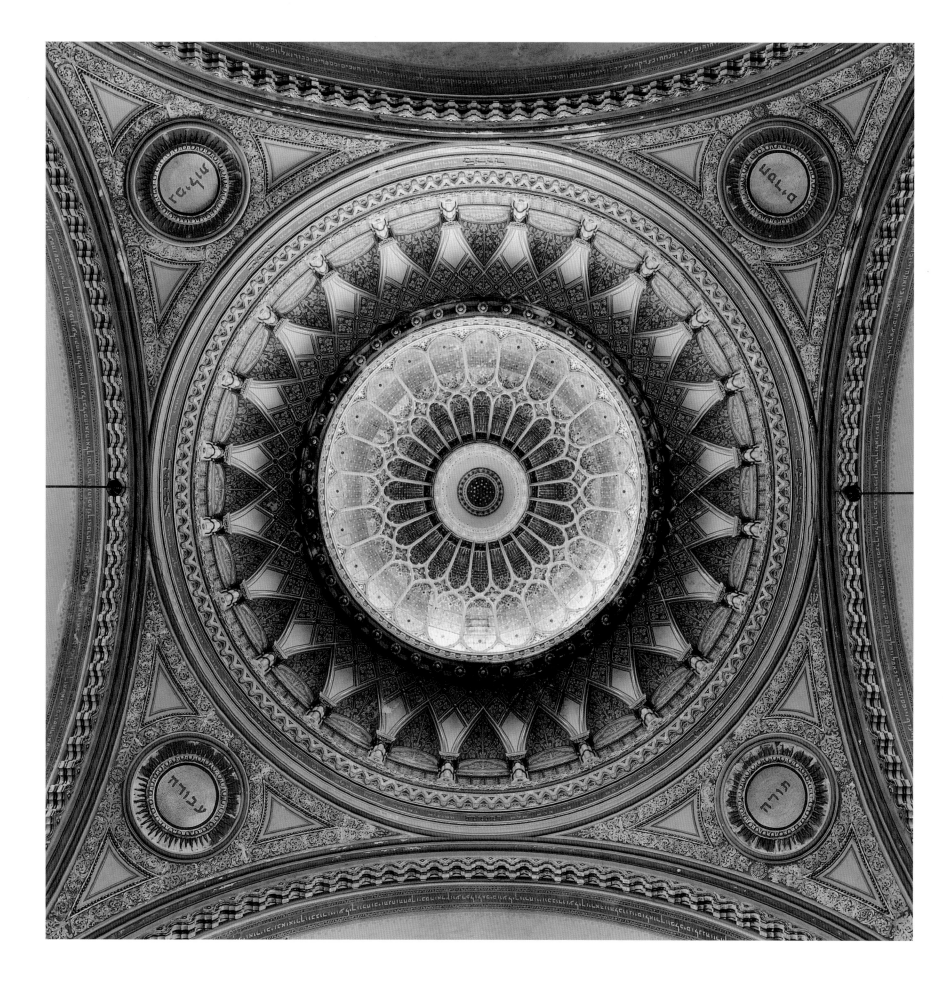

NEW SYNAGOGUE
Szeged, Hungary, 1900–03,
Lipot Baumhorn (1860–1932), stained-glass dome by Miksa Roth (1865–1944)

The Dome in
European Architecture

by Victoria Hammond

The nature of the universe which stilleth
the centre and moveth all the rest around
hence doth begin as from its starting point
And this heaven hath no other where than the
Divine mind.

—Dante Alighieri, *Paradiso,* Canto XXVII, 106–110

In the *Paradiso,* Dante's (1265–1321) soaring journey up through the nine heavenly circles leads to his ultimate vision of beauty and light: the Empyrean heaven. At this highest point of transcendence the poet finally apprehends the mysteries of time and space, for in this still center all space is *here* and all time is *now.* In the mystical language of architecture this heavenly sphere is symbolized by the dome, and the point of infinity beyond by the oculus—the void ringed by the central aperture of the dome. Though Dante's vision of heaven is medieval, its circular imagery is a timeless metaphor for the marriage of geometry and the sacred in the form of the dome. Since its beginnings the dome has been used for religious purposes, becoming architecture's universal expression of heaven.

David Stephenson's photographs of domes span nearly two thousand years, offering a kaleidoscope of shifting visions of heaven ranging from the grand cosmology of imperial Rome, through richly embroidered Byzantine worlds and the mystical geometry of Islam, to the sublime serenity of the Renaissance and the gravity-defying transfigurations of the baroque, culminating in the ethereal lightness of the rococo and beyond. As a photographer, Stephenson is both an artist mesmerized by the beauty of these forms and a visual historian who over ten years has traveled to fifteen countries in Europe and the former U.S.S.R. to document hundreds of domes. His camera, set to a long exposure, illuminates these monumental structures as they were meant to be seen: glowing with rich materials, color, gilding, and light. Today, in reality, the great celestial vaults are swathed in gloom, their decoration and fine detail dimmed by time. Stephenson's obsession also arises from his awareness of the history of the dome, which is at once the most sophisticated of architectural forms as well as the most primitive. The word's derivation from the Latin *domus,* which means house, hints at the archetypal nature of the dome. In imitation of earth forms, the earliest architecture was curved, vaulted, domical; it was only later that it became rectilinear.

Besides their great beauty as photographs, these images of the crowning architectural achievements of Europe's most splendid cultures chart not only changing

visions of heaven but also cosmological ideas, powerful rulers, genius architects, and the rise and collapse of civilizations. Just as the dome form itself represents the transcendent sphere, so its history transcends race and religion. Since its prehistoric origins as a hemispherical hut, this archetypal form has symbolized the celestial realm to the ancients, to the peoples of the classical world, to Jews, Christians, and the peoples of Islam alike.

In his *De architectura*, the only surviving classical treatise on architecture, the Roman architect Vitruvius (*active* 40 B.C.) made the famous observation that the salient features of the Doric order were mutations of far earlier forms fashioned in wood. Similarly, the dome has its origins in primitive shelters such as those made from a circle of saplings bound together and bent inwards to meet at the top, forming a domelike roof. Over time, the form translated into more durable materials such as brick and, finally, the permanence of stone.[1] On occasion the form was even hewn out of rock. Variations of the roundhouse developed in many parts of the ancient world, from Nineveh to India to North America, becoming increasingly sophisticated and taking on a fascinating variety of localized forms, names, ritual usages, and symbolic associations. In Iran, for example, forms of early Islamic mosques have been traced back to prehistoric Zoroastrian fire temples, simple square structures with domed roofs and axial openings.[2]

The ancient apprehension of the sky as the vault of heaven was echoed by the dome form, which conferred on it an inherent mysticism. Indeed, sometimes a conical form itself was worshipped as a manifestation of the sky god, and in many cultures the dome became the symbolic form in which to place the dead for the soul's journey to the afterlife.[3] By classical times these ancient funerary mounds had developed into the more sophisticated, monumental forms of Asian stupas and Roman mausolea.

The custom of decorating the interior of the dome is also ancient in origin. Long before the Greeks and Romans painted the coffers of their temples with stars, blue ceilings with stars existed in Egyptian tombs, Babylonian palaces, and portable structures such as royal tents and baldachins. Alexander the Great is said to have slept under a canopied tent painted with heavenly constellations. From these primitive beginnings a wealth of symbolic images developed that referred variously to divinities, the planets, the zodiac, the cycle of the seasons, and other phenomena, evolving by classical times into entire cosmological systems.

One of the earliest surviving examples of ceiling decoration from the ancient world is the Tomb of the Monkey at Chuisi in Tuscany (500 B.C.).[4] Although it is not a dome, the main element of its painted ceiling is a large circle ringed by another circle—rather like a primitive illusion of a dome. Leaf forms within the circle dissect it into four, and the circle is supported by four winged figures—sirens; the whole is

encompassed within a square. What is of great interest here is the combination of mythological figures with forms from the natural world, set within a strict geometrical arrangement: a compositional format for domical decoration that endured into the Byzantine era and beyond. The sacred associations of geometry were already firmly established by this time, the square and the circle symbolizing respectively the worldly and the divine.

CLASSICAL DOMES

While the form of the dome was a common architectural feature in ancient times, these early examples were usually on a small scale. Larger domes required thicker walls near the base, and the resulting compression of the radial arcing caused the base to crack, or the sides to burst outwards near the base, presaging collapse. Even with many small early domes, only the lower courses have survived. It was the Romans who fully developed larger domes in their temples, baths, and other structures. The finest example is the Roman PANTHEON (117–138), which is as massive, imperious, and indestructible as the Roman Empire considered itself to be and has weathered the battering of almost two thousand years. Its miraculous survival is due both to its awesome presence and to the ingenuity of Roman structural engineering. The use of the drum, a cylindrical wall, as a support for the dome was ubiquitous by this time, but the Roman use of concrete, lighter than stone, allowed for greater flexibility and size in dome construction as the lightening of the weight-bearing mass reduced circumferential compression and resolved the problems of cracking and bursting. The Romans had also developed a method of reducing the weighty mass of domes by embedding interlocking amphorae into the concrete, thereby creating internal voids. In the Pantheon, however, these voids were much larger.[5] Mass was further reduced by leaving the oculus—which spans twenty-seven feet—open at the top.

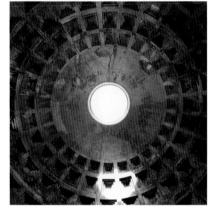

PANTHEON (*see p. 15*)

In *Memoirs of Hadrian*, the classical scholar Marguerite Yourcenar's brilliant "invented" autobiography of the Emperor Hadrian, she imagines Hadrian dedicating the Pantheon with this moving oration:

> My intention has been that this sanctuary of All Gods should reproduce the likeness of the terrestrial globe and the stellar sphere, that globe wherein are enclosed the seeds of eternal time, and that hollow sphere containing all. Such was also the form of our ancestors' huts where the smoke of man's earliest hearths escaped through an orifice at the top. The cupola constructed of hard but lightweight volcanic stone, which seemed still to share in the upward movement of flames, revealed the sky through a great hole at the centre showing alternately dark and blue. This temple,

both open and mysteriously closed, was conceived as a solar quadrant. The hours would make their round on that caissoned ceiling, so carefully polished by Greek artisans; the disc of daylight would rest suspended there like a shield of gold; rain would form its clear pool on the pavement below; prayers would rise like smoke toward that void where we place the gods.[6]

In the sublimely classical Pantheon, the chief decorative element, the coffered ceiling, is an integral part of its construction and function. Its symbolic meaning resides in the cassioned form of the dome itself. Though we now consider such decorative restraint to be the essence of classicism, the Pantheon was once richly decorated. Long ago it was pillaged of its bronze, its statues of gods and emperors, and the symbolic gilding that rimmed its oculus. Yet no building has been so consistently eulogized. The countless commentaries and poems written over the centuries expressing awe at the Pantheon's mystery and magnificence are perhaps best summed up by the inscription Pope Urban VIII had placed to the left of its bronze doors in 1632: "Pantheon. The most celebrated edifice in the whole world." Consecrated as a Christian church in the seventh century, it has been in continuous use and became the inspiration for many Renaissance domes.

In the early Christian period the dome was used for relatively small circular structures such as mausoleums and baptisteries, but it was in the eastern part of the Roman Empire where the first large domed churches were built. Indeed, the dome was to become an essential feature of Byzantine architecture.

The Byzantine

In the seventh century B.C. a Greek adventurer named Byzas sailed to the coast of Asia Minor and founded a small city-state there. Poised between East and West, at a focal point of land and sea routes, the city flourished and became a capital of three great civilizations successively: Byzantium under the Greeks; Constantinople, the capital of the eastern half of the Roman Empire; and, after 1453, Istanbul under the Ottomans. In Roman times it became the cradle of Byzantine art, its influence spreading as far afield as Ravenna, Venice, Sicily, Russia, the former Yugoslavia, and the Balkans.

It was the Emperor Constantine (306–37) who gave the Roman Empire not only a new capital but also a new state religion. He converted to Christianity in 312 after claiming to have seen a luminous cross in the sky and around 324 made Byzantium his seat of government, in the process rebuilding and enlarging the city. It was he who introduced the Roman basilica, which became the model for Byzantine architecture. The Christian church required buildings large enough to contain congregations, and the large basilica, formerly used for civic purposes, with its spacious, domed, audience-hall interior seemed the ideal building form to adapt to the Church's needs. The dome became the distinguishing feature

of Byzantine architecture. The form of the old Roman basilica, rectangular with three aisles and an uninterrupted roof-line, was transformed into a square, Greek-cross plan surmounted by clusters of dome and semi-domes.

By the fifth century Constantinople had become the spiritual center of the Eastern Orthodox religion. Its position on the Bosphorus opened the city to myriad influences from Asia Minor, Syria, and Egypt, and all of these were duly absorbed into Byzantine art. It was under the Emperor Justinian (527–65) in the sixth century that the golden age of Byzantine architecture and art began, marked by the building of his immense basilica Hagia Sophia (Divine Wisdom; consecrated 537). Hagia Sophia, later stripped of its Christian imagery, was then a perfect blend of East and West, the grandeur of imperial Rome married with the richness of Constantinople's Hellenistic heritage and Eastern-inspired gold mosaic ornament.

Hagia Sophia greatly influenced the development of Byzantine architecture. Mathematics was at this time considered the highest of the sciences, and the basilica's two architects, Anthemius of Tralles and Isodorus of Miletus, were primarily mathematicians. The method they introduced of supporting its huge dome, thought to have been initiated in Iran or Armenia, was perfected by later Byzantine architects. The dome rests not on a drum but on pendentives, spherical triangles that arise from four huge piers that carry the weight of the cupola. The pendentives made it possible to place the dome over a square compartment, whereas, in Roman architecture, domes were placed over a circular one. Additional half domes and smaller domes rise at a lower level. The basilica's other great innovation was the spaciousness and great height of its interior, which allowed light to be experienced as divine radiance. The sunlight emanating from the windows surrounding its lofty cupola, suffusing the interior and irradiating its gold mosaics, seemed to dissolve the solidity of the walls and created an ambience of ineffable mystery. On the completion of Hagia Sophia, Justinian is said to have remarked, "Solomon, I have outdone thee."

Another church founded by Emperor Justinian is SAN VITALE (526–47) in Ravenna, one of the most beautiful of early churches. Built to commemorate the emperor's recovery of Ravenna from the Goths, San Vitale is, though influenced by Hagia Sophia, very different in spirit and scale. It was designed on a Roman model, taking the form of an inner octagon enclosed by an outer one twice its size (the octagon in number symbolism being synonymous with eternity). The dome is constructed of interlocking amphorae, its lightness dispensing with the need for the supporting arches and buttresses necessary at Hagia Sophia. Like Hagia Sophia's, San Vitale's dome rests on pendentives, which are formed of small arches. The remarkable pottery dome is protected by a timber roof, an unusual practice at this time and one later favored by medieval architects.

The early Christians eschewed direct representations of Christ, associating them with idolatry. However, as the Church established itself and sought to assert its authority over populations that were largely illiterate, the power of images to educate and instill awe soon

became apparent. In the year 325 the Nicene Creed was formulated, which stated that Christ was "of one substance with the Father" and "for us men and our salvation came down and was made of flesh and became man." This was taken as sanctioning the representation of Christ as a man.

When the early Christian fathers first began to decorate the domes of churches, Christian iconography was in its infancy, so they drew upon the wealth of existing symbolic imagery from imperial Rome and earlier pagan sources, imagery that was in its connotations divine, royal, and cosmological, and adapted it to their own didactic purposes. For the rich, intricate mosaic above the apse at San Vitale a decorative scheme was devised that, with variations, would endure for centuries. The apse is remarkable not only for its fusion of diverse pagan elements, but also for the way in which it integrates them into a Christian context. The theme, with the Lamb of God against a starry sky in the center of the vault, is the Eucharistic sacrifice.

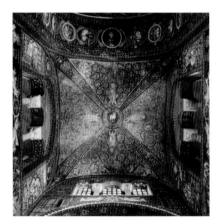

APSE, SAN VITALE (*see p. 17*)

The overall form of the San Vitale vault over the apse as a sky canopy has its origins in the East. With its rich decoration, San Vitale also recalls the domed, bejeweled forms of the most poetic of sky canopy developments, the imperial baldachin. These were exotic tent forms supported by posts or pillars, placed over altars or above an enthroned ruler, and rich in ancient cosmic associations. Often golden— a famous Parthian one was studded with sky-blue sapphires—they were referred to as "heavens."[7] The association of imperial baldachins with a divine and universal ruler, a concept introduced by the Persians,[8] held a strong appeal for Roman and Byzantine emperors who, beginning with Nero (54–68 A.D.), introduced them into the paraphernalia of statehood, from whence, transformed, they were assimilated into Christian iconography, and, in the case of San Vitale, the form of the dome itself. The baldachin form, the decorated canopy on supporting pillars, recurs throughout the development of the Christian dome, cropping up in Russia as late as the fifteenth century in the Cathedral of the Assumption at the Kremlin (see p. 168), where it is translated into monumental supporting pillars surmounted by a richly painted canopy.

The paradisiacal setting of the San Vitale vault, a flowery garden with peacocks, is Persian in origin, though intertwined with the vines of Christ. The composition— a central circle supported by four winged figures set within a square dissected by four diagonals—looks back a millennium to ceiling decorations such as the Tomb of the Monkey's mentioned previously. By Roman times, the earlier winged sirens had developed into winged victories like those that once "supported" the heaven on the dome of the Emperor Hadrian's legendary villa at Tivoli. Here the four victories hovered on globes with subtle differences in size and shading, thereby symbolizing the seasonal cycles of nature.[9] This emblematic composition recurs in the San Vitale dome,

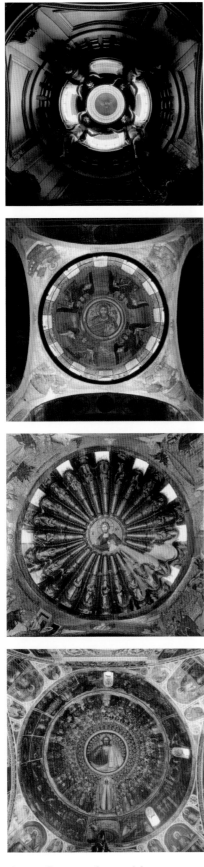

AVILA CHAPEL, SANTA MARIA IN
TRASTAVERE (*see p. 87*)

ST. SOPHIA (*see p. 23*)

CHURCH OF THE CHORA (*see p. 27*)

BATTISTERO (*see p. 30*)

right down to the subtle variations in the globes, but here the winged victories have metamorphosed into hovering Christian angels. This compositional format with its four supporting angels is revisited throughout the development of the dome, reaching an illusionistic climax with the four sculpted putti of the AVILA CHAPEL in Santa Maria in Trastevere in Rome (begun 1680).

An important feature of many Byzantine domes from the ninth century onward is the depiction of Christ as Pantocrator (All-ruler), a concept derived from the ancient notion of the Cosmocrator—Zeus in the classical world and, in the East, particularly Persia, rulers who styled themselves as kings of the universe. The Pantocrator is a representation of Christ clasping the Gospel with his left hand while with the right he makes a blessing gesture with raised index finger, although some have interpreted this as a gesture of admonishment and others as signifying both welcome and rebuke.[10] The Pantocrator commonly occupies the central medallion, surrounded by representatives of heaven, as in ST. SOPHIA in Kiev (begun 1037), the CHURCH OF THE CHORA in Istanbul (c. 1050–1320), and the BATTISTERO in Padua (c. 1200–1378). A comparison of the surrounding figures in these three domes, whose religious meaning is essentially the same, illustrates how the dome form dictated the development of Byzantine decoration. St. Sophia, with its four angels, is not vastly different in composition from San Vitale. The pumpkin dome of the Church of the Chora, with its sunburst of twenty-four fluted golden radials bearing images of Christ's Old Testament ancestors, is dazzling and infinitely more complex. The Pantocrator of the Padua Battistero dome, however, has acquired an entire heavenly host, ringed by hundreds of haloed prophets, martyrs, and saints, circle after circle of them emphasizing the hemispherical form of the dome, their size increasing in symphony with its concave perspective until they attain full length near the periphery.

In Byzantine architecture the form of the dome is eloquently expressed on the exterior of the building, whereas the Pantheon, for example, is essentially just one massive, domed, round-house form. Churches therefore became an imposing and often magnificent presence on the city skyline. The fantastical outline of SAN MARCO in Venice (begun 1063) with its multiple domes has a magical effect, which so impressed the English art critic John Ruskin:

> Domes ... concentrate light upon their orbed surfaces and ... the bulging form may also be delightful ... Their chief charm is, to the European eye, that of strangeness. I enjoy them at St. Mark's chiefly because they increase the fantastic and unreal character of St. Mark's Place; and because they appear to sympathize with an expression of natural buoyancy, as if they floated in the air or on the surface of the sea.[11]

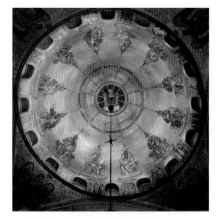

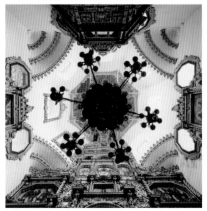

PENTECOST DOME, SAN MARCO
(*see p. 18*)

CHURCH OF THE INTERCESSION IN
FILI (*see p. 153*)

San Marco was built to house the remains of the apostle St. Mark and is based on Justinian's Church of the Holy Apostles in Constantinople. Inside, the presence of the Holy Ghost, believed to descend during the feast of Pentecost, is symbolized by the radiant gold of the Pentecost dome. In the cupola a circle of the twelve seated apostles is linked by rays to the central *hetoimasia*—the gospel book symbolizing the preparation of the Throne for the Last Judgment. The mosaicists who decorated the church were Byzantine, and the *hetoimasia* developed in Byzantine art as an iconographic symbol representing the empty Throne—a reference to God having not yet taken his place upon it to deliver the Last Judgment.

The Byzantine became a powerful tradition within the Russian Orthodox Church. It has endured in Russia for over a thousand years, its forms serving as an endless source of inspiration for jewel-like icons, magnificent churches, and the iconostasis tradition established by Theophanes the Greek, a painter who worked in Moscow in the fourteenth century. Stephenson's photograph of the Moscow CHURCH OF THE INTERCESSION IN FILI (c. 1690–93) shows a splendid, multi-tiered gilt iconostasis—the screen or partition on which icons are placed. Greek artists from Constantinople began traveling to Russia and introducing Byzantine art and architecture in the tenth century, when Moscow was a tiny frontier town and the main cities were Kiev and the grand princedom of Vladimir. The wide adoption of the Byzantine in Russia has its origins in one man: the pagan Prince Vladimir of Kiev. In the tenth century he sent emissaries to various parts of Europe in search of the True Faith. They were unimpressed until they reached Constantinople, the beauty and power of whose religious architecture moved them to report, "We knew not whether we were in heaven or on earth, for surely there is no such splendor or beauty anywhere on earth."[12] Such architectural magnificence was evidently considered to be a manifestation of the True Faith, for it was from the time of Vladimir that Christianity began to be introduced into Russia; its churches, initially built of wood, were modeled on those of Constantinople, developing over time into a distinctively Russian form with clusters of onion domes. Now silvered by time, these hand-carved timber domes are a miracle of workmanship. The city of Moscow, too, was built entirely of timber until it was burnt to the ground during an invasion. This resulted in its important buildings, particularly churches, being subsequently built of stone. By the beginning of the fourteenth century, due to populations fleeing the Mongol invasion, Moscow and its territories became the most densely inhabited in all of Russia.

The CATHEDRAL OF THE ASSUMPTION at the Kremlin (1475–79) was built as an expression of the new power the princes of Moscow enjoyed after receiving the support of the Church and housed the most revered treasure in all of Russia: the icon of Our Lady of Vladimir (the city of Vladimir had been destroyed, probably during one of the Mongol invasions). The baldachin form of the dome with its massive, richly painted supporting

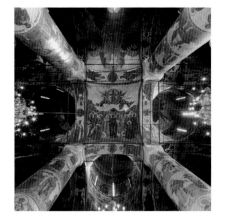

CATHEDRAL OF THE ASSUMPTION
(*see p. 34*)

columns indicates the love of the Russian Orthodox Church for traditional forms, somber richness, and the architecture of patriarchal authority. The great gouged circles surrounding the dome are the bases of smaller domes, the form of the dome-cluster going back to Russia's early timber churches. Russia has a long tradition of importing European architects, here the celebrated Italian Alberto Fioraventi (c. 1415–1486), who studied examples of traditional Russian architecture before designing the cathedral. The frescoes were painted well over a century later (1642–44), by which time the great tradition of Russian religious painters was firmly established. Ivan and Boris Paisein's and Sidor Pospeev's central fresco, with Christ ascending to heaven in a mandorla, has all the narrative lucidity and symbolic resplendence of Russian icon painting. At the time it was painted there was a new emphasis in Russian art on "real" people in a "real" world and a new interest in nature. Hence behind the figures is a landscape, which is unusual in Byzantine art. The mandorla, however, is an important Byzantine symbol, as it represents the transfigured Christ, the heavenly shield of God's radiance, and is often supported by winged angels, as it is here. The word derives from the Italian expression for "almond," which is usually the shape of mandorlas.

The endurance of Byzantine iconography in Russia and former Soviet countries is illustrated by the wonderfully complex forms, brilliant gold haloes, and Pantocrator image of the ALL SAINTS CHURCH in Kiev (1696–98), whose paintings were executed in the twentieth century.

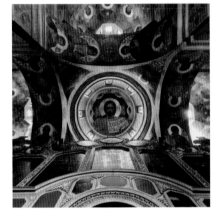

ALL SAINTS CHURCH (see p. 152)

ISLAMIC DOMES

In 1453, after its capture by the Turks, Constantinople was rapidly transformed from a capital of the Christian world into a great center of Islamic culture. It became Istanbul, the seat of the vast Ottoman Empire. Just as Byzantine architecture and art had married East and West, so the Ottomans absorbed aspects of Istanbul's Christian cultural heritage. The most obvious example is that of Hagia Sophia, which was, after its Christian iconography had been removed, converted to a mosque. The form of the dome itself had, long before the onset of Islam in the seventh century, been regarded by its people as inherently symbolic, a heavenly canopy. This interchange between Islam and Christianity, the borrowing of forms, symbolism, and materials—buildings even—and their development within the opposing belief system, was nothing new. It had been occurring in Spain for centuries, after its conquest by the Moors in 711.

The MEZQUITA or GREAT MOSQUE at Córdoba (c. 961–76) is lauded as one of the most unique and influential monuments of the Islamic world for "its unsurpassed integration of architecture and decoration."[13] It was developed on the site of an ancient Visigothic church, and during the course of its construction and enlargement over two centuries, it absorbed myriad influences: Roman and Visigothic as well as features of earlier mosques in Syria and Palestine. The famous pumpkin shape of its dome, Eastern in origin, was in turn

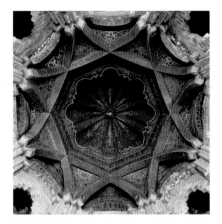

Mezquita (*see p. 42*)

exploited by both Byzantine and Islamic architects. The Great Mosque was begun in 785 under the last of the powerful Umayyad caliphs, whose family came from the same tribe as the prophet Mohammed's. It was built as a symbol of the new Islamic state and Córdoba's preeminence as Islam's center of culture and influence in the west. The mosque was enlarged under successive caliphs, attaining its full magnificence in 976 under Hakam II, who carried out extensive additions and imported Byzantine craftsmen from Constantinople to execute its rich mosaic decoration. Hakam added four domes to accentuate the remodeled *mihrab*—the symbolic niche that indicates the direction of Mecca. In front of the *mihrab* area the great, gouged central dome blossoms like some heavenly flower, its center a star in a radiating sun, set jewel-like within the surrounding star of eight golden, floral-patterned, arched, and interlocking ribs, which in turn rise above the intricate crystalline geometry of supporting squinches. The squinch is an Islamic version of the pendentive and was very important to the development of the Islamic dome, as will be seen. At this stage in its development, the squinches' manifestation as a decorative scheme masks their engineering function as supporting elements.

In the Qur'an, as in the Bible, light is a manifestation of God's presence. Light and solar symbolism had since Babylonian times reflected divine attributes upon the sovereign and here the decoration explicitly honored the ruler. Hakam II would have sat under the sun symbol, illuminated by a lamp attached to the star, his eyes occasionally falling on the golden inscription, the *sura* of light from the Qur'an, surrounding the *mihrab*. The overall effect of the dome is one of radiant strength married with the delicacy of fine embroidery. In 1523, long after the Reconquista—the Christian reconquest of Spain—the Christian clergy built a Gothic cathedral in the middle of the prayer hall, which had a wonderful over-arching forest of slender striped columns, although the domes were left intact. On a visit, King Charles V was horrified by the transformation: "If I had known what you wished to do, you would not have done it, because what you are carrying out here is to be found else-where, and what you had formerly does not exist anywhere else in the world."[14]

The ALHAMBRA in Granada (begun 1258), a dreamworld of halls, gardens, intricate arabesque decoration, and fountained courtyards, whose lions once spouted perfume, was built at a time of waning Islamic power in Spain. Córdoba had fallen in 1253, and Granada, which was not a powerful capital like Córdoba, was one of Islam's last bastions. The Alhambra was built as a royal city, inspired by the Qur'an's images of paradise and Muslim fables of the magical palaces built by Solomon. Its architecture and decoration are arranged according to a complex geometric scheme and are permeated with symbolic significance, both royal and cosmological. The great domed audience halls were built to mirror the heavenly constellations, and their architecture is one of illusion and the dematerialization of matter. The exquisite stalactite dome of the SALA DE LOS ABENCERRAJES (c. 1333–91) appears to be a shimmering source of light, though in fact it merely reflects light. In

SALA DE LOS ABENCERRAJES,
ALHAMBRA (*see p. 49*)

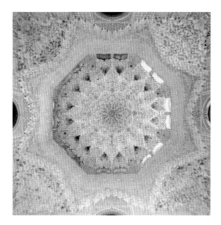

Sala de las Dos Hermanas, Alhambra (*see p. 48*)

emulation of the legendary Hall of the Caliphs in the palace at Madinat az-Zahra, the dome was designed to appear as if it was rotating like the constellations. The mesmerizing dome, like others at the Alhambra, is a "false" one, concealing the sturdy vaulted brick supporting dome that was modeled on Hagia Sophia's.

Both this and the equally dazzling one in the Sala de las Dos Hermanas (c. 1333–54) are highly developed examples of *maqarnas* domes, composed of thousands of stalactite squinches. Squinches—a series of arches placed at each of the four corners to link them to the dome above—were initially used in Islamic architecture as diagonal supports. Over time, they became a highly ornamental means not only of vaulting but also of articulating the space between walls and dome, thereby concealing the transition as they do in the Great Mosque.[15] In the Alhambra the *maqarnas* have multiplied into infinity and, hovering suspended, have become the form of the star dome itself.

The Sala de las Dos Hermanas has an extraordinary Arabic inscription that describes its dome as more beautiful than heaven itself, indeed so beautiful that it beckons the stars from the sky. Part of the inscription, translated, reads:

> In here is a dome which by its height becomes lost from sight; beauty in it becomes both concealed and visible. . . . And the bright stars would like to establish themselves firmly in it rather than to continue wandering about in the vault of the sky. . . . It is no wonder that it surpasses the stars in the heavens, and passes beyond their furthest limits.

The Arabs considered beauty to have a healing effect: "I saw this and forgot my burden," reads a line from an Arabic poem written in praise of the Alhambra domes.[16] The heavenly insubstantiality of these domes can be understood as an architectural manifestation of the orthodox Islamic concept of God as absolute and eternal, as opposed to the world, which is, as architectural historian Camilla Edwards observes, "composed only of atoms and accidents which in the form of a *Maqarnas* dome would be indistinct units arranged in a complex manner and (like the universe) supported and kept whole by the will of God."[17]

In Istanbul, later Islamic developments of the dome show a far different treatment. The mid-sixteenth century in Istanbul was a golden age long presided over by Suleyman the Magnificent (1494–1566), who ruled a vast territory that embraced large tracts of Africa, Asia, Europe, and Russia. Suleyman's unimaginable wealth, together with the synthesis of European, Islamic, and Turkish traditions, saw the creation of architecture and art that was unique to the Ottoman world. In Ottoman tradition every ruler was required to have a practical trade and Suleyman was himself a goldsmith as well as being a great patron and ardent supporter of the arts. Ottoman architecture reached its greatest monumentality when he appointed Sinan (c. 1490–1588) royal architect. Of the more than three hundred monuments Sinan created for the Ottoman Empire, the most spectacular is the Suleymaniye.

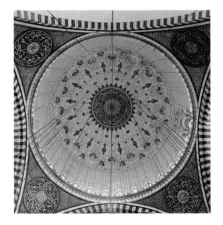

SULEYMANIYE MOSQUE (*see p. 28*)

This enormous complex expressed the concept of the unity of life, which is at the very heart of Islamic teaching. It consisted of a college of medicine, hospitals, a mosque, and schools, together with caravanserais and kitchens to accommodate and refresh travelers. On the exterior of the SULEYMANIYE MOSQUE (1550–57), domes and semi-domes cascade spectacularly downward from the roof, balanced by the upward thrust of minarets. On the interior, however, the decoration of the main dome is, in comparison with the Spanish Islamic ones, restrained and even didactic in atmosphere. Its classical circular arrangement with its quiet symbolic forms and beautiful calligraphic medallions, attesting to the preeminence in Islamic faith of the word rather than the image, was doubtlessly influenced by the Renaissance, which had been taking place in nearby Italy for well over a century. Several notable developments in Christian architecture had taken place prior to the onset of the Renaissance, during the medieval, Romanesque period.

THE ROMANESQUE

The term Romanesque refers to a reversion to precedents set by classical Roman architecture that occurred in the Middle Ages roughly between 600 and 1150. Although the forms differed in various regions, the placement of the dome in a crossing tower (a tower at the intersection of the nave, chancel, and transept), where it is not visible on the exterior, is a general characteristic of Romanesque churches. Constructing the dome as the summit of the church's center accentuated its sacred significance. Another common factor is that these churches were founded not by powerful rulers but by Christian bishops, monastic orders, or crusading knights; many of the churches were, or began as, monasteries.

The development of the Romanesque in Spain differed from that in other European countries, largely because it stemmed from different origins, but also because churches there were expressions of a Christianity eager to assert its preeminence over the strong Muslim presence in Spain at this time. This was the period of the Reconquista, when large parts of Spain were reclaimed from the Moors under the Christian banner, particularly in the south. In Castile, there is one superb exception to the externally hidden crossing tower dome: the extraordinary CATEDRAL at Zamora (1151–74). Here, the dome is far more articulated externally than in the interior, for it is covered with lavish ornament that resembles the scales of some mythical beast; in mood it is more darkly Gothic than Romanesque. Its complex intricacy has been compared to a "work of art produced by a goldsmith."[18] These "scales"—a cacophony of turrets and miniature arcades with domes or pediments—are as much structural as ornamental as they help absorb the thrust of the curious domed tower, referred to as a *cimborio*. The origins of this remarkable structure have excited much debate— Jerusalem, the Limousin in western France, and Islamic Spain are among the possibilities— but what is clear is that it is a Christian example of the marvelous forms that can result from an intermingling of local, western, and Islamic elements. Internally, the dome rests on

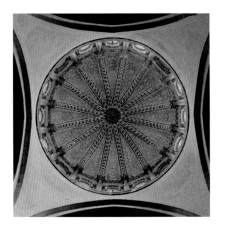

CATEDRAL at Zamora (*see p. 45*)

pendentives, with sixteen windows spaced between a circle of sixteen gilded ribs—the ribbing introduced by Islam now replacing the earlier vaulting. The windows are significant, for early Romanesque churches were usually very dark, and illumination became a pressing concern. At Zamora, the well-lit drum casts a pool of light into the center of the church.

The IGLESIA DEL SANTO SEPULCRO in Torres del Rio, Navarre (late twelfth/early thirteenth century) is another Spanish example, which is historically very interesting as it may have been built by the Knights Templar. Certainly its name—Church of the Holy Sepulcher—suggests it. The Templars were an aristocratic order of knights whose original mission had been to protect pilgrims on their journey to the Holy Land. Jerusalem's famous Church of the Holy Sepulcher, built on the site of Christ's entombment, was a shining beacon of Christianity at this time, highly significant during the Crusades, when Christians could no longer make pilgrimages to the Holy Land as it had been captured by the Muslims. This profoundly affected the style of new Christian churches, many of which were built in emulation of Jerusalem's Church of the Holy Sepulcher, thereby serving as substitutions for the pilgrimage to the Holy Land. The effect was most profound in northern Spain as many Christians now made their pilgrimage across the Pyrenees from France to the shrine of St. James at Santiago de Compostela, the apostle revered as a legendary fighter against the Moors. Along this pilgrims' route, the needs of the travelers were catered to by monastic communities, which resulted in the increased construction of churches and shrines to saints and increasing international influences in their architecture, particularly from western France. Monastic orders such as the Cistercians also played an influential role in church design, as did the Knights Templar—who were strongly influenced by French culture—and other aristocratic knightly orders, whose mission was now to provide safe passage for these pilgrims as well as to reconvert the Muslim populations of Spain to Christianity. Thus building a Church of the Holy Sepulcher at Torres del Rio in Navarre was in two senses an assertion of Christianity. The plan of the church is characteristic of those along the pilgrims' route: a centrally planned building with an octagonal layout. The dome, however, is a superb reinterpretation of the geometric structure of the Great Mosque at Cordoba's second *mihrab* dome. But here Cordoba's heavenly decoration has been relinquished for austere stonework, laying a new emphasis on the beauty and symbolic power of unadorned geometry. The entire dome is made of stone, including ribs and center, the treatment being essentially sculptural, with sixteen interlocking ribs and additional ones that rise from French-style piers creating triangles and other geometric configurations. The curved geometry of this dome's star form is indeed a singular example of thirteenth-century Romanesque as it antici- pates by four centuries one of the great masterpieces of the Baroque: Guarini's San Lorenzo in Turin (see p. 180).

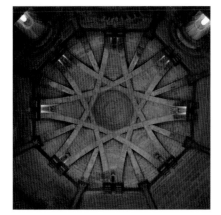

IGLESIA DEL SANTO SEPULCRO

(*see p. 43*)

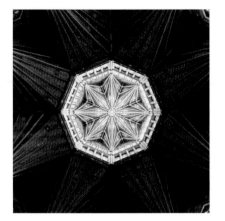

ELY CATHEDRAL (*see p. 41*)

GOTHIC ARCHITECTURE

It is perhaps ironic that the increasing application of ribs to domes at the end of the eleventh century led eventually to the elimination of hemispherical domes in most western churches—that is, until the onset of the Renaissance. The dome is not central to Gothic architecture as its most significant symbol of heavenly aspiration is the towering steeple. However, in the development from the Romanesque, Gothic architects introduced small octagonal domes over the crossings of cathedrals. One of the most beautiful and architecturally integrated of these is the octagonal dome of ELY CATHEDRAL near Cambridge in England (1328–42), which straddles the Romanesque and Gothic styles. Here an eight-pointed star, illuminated by thirty-two surrounding windows, radiates in the center of eight monumental thrusting vaults, which themselves are like somber star rays. An enthusiastic commentator on the cathedral, after describing the dome as "one of the great architectural wonders of the world," writes:

> All is light and space and movement. The eye shoots back and forth, no longer confined to perpendiculars and horizontals, but in soaring, swooping diagonals … the eight angle shafts suddenly burst out, like fireworks, into a profusion of ribs, upon forty of which—five from each shaft—there rises the dome itself, so light, so airy, that it seems ready to take off at the first breeze. One finds it hard to believe that the supporting timber structure of the octagon—most of it hidden from sight—supports 400 tons of wood and lead.[19]

Interestingly, the Islamic concept of the shimmering star dome was later adapted in Spain by Christian architects in the crossing tower of the CATEDRAL at Burgos (1567). The Gothic cathedral it crowns was built far earlier, begun in 1221 on the site of an earlier Romanesque church. The model is clearly Islamic, for the dome is a "fake" one; its eight-pointed star gives a supernatural impression of being unattached to its perforated support, hovering in space like a divine vision. It was doubtlessly inspired by the octagonal star dome constructed seventy years earlier in the same cathedral's separate chapel or CAPILLA CONDESTABLE (1482–94). Although the supporting structures of the domes are vastly different, the earlier one Gothic and the other Renaissance, the eight-pointed star forms are similar. It would seem that the architects of the brilliant later one, Francesco de Colonia and Juan de Vallejo, may have been inspired by the example of the Alhambra.

THE RENAISSANCE

After the relative anonymity of Romanesque and Gothic architects, the Italian Renaissance is the period of the universally applauded genius, often a painter, sculptor, and great thinker as well as an architect. Filippo Brunelleschi (1377–1446) was all of these things as well as being the inventor of linear perspective; he also had substantial gifts as an engineer and

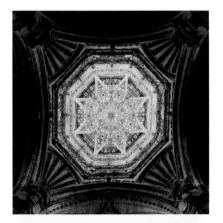

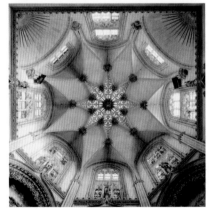

CATEDRAL at Burgos (*see p. 55*)

CAPILLA CONDESTABLE (*see p. 53*)

builder. Brunelleschi was the first Renaissance architect to study classical buildings and introduce classical forms into his designs, and it was his revolutionary design of the dome for the Cathedral in Florence, Santa Maria del Fiore, that virtually heralded the beginnings of the Renaissance in architecture. The Gothic Cathedral had been sitting in the middle of Florence for a century without a roof and, as his great patron Cosimo de Medici remarked, "Without a dome, you don't have a sacred building."[20]

Brunelleschi's model was the timeless Pantheon—the span of its dome approaching the unprecedented span of the Cathedral's—but he faced three great problems: the recipe for concrete had been lost in classical times; the plan of the drum was octagonal not circular; and there was insufficient timber in Florence to build supports for the dome's construction. It would have to support itself as it was being built. To illustrate to members of the *Commune* how his design would distribute weight, Brunelleschi famously lopped the top off an egg and sat it on its end. A single dome of this size would have been too thick and too heavy at the top for the supports to carry the mass, so to distribute the weight Brunelleschi designed a double-shelled dome that acted as one, with internal circular rings as supports. As building progressed, the thinner outer shell was partly supported by radial ribs between the shells, while for the inner, thicker shell Brunelleschi devised a brickwork bond: the bricks were laid in a herringbone style for greater strength, and through a complex kind of locking system successive rings were keyed into those already built. The dome, described as "a miracle of design"[21] took sixteen years to build as it was necessary to allow time for the successive rings to harden sufficiently to carry the compression.[22] The majestic elongated curves of the octagonal structure to this day dominate the Florence skyline, and it remains the largest unsupported dome in Christendom.

While the Cathedral's dome indicates Brunelleschi's engineering genius, his dome for the CAPELLA DEI PAZZI (Pazzi Chapel), SANTA CROCE in Florence (1430–52) illustrates the harmony and restraint of his classical Renaissance aesthetic. In the Vatican Palace, there is a marvelous Renaissance painting by Pinturicchio entitled *Geometry*. The setting is antique, a reference to the classical world where geometry was seen as the key to understanding, a belief that had its genesis among the ancient Greeks when Pythagoras first assigned a mathematical basis to the universe. The painting is riddled with geometric symbols but geometry itself is allegorized as a calmly beautiful, enthroned woman in jeweled clothing, flirtatiously holding open a fan patterned with perspectival squares. At her feet sits a scholar, intent on solving the mystery of the circular configuration he is describing with a gleaming compass. This painting indicates the seductiveness of geometry to Renaissance thinkers: they believed it could unlock the mysteries of the universe and reveal God's intentions. As the Florentine humanist Giannozzo Manetti wrote in his *On the Dignity and Excellence of Man,* the truths of the Christian religion were as clear and self-evident as the principles of mathematics.[23] This is the spirit behind the serene classicism

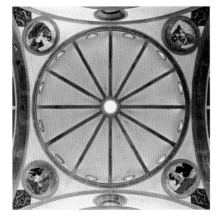

CAPELLA DEI PAZZI (Pazzi Chapel), SANTA CROCE (*see p.* 64)

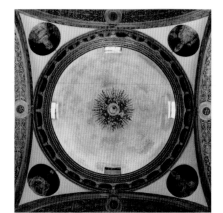

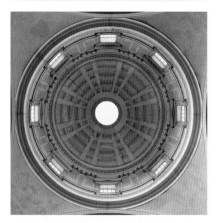

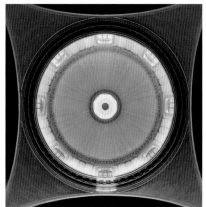

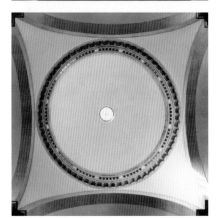

SAN SISTO (*see p. 65*)

SANTA MARIA DI CARIGNANO
(*see p. 73*)

DUOMO in Padua (*see p. 69*)

SAN GIORGIO MAGGIORE (*see p. 71*)

of Brunelleschi's architectural and decorative scheme for the Capella dei Pazzi, where the sublime order of heaven is reflected in the lucidity of the twelve-ribbed geometric structure. The circle was viewed as geometry's supreme form, signifying perfection and transcendence, so it is not surprising that the three-story building is constructed around a circular plan. Within the dome, the form is repeated by the circularity of its twelve windows, the echoing forms of its medallions, and the lower windows set within the upstanding drum. The perfect proportions of the chapel result in a still, meditative atmosphere of absolute tranquility. The Capella was commissioned by the rich and powerful Pazzi family, whose coat of arms is repeated in the pendentive corners below the four ceramic medallions with their serenely meditative depictions of Christ outlined against celestial blue. Florence was an important center of ceramics during the Renaissance, and ceramic design was often incorporated into the decorative schemes of churches, as it was here.

Brunelleschi's reduction of domical decoration to its symbolic geometric essentials became highly influential. SAN SISTO in Piacenza (1499–1514), for instance, repeats the Capella dei Pazzi's circular form with its four corner medallions. The Renaissance was in a sense a massive archeological enterprise: numerous forms, symbols, and ideas from the classical world were excavated and reinterpreted afresh within a Christian context. San Sisto's oculus decoration, a sunburst writhing with snakes, is the marriage of two of the most archaic of all symbols: the sun and snakes—ancient mediators between this world and the next. The concept of incorporating portraits of divinities or rulers in ceiling medallions in turn goes back to antiquity.

The Pantheon endured as a fertile source of inspiration, its coffered dome and mighty oculus reworked in the clear light of High Renaissance rationality in SANTA MARIA DI CARIGNANO in Genoa (1549–72). When the great Michelangelo Buonarotti (1475–1564), chiefly acclaimed as a sculptor, painter, and architect of mannerist complexity, remodeled with Andrea della Valle (d. 1577) and others the DUOMO in Padua (1552), he too married grandeur with classical simplicity. He introduced far higher windows, so that the main feature of the cupola rising above the celestial blue canopy is the experience of evenly diffused, radiant light. Stephenson's photograph captures a rectangle of warm sunlight that travels around the dome as the hours pass, just as it does in the Pantheon. In Venice, at SAN GIORGIO MAGGIORE (1566–1610), the most classical of Renaissance architects, Andrea Palladio (1508–1580), allowed the experience of light and the purity of white to dominate, accentuating the harmonious proportions of the dome by reducing it to its simplest elements: a quiet through elegantly articulated circle of windows.

In the same decade austere classicism was also expressed in Spain's architecture, although the ideology behind it was worlds away from Renaissance Italy. Philip IV of Spain, having read Vitruvius, and inspired by imperial Rome and the reign of Augustus in particular, devised El Escorial—a palace, monastery, and hospital complex—as the seat of

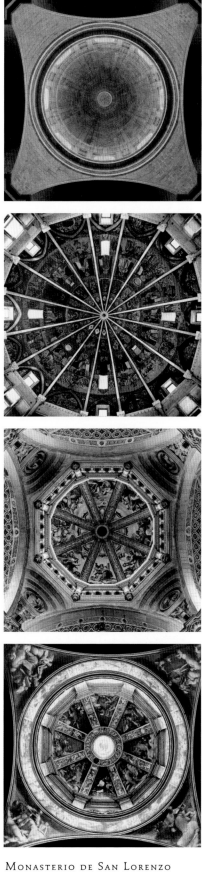

MONASTERIO DE SAN LORENZO
DE EL ESCORIAL (*see p. 79*)

BATTISTERO (*see p. 31*)

CERTOSA DI PAVIA (*see p. 57*)

MADONNA DI COMPAGNA (*see p. 58*)

an absolute monarch who ruled by divine right. The complex also contained a mausoleum for the Hapsburg rulers and their families. The inclusion of the monastery was significant as it denoted the Hapsburg rulers' dominion over church as well as state. El Escorial's architecture is severe, and the local gray granite it is built of makes it even more so. It may come as no surprise to learn that the complex was built at the height of the Spanish Inquisition. The dome of the MONASTERIO DE SAN LORENZO DE EL ESCORIAL (1563–84) is cold, hard, and forbidding, the expression of an autocratic monarch.

Several Italian Renaissance domes take a spoked wheel form reminiscent of earlier Byzantine-style domes such as the BATTISTERO in Parma (1196–1216), where it segments the imagery. In the Renaissance domes of the CERTOSA DI PAVIA (1396–1473) and the MADONNA DI CAMPAGNA in Piacenza (1522–28), however, the wheel form has become a separate entity, demarcating God's separation of the Earth and the heavenly zone beyond. This gives the dome a lightness, as if it could be spun like a roulette wheel. The popularity of the wheel form at this time may have been due to Dante's *Paradiso* (c. 1314) with its recurring images of flaming wheels. Many of Stephenson's photographs of domes resemble mandalas—Buddhist meditation instruments that represent the cosmos in relation to divine powers—but these two domes particularly do so, recalling the cosmic mandala that was revealed to Dante in a vision.

The two churches are also notable for their painted visions of heaven. The Renaissance is the great age of genius painters, Brunelleschi's linear perspective having paved the way for greater and greater feats of illusionism, and the concave form of the dome was the perfect place to exploit the painterly possibilities of three-dimensional space. Renaissance painters drew heavily on classical mythology, sometimes producing secular or "pagan" works such as Botticelli's *Birth of Venus,* and at other times introducing the drama, grandeur, and personified emotions of classical myth into Christian narrative cycles. The imaginative world of myth in fact liberated Christian iconography, loosening the rigid hierarchical forms of Byzantine and medieval art. The result on domes was a circular rhythm of gesturing figures. Nowhere is the blend of Christian and classical-inspired iconography more apparent than in the dramatic crowd of figures in the meticulously painted fresco of the dome of SAN SIGISMONDO in Cremona. In 1441, the marriage between Francesco Sforza and Bianca Visconti at San Sigismondo had brought together two powerful ruling families, and the church was rebuilt in 1463 to commemorate the occasion. The frescoes (c. 1533–59) were executed by members of the Cremona School: Camillo Boccaccino (1511–1546), and Giulio (c. 1508–1573) and Bernardino (c. 1522–1590) Campi. The fresco of the cupola imaginatively recreates the marriage, celebrating its historic significance by introducing timeless classical figures amidst the members of the wedding party. The clever composition compels the viewer to look where they are gesturing: to the Holy Spirit fluttering in the oculus. The elongation of these figures indicates mannerism—the expression of individuality and spirit

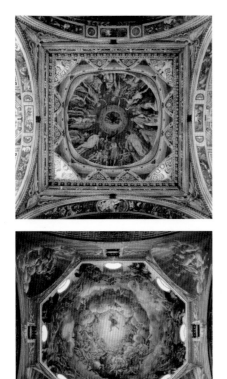

San Sigismondo (*see p. 76*)

Duomo in Parma (*see p. 60*)

of improvisation that began in Florence in the mid-sixteenth century and flourished during the Baroque period.

In the High Renaissance great painters began to fully exploit the hemispherical form of the dome, the earlier circle of figures developing into the depth-oriented illusionism of the spiral. This is when the painterly dome truly comes into its own, heralding the Baroque manipulation of space. The cupola of the Duomo in Parma (1090–1130) was remodeled between 1523 and 1530 with frescoes by one of the great Italian masters, Antonio Correggio (1489?–1534). Correggio was a native of Parma, and the onset of his career coincided exactly with the beginnings of the Renaissance there. The Duomo frescoes were among his last works, by which stage he had developed his instinctive feel for movement and the individualism of the mannerists, both of which he here expanded into a full painterly expression of the dome as a concave form. The imposing proportions of the dome, which was very deep with an octagonal base, invited Correggio's handling of it as an infinite, luminous space. The outer rim forms a kind of balustrade between heaven and Earth, with darkly clothed figures linking it to the glorious blue shell-form lunettes below. On Earth, the Burial of the Virgin is taking place, while a whirl of angels carries her upwards to St. Michael, who awaits her in heaven, watched by a frantically crowded, ascending spiral of apostles, saints, and biblical characters. The billowing clouds breathe air, weightlessness, into the ascending rhythms—features that were to become hallmarks of the baroque.

The Baroque in Southern and Western Europe

The baroque period coincided with the great age of exploration and circumnavigation, which resulted in the Renaissance emphasis on geometry being married with the new sense of an expanding world. Architecturally, this was expressed as a "stretching" of space, particularly from the circle to an ellipse form, which was designed to have an emotional impact on the viewer. Copernicus's *De revolutionibus,* published in 1543, profoundly changed cosmological concepts, propounding the theory that the planets, including the Earth, move in elliptical orbits around the sun. This new vision of the solar system was doubtlessly influential in the development of elliptical forms in baroque architecture. Beginning with Michelangelo Buonarotti's revolutionary design for St. Peter's (begun 1546), distinguished by its unclassical use of classical forms, Rome now came into its own as a city of new architectural developments with a fresh offering of genius architects.

Influenced by Michelangelo's principles of design, Francesco Borromini's (1599–1667) approach to architecture was singular, a result of his practical beginnings as a builder and trained specialist, and his subscription to Galileo's concept that the essence of nature is circles, triangles, and other geometric forms. After working on the decoration of St. Peter's as an assistant to Bernini (see below), the commission from the order of the Spanish Discalced Trinitarians for the monastery of San Carlo alle Quattro Fontane in

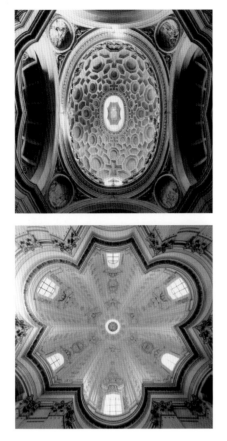

San Carlo alle Quattro Fontane (*see p. 84*)

Sant'Ivo alla Sapienza (*see p. 85*)

Rome (1638–41) was an opportunity to prove himself as an architect. The Trinitarians were not a wealthy order, so the challenge was to achieve richness and complexity without the use of rich materials. Although well positioned in the center of Rome, the monastery's block was a small one, so a further challenge was to create a sense of spaciousness in a restricted space. Borromini achieved this through the complex geometrical manipulation of overlapping circles, triangles, and ellipses. The interior is a rhythmic, open plan of tall, narrow columns, recesses that open up the space horizontally, and arches that open it vertically. This sweeping interior space with its dynamic articulation leads the eye up to the elliptical dome, rising above a barrel vault. The motif of the cupola, crosses and lozenges that increase in size as they approach the rim, is a curious though marvelous feat of architectural illusionism. Its membranous quality makes it seem higher and lighter, as if it were floating above the space. Borromini emphasized this effect by lighting it uniformly, from both above and below. The church inaugurated the high baroque in Rome and was an immediate success, attracting architectural enthusiasts from all over Europe.[24]

Borromini's next commission would become his masterpiece, the university church of Sant'Ivo alla Sapienza in Rome (1642–50). From the ellipse, he moved to a radical treatment of the dome form, eschewing even recent developments in curved space and designing an entirely fresh geometric configuration. This important commission came from Pope Urban, so Borromini was not constricted in his use of materials and labor. The centralized floor plan of overlapping geometric figures was infinitely more complex than San Carlo's, consisting of six circles superimposed upon a six-pointed star formation. This beautiful, parterre-like form is echoed in the dome, where hemispherical space resolves it into a kind of star-flower: six airy, multi-faceted, windowed recesses with pale stucco ornament are set between the strong ribs. Ingeniously, Borromini has made the windows themselves a feature, emphasizing them with the only elaborate ornament in the dome instead of relegating them to the sidelines, where they would modestly emit light without encroaching on the experience of the dome. The architect's dynamic stretching of circular space, apparent in both churches, profoundly influenced later baroque architects.

Gian Lorenzo Bernini (1598–1680) is perhaps chiefly known as one of the greatest sculptors; his Trevi Fountain in Rome is a byword for the baroque. He is the only Italian artist of the period to have produced a work that is still controversial: his darkly massive, looming sculpture that marks the grave of the first pope at St. Peter's continues to invoke both reverence and revulsion. Within the context of the early history of domes this is a highly interesting work, for it is a baldachin, or *baldaccino*, and was inspired by biblical descriptions of King Solomon's Temple—as were so many royal builders of domes; its twisted columns were modeled on those preserved from Emperor Constantine's first basilica. The glory associated with these antique items would have appealed strongly to Bernini, who had a high sense of drama and a gift for theatrical effects, both of which he fully expressed in

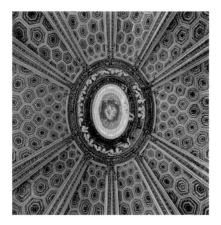

Sant'Andrea al Quirinale (see p. 86)

his architecture. SANT'ANDREA AL QUIRINALE in Rome (1658–61) was his own favorite work. Its dome is elliptical in form, and a glance will reveal that it was in part influenced by Borromini's earlier San Carlo dome, particularly in the lozenge form of its coffers, whose decrease in size towards the oculus gives an illusion of greater height. The rich gold that irradiates the dome and the sculpted cherubim peeping down from heaven, however, are pure Bernini. These and the Holy Dove set within its luminous gold oval are his representation of heaven. Bernini was not interested in creating a new spatial vision of heaven. In his view, if the dome symbolizes heaven, then the chief requirement was to communicate to the congregation the overwhelming desirability of being in this perfect place. So he made the area below the cupola a theater in which this powerful desire is eternally enacted. From a break in the pediment above a door emerges Antonio Raggi's marvelously expressive, larger-than-life sculpture of the suffering Sant'Andrea. He gestures yearningly toward heaven, his face pleading to journey upwards to its dome, drawing the congregation not only into the drama of his suffering, but the drama of the architecture as well. With this, Bernini not only introduced three-dimensional movement and pure theater into church story-telling, he also integrated the dome with art and architecture in an adventurous and highly imaginative way.

Some of the most brilliant expressions of baroque architecture can be found in Turin, which during the seventeenth century was the capital of the powerful house of Savoy. In contrast to the opulent extravagance of Bernini's Roman domes, Turin's baroque architecture is, though equally gravity-defying, more restrained in nature, expressive of an obsession with the mathematics of geometric structure. Guarino Guarini (1624–1683), a Theatine monk, led a peripatetic life whose only settled period was his last fifteen years, which he spent at Turin. At various times—in Paris, Lisbon, and parts of Italy (some speculate that he must have traveled to the Orient)—Guarini held important court appointments as, respectively, philosopher, mathematician, engineer, and architect. Some modern scholars consider him to be the greatest of baroque architects, perhaps because his diverse knowledge equipped him to so supremely fuse the mystical with the mathematical. Unlike his contemporaries, Guarini did not despise the ribs and buttresses of Gothic architecture. His complex, ingenious method of replacing the solid dome with interlocking ribs enabled him to build his churches to a vast height, dome upon dome, as it were. SAN LORENZO (1668–87), one of only two of his several works to have survived, is where he first experimented with these intricate banded vaults. Given that he traveled to Lisbon, it is tempting to think Guarini may have visited Spain and derived his radical design from the Mosque at Cordoba or even the Iglesia del Santo Sepulcro in Torres del Rio. As Stephenson's photograph impressively shows, Guarini wished light to be sensed as a tangible presence. Of all the domes Stephenson photographed, this one is the most dramatically illuminated, effulgence streaming in through the lantern windows—their kidney shape another Guarini invention—and those of the

San Lorenzo (see p. 89)

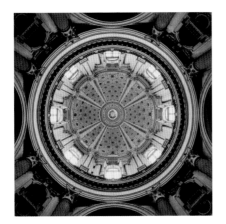

BASILICA DI SUPERGA (*see p. 93*)

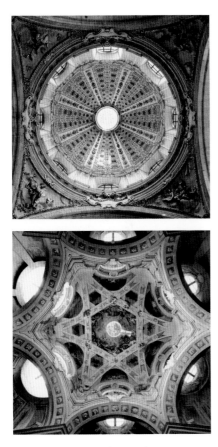

DUOMO at Como (*see p. 91*)

CAPPELLA DELLA VISITAZIONE
(*see p. 94*)

drum. Here geometry takes again centerstage, with the frescoes being pushed into the wings, mere intervals between the imposing arched windows of the drum. Like a network woven by some giant spider, the great binding intersecting arches span the ring of the dome, forming a symmetry of squares, rectangles, hexagons, stars, triangles, and rhomboids. It is as if Guarini, like the scholar in Pinturicchio's painting, is preoccupied with solving the mystical geometric problem of squaring the circle. "This type of vault is my own," he wrote proudly in his influential treatise, *Architettura Civile ed Ecclesiastica.*

In contrast to this celebration of architectural anatomy, Filippo Juvarra's later BASILICA DI SUPERGA at Turin (1717–31) seems weightless. Juvarra (1678–1736), who trained under his goldsmith father and later in Rome, early in his career became known as a skilled stage designer throughout Europe. He was interested in geometry but deployed it as an illusion, translating it into decorative stuccowork that denies the dome's heavy structure. This lightness is also due to the unusual absence of a pendentive zone beneath the cupola, which is supported by a continuous circular entablature with eight columns. The dome's even lighting can be attributed to the architect's experience with lighting effects in the theater. Juvarra had come to Turin in 1714, the same year he was appointed First Architect to the King by King Vittorio Amedeo II of Savoy, for whom he designed four royal residences and a number of churches. He also designed major extensions to the city of Turin. The eclecticism of his architecture stemmed from his scholarly interest in the subject. Juvarra had worked in Rome for ten years at the studio of Carlo Fontana (1638–1714), who designed in an academic late-baroque style. The punctured surfaces of the central golden motif in Fontana's beautiful cupola for the DUOMO at Como (1688) derive from Bernini and were in turn taken up by Juvarra, becoming a feature of much of his work. While in Rome, Juvarra managed to study the entire Roman historical building inventory. He was particularly interested in Michelangelo and the Roman baroque masters. His fusion of classical, baroque, and rococo elements with rich unorthodox detail was a formative influence on one of his greatest pupils, Bernardo Vittone.

Vittone (1702–1770) was the heir to Guarini's and Juvarra's architectural legacy in Turin. He was intimate with the work of both. He trained under Juvarra in Rome between 1731 and 1733, and on his return to Turin he was commissioned by the Theatine order to have published Guarini's architectural treatise; in so doing he studied and absorbed the lessons of his other master. Being so different from each other, Juvarra and Guarini were an ideal pair of teachers. In his own work Vittone blended Guarini's mastery of skeletal structure and Juvarra's eclecticism and scholarship with his own highly poetic creative imagination. He also developed Juvarra's punctured surfaces in a markedly individual way. Vittone's dome for the CAPPELLA DELLA VISITAZIONE near Carignano (1738–39) playfully reinterprets and embellishes Guarini's San Lorenzo, translating Guarini's powerful geometry into an open weave. The architect became noted for open structures of this kind and the

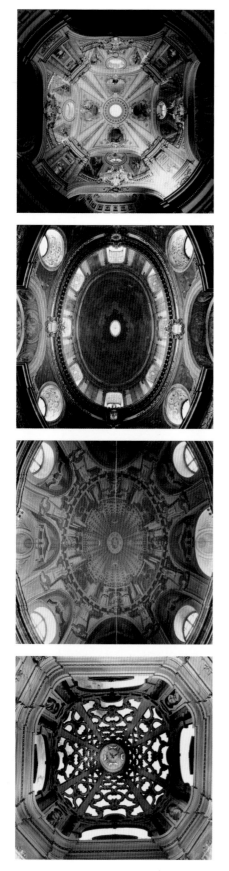

way light diffuses through them, as can be seen from his exquisite dome for SANTA CHIARA in Bra (1742–48).

Vittone, a prolific reader and writer, was influenced by the great architect of the Austrian Baroque, Fischer von Erlach (see below), whose sketched archeological reconstructions had recently been published and were all the rage in Rome. He responded with pleasure to these detailed drawings of triumphal arches, curved porticoes, and domes with antique motifs, incorporating them into his interior designs from whence they filtered through to his architecture. In its studied orchestration of a plethora of design elements, the cupola of Santa Chiara is a virtuoso work. Vittone incorporates references to the antique—classical statuary flanked by marbled columns surmounted by entablatures—with numerous rococo cartouche and rocaille motifs containing angels with spread wings, not to mention fresco inserts, round windows, and diagonal ribs. Yet astonishingly, the dome is not crowded or overwhelming; on the contrary, it is the light, exuberant expression of an architect in love with these forms. Italians have a delightful expression for describing Vittone's work: *di scherzo e bizzaria*—playful and incongruous. In a sense it is the Italian rococo equivalent of postmodern "quotation" in architecture.

Antonio Galli Bibiena (c. 1700–1774) was even more theatrically oriented, though his background was strongly artistic as well: he belonged to a dynasty of painters, architects, and designers. The entire family worked in a lavish baroque style, creating drawings, theater designs, and opera houses dripping with baroque ornament. It was the Bibiena family who reinvigorated the late baroque through their introduction of stage design skills and *trompe l'oeil* schemes of decoration. Antonio Bibiena began his career by assisting his father, a master of festival decorations, and then his uncle, who designed theater sets. He went on to Vienna where he worked with his brother on theater decoration. The two brothers invented the diagonal stage, which became a dominant feature of eighteenth-century theater. In Vienna, Bibiena began to receive important architectural commissions for churches. He assisted with the completion of PETERSKIRCHE in Vienna (1702–33), which was designed by another architect, Johann Lukas von Hildebrandt (1668–1745). Its dome is almost a copy of designs by the great Fischer von Erlach (see below), and Bibiena's hand is not discernable. The dome of the HOLY TRINITY in Bratislava (1717–45) is more original. As a young designer eager to prove himself as an architect, Bibiena here does something remarkably clever: he borrows the Fischer von Erlach-inspired dome of Peterskirche and adapts it as the "ceiling" of the theatrical set-piece "room" the *trompe l'oeil* dome gives the illusion of being.

Bibiena's love for theatrical effects was quite different from Bernini's instinct for dramatic performance. His was, rather, a love for the stage set itself: an interest in illusion and disguise, sleight of hand, and the visual tricks of *trompe l'oeil* painting. Bibiena brought all of this to his design of SANTA MARIA ASSUMPTA (c. 1770), which was commissioned after his return to Italy. The church is in the city of Sabbionetta, which is in itself interesting

SANTA CHIARA (*see p. 95*)

PETERSKIRCHE (*see p. 142*)

HOLY TRINITY in Bratislava (*see p. 143*)

SANTA MARIA ASSUMPTA (*see p. 96*)

because Sabbionetta was designed as an entire Renaissance city by Renaissance town-planners. The city's complicated geometric plan is reminiscent of Borromini's architecture. Bibiena's dome is a superb piece of theatrical illusionism; in Stephenson's photograph it seems certain that the blue beyond its pierced fretwork is most definitely the sky. Bibiena achieved this effect by designing an unusually formed double-dome, the outer one with a *trompe l'oeil* painted sky glimpsed through the inner one resembling a fretwork pergola. The heavy frame of the drum reinforces the lightness and delicacy of the pergola.

Italy allowed its architects the independence and intellectual freedom to create these baroque masterpieces. In other countries architects tended to be more constrained by ecclesiastical or royal patrons. The baroque in England and France was in comparison to Italy quiet and classical, still under the spell of the Renaissance and its circular dome, although Italian developments inevitably filtered through. The baroque emphasis on dramatized space and rich ornamentation was particularly suited to the divine pretensions of French royalty, but it was not fully integrated into French styles until the flamboyant reign of the Sun King, Louis XIV. François Mansart (1598–1666) was born in the same year as Bernini and worked throughout the period of the Italian baroque and high baroque, yet he is regarded as France's first great Renaissance architect. The elegant mansard roof, which he used on his numerous chateau designs, is named after him. Mansart's achievements were singular considering that he was not formally educated as an architect, having been trained by his brother-in-law, from whom he received knowledge of classical design. It is clear that he also followed the developments in Italy, though he never traveled there, as his serene dome in ST. MARIE DE LA VISITATION in Paris (1632–33) reinterprets Borromini's accentuated windows and handling of stuccowork within a circular framework. Mansart, who later designed one of the dazzling interiors at Versailles, began the VAL DU GRACE in Paris (1645–1710), which was built to commemorate the birth of Louis XIV. Inspired by classical architecture, Mansart favored monumental forms, so, like Bernini, he had the chapels open directly onto the apse in order to accentuate the dome above. The cupola itself was designed by Jacques Lemercier (c. 1585–1654), who had previously worked in Rome for seven years. Lemercier's dome is a blend of Italian Renaissance and baroque elements with its dominating circle, dramatic lighting, and a painted swirl of figures spiraling heavenward amidst clouds. The fluid stuccowork anticipates French rococo, and the inscription circling the dome, linking the Bourbon kings to God in heaven, is also distinctly French.

The imposing ST. PAUL'S CATHEDRAL in London (1675–1711) might be described as Sir Christopher Wren's life's work, although he designed fifty-two churches in all. Wren (1631–1723) worked on remodeling the old Romanesque cathedral before the Great Fire of London in 1666, which burnt it to ashes, and for years afterwards, producing in all three plans, which required the approbation of a stern ecclesiastical committee before building could commence. The Anglican Church, steeped in tradition, wanted a "real" cathedral, and

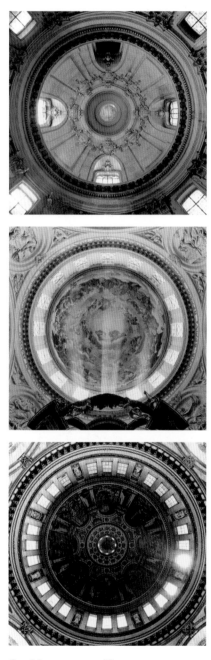

ST. MARIE DE LA VISITATION
(see p. 100)

VAL DU GRACE (see p. 99)

ST. PAUL'S CATHEDRAL (see p. 101)

the reestablishment of the Stuart monarchy reaffirmed those traditions. Wren, a scholar of anatomy, astronomy, and mathematics who began his working life as a professor of anatomy, was well aware of continental developments, in science and thinking as well as architecture. He had traveled abroad and in Paris met both Mansart and Bernini, whose initial design for the Louvre he thought marvelous. As a result he searched for an architectural language that was both modern and acceptable to Restoration England. His design is an extraordinary amalgamation of architectural forms, classical and contemporary. Externally, in spite of its many diverse, and one would think opposing, features the cathedral manages to be majestic. This is perhaps due to its massive symmetry and the way the dome, rising above the tambour's balustraded circle of columns, is flanked by two tall towers capped by mini-domes. The triple-shelled dome itself is enormous, over 350 feet high—so high that looking up at its oculus is like looking through a telescope at a distant planet, an experience Wren would have been familiar with as an astronomer. Wren was not trained as an architect, and it is tempting to think that his early life as an anatomist in large part substituted for this lack, driving his talent for analyzing, dissecting, and rearranging the corpus of existing forms. In this age of skyscrapers it is perhaps difficult to imagine how enormous and amazingly high St. Paul's seemed at the time it was built. It was surely St. Paul's that the great English poet, Alexander Pope, was thinking of when he wrote these wry lines from *The Temple of Fame* in 1712:

> There massie Columns in a Circle rise,
> O'er which a pompous Dome invades the Skies
> Scarce to the Top I stretched my aching Sight,
> So large it spread, and swelled to such a Height.

The baroque was eminently suited to Catholic Spain, although until the eighteenth century, when it became the dominant mode, it defies the categories of early baroque, late baroque, and rococo, which are more or less clearly demarcated in Italy. The situation in Spain was vastly different from Italy, where great architecture was documented and its architects and artists were written about and eulogized. Spanish architects and makers of the early baroque period did not attain this personality status, and many of them were even anonymous. However, splendid, highly ornamented architecture was produced, much of it stylistic developments of specific regions mixed with Renaissance and mannerist influences introduced through Hapsburg patronage.

Granada in Andalusia remained the ideal city although it was now Catholic, its conquest in 1492 having completed the Reconquista; in the sixteenth century, Charles V had a Christian palace and cathedral added to the Alhambra complex. Due to its magnificent Moorish architectural heritage baroque developments in Andalusia, particularly in Granada,

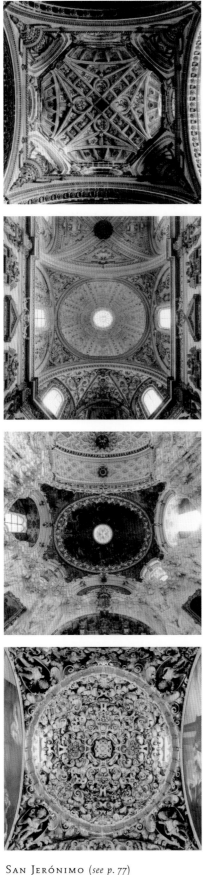

were different from those in the rest of Spain. Moorish influence prior to the baroque period is evident in the highly idiosyncratic though beautiful dome of SAN JERÓNIMO in Granada (1523–43) by Francesco Florentino and Diego de Siloe (c. 1495–1563). Siloe was an architect who worked on the nave of the Granada cathedral a century before its completion by another; little is known about him and even less of Florentino. Their creation is unique, a work of meticulous craftsmanship with a joyous innocence reminiscent of naïve or folk art. The ribs are presented as diagonal rows of open boxes containing votive statues, while the pendentives are disguised as beautifully carved corbel figures. Dancing amidst this intricate interplay of geometry and statuary are painted angels with billowing draperies.

By 1700 in Granada classical forms were being increasingly overlaid with decoration, heralding the onset of the baroque. Stuccowork, one of the chief means of baroque expression, was introduced to Granada by Francisco de Hurtado Izquierdo (1669–1725), a master builder chiefly employed by the clergy. Several highly embellished churches in Granada are known to have been built by him; LA CARTUJA (begun in 1702) has been ascribed to him. The stuccowork of the dome, with its elegantly arranged floral forms, royal escutcheons, and pendentive angels poised on wreaths, attains the highest degree of artistry in stucco. The SACRISTIA DE LA CARTUJA (1713–42) features even more elaborate stucco embellishment, reminiscent of the stalactite decoration at the nearby Alhambra. The church is sumptuous, like a grotto with an opening at the top revealing the painted cupola with its gold stuccowork, which is in turn surrounded by another fresco. Every surface is covered with luxuriant ornamentation. The baroque concept of the total work of art held a strong appeal for the faithful as such all-encompassing artistic expression was viewed as the embodiment of devotion. From his designs it is evident that Hurtado embraced this concept wholeheartedly.

In Seville, stucco was an equally exuberant means of expression in the dome of SANTA MARIA LA BLANCA (begun 1659). Pedro and Miguel de Borja here translated Islamic arabesque ornament into a new form of dome decoration: a veritable stucco jewel of densely ornamented, interlaced scrolling foliage patterns in deep relief. Its complexity is like the fine filigree work of gold or silversmiths. Like regional art in many parts of the world, Spanish architecture of this period was often highly idiosyncratic and consequently despised right up until the twentieth century, when the rigid canons of "high art" were relaxed and even so-called folk art was discovered to be of great interest.

THE BAROQUE AND ROCOCO IN CENTRAL AND EASTERN EUROPE

In Austria, the baroque was taken to new heights by the masterful Johann Bernard Fischer von Erlach (1656–1723). His father was a sculptor with important connections in the Austrian court, which enabled him to send the fifteen-year-old Fischer von Erlach to study in the very city that became his chief inspiration: Rome. His studies were wide-ranging,

SAN JERÓNIMO (*see p. 77*)

LA CARTUJA (*see p. 110*)

SACRISTIA DE LA CARTUJA (*see p. 111*)

SANTA MARIA LA BLANCA (*see p. 106*)

including the study of architecture under a pupil of Bernini and architectural theory through the writings of great Italians from Vitruvius to Alberti; the many influential scholars who befriended him introduced him to science, mathematics, history, and all kinds of new ideas, in all of which he retained a life-long interest. Fischer von Erlach, who began work under Phillip, a painter and architect to the papal court, imbibed Rome: its antiquity, its classical past, the baroque masterpieces of Borromini and Bernini, and the elaborate temporary buildings constructed for grand festive occasions. All of this he absorbed and later assimilated into his work in Austria.

In the 1690s, Salzburg's prince-archbishop, Count Thun, appointed Fischer von Erlach inspector of buildings and engaged him as his architectural advisor. Count Thun wished to transform Salzburg into the Rome of the North and gave Fischer von Erlach the commission for the Church of the Holy Trinity or DREIFALTIGKEITSKIRCHE (begun 1694). He used as his model Borromini's St. Agnes in Agony in Rome, its central dome rising behind a concave front flanked by two towers. In the interior of the dome he combined elements of Borromini's Roman baroque—the ellipse, the purity of whiteness, the accentuated windows —with slender pilasters and a somber though grand fresco whose figures spiral upward to a darkly circled "eye of God" oculus. The translation of the crowded baroque swirl into an oval composition is superb, as is the fresco's setting deep within the high tambour of the dome, where it provides a dramatic contrast to the elegantly articulated architecture that presents it to the viewer. The Church of the Holy Trinity introduced a new energy and individualism that gave distinction to the Austrian baroque.

Fischer von Erlach's talent for combining disparate, eclectic elements led to his being acclaimed as "a master of syncretism." The highly individual facade of the KARLSKIRCHE in Vienna (1716–24) is sheer genius, a truly adventurous fusion of numerous elements derived from classical and baroque Rome. Trajan's Column is doubled here, forming two soaring Oriental-style minarets that flank a classical pediment with columns. As one commentator has observed, "Here biblical, imperial, antique, Solomonic, Roman baroque and many influences coalesce."[25] The complexity of Karlskirche, together with the focus on the dome, are similar to Wren's St. Paul's, although the effect here is more elegant and far more harmonious. In the interior of the dome Fischer von Erlach repeated the Holy Trinity format. He sought to improve upon it by framing the fresco (by Johann M. Rottmayr) with dark articulation around the edge of the tambour, which gives it a certain funereal quality, and by interrupting its space with circular windows. Which of the two cupolas is the more successful is a matter of taste. The title "von Erlach" was conferred on Fischer in recognition of his success. In 1721 he published his *Entwurf einer Historischen Architektur*, which became highly influential for over a century, particularly on French neoclassicism. Among those it inspired was the great architectural visionary Andre Bouleé, whose futuristic flights of fancy were, regrettably, largely confined to works on paper.

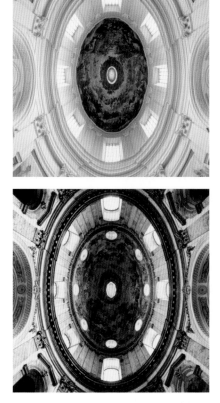

DREIFALTIGKEITSKIRCHE (*see p. 140*)

KARLSKIRCHE (*see p. 141*)

In Germany the baroque developed later than in other countries due to the Thirty Years War, which left many of its palaces and churches destroyed. A new spate of building finally began towards the end of the seventeenth century. The mood of the baroque princes and dukes was strongly attuned to festivities and theatrical entertainments, and this world of play and illusion was absorbed into German architecture, where it was readily taken up and developed into the fantasy realms of the rococo by the Asam brothers, the Zimmermanns, and others.

Although both brothers were architects, Cosmas Damian Asam (1686–1739) was primarily a painter of frescoes and his younger brother, Egid Quirin (1692–1750), primarily a sculptor. After the death of their father, a leading Bavarian fresco painter, the brothers were taken under the wing of an abbot who sent them to study in Rome. On their return to Bavaria they became much in demand as decorators of churches, where ceiling painting was becoming the chief means of ornamention. Cosmas Asam's Italian training is immediately evident in the painted dome of WEINGARTEN ABBEY (1715–20), where a heavenly host whirls amidst clouds and intense blues, with a darker ring of figures clustered around the golden oculus. It was in the Benedictine Abbey at WELTENBURG (1716–21) that Cosmas Asam came into his own as a master of illusionistic devices, combining elongated elliptical architecture with painting, sculpture, invisible lighting, and gilt stuccowork to create a jewel-like richness. As in much of Bernini's work, the atmosphere of great emotional intensity spills over into pure theater. The form of a double dome looks almost like a marvelous, greatly magnified cameo brooch. It is unusual in that the central area with its painted columns is, in fact, flat, painted so as to appear curved. The fresco is a triumph of illusionism with a golden flurry of figures occupying one half, while in the other the space is allowed to breathe between the circle of clouds and the outer figures looking out or down over a delicately ornamented fence. This composition—crowding the figures into one half of the picture—is a fresh departure, intensifying the drama. Egid Asam's fine gilt stuccowork with its intricately modeled classical figures gleams like bronze. The subject is a glorious one—the Church Triumphant—although Cosmas Asam's playfulness is evident in the sculpted figure of himself in the gallery, leaning over the rail and smiling down at us.

The Zimmermann bothers were born in the stuccowork center of Bavaria and both trained under a leading stuccoist and architect. They were accomplished stuccoists, but Domenikus Zimmerman (1685–1766) became one of south Germany's greatest rococo architects, while his brother Johann Baptist (1680–1758) achieved fame as a painter of genius. Both were exceptional craftsmen who married local traditions of country craftsmanship, which went back to the Middle Ages, with the courtly world of the rococo, fusing them seamlessly. The brothers were intensely pious Roman Catholics, and they expressed their faith in deliciously light, exquisitely painted interiors that have been aptly compared to Meissen porcelain. Moreover, their churches are distinguished by a fluid

WEINGARTEN ABBEY (*see p. 137*)

WELTENBURG (*see p. 145*)

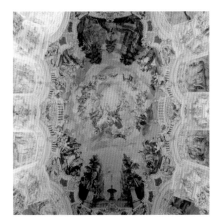

St. Peter and Paul (see p. 146)

handling of space, which makes it impossible to tell where architecture ends and decoration begins. Like several other Bavarian rococo churches, the interiors of those by the Zimmermanns present a wonderful surprise to the visitor, for like a box of goodies they are wrapped in external architecture that is elegant but relatively simple. A sense of delight pervades the Zimmermanns' work, as can be seen from the garden perspectives and the airy heavenly vista of the garden of Paradise as depicted on the cupola of St. Peter and Paul at Steinhausen (1728–31). Johann Baptist Zimmerman dispensed with the usual crowding of figures; the perspective of the surrounding balustraded balconies cleverly suggests other spectators, who are invisible to the viewer. Domenikus Zimmermann introduced a "pier oval," an additional oval form, into the elliptical ground plan so that the illusionistic balconies above, with their playfully climbing and balancing putti, arise uninterruptedly from the architecture and merge with the real arches and cornices below. The message that heaven is distant but accessible to believers is charmingly suggested by animals randomly placed in the stuccowork: a magpie in its nest, a woodpecker on the pier, a squirrel, a butterfly, and a hoopoe. The mystical, indirect lighting of the Asam brothers was abandoned in favor of direct lighting to intensify the stucco's brilliant whiteness, resulting in a blissful sense of weightlessness.

This innocent, pastoral world was reworked to even greater effect at the Wieskirche at Wies (1745–54), perhaps because the Zimmermanns took inspiration from its surrounding natural environment. The church stands amidst fields and woods at the foot of the Bavarian Alps—hence "Wies," which means field. It was commissioned not by the church or the aristocracy, but by a local farming community. Dominikus Zimmermann here abandoned the ellipse for a plan of two semi-circles attached to a rectangle, although he retained the great central space of St. Peter and St. Paul, together with its lightness, brilliance, and porcelain delicacy. In the dome, Johann Baptist Zimmermann retained the *trompe l'oeil,* balconied composition of the earlier fresco, but here the vista is broader and even more opened up, creating a vertiginous space where at least one of the floating figures seems about to plummet from the heavens. Unusually, the blinding light of heaven has been pushed off-center, the asymmetry introduced by Asam now becoming a feature of German rococo. The fresco depicts Christ on a rainbow prior to his sitting on the throne for the Last Judgment. To the west is the portal of heaven and to the east the Mercy Seat. The painting is delicately framed by white and gold rocaille, or shell-formed stuccowork. Heavenly symbolism—the Eye of God, the Descending Dove—spills down to the area above the altar and to the base of the pulpit below, where a boy holds a fish. Everything in the work of the Zimmermann brothers is highly symbolic of their faith, even their choice of color. The Wieskirche is considered by many to be the triumph of south German rococo.

Farther east, in the Czech Republic, Jan Santini-Aichel produced fascinating, highly idiosyncratic architecture that has come to be termed baroque Gothic. Santini-Aichel

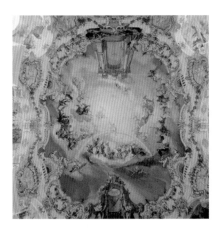

Wieskirche (see p. 147)

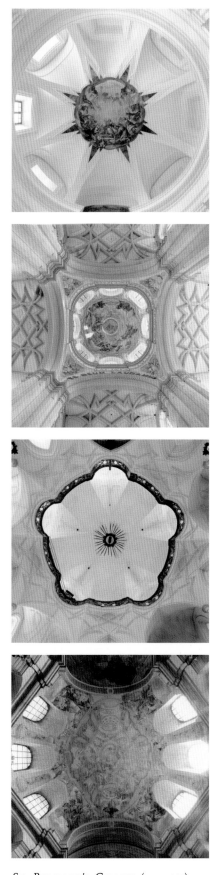

St. Bernard's Chapel (*see p. 149*)

Benedictine Monastery (*see p. 150*)

Chapel of St. Jan Nepomuk (*see p. 151*)

St. Peter and Paul (*see p. 148*)

(1667–1723) was born in Prague, in what was then known as Bohemia. He was placed in charge of monastic architecture in Bohemia and Moravia, becoming one of Bohemia's greatest architects. The preference for Gothic forms was instigated by a program in the seventeenth century to re-Catholicize Bohemia, where the Gothic was seen as synonymous with the Catholic faith. Santini-Aichel began his career remodeling Gothic churches partly destroyed during the Thirty Years War, and this work gave him an intimate knowledge of Gothic forms, particularly the Flamboyant Gothic of Northern Europe. With the new pilgrimage churches and mercy chapels he designed, he integrated these forms within the manipulated space of the baroque. He drew from a wide range of sources, from the international—Borromini and Fischer von Erlach, among others—to the local vernacular, particularly Bohemia's bud-shaped mercy chapels. The architect's restless search for ever-new configurations resulted in a fresh approach with each building he designed, as is illustrated here by Stephenson's photographs of four of his domes. In this respect he had a great deal in common with Cosmas Asam, and the two of them indeed formed a harmonious though brief aesthetic relationship, working together on the decoration of the BENEDICTINE MONASTERY at Kladruby (1712–26). Santini-Aichel replaced the Romanesque three-apsed church, destroyed in the Thirty Years War, in accordance with his own highly individual interpretation of the Gothic, introducing a central clover-leaf choir—a form he favored—and unifying the diverse interior spaces by means of vault ribs. The powerful dome rises above the elegant tracery-work of the crossing, the warm tonality of Asam's swirling octagonal fresco, framed by the dazzling light of high windows, enlivening its creamy rococo color scheme.

Santini-Aichel's later CHAPEL OF ST. JAN NEPOMUK on Green Mountain near Zd'ar (1719–22) shows a Borromini-like modeling of space. Here he developed the traditional Bohemian star-shaped mercy chapel, transforming it into the five-arm star symbolic of St. Jan Nepomuk—according to legend five stars surrounded the head of the saint after he was drowned in the River Vltava. The emphasis here is not on decoration but on the linear movement of both its cornice tracery and the mock balcony that outlines it. The form of the dome is sculptural, a play of faceted curves and rectangles that in turn form an abstraction of the symbolic five-pointed star.

The ST. PETER AND PAUL Benedictine Monastery at Rajhrad (1722–24) illustrates Santini-Aichel's command of architectural moods and styles. Within the space of a year he moved from the clarity of the chapel's abstracted forms to baroque-inspired grandeur. The monastery's cupola is quite unarticulated, the focus being on the splendor of its windows and the magnificent illusionistic fresco, which combines baroque movement at the edges with an exquisite rococo centerpiece.

The clearly demarcated relationship between the baroque and rococo in this dome is unusual and indicates that by this late stage in the development of the south German

baroque, the wide range of forms available to the architect had become a kind of artist's palette from which he could select and mix various motifs and embellishments.

THE NINETEENTH CENTURY

The nineteenth century was the era of historicism: the styles of virtually all great periods of architecture were retranslated with characteristic Victorian reverence for history. Domes were modeled on the great domes of the past just as, in a sense, they always had been. Part of the immense power of this architectural form is that it resonates with archetypal as well as more localized, temporal meanings. MADONNA DEGLI ANGELI in Turin (begun in 1665) is a perfect example. The sunburst dome by Carlo Ceppi (1829–1921) was executed much later, in 1901. The circle as a symbol has its origins in primitive sun worship. In Zen Buddhism it represents enlightenment and completeness. The early sun-wheel evolved into the Eastern rayed mandala, and in the medieval period there is Dante with his cosmic mandala and flaming sun-wheels. By the seventeenth century, the Christian church had adjusted to Copernicus's sun-centered universe. It is clear how this history of ideas is fused in the great, golden, rayed sun-wheel of Madonna degli Angeli.

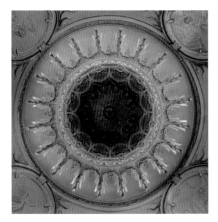

MADONNA DEGLI ANGELI (*see p. 155*)

The late nineteenth century marks the end of stylistic developments of the dome in sacred architecture, and indeed the demise of the dome as architecture's most awe-inspiring form. Since the early years of the twentieth century, that distinction has been usurped by the skyscraper.

Humankind has always yearned for immortality and a sacred, transcendent sphere—a divine order, a God in heaven, an afterlife. The history of the dome is the history of how that yearning has been expressed through spatial geometry, design, and decoration. The passage of time and the domes' great height obscures this sacred imagery when the cupolas are experienced *in situ*. Stephenson's photographs open it up to view, as it were, by flattening the space and emphasizing the domes as symbolic decorative forms—plays of color, pattern, and light—rather than massive three-dimensional volumes. The photographs have an additional revelatory function as a typology: Stephenson's collecting, classifying, and cataloging of the domes serves as a record of their geometric and decorative developments through time and across cultures. In this aspect of his work, Stephenson belongs to the tradition of photographers who document aspects of material culture or the natural world that are seen to be under threat from destruction, extinction, or the inexorable passage of time. Even though they span nearly two millennia and were built under vastly different cultures and religions, the common factor of these domes is the association of beauty with the mystical, an association that is remote from the concerns of most present-day architecture. Stephenson's photographs emphasize this beauty while unobtrusively indicating its vulnerability to time and the elements in details such as the water-stains on the Pantheon or the rectangle of sunlight making its way around the Duomo in Padua. There is a certain

poignancy to this, which makes us aware that the building of magnificent structures such as these is now locked firmly into the past, that these domes and the shared sense of a sublime dimension to life, which gave birth to them, are history.

1 For a full account of the origins, type, and development of these early domical forms see Earl Baldwin Smith, *The Dome and Its Origins* (Princeton: Princeton University Press, 1972).

2 Camilla Edwards, "Islamic Domes, in *Domes; Papers Read at the Annual Symposium of the Society of Architectural Historians of Great Britain* (Society of Architectural Historians, 2000), 29.

3 Smith, *The Dome and Its Origins*, 72.

4 Karl Lehmann, "The Dome of Heaven," in *The Art Bulletin,* vol. 27 (March 1945): 4.

5 Rowland Mainstone, "Domes: A Structural Overview," in *Domes; Papers Read at the Annual Symposium of the Society of Architectural Historians of Great Britain,* 5–6.

6 Marguerite Yourcenar, *Memoirs of Hadrian* (Penguin Books, London, 1952), 127.

7 Smith, *The Dome and Its Origins,* 82.

8 Ibid., 79.

9 Lehmann, "The Dome of Heaven," 11.

10 Jane Timkin Matthews, *The Pantocrator: Title and Image* (PhD. thesis, Fine Arts, New York University, 1976), 90.

11 John Ruskin, "Notes for The Stones of Venice," *The Stones of Venice* (London: J. M. Dent & Co., 1907), 15.

12 Orlando Figes, *Natasha's Dance: A Cultural History of Russia* (London: Allen Lane, The Penguin Group, 2002), 297.

13 Thomas Genheimer, "Cordoba: Cathedral/Mosque of Cordoba," *International Dictionary of Architects and Architecture,* ed. by Randall J. van Vynckt (Detroit: St. James Press, 1993), 814.

14 Ibid., 815.

15 Edwards, "Islamic Domes," 35.

16 Quoted by Frederick P. Bargebuhr, *The Alhambra* (Berlin: Walter de Gruyter & Co., 1968), 189.

17 Edwards, "Islamic Domes," 34.

18 Rolf Toman, ed., *Romanesque: Architecture, Sculpture, Painting* (Cologne: Koneman, 1997), 201.

19 John Julius Norwich, *The Architecture of Southern England* (London: Macmillan, 1985), 103.

20 *The Medici,* SBS Television program, screened Australia, 5 January 2005.

21 Guiliano Chelazzi, "Filippo Brunelleschi," *International Dictionary of Architects and Architecture,* 120.

22 Mainstone, "Domes: A Structural Overview," 6–8.

23 Chelazzi, "Filippo Brunelleschi," 121.

24 Wolfgang Jung, "Architecture and City in Italy from the Early Baroque to the Early Neo-Classical Period," Rolf Toman, ed., *Baroque Architecture, Sculpture, Painting* (Cologne: Konemann, 1998), 24.

25 James Stevens Curl, "Fischer von Erlach," *International Dictionary of Architects and Architecture,* 260.

BIBLIOGRAPHY

Benevolo, Leonado. *The Architecture of the Renaissance*. London: Routledge and Kegan Paul Ltd., 1978.

Berton, Kathleen. *Moscow: An Architectural History*. London: Studio Vista/Macmillan, 1977.

Blair, Sheila S. and Jonathan M. Bloom. *The Art and Architecture of Islam 1250 to 1800* (Pelican History of Art). New Haven and London: Yale University Press, 1994.

Bussagli, Marco, ed. *Rome—Art and Architecture*. Cologne: Konemann, 1999.

Conant, Kenneth John. *Carolingian and Romanesque Architecture 800 to 1200* (Pelican History of Art). Harmondsworth, Middlesex: Penguin Books, 1959.

Edwards, Camilla. "Islamic Domes. In *Domes; Papers Read at the Annual Symposium of the Society of Architectural Historians of Great Britain*. Society of Architectural Historians, 2000.

Figes, Orlando. *Natasha's Dance: A Cultural History of Russia*. London: Allen Lane, The Penguin Group, 2002.

Guerra de la Vega, Ramon. *Iglesias y Conventos del Antiguo Madrid*. Madrid: Ramon Guerra de la Vega, 1996.

Hartt, Frederick. *History of Italian Renaissance Art*. New York: Abrams, 1975.

Harvey, John. *English Mediaeval Architects*. Gloucester: Alan Sutton, 1984.

Hempel, Eberhard. *Baroque Art and Architecture in Central Europe* (Pelican History of Art). Harmondsworth, Middlesex: Penguin Books, 1965.

Heydenreich, Ludwig H. and Wolfgang Lotz. *Architecture in Italy 1400 to 1600* (Pelican History of Art). Harmondsworth, Middlesex: Penguin Books, 1974.

Hitchcock, Henry-Russell. *Architecture: Nineteenth and Twentieth Centuries* (Pelican History of Art). Harmondsworth, Middlesex: Penguin Books, 1968.

Hitchcock, Henry-Russell. *Rococo Architecture in Southern Germany*. London: Phaidon, 1968.

Hughes, J. Quentin and Norbert Lynton. *Renaissance Architecture*. London: Longmans, Green and Co, 1962.

Huyghe, Rene, ed. *Larousse Encyclopedia of Renaissance and Baroque Art*. Middlesex: Hamlyn, 1964.

Krautheimer, Richard. *Early Christian and Byzantine Architecture* (Pelican History of Art). Harmondsworth, Middlesex: Penguin Books, 1965.

Kubler, George and Martin Soria. *Art and Architecture in Spain and Portugal and their American dominions 1500 to 1800* (Pelican History of Art). Harmondsworth, Middlesex: Penguin Books, 1959.

Lehmann, Karl. "The Dome of Heaven," in *The Art Bulletin*, vol. 27 (March 1945): 4.

Mainstone, Rowland. "Domes: A Structural Overview," In *Domes; Papers Read at the Annual Symposium of the Society of Architectural Historians of Great Britain*, 5–6.

Matthews, Jane Timkin. *The Pantocrator: Title and Image*. PhD. thesis, Fine Arts, New York University, 1976.

Norwich, John Julius. *The Architecture of Southern England*. London: Macmillan, 1985.

Placzek, Adolf K., ed. *Macmillan Encyclopedia of Architecture*. New York: The Free Press, 1982.

Portoghesi, Paolo. *Roma Barocca: The History of an Architectonic Culture*. Cambridge and London: MIT Press, 1970.

Powell, Nicolas. *From Baroque to Rococo*. London: Faber and Faber, 1959.

Romanelli, Giandomenico, ed. *Venice—Art and Architecture*. Cologne: Konemann, 1997.

Ruskin, John. "Notes for The Stones of Venice." *The Stones of Venice*. London: J. M. Dent & Co., 1907.

Stierlin, Henri. *Islam: Early Architecture from Baghdad to Cordoba*. Cologne: Taschen, 1996.

Smith, Earl Baldwin. *The Dome and Its Origins*. Princeton: Princeton University Press, 1972.

Toman, Rolf, ed. *The Art of the Italian Renaissance*. Cologne: Konemann, 1995.

Toman, Rolf, ed. *Baroque: Architecture, Sculpture, Painting*. Cologne: Konemann, 1998.

Toman, Rolf, ed. *Gothic: Architecture, Sculpture, Painting*. Cologne: Konemann, 1998.

Toman, Rolf, ed. *Neoclassicism and Romanticis: Architecture, Sculpture, Painting*. Cologne: Konemann, 2000.

Toman, Rolf, ed. *Romanesque: Architecture, Sculpture, Painting*. Cologne: Konemann, 1997.

Van Vynckt, Randall, ed. *International Dictionary of Architects and Architecture*. Detroit: St. James Press, 1993.

White, John. *Art and Architecture in Italy 1250 to 1400* (Pelican History of Art). Harmondsworth, Middlesex: Penguin Books, 1966.

Wittkower, Rudolf. *Art and Architecture in Italy 1600 to 1750* (Pelican History of Art). Harmondsworth, Middlesex: Penguin Books, 1973.

Yourcenar, Marguerite. *Memoirs of Hadrian*. London: Penguin Books, 1952.